W9-CED-416

More

Joy of Painting

with

Bob Ross

America's Favorite Art Instructor

by Annette Kowalski

Quill
William Morrow
New York

Copyright © 1991 by Bob Ross, Inc.

All rights reserved. No part of this book may be reproduced or utilized in any form or by any means, electronic or mechanical, including photocopying, recording, or by any information storage or retrieval system, without permission in writing from the Publisher. Inquiries should be addressed to Permissions Department, William Morrow and Company, Inc., 1350 Avenue of the Americas, New York, N.Y. 10019.

It is the policy of William Morrow and Company, Inc., and its imprints and affiliates, recognizing the importance of preserving what has been written, to print the books we publish on acid-free paper, and we exert our best efforts to that end.

Library of Congress Cataloging-in-Publication Data

Ross, Bob, 1942–1995
 More joy of painting / by Bob Ross.
 p. cm.
 ISBN: 0-688-14355-5
 1. Painting—Technique. I. Title.
 ND1500.R655 1991
 751.45—dc20 91-15232
 CIP

Manufactured in China.

First Quill Edition

12 13 14 15 16 17 18 19 20

Mrs. Rosemary Dunlop
1401 Bridge Water Way
Mishawaka, IN 46545

To Jane,
for her many years of personal and business support
without which there would be no
Joy of Painting.

—B. and A.

A LETTER TO THE ARTIST

Perhaps the one common denominator we all share is the desire to paint. It has been said that fully ninety percent of us would like to paint, put our "dreams" on canvas.

I have had the great fortune of traveling and teaching for many years, and many miles, with Bob Ross and I can truly say I have never known a person to admit he had no *interest* in painting. When I meet people who appear to be disinterested, upon investigation I hear "but, I can't even draw a straight line" or "I never studied painting in school" or "I have no talent" or "I just don't have the time" or "I'm too old to devote the years it would take to learn" or "if painting is not difficult, than it is junk art" or "Bob Ross just makes it *look* easy". Have *you* ever heard these comments; do they reflect your own reluctance to attempt this means of enriching your life? If so, then this is the book for you.

Let's begin by examining some of these objections or the fears that you may be experiencing.

I can't even draw a straight line.

You know, I have never seen an artist who draws very many straight lines. And come to think of it, I haven't seen very many straight lines in nature, either. In fact, in my opinion too much drawing, of any type, can make your painting appear tight and over-worked.

I never studied painting in school.

I feel it is a sad commentary that more of us didn't paint as children in school (through no fault of our own) but it certainly does not preclude learning to paint now. Children seem to have no fear or reservation of expressing themselves through painting. Perhaps we should conjure up the child within.

I have no talent.

Perhaps we should redefine "talent"; and examine the notion, that all of us seem to share, that one must be "talented" in order to paint. How many times has Bob Ross said it; "talent is nothing more than a pursued interest".

I just don't have the time.

Have you noticed that somehow we seem to find the time for things we really want to do; perhaps all we need is the desire. One of the most exciting elements of this technique of painting is how little time is required. You will be able to produce a painting in hours, or even minutes; not months, as with more traditional methods.

I'm too old to devote the years it would take to learn.

Age, are we ever too old to learn? To master this method of painting, we are not talking years. I promise you that with very little dedicated time, and a lot of desire, you will be producing your own "masterpieces" in days or weeks.

If painting is not difficult, then it is "junk art".

Yes, unfortunately there are many people who feel that if it is not difficult, then it is not "good". Upon close examination,

you will find that many of the old masters were employing the same "easy" techniques that we advocate in this book.

What is art, anyway? If it pleases you, if it pleases the eye of the beholder, isn't that art? I am not suggesting that your paintings are sure to hang in the world's galleries. But, on the other hand, with the excitement and motivation that come from experiencing immediate results, who knows what doors you will choose to open; what galleries you will hang in?

Bob Ross just makes it look easy.

Yes, Bob does make it look easy; and no, it is not as easy as Bob makes it look. (However, I know of no less difficult method of painting.) Look, let's face it, if Bob didn't make painting appear so easy, you might not even consider making an attempt. If he has created the desire in you to give it a try, to take that first step, then he has succeeded in all he has set out to do. Try it, you'll like it!

This book has been designed to lead you step-by-step through 60 painting projects. Because the projects are not arranged in order of difficulty, and because each set of instructions is self-contained, feel free to start with any one of these beautiful paintings. Read the instructions carefully, before you begin, and then refer to the "How-To" photos as you need them. You can duplicate the painting exactly, or simply use each painting as a guide to creating your very own unique masterpiece.

With the Bob Ross technique of painting, soon you will see how exciting it is to put your very own "dreams" on canvas.

Once you have discovered THE JOY OF PAINTING, may you have MORE JOY OF PAINTING,

Annette Kowalski

Acknowledgements

Thanks again to Bill Adler and the William Morrow Company, for the concept; Jim Needham, WIPB-TV, Muncie, Indiana, for the television series; Joan Kowalski, editorial assistance; Nancy Cox and J. Bruce Scott, how-to photo photography; Ron Markum, cover portrait; Rick Kinkead, you know why; Family, friends, students, loyal television viewers, for years of encouragement.

But most of all, Walt and Jane, for being there and never giving up!

INTRODUCTION

There are no great mysteries to painting. You need only the desire, a few basic techniques and a little practice. If you are new to this technique, I strongly suggest that you read the entire Introduction prior to starting your first painting. Devote some time to studying the instructions, looking carefully at the "how-to" pictures and at the finished paintings. Use each painting as a learning experience, add your own ideas, and your confidence as well as your ability will increase at an unbelievable rate. For the more advanced painter, the progressional "how-to" photographs may be sufficient to paint the picture.

PAINTS

This fantastic technique of painting is dependent upon a special firm oil paint for the base colors. Colors that are used primarily for highlights (Yellows) are manufactured to a thinner consistency for easier mixing and application. All of the paintings in this book were painted with the Bob Ross Paint Products. The use of proper equipment helps assure the best possible results.

The Bob Ross technique is a wet-on-wet method, so normally our first step is to make the canvas wet. For this, apply a thin, even coat of one of the special base paints (Liquid White, Liquid Black or Liquid Clear) using the 2" brush. Long horizontal and vertical strokes, assure an even distribution of paint. The Liquid White/Black/Clear allows us to actually blend and mix colors right on the canvas rather than working ourselves to death on the palette.

The Liquid White/Black/Clear can also be used to thin other colors for application over thicker paints much like odorless thinner or Copal Medium. The idea that a thin paint will stick to a thick paint is the basis for this entire technique. This principle is one of our Golden Rules and should be remembered at all times. The best examples of this rule are the beautiful highlights on trees and bushes. Your Liquid White/Black/Clear is a smooth, slow-drying paint which should always be mixed thoroughly before using.

Liquid Clear is a particularly exciting ingredient for wet-on-wet painting. Like Liquid White/Black, it creates the necessary smooth and slippery surface. Additionally, Liquid Clear has the advantage of not diluting the intensity of other colors especially the darks which are so important in painting seascapes. Remember to apply Liquid Clear *very* sparingly! The tendency is to apply larger amounts than necessary because it is so difficult to see.

Should your Liquid White/Black/Clear become thickened, thin it with Ross Odorless Thinner (not turpentine or other substances).

I have used only 13 colors to paint the pictures in this book. With these 13 colors the number of new colors you can make is almost limitless. By using a limited number of colors, you will quickly learn the characteristics of each color and how to use it more effectively. This also helps keep your initial cost as low as possible. The colors we use are:

*Alizarin Crimson	*Sap Green
Bright Red	*Phthalo (Phthalocyanine) Blue
*Dark Sienna	*Phthalo (Phthalocyanine) Green
Cadmium Yellow	Titanium White
*Indian Yellow	*Van Dyke Brown
*Midnight Black	Yellow Ochre
*Prussian Blue	

(*Indicates transparent or semi-transparent colors, which may be used as underpaints where transparence is required.)

MIXING COLORS

The mixing of colors can be one of the most rewarding and fun parts of painting, but may also be one of the most feared procedures. Devote some time to mixing various color combinations and become familiar with the basic color mixtures. Study the colors in nature and practice duplicating the colors you see around you each day. Within a very short time you will be so comfortable mixing colors that you will look forward to each painting as a new challenge.

Avoid overmixing your paints and strive more for a marbled appearance. This will help keep your colors "alive" and "vibrant." I try to brush-mix a lot of the colors, sometimes loading several layers of color in a single brush. This double and triple loading of brushes creates effects you could never achieve by mixing color on the palette. Pay very close attention to the way colors are loaded into the brushes or onto the knife.

THE PAINTER'S GLOVE

To solve the problem of removing paint from hands after completing a painting project, try using a liquid hand protector called THE PAINTER'S GLOVE, which I developed. This conditioning lotion is applied to the hands *before* you begin painting. Then, simply wash with warm, soapy water.

PALETTE

To me, my palette is one of the most important pieces of equipment I own. I spent a lot of time designing the palette I use, making it both functional and comfortable. It is large enough to provide ample working space for the large brushes and knives, yet lightweight. I recommend that your palette be made from a smooth, nonporous material such as clear acrylic plastic. Avoid wooden palettes which have not been varnished, or fiberboard or paper palettes. Wood palettes are rarely smooth and, unless well sealed, will absorb the oil from your paint as will fiberboard and paper. These types of palettes can cause your paint to become dry and chalky causing numerous problems. My palette is clear, so it will not distort color, is extremely smooth for easy brush or knife loading, and the plastic will not absorb oil and is easy to clean.

Form the habit of placing your paints in the same location

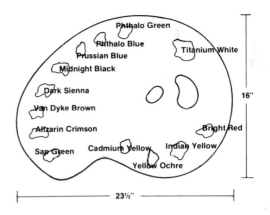

on your palette each time you paint. You can spend an unbelievable amount of time looking for a color on an unorganized palette. The illustration gives the dimensions and color layout of my palette as used on the TV series.

Unused colors may be saved for several days if covered with plastic wrap or foil; for longer periods, cover and freeze. To clean your palette, scrape off excess paint and wipe clean with the thinner. Do not allow paint to dry on your palette. A smooth, clean surface is much easier to work on.

BRUSHES

The brushes you use should be of the finest quality available. Several of the brushes I paint with look very similar to housepainting brushes, but are specifically designed for this method of painting. They are manufactured from all-natural bristles and come in four basic shapes: 2", 1", 1" round and 1" oval. Be careful not to confuse natural bristle with man-made bristles such as nylon, polyester or other synthetic bristles. AVOID WASHING THE BRUSHES IN SOAP AND WATER. Clean your brushes with odorless thinner.

The four large brushes will normally be your most used pieces of equipment. They are used to apply the Liquid White/Black/Clear, paint clouds, skies, water, mountains, trees, bushes and numerous other effects with surprising detail. The 2" brush is small enough that it will create all the effects the 1" brush is used for, yet large enough to cover large areas very rapidly. Another member of the large-brush family is the 1" round brush. This brush will create numer-

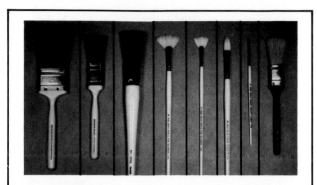

From left to right: 2" Brush, 1" Brush, 1" Round Brush, #6 Fan Brush, #3 Fan Brush, #6 Filbert Brush, Liner Brush, and 1" Oval Brush.

ous fantastic effects such as clouds, foothills, trees and bushes. Using several of each brush, one for dark colors and one for light colors, will save you brush-washing time and lessen the amount of paint used.

A #6 Filbert Bristle Brush is used mostly for the seascapes and can also be used for tree trunks and other small detail work.

The 1" Oval Brush is primarily used for making evergreen trees and foothills and for highlighting trees and bushes. This is a brush specially formed by hand with high quality, split-end bristles.

Two other brushes that I use a great deal are the #6 and #3 bristle fan brushes. Your fan brush may be used to make clouds, mountains, tree trunks, foothills, boats, soft grassy areas and many other beautiful effects. Devote some practice time to these brushes and you will not believe the effects you can achieve.

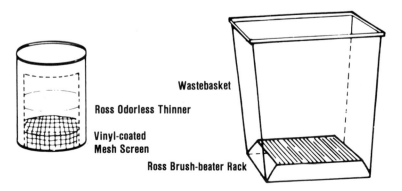

Wastebasket

Ross Odorless Thinner

Vinyl-coated
Mesh Screen

Ross Brush-beater Rack

A #2 script liner brush is used for painting fine detail. This brush has long bristles so it holds a large volume of paint. Normally, the paint is thinned to a water consistency with a thin-oil (such as linseed or Copal oil) or odorless thinner. Turn the brush in the thin paint to load it and bring the bristles to a fine point. This brush is also used to complete one of the most important parts of the painting, your signature.

CLEANING THE BRUSHES

Cleaning the brushes can be one of the most fun parts of painting. It's an excellent way to take out your hostilities and frustrations without doing any damage. I use an old coffee can that has a ¼" mesh screen in the bottom. The screen stands about 1" high and the Ross Odorless Thinner is approximately ¾" above that. To clean your brush, scrub the bristles firmly against the mesh screen to remove the paint. (Be sure to use a screen with vinyl coating to avoid damage to your brush bristles.) Shake out the excess thinner then beat the bristles firmly against a solid object to dry the brush. Learn to contain this procedure or you will notice your popularity declining at a very rapid rate. One of the simplest and most effective ways of cleaning and drying your brushes is illustrated below (left).

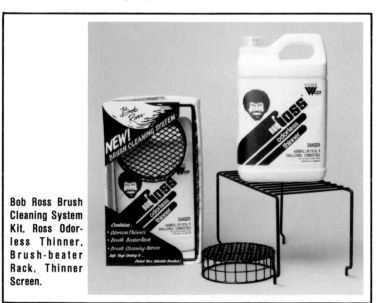

Bob Ross Brush Cleaning System Kit, Ross Odorless Thinner, Brush-beater Rack, Thinner Screen.

The brush is shaken inside the wastebasket to remove excess thinner, then the bristles are firmly beaten against the Ross Brush-beater Rack. (The rack size is 10¾"L x 5¼"W x 5¾"H.)

Odorless thinner never wears out. Allow it to settle for a few days, then reuse. Smaller brushes are cleaned with the thinner and wiped dry on a paper towel or rag.

After cleaning, your brushes can be treated and preserved with THE PAINTER'S GLOVE lotion before storing. Take care of your brushes and they will serve you for many years.

PALETTE KNIFE

The palette knifes I use are very different from traditional painting knives. They are larger and firmer. Practice is required to make these knives into close friends, so spend some time learning to create different effects.

I use two different knives, a large one as well as a smaller knife. The smaller knife is excellent for areas that are difficult to paint with the standard-size knife. The knives have straight edges, so loading is very easy and simple.

The palette knives are used to make mountains, trees, fences, rocks, stones, paths, buildings, etc. Entire paintings can be done by using only knives. The more you use the knives the more your confidence will increase and very soon you will not believe the many effects you can create.

The edge on both knives is straight for easy loading and use.

BLACK GESSO CANVAS PRIMER

I have recently developed a new product called Black Gesso. This is a flat-Black acrylic liquid primer used in projects requiring a dry pre-coated Black canvas. This water-based paint should be applied very thinly with a foam applicator (not a brush) and allowed to dry completely before starting your painting. Clean the foam applicator with water.

EASEL

A sturdy easel that securely holds the canvas is very important when painting with large brushes. I made the easel I use for mounting on a platform ladder. Any type of step ladder also works well for this type of easel.

CANVAS

The canvas you paint on is also very important. You need a good quality canvas that will not absorb your Liquid White/Black/Clear and leave you with a dry surface.

For this reason, I do not recommend canvas boards or single-primed canvases. I use only very smooth, pre-stretched, double-primed, canvases that are covered with a Grey primer. (The Grey-primed canvas allows you to see at a glance if your Liquid White is properly applied.) You may prefer a canvas with a little tooth, particularly when your painting involves a great deal of work with the knife. Whether the canvas is ultra-smooth or has a little tooth is a matter of individual choice.

All of my original paintings in this book and on the TV series were painted on 18" x 24" canvases. The size of your paintings is totally up to you.

OTHER INSTRUCTIONAL AIDS

In addition to the "Joy of Painting" television series, you will find that workshops, seminars and video tapes are the means of furthering your understanding of the Bob Ross painting technique.

Basic "How To" Photographs: Learn and master these procedures as they are used repeatedly to complete the paintings.

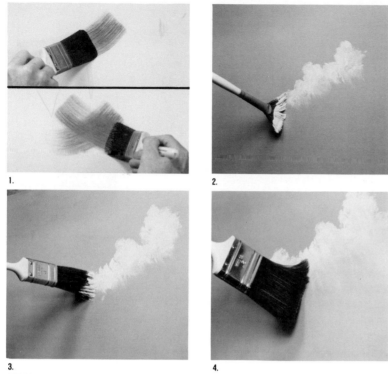

1.

2.

3.

4.

SKIES

Load the 2" brush with a very small amount of paint, tapping the bristles firmly against the palette to ensure an even distribution of paint throughout the bristles. Use criss-cross strokes to begin painting the sky, starting at the top of the canvas and working down towards the horizon. (Photo 1.) Add cloud shapes by making tiny, circular strokes with the fan brush (Photo 2) the 1" brush (Photo 3) or you can use the 2" brush, the 1" round brush or the oval brush. Blend the base of the clouds with circular strokes using just the top corner of a clean, dry 2" brush. (Photo 4.)

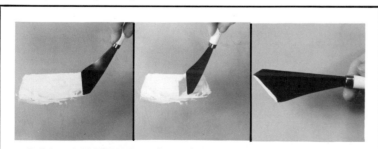

5. Pull the paint out flat on your palette—then cut across to load the long edge of the knife with a small roll of paint.

6.

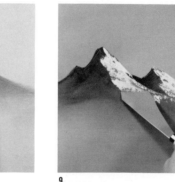

7.

8.

9.

MOUNTAINS

Load the long edge of the knife with a small roll of paint and use firm pressure to shape just the top edge of the mountain. (Photo 6.) Remove the excess paint with a clean knife (Photo 7) and then use the 2" brush to pull the paint down, completing the entire mountain shape. (Photo 8.) With a small roll of paint on the long edge of the knife, apply highlights and shadows (paying close attention to angles) using so little pressure that the paint "breaks." (Photo 9.) Use a clean, very dry 2" brush to tap and diffuse the base of the mountain, creating the illusion of mist. (Photo 10.)

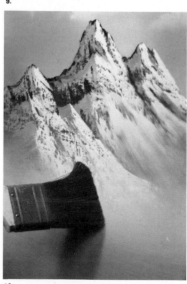

10.

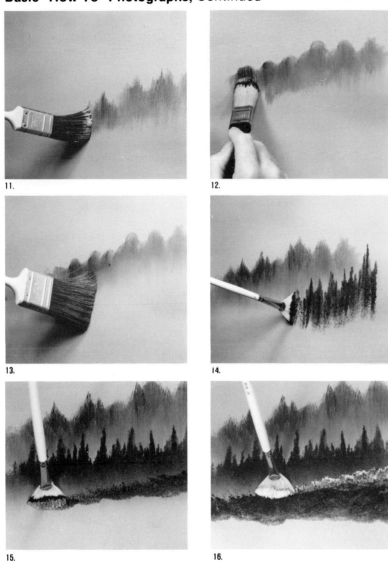

11.

12.

13.

14.

15.

16.

FOOTHILLS

Foothills are made by holding the 1" brush vertically (Photo 11) or the oval brush (Photo 12) and tapping downward. Use just the top corner of the 2" brush to firmly tap the base of the hills, to create the illusion of mist. (Photo 13.) Indicate tiny evergreens by tapping downward with the fan brush. (Photo 14.) The grassy area at the base of the hills is added with the fan brush (Photo 15) and then highlighted, forcing the bristles to bend upward. (Photo 16.)

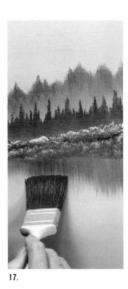

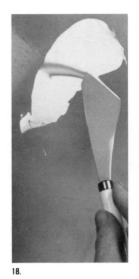

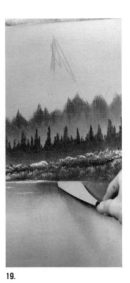

17.

18.

19.

REFLECTIONS

Use the 2" brush to pull the color straight down (Photo 17) and then lightly brush across to give the reflections a watery appearance. Load the long edge of the knife with a small roll of Liquid White (Photo 18) and then use firm pressure to cut-in the water lines. (Photo 19.) Make sure the lines are perfectly straight, you don't want the water to run off the canvas.

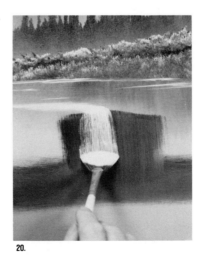

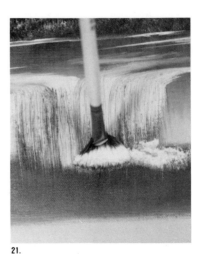

20.

21.

WATERFALLS

Use single, uninterrupted strokes with the fan brush to pull the water over the falls (Photo 20) then use push-up strokes to "bubble" the water at the base of the falls. (Photo 21.)

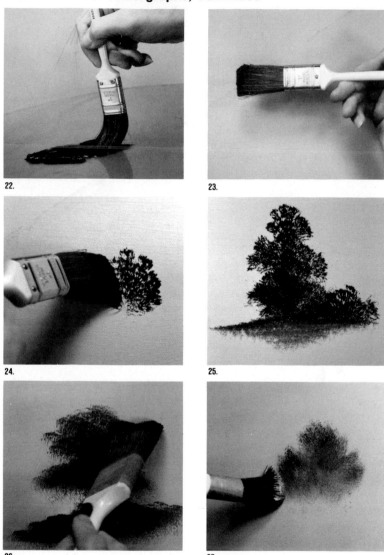

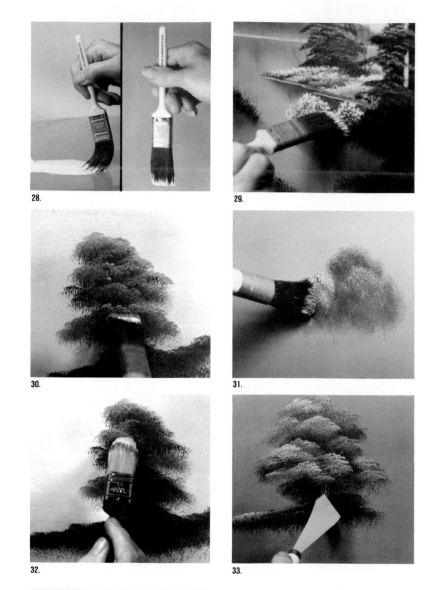

LEAF TREES AND BUSHES
Pull the 1" brush in one direction through the paint mixture (Photo 22) to round one corner. (Photo 23.) With the rounded corner up, force the bristles to bend upward (Photo 24) to shape small trees and bushes. (Photo 25.) You can also just tap downward with the 2" brush (Photo 26) or the round brush. (Photo 27.)

HIGHLIGHTING LEAF TREES AND BUSHES
Load the 1" brush to round one corner. (Photo 28.) With the rounded corner up, lightly touch the canvas, forcing the bristles to bend upward. (Photo 29.) You can also tap to highlight using the corner of the 1" brush or 2" brush (Photo 30) the round brush (Photo 31) or the oval brush. (Photo 32.) Use just the point of the knife to scratch in tiny trunks, sticks and twigs. (Photo 33.)

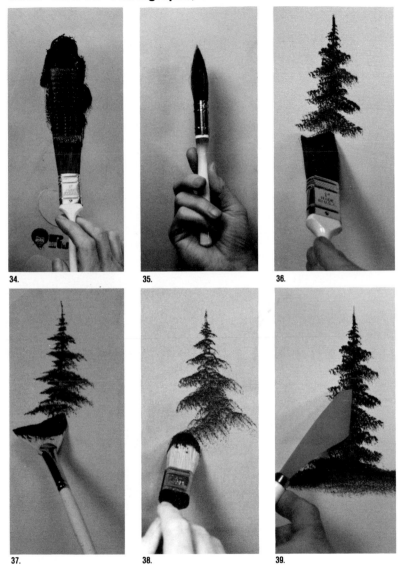

34. 35. 36.

37. 38. 39.

EVERGREENS

"Wiggle" both sides of the 1" brush through the paint mixture (Photo 34) to bring the bristles to a chiseled edge. (Photo 35.) Starting at the top of the tree, use more pressure as you near the base, allowing the branches to become larger. (Photo 36.) You can also make evergreens using just one corner of the fan brush (Photo 37) or the oval brush (Photo 38.) The trunk is added with the knife. (Photo 39.)

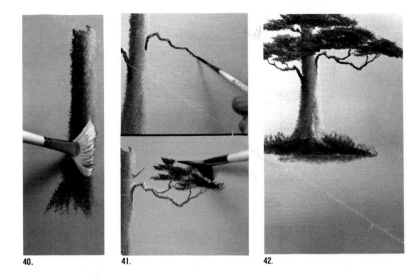

40. 41. 42.

LARGE EVERGREEN TREES

Hold the fan brush vertically and tap downward to create the "fuzzy" bark (Photo 40.) Use thinned paint on the liner brush to add the limbs and branches then push up with just the corner of the fan brush (Photo 41) to add the foliage (Photo 42.)

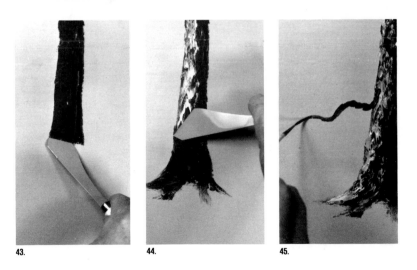

43. 44. 45.

LARGE TREE TRUNKS

Load the long edge of the knife with paint and starting at the top of the tree, just pull down. (Photo 43.) Apply highlights, using so little pressure that the paint "breaks." (Photo 44.) With a very thin paint on the liner brush, add the limbs and branches. (Photo 45.)

1. FROSTY WINTER MORN

MATERIALS

2" Brush	Phthalo Blue
#6 Fan Brush	Prussian Blue
#2 Script Liner Brush	Midnight Black
Large Knife	Van Dyke Brown
Liquid White	Alizarin Crimson
Liquid Clear	Sap Green
Titanium White	Cadmium Yellow

Use the 2" brush to cover the entire canvas with a thin, even coat of a mixture of Liquid White and Liquid Clear. With long horizontal and vertical strokes, work back and forth to ensure an even distribution of paint on the canvas. Do NOT allow the Liquid White/Clear to dry before you begin.

SKY

Load the 2" brush by tapping the bristles into a small amount of Phthalo Blue and begin with circular strokes, just off-center, in the sky. (Photo 1.) Reload the brush with a small amount of Prussian Blue and work outward with criss-cross strokes. (Photo 2.) Use a mixture of Midnight Black and Prussian Blue along the dark edges of the sky. Blend the sky with a clean, dry 2" brush.

Use Titanium White on the 2" brush and criss-cross strokes to add the lightest area of the sky. (Photo 3.) Again, blend with a clean, dry brush. (Photo 4.) (You can add a very small amount of a mixture of Titanium White and Cadmium Yellow to the bright center of the sky.)

BACKGROUND

With a Gray mixture (Titanium White, Midnight Black and Prussian Blue) tap downward with one corner of the brush to shape the distant hills. (Photo 5.) With short, upward strokes you can make the impression of tiny tree tops. (Photo 6.) Tap the base of the hills with a small amount of Titanium White on the brush to create the illusion of mist. (Photo 7.)

Add the second range of hills with a darker mixture (less Titanium White). (Photo 8.) Load the fan brush with the same mixture and tap downward (Photo 9) to indicate the tiny tree tops. (Photo 10.)

Use a mixture of Titanium White with a very small amount of Cadmium Yellow on the 2" brush to add the snow (Photo 11) at the base of the hills (Photo 12). Lay in the snow with long, horizontal strokes (Photo 13) paying close attention to the lay-of-the-land. The shadowed areas in the snow are made by adding small amounts of the Gray mixture to the brush. (Photo 14.)

To paint the cluster of larger evergreens, load the fan brush to a chiseled edge with Prussian Blue, Midnight Black, and a very small amount of Titanium White. Holding the brush vertically, touch the canvas to create the center line of each tree. Use just the corner of the brush to begin adding the small top branches. Working from side to side, as you move down each tree, apply more pressure to the brush, forcing the bristles to bend downward and automatically the branches will become larger as you near the base of each tree. (Photo 15.)

Again, paying close attention to angles, use Titanium White on the 2" brush to add snow to the base of the evergreens. Allow the brush to "pull" in some of the dark tree color for shadows. (Photo 16.)

You can use the fan brush to paint small patches of grass at the base of the trees (Photo 17) then use the knife to "cut" in the indication of trunks. (Photo 18.)

CABIN

Use a clean knife to remove paint from the canvas in the basic shape of the cabin. Load the long edge of the knife with a small roll of Van Dyke Brown by pulling the paint out very flat on your palette and just cutting across.

Paying close attention to angles, paint the back edge of the roof. Pull down the front and then the side of the cabin.

With a mixture of Van Dyke Brown and Titanium White, highlight the side of the cabin, using so little pressure that the paint "breaks". Use Midnight Black on the short edge of

the knife to add the door and windows.

Use Titanium White to add the front of the roof and to touch snow to the back edge of the roof to complete the cabin. *(Photo 19.)*

Add snow to the base of the cabin with Titanium White on the 2″ brush. *(Photo 20.)*

FOREGROUND TREES

Load the fan brush with a mixture of equal parts of Alizarin Crimson and Sap Green (to make Brown). Hold the brush vertically, start at the top of each tree and pull down the trunks.

With a mixture of Titanium White and the Brown on the knife, hold the knife vertically and just touch highlights to the left edges of the trunks. *(Photo 21.)*

Add limbs and branches to the trunks with the Brown mixture on the liner brush. (To load the liner brush, thin the Brown to an ink-like consistency by first dipping the liner brush into paint thinner. Slowly turn the brush as you pull the bristles through the mixture, forcing them to a sharp point.) Apply very little pressure to the brush, as you shape the limbs and branches, turning and wiggling the brush, to give your trees a gnarled appearance. *(Photo 22.)*

FINISHING TOUCHES

With a small roll of the Brown mixture on the knife, add the fence posts *(Photo 23)* then highlight with Titanium White. Use thinned Brown on the liner brush to add the shadows *(Photo 24)* and your painting is complete *(Photo 25).*

Frosty Winter Morn

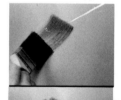
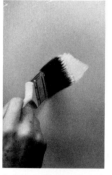

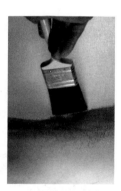

1. Begin painting the sky with circular strokes . . .

2. . . . then work outward with criss-cross strokes.

3. Add the light area with criss-cross strokes . . .

4. . . . then blend the entire sky.

5. Tap in foothills with the 2″ brush . . .

6. . . . then use upward strokes for tiny tree tops.

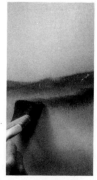

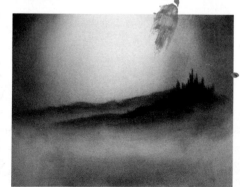
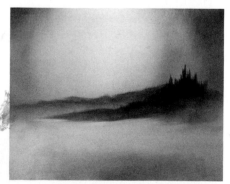

7. Tap to mist the base of the hills . . .

8. . . . before adding the second range of hills.

9. Use the fan brush to add evergreens . . .

10. . . . to the hill top.

11. Use long, horizontal strokes . . .

12. . . . to lay in snow at the base of the hills.

Frosty Winter Morn

 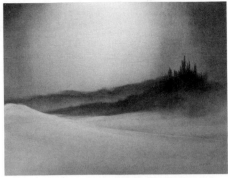 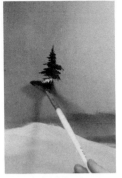 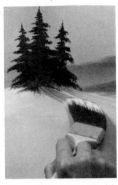 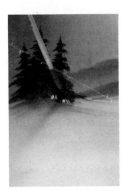 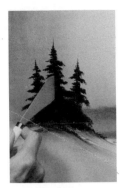

13. Work forward adding snow . . .

14. . . . paying close attention to the lay-of-the land.

15. Use the fan brush to paint evergreens . . .

16. . . . then add snow with the 2" brush.

17. Add grassy patches with the fan brush . . .

18. . . . and trunks with the knife.

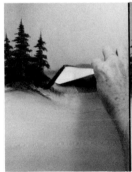 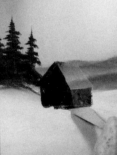 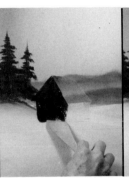 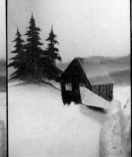 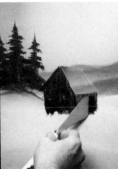 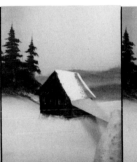 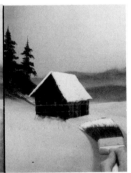

19. Progressional steps used to paint the cabin.

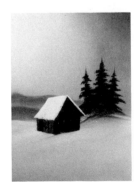

20. When the cabin is complete . . .

21. . . . add the large tree trunk.

22. Paint limbs and branches with the liner brush.

23. Use the knife to add the fence . . .

24. . . . then use the liner brush for shadows . . .

25. . . . and the painting is complete.

2. VALLEY OF TRANQUILITY

MATERIALS

2″ Brush	Midnight Black
1″ Brush	Dark Sienna
#6 Fan Brush	Van Dyke Brown
Large Knife	Alizarin Crimson
Small Knife	Sap Green
Liquid White	Cadmium Yellow
Titanium White	Yellow Ochre
Phthalo Green	Indian Yellow
Phthalo Blue	Bright Red
Prussian Blue	

Start by covering the entire canvas with a thin, even coat of Liquid White using the 2″ brush. Do NOT allow the Liquid White to dry before you begin.

SKY

With Phthalo Blue on the 1″ brush, use circular strokes to form the cloud shapes. (Photo 1.) Actually, you are not painting "cloud" shapes, but shaping the Blue-sky area behind the clouds. Still with the 1″ brush, use criss-cross strokes to carefully blend the sky. The portions of the canvas which remain White will be the clouds, so try not to drag the Blue into the White shapes as you blend.

Use Titanium White and a very small amount of Bright Red on the 1″ brush and tiny, circular strokes to highlight just the edges of the clouds. (Photo 2.) Still using circular strokes, blend with the top corner of a clean, dry 2″ brush. (Photo 3.) Use upward sweeping strokes to "fluff".

MOUNTAINS

The mountains are made with the knife and a mixture of Midnight Black, Phthalo Blue, Alizarin Crimson and Van Dyke Brown. Pull the mixture out very flat on your palette, hold the knife straight up and "cut" across the mixture to load the long edge of the blade with a small roll of paint. (Holding the knife straight up will force the small roll of paint to the very edge of the blade.)

Starting with the most distant mountain, use firm pressure to shape just the top edge of the mountain. (Photo 4.) Then, with a clean, dry 2″ brush, blend the paint down to the base of the mountain, to diffuse and complete the entire mountain shape. (Photo 5.)

Subtle highlights are added with the small knife and Titanium White. Again, load the long edge of the knife blade with a small roll of paint. The source of light in this painting is on the right, so starting at the top (and paying close attention to angles) apply the highlight mixture to the right side of each peak, using so little pressure that the paint "breaks". (Photo 6.)

Diffuse the base of the mountain by tapping with a clean, dry 2″ brush (carefully following the angles) and then gently lift upward to create the illusion of mist. (Photo 7.)

Moving forward in the painting, use the same dark mountain-mixture to shape the larger, closer mountain top and again, use the 2″ brush to blend the paint down to the base of the mountain completing the entire mountain shape. (This is a good time to add the water to the lower portion of the canvas, so without cleaning the brush, load it with a mixture of Phthalo Green, Phthalo Blue and Midnight Black. Use horizontal strokes, pulling from the outside edges of the canvas in towards the center.)

Highlight the mountain with a small roll of Titanium White on the knife, carefully following angles and again using so little pressure that the paint "breaks". The shadowed sides of the peaks are a mixture of Titanium White, Phthalo Blue and Midnight Black, still following angles and allowing the paint to "break".

With a clean, dry 2″ brush, and carefully following the angles, tap to blend and diffuse the base of the mountain. Gently lift upward to create the illusion of mist.

Use various mixtures of Cadmium Yellow, Sap Green, Yellow Ochre, Indian Yellow and a small amount of the dark mountain mixture on the same 2″ brush, to add the Green

area, or tree line at the base of the mountain. *(Photo 8.)* Carefully following the angles, just tap downward. Use a clean, dry 1" brush and very short upward strokes to indicate tiny tree tops, again carefully following the angles of the mountain.

BACKGROUND

Load the fan brush with a mixture of Midnight Black, Prussian Blue, Phthalo Green, Van Dyke Brown and Alizarin Crimson. Holding the brush vertically, use a series of downward tapping strokes to indicate the small trees at the base of the mountain. Be very careful not to make "fence posts". *(Photo 9.)*

To indicate the tiny tree trunks, use Titanium White on a clean fan brush. Hold the brush horizontally and starting at the base of the trees, make a series of very short, upward strokes.

Under-paint the grassy area at the base of the small trees with the same dark tree mixture, using "push-up" strokes with the fan brush.

Use various mixtures of Sap Green, all of the Yellows and a very small amount of Bright Red to highlight the soft grassy area at the base of the trees. Load the 2" brush by holding it at a 45-degree angle and tapping the bristles into the various paint mixtures. Allow the brush to "slide" slightly forward in the paint each time you tap (this assures that the very tips of the bristles are fully loaded with paint). Hold the brush horizontally and gently tap downward. Work in layers, carefully creating the lay-of-the-land. If you are also careful not to destroy all of the dark color already on the canvas, you can create grassy highlights that look almost like velvet. *(Photo 10.)*

WATERFALL

Use Van Dyke Brown on the knife to add the banks along the water's edge. *(Photo 11.)*

Load the fan brush with a mixture of Liquid White, Titanium White and a very small amount of Phthalo Blue. Starting with the distant water, make a short, horizontal stroke then pull straight down to create the waterfall. *(Photo 12.)* Paint the foam at the base of the falls with tiny "push-up" strokes, using the Titanium White mixture on the fan brush. Highlight the banks with a mixture of Titanium White, Dark Sienna and Van Dyke Brown on the knife.

Use the 2" brush to extend the dark under-colors into the water for reflections, then brush across to give the reflections a watery appearance. *(Photo 13.)*

Working forward in layers, continue adding the banks along the water's edge, reflections and the soft, grassy areas.

EVERGREENS

For the larger evergreens, load the fan brush to a chiseled edge with the dark tree-mixture. (Midnight Black-Prussian Blue-Phthalo Green-Van Dyke Brown-Alizarin Crimson.) Holding the brush vertically, touch the canvas to create the center line of each tree. Use just the corner of the brush to begin adding the small top branches. Working from side to side, as you move down each tree, apply more pressure to the brush, forcing the bristles to bend downward *(Photo 14)* and automatically the branches will become larger as you near the base of each tree.

Continue bringing the water forward with the thin White on the fan brush *(Photo 15)* to complete the background.

FOREGROUND

Under-paint the foreground with the dark tree-mixture on the 2" brush. *(Photo 16.)*

Add the large evergreen trunk with a small roll of a mixture of Titanium White and Dark Sienna on the knife. Use the fan brush to very lightly touch highlights to the branches of the evergreen with a mixture of the dark tree color and the Yellows.

Use various mixtures of Liquid White, Sap Green, all of the Yellows and Bright Red to highlight the small trees and bushes at the base of the large evergreen. Pull the 1" brush through the mixtures in one direction, to round one corner. With the rounded corner up, touch the canvas and force the bristles to bend upward as you create individual tree and bush shapes. *(Photo 17.)* Try not to just hit at random and be careful not to "kill" all of the dark base color; use it to separate the individual shapes.

FINISHING TOUCHES

Use a thinned mixture on the liner brush to add sticks and twigs and other small final details, not the least of which is your signature! *(Photo 18.)*

Valley Of Tranquility

1. Use the 1" brush to paint the sky.

2. Highlight the clouds with the 1" brush . . .

3. . . . then blend with the 2" brush.

4. Shape the distant mountain top . . .

5. . . . then blend downward with the 2" brush.

6. Highlight the mountain with the knife . . .

7. . . . then use the 2" brush to mist the base.

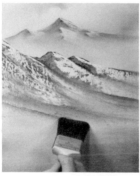
8. Use the 2" brush to tap Green at the base of the mountain.

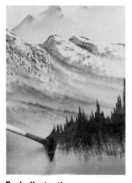
9. Indicate tiny evergreens with the fan brush.

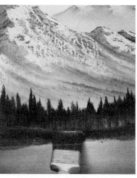
10. Highlight soft, grassy areas.

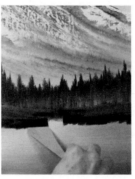
11. Use the knife to add banks along the water's edge.

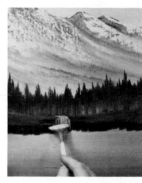
12. Paint the waterfall with the fan brush . . .

13. . . . and pull down reflections with the 2" brush.

14. Paint evergreens with the fan brush.

15. Continue "swirling" the water forward.

16. Under-paint the foreground with the 2" brush . . .

17. . . . then add highlights with the 1" brush . . .

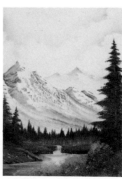
18. . . . to complete the painting.

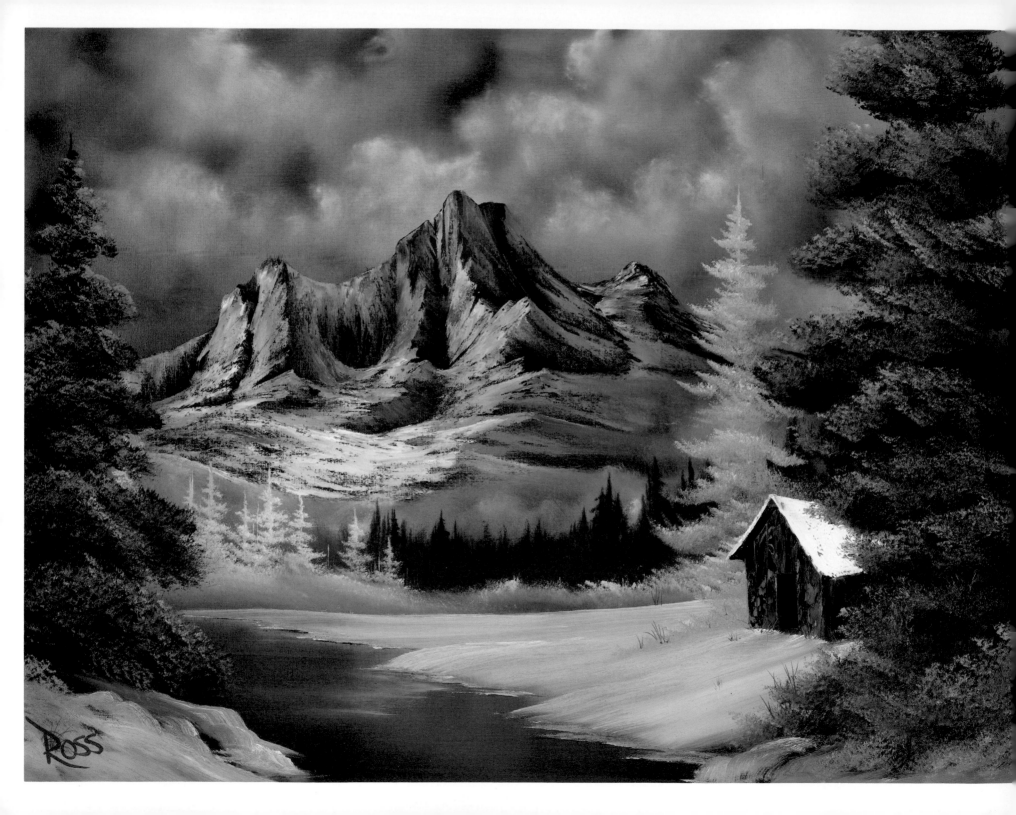

MATERIALS

2" Brush	Titanium White
1" Brush	Phthalo Blue
#6 Fan Brush	Prussian Blue
#2 Script Liner Brush	Midnight Black
Large Knife	Dark Sienna
Black Gesso	Van Dyke Brown
Liquid Clear	Alizarin Crimson

There are three steps to preparing your canvas for this painting. First, use a foam applicator to apply a thin, even coat of Black Gesso to the canvas and allow it to DRY COMPLETELY before you begin your painting.

Second, when the Black Gesso is dry, use the 2" brush to completely cover the canvas with a VERY THIN coat of Liquid Clear. (It is important to stress that the Liquid Clear should be applied VERY, VERY sparingly and really scrubbed into the canvas!

The third step is to use a clean, dry 2" brush to apply a thin, even coat of Phthalo Blue over the Liquid Clear. Again, do NOT allow the paint to dry before you begin.

SKY

Load the 1" brush with Titanium White and, starting at the top of the canvas, use small circular strokes to shape the clouds. (Photo 1.)

Use circular strokes with just the top corner of a clean, dry 2" brush to blend the clouds. (Photo 2.) At this point, you can use the 1" brush with Titanium White for additional clouds, if necessary. (Photo 3.)

MOUNTAIN

The mountain is made with the knife and a mixture of Midnight Black, Prussian Blue, Alizarin Crimson and Van Dyke Brown for the mountain. With firm pressure, shape just the top edge of the mountain. (Photo 4.) Use the knife to remove any excess paint and then with the 2" brush, pull the paint down to the base of the mountain to blend and com-

plete the entire mountain shape.

To highlight the mountain, use a mixture of Titanium White with a small amount of Dark Sienna and Van Dyke Brown. Starting at the top of the mountain (and paying close attention to angles) apply the snowy highlights to the left side of each peak, using so little pressure that the paint "breaks". (Photo 5.)

Use a mixture of Titanium White with Prussian Blue and Alizarin Crimson for the shadow sides of the peaks. Again, use so little pressure that the paint "breaks".

The brightest highlights, or the glacier, is added at this point with a mixture of Titanium White with a very small amount of Phthalo Blue. (Photo 6.) If necessary, you can accentuate the darker recesses with the original, dark mountain mixture.

With a VERY small amount of Titanium White on the top corner of the 2" brush, use small, circular strokes (Photo 7) to create and blend the mist at the base of the mountain (Photo 8).

BACKGROUND

Load the fan brush with the dark mountain mixture (Midnight Black, Prussian Blue, Alizarin Crimson and Van Dyke Brown). Holding the brush vertically, just tap downward to indicate the small evergreens at the base of the mountain. (Photo 9.) Load the fan brush with a small amount of Titanium White. Holding the brush horizontally and starting at the base of the trees, make a series of short upward strokes to suggest the tiny tree trunks. (Photo 10.)

Use various mixtures of Titanium White and Phthalo Blue on the fan brush for the larger evergreens. Holding the brush vertically, touch the canvas to create the center line of each tree. Use just the corner of the brush to begin adding the small top branches. Working from side to side, as you move down each tree, apply more pressure to the brush, forcing the bristles to bend UPWARD and automatically the branches will become larger as you near the base of each tree. (Photo 11.)

Hold the brush horizontally and force the bristles to bend upward to add the small bushes at the base of the trees. *(Photo 12.)*

Use the top corner of a clean, dry 2″ brush to firmly tap the base of the trees and bushes *(Photo 13)* creating the illusion of mist. *(Photo 14.)*

With Titanium White on the 2″ brush, use long horizontal strokes to begin underpainting the ground area, starting at the base of the background trees and working forward. *(Photo 15.)* At the same time, hold the brush flat against the canvas and pull straight down to create the water area. *(Photo 16.)* Very lightly brush across and instantly, you have reflections! *(Photo 17.)*

Re-load the fan brush with the Titanium White-Phthalo Blue mixture to add the larger, light-colored evergreen and then use Titanium White on the fan brush and long, horizontal strokes to apply snow to the base of the tree *(Photo 18)* concentrating on the lay-of-the-land along the water's edge *(Photo 19)*.

CABIN

Start by using the knife to remove excess paint from the canvas in the basic shape of the cabin. With Van Dyke Brown on the knife, add the underside of the back of the roof and then pull straight down to add the front and side of the cabin. Paying close attention to angles, use Titanium White for the snow-covered roof.

With a mixture of Titanium White and Van Dyke Brown, highlight just the front of the cabin, using so little pressure that the paint "breaks". Add the door with Van Dyke Brown, then

use the point of the knife to "cut-in" the indication of boards. With a very small amount of Cadmium Yellow on the short edge of the knife, add a small window. Use Titanium White on the fan brush to add snow to the base of the cabin perhaps creating a small path with Phthalo blue *(Photo 20)*.

FOREGROUND

For the large evergreen on the left side of the painting, load the 2″ brush to a chiseled-edge with a mixture of Midnight Black, Phthalo Blue and Prussian Blue. Working from side to side, as you move down the tree, apply more pressure to the brush, forcing the bristles to bend UPWARD and automatically the branches will become larger as you near the base of the tree.

Use the same mixture on the 2″ brush to underpaint the basic shape of the large tree on the right, again forcing the bristles to bend upward. *(Photo 21.)*

Add Titanium White to the same brush to very lightly highlight the trees, still forcing the bristles to bend upward. Try not to just hit at random, concentrate on the shape and form of each tree and be very careful not to completely cover all of the dark undercolor. *(Photo 22.)*

Use Titanium White on the fan brush to add the snow-covered ground area at the base of the trees. *(Photo 23.)*

FINISHING TOUCHES

Add the frozen edges of the water (using a very small roll of Liquid White on the long edge of the knife) then use the liner brush to sign your completed painting. *(Photo 24.)*

Mountain Seclusion

 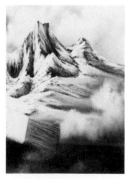

1. Use circular strokes . . .

2. . . . to paint . . .

3. . . . and blend the cloud shapes.

4. Use the knife to shape the mountain top . . .

5. . . . and to apply highlights . . .

6. . . . and the glacier.

7. Use circular strokes with the 2″ brush . . .

Mountain Seclusion

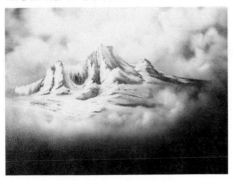

8. . . . to mist the base of the mountain.

9. Tap down with the fan brush . . .

10. . . . then lift up trunks.

11. Add more distinct evergreens . . .

12. . . . and grassy areas with the fan brush.

13. Tap with the corner of the 2" brush . . .

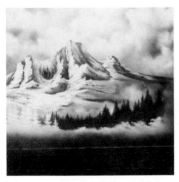

14. . . . to create the illusion of mist.

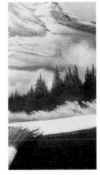

15. Use horizontal strokes to add snow . . .

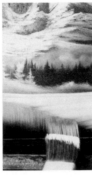

16. . . . and vertical strokes to add the water . . .

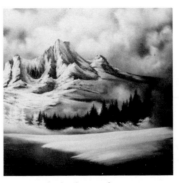

17. . . . to the background.

18. Larger evergreens and snow . . .

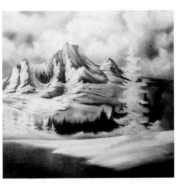

19. . . . can be added to complete the background.

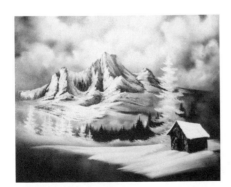

20. The cabin is complete.

21. Use the 2" brush . . .

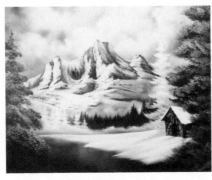

22. . . . to paint the large evergreens in the foreground.

23. Add snow to the base of the evergreens . . .

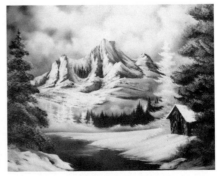

24. . . . and the painting is finished.

MATERIALS

2″ Brush	Phthalo Blue
1″ Brush	Midnight Black
1″ Oval Brush	Dark Sienna
#6 Fan Brush	Van Dyke Brown
#2 Script Liner Brush	Alizarin Crimson
Large Knife	Sap Green
Liquid White	Cadmium Yellow
Liquid Black	Yellow Ochre
Liquid Clear	Indian Yellow
Titanium White	Bright Red

Start by using the 2″ brush to cover the center top portion of the canvas with a thin, even coat of a mixture of Liquid White and Liquid Clear. Swirl a thin, even coat of Liquid Black around the sides and lower portion of the canvas, blending it lightly into the Liquid White/Clear mixture. Do NOT allow the canvas to dry before you begin. (Photo 1.)

SKY

Load the 2″ brush by tapping the bristles into a mixture of Cadmium Yellow and Yellow Ochre. Begin painting with criss-cross strokes in the center of the light area of the sky. (Photo 2.) Without cleaning the brush, re-load it by tapping the bristles into Alizarin Crimson and continue working outward with criss-cross strokes. Re-load the brush with a mixture of Alizarin Crimson and Dark Sienna and continuing outward, use criss-cross strokes to extend the color into the Liquid Black.

Use a clean, dry 2″ brush and criss-cross strokes to blend the entire sky, starting in the center and blending outward. You can lighten the center of the sky with Titanium White on a clean 2″ brush; still using criss-cross strokes and working outward. Blend the entire sky. (Photo 3.)

BACKGROUND

Load the 2″ brush by tapping the bristles into Dark Sienna. Holding the brush vertically, tap downward with the top corner of the brush to underpaint the small trees along the horizon. (Photo 4.) As you work forward, add Van Dyke Brown to the brush.

Add the background tree trunks with Dark Sienna and the liner brush. (To load the liner brush, thin the paint to an ink-like consistency by first dipping the liner brush into paint thinner. Slowly turn the brush as you pull the bristles through the paint, forcing them to a sharp point.) Paint the trunks with very little pressure, turning and wiggling the brush to give your trunks a gnarled appearance. (Photo 5).

To highlight the background trees, load the oval brush by tapping the bristles into various mixtures of Sap Green, all of the Yellows and a very small amount of Bright Red. Tap downward with the brush to shape the individual trees (Photo 6); try not to just hit at random. (Photo 7).

EVERGREENS

To paint the clump of small evergreens, load the fan brush to a chiseled edge with a mixture of Dark Sienna, Van Dyke Brown, Yellow Ochre and Midnight Black. Holding the brush vertically, touch the canvas to create the center line of each tree. Use just the corner of the brush to begin adding the small top branches. Working from side to side, as you move down each tree, apply more pressure to the brush, forcing the bristles to bend downward and automatically the branches will become larger as you near the base of each tree. (Photo 8.)

Diffuse and mist the base of the evergreens by firmly tapping with a clean, dry 2″ brush. (Photo 9.) Use the knife to scratch in the indication of the evergreen trunks, then use the highlight mixtures on the oval brush (Photo 10) to add the small trees at the base of the evergreens (Photo 11).

Use the same highlight mixtures to add the soft grassy area at the base of the trees. Load the 2″ brush by holding it at a 45-degree angle and tapping the bristles into the various paint mixtures. Allow the brush to "slide" slightly forward in the paint each time you tap (this assures that the very tips of the bristles are fully loaded with paint).

Hold the brush horizontally and gently tap downward. (Photo 12.) Work in layers, carefully creating the lay-of-the-land. You can use a small amount of Titanium White for extra sparkle.

CABIN

Use the knife to remove paint from the canvas in the basic shape of the cabin.

With a small roll of Van Dyke Brown on the knife, paint the back edge of the roof. Pull straight down to add the front of the cabin. Paying close attention to angles, continue using the Brown to add the roof and side of the cabin. Then, add the small room on the side.

Load the long edge of the knife with a small roll of a mixture of Bright Red, Dark Sienna, Yellow Ochre and Titanium White. Highlight the front of the cabin and the small room, using so little pressure that the paint "breaks". Use the same mixture without Titanium White to add the dark side of the small room.

Use a small roll of a mixture of Titanium White, Midnight Black and Van Dyke Brown to "bounce" highlights on the roof. Use Van Dyke Brown on the knife and just touch to indicate boards. To soften the wood, brush lightly with the 2" brush.

With Van Dyke Brown, use the long edge of the knife to add the door and the short edge to add the window. Outline the door, the window and the roof with a very small amount of Titanium White.

Paying close attention to angles, use the knife to remove excess paint from the base of the cabin. (Photo 13.)

With the 2" brush and the Yellow highlight mixtures, tap in the grassy areas at the base of the cabin. Use Van Dyke Brown on the fan brush and short horizontal strokes to add the path (Photo 14) then highlight with a mixture of Van Dyke Brown and Titanium White on the knife (Photo 15) still using horizontal strokes and so little pressure that the paint "breaks" (Photo 16).

With Titanium White on the liner brush, add the clump of birch trees along side the cabin. (Photo 17.) Add foliage to the trees with the Yellow highlight mixtures on the oval brush.

FOREGROUND

Continue using the Yellow highlight mixtures on the 2" brush to extend the soft grassy areas to the bottom of the canvas.

Use Van Dyke Brown on the knife to add the fence posts, then highlight with Titanium White. Touch a small amount of Bright Red to the top of each post. The wire on the posts is made with a thinned mixture of Van Dyke Brown and Titanium White on the liner brush. The small fence near the cabin is painted with thinned Van Dyke Brown on the liner brush. Watch your perspective here!

FINISHING TOUCHES

Add Phthalo Blue to the grassy highlight mixtures to tap in the soft grass at the base of the foreground fence posts and your painting is complete. (Photo 18.) Don't forget to sign your masterpiece.

New Day's Dawn

1. Cover the canvas with Liquid White and Liquid Black . . .

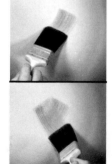

2. . . . then use criss-cross strokes . . .

3. . . . to paint the sky.

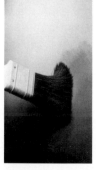

4. Tap down background trees with the top corner of the 2" brush . . .

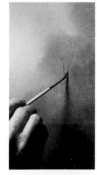

5. . . . add trunks with the liner brush . . .

6. . . . and then use the oval brush . . .

New Day's Dawn

7. . . . to add subtle highlights.

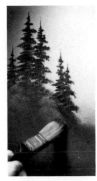

8. Use one corner of the fan brush to paint evergreens . . .

9. . . . then mist the base by tapping with the 2" brush.

10. Use the oval brush to highlight leafy trees . . .

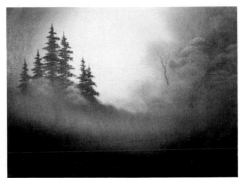

11. . . . at the base of the evergreens.

12. Tap down with the 2" brush to paint grassy areas.

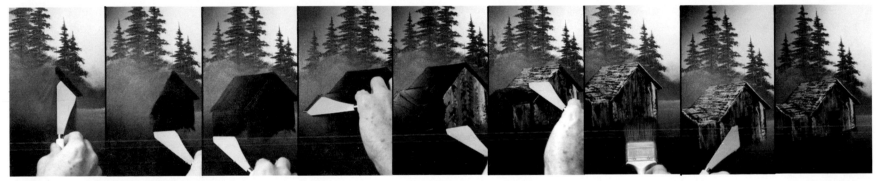

13. Progressional steps used to paint the cabin.

14. Add the path with the fan brush . . .

15. . . . then use the knife and horizontal strokes . . .

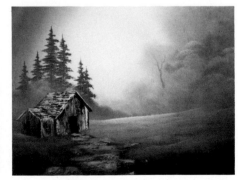

16. . . . to highlight the path.

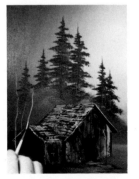

17. Use the liner brush to add a tree trunk near the cabin.

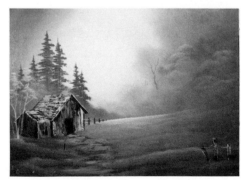

18. The completed painting.

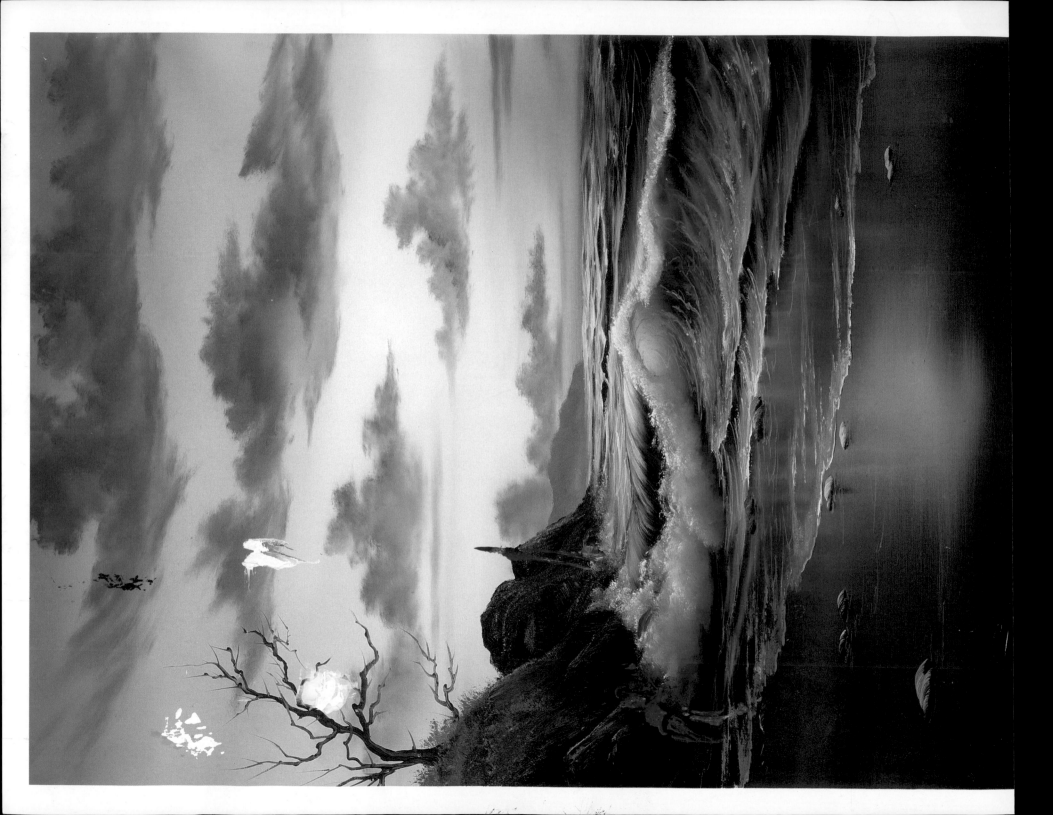

MATERIALS

2″ Brush	Phthalo Blue
#6 Fan Brush	Dark Sienna
Filbert Brush	Van Dyke Brown
Script Liner Brush	Alizarin Crimson
Large Knife	Sap Green
Black Gesso	Cadmium Yellow
Liquid White	Yellow Ochre
Liquid Clear	Indian Yellow
Titanium White	Bright Red
Phthalo Green	

Before starting your painting, mark the horizon with a strip of masking tape just below the center of the canvas. Use a foam applicator to cover the area below the horizon with a thin, even coat of Black Gesso and allow to DRY COMPLETELY. *(Photo 1.)*

Reposition the masking tape across the top edge of the dry Black Gesso and then use the 2″ brush to cover the entire area above the horizon with a thin, even coat of Liquid White.

With a clean, dry 2″ brush, completely cover the DRY Black Gesso with a VERY THIN coat of Liquid Clear. Still using the 2″ brush, apply a thin, even coat of a mixture of Phthalo Green and Phthalo Blue across the lower portion of the canvas (to underpaint the large wave). The areas above and below the large wave should be covered with a thin, even coat of a mixture of Alizarin Crimson and Phthalo Blue. The very bottom of the canvas should be covered with a thin, even coat of Van Dyke Brown. Do NOT allow the Liquid White or these colors to dry before you begin.

SKY

Load the 2″ brush with a small amount of Indian Yellow and start with criss-cross strokes above the horizon. *(Photo 2.)* Re-load the brush with Yellow Ochre and continue with criss-cross strokes above and below the Indian Yellow. Re-load the brush with a small amount of Alizarin Crimson and use criss-cross strokes above the Yellow Ochre and then use a mixture of Alizarin Crimson and Phthalo Blue at the top of the canvas. Blend the entire sky. With a very small amount of Bright Red on the 2″ brush, add the suggestion of a warm glow, just above the horizon.

Make a Lavender mixture with Alizarin Crimson and a very small amount of Phthalo Blue.

Load the fan brush with a small amount of the Lavender mixture and begin shaping the clouds with small circular strokes. *(Photo 3.)* Add the sun with Titanium White on your fingertip. *(Photo 4.)* Allow some of the clouds to drift right across the sun. *(Photo 5.)* Blend the clouds with the top corner of a clean, dry 2″ brush *(Photo 6)* then use upward strokes to "fluff". Blend the entire sky with long, horizontal strokes.

When you are satisfied with the sky, carefully remove the masking tape from the canvas *(Photo 7)* to expose a nice, straight, horizon line. Cover the small area (left dry by the masking tape) with the Lavender mixture on the 2″ brush.

Use Titanium White on the fan brush to roughly sketch the basic shape of the large wave. *(Photo 8.)*

BACKGROUND WATER

With Titanium White on the fan brush, use short, horizontal rocking strokes to paint the background swells, just below the horizon. *(Photo 9.)* Again, use short, rocking strokes to pull the top edges of the swells back, to blend. *(Photo 10.)*

LARGE WAVE

Use the filbert brush and a mixture of Titanium White with a very small amount of Cadmium Yellow to scrub in the "eye" of the large wave. *(Photo 11.)* Blend with circular strokes using the top corner of a clean, dry 2″ brush. *(Photo 12.)* Pay close attention to the shape of your wave. *(Photo 13.)*

In the lightest area of the foreground, pull down long, vertical strokes with the Titanium White-Cadmium Yellow mixture on the 2″ brush. *(Photo 14.)* Lightly brush across to create the reflected light on the beach.

With Titanium White on the fan brush, pull the water over

the top of the crashing wave. *(Photo 15.)* Be very careful of the angle here!

Load the fan brush with Titanium White, the Alizarin Crimson-Phthalo Blue mixture and a very small amount of Phthalo Green. Make small circular strokes with one corner of the brush to scrub in the foam shadows along the edges of the large wave. *(Photo 16.)*

LARGE ROCKS

Continue using the fan brush with the Lavender mixture to shape the distant rocks. Use a mixture of the Lavender, Titanium White and Bright Red on the fan brush to highlight and contour the rocks, paying close attention to angles. *(Photo 17.)* With a clean, dry 2" brush, lightly blend the large, distant rocks.

FOREGROUND

Load a clean fan brush with Titanium White and make small, circular push-up strokes to highlight the top edges of the foam, where the light would strike. *(Photo 18.)*

Working forward in layers, use the Lavender mixture, Van Dyke Brown and Dark Sienna on the fan brush to shape the larger closer rocks. Highlight and contour the large, foreground rocks by tapping with a mixture of Titanium White, Dark Sienna and a small amount of Bright Red on the fan brush. Again, pay close attention to angles as you blend and shape with a clean, dry 2" brush.

Re-load the fan brush with the Titanium White-Cadmium Yellow mixture and continue adding foam to the base of the large, foreground rock, then swirl in the foam patterns in the

large wave. *(Photo 19.)* Pay close attention to angles and the shape of the wave.

Load the long edge of the small knife with a very small roll of a mixture of Titanium White and the Lavender mixture. Hold the knife flat against the canvas and use firm pressure and long horizontal strokes to add the foamy water action on the beach. *(Photo 20.)* Use a clean fan brush to pull the top edge of the paint back towards the large wave *(Photo 21)* creating swirling foam patterns. *(Photo 22.)*

Use thinned Van Dyke Brown on the liner brush to add the small tree on top of the large rock *(Photo 23)* then use a mixture of Sap Green and Yellow to pop in grass at the base of the tree *(Photo 24)*.

SMALL ROCKS AND STONES

Load both sides of the filbert brush with Van Dyke Brown and then pull one side of the bristles through a mixture of Liquid White, Dark Sienna and Yellow Ochre (to double-load the brush). With the light side of the brush towards the top, use a single, curved stroke to both shape and highlight each small rock on the beach. *(Photo 25.)*

FINISHING TOUCHES

Use thinned mixtures on the liner brush to add the final details to your painting. (To load the liner brush, thin the paint to an ink-like consistency by first dipping the liner brush into the paint thinner. Slowly turn the brush as you pull the bristles through the paint, forcing them to a sharp point.)

With very little pressure on the brush, add highlights to the top edges of the waves, foam patterns and shadows to the water and finally, your signature. *(Photo 26.)*

By-The-Sea

1. Prepaint the lower portion of the canvas with Black Gesso.

2. Use criss-cross strokes to paint the sky . . .

3. . . . then use circular strokes to add clouds.

4. After painting the sun . . .

5. . . . continue adding clouds.

6. Blend the sky with the 2" brush . . .

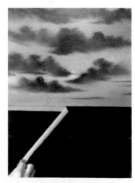
7. . . . then remove the masking tape.

By-The-Sea

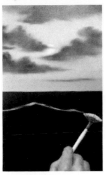 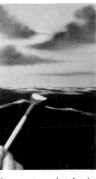 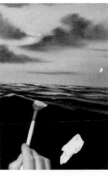

8. Use the fan brush to sketch the large wave . . .

9. . . . to paint background waves . . .

10. . . . and to blend the water.

11. Add the "eye" of the wave with the filbert brush . . .

12. . . . then blend with the 2" brush . . .

13. . . . paying close attention to the angle of the water.

14. Use the 2" brush to reflect water on the beach.

 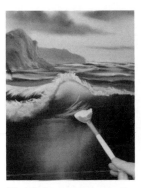 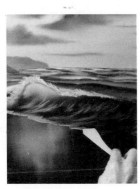

15. Use the fan brush to highlight the wave . . .

16. . . . and to paint foam shadows.

17. Paint background rocks with the fan brush.

18. Highlight the foam with the fan brush.

19. Add foam patterns to the water with the fan brush.

20. Use the knife to paint water on the beach . . .

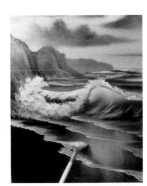 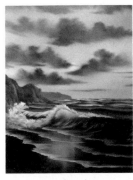

21. . . . then pull back with the fan brush . . .

22. . . . to create swirling water on the beach.

23. Add the tiny tree with the liner brush . . .

24. . . . then use the fan brush to add grass.

25. Make single strokes with the filbert brush . . .

26. . . . to add small rocks to the finished painting.

33

MATERIALS

2″ Brush	Midnight Black
#6 Filbert Brush	Dark Sienna
#6 Fan Brush	Van Dyke Brown
#3 Fan Brush	Alizarin Crimson
#2 Script Liner Brush	Sap Green
Large Knife	Cadmium Yellow
Adhesive-Backed Plastic	Yellow Ochre
Liquid White	Indian Yellow
Titanium White	Bright Red
Phthalo Blue	

Start by covering the entire canvas with an adhesive-backed plastic (such as Con-Tact Paper) from which you have removed a center oval. (16x20 oval on an 18x24 canvas.) (Photo 1.)

Use the 2″ brush to cover the exposed area of the canvas with a thin, even coat of Liquid White. Do NOT allow the Liquid White to dry before you begin.

SKY

Load the 2″ brush by tapping the bristles into Yellow Ochre. Start painting in the center of the sky with criss-cross strokes. (Photo 2.) Use horizontal strokes to reflect this Yellow color into the center of the water area on the lower portion of the canvas.

Use the knife to make a Blue-Lavender mixture with Alizarin Crimson and Phthalo Blue. (The mixture will look quite dark but you can test the color by adding a small amount of the mixture to a small amount of Titanium White.)

Re-load the 2″ brush with the Lavender color and paint the remainder of the sky, still using criss-cross strokes. Use horizontal strokes to add this color to the water, pulling from the outside edges of the canvas in towards the center.

Use a clean, dry 2″ brush and criss-cross strokes to blend the sky and long horizontal strokes to blend the water. Try not to destroy the light, Yellow area in the center of the water. (Photo 3.)

BACKGROUND

Load the 2″ brush with the Lavender mixture and tap downward with the top corner of the brush to shape the small trees along the horizon. (Photo 4.)

Use a mixture of paint thinner and the Lavender on the liner brush to add the indication of tiny tree trunks. (Photo 5.)

Load the #3 fan brush with various mixtures of Titanium White and a small amount of Yellow Ochre. Push up with one corner of the brush to add the small bushes at the base of the background trees. (Photo 6.) With a mixture of Dark Sienna, Van Dyke Brown and Titanium White on the knife, scrub in the land area at the base of the bushes. (Photo 7.)

WATERFALL

Use Liquid White, Titanium White and a very small amount of Phthalo Blue on the large fan brush to begin adding the waterfall. Starting at the horizon, use short, swirling, horizontal strokes to bring the water forward use downward strokes (Photo 8) for the falling water (Photo 9).

Load the 2″ brush with a mixture of Sap Green and Alizarin Crimson (to make Brown). Working forward in layers, tap downward with one corner of the brush to underpaint the small bushes and grassy area along the left side of the water's edge. (Photo 10.) Pull straight down with the brush to reflect the color into the water and lightly brush across to give the reflections a watery appearance. (Photo 11.)

Add a small amount of Titanium White to the Brown mixture to underpaint the large trees on the right side of the water. (Photo 12.) Again, pull straight down to reflect the color into the water. (Photo 13.) You can also use the original Lavender mixture to darken the reflections. Again, lightly brush across—two hairs and some air.

Add small tree trunks with thinned Brown on the liner brush. (Photo 14.) Use various mixtures of all of the Yellows and a small amount of Bright Red on the 2″ brush to highlight all of the trees and bushes. Again, tap downward with one corner of the brush, carefully shaping individual trees

and bushes. Pay close attention to shape and form—don't just hit at random. You can "sparkle" the trees on the left side of the water by adding a small amount of Titanium White to the highlight mixtures. Be very careful not to "kill" all of the dark undercolor. Use it to separate the individual shapes.

Use a dark mixture of just Sap Green and Alizarin Crimson on the 2" brush to add the large tree on the right side of the painting. (Photo 15.) Use the same mixture with paint thinner on the liner brush to add the trunks. (Photo 16.)

With various mixtures of Sap Green, Cadmium Yellow and Midnight Black on the same brush, highlight the grassy area at the base of the large trees. (Photo 17.)

Load the long edge of the knife with a small roll of Van Dyke Brown to add the banks along the water's edge. (Photo 18.)

ROCKS AND STONES

Load the filbert brush with Van Dyke Brown and Dark Sienna, then pull ONE side of the brush through a thin mixture of Liquid White, Dark Sienna, Yellow Ochre and Van Dyke Brown. With the light side of the brush UP, use single curved strokes to add the rocks and stones. (Photo 19.)

FOREGROUND

Working forward in layers, continue adding the grassy areas and rocks and stones. Extend the water forward (Photo 20) swirling it around the base of the rocks with Titanium White on the fan brush (Photo 21).

At this point you can remove the Con-tact Paper (Photo 22) from the canvas (Photo 23).

LARGE TREE

Load the fan brush with a mixture of Van Dyke Brown and Dark Sienna. Holding the brush vertically, start at the top of the canvas and pull down to the bottom of the oval, to paint the large tree trunks in the foreground. (Photo 24.) Try not to paint straight lines, let the lines bend and curve, give your trees character—don't paint telephone poles.

Thin the mixture with paint thinner and use the liner brush to add the limbs and branches to the trees. (Photo 25.) Use a mixture of Titanium White and Van Dyke Brown on the knife to touch highlights to the trunks, tapping the knife to create the appearance of bark. (Photo 26.)

FINISHING TOUCHES

Use thinned paint on the liner brush to add small sticks and twigs, long grasses and most importantly—your signature. (Photo 27.)

Hazy Day

1. After covering the canvas with Con-Tact Paper . . . 2. . . . use criss-cross strokes . . . 3. . . . to paint the sky. 4. Add background trees with the 2" brush . . . 5. . . . and trunks with liner brush. 6. Add tiny bushes with the fan brush . . . 7. . . . then banks with the knife.

Hazy Day

8. Pull down with the fan brush . . .

9. . . . to paint the small waterfalls.

10. Use the 2" brush to paint the trees on the left side . . .

11. . . . then pull down to reflect them into the water.

12. Add the trees . . .

13. . . . and reflections on the right side of the painting.

14. Use the liner brush to add tiny tree trunks.

15. Working forward, underpaint trees . . .

16. . . . then add the trunks . . .

17. . . . the grassy areas . . .

18. . . . and the banks along the water's edge.

19. Use the filbert brush to add rocks . . .

20. . . . and the fan brush . . .

21. . . . to continue "swirling" in the water.

 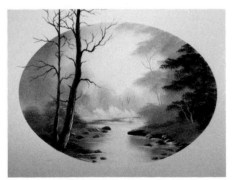

22. Remove the Con-Tact Paper . . .

23. . . . and your oval is ready . . .

24. . . . for the addition of large tree trunks.

25. Add limbs and branches...

26. . . . then highlight the trunk . . .

27. . . . to complete the painting.

37

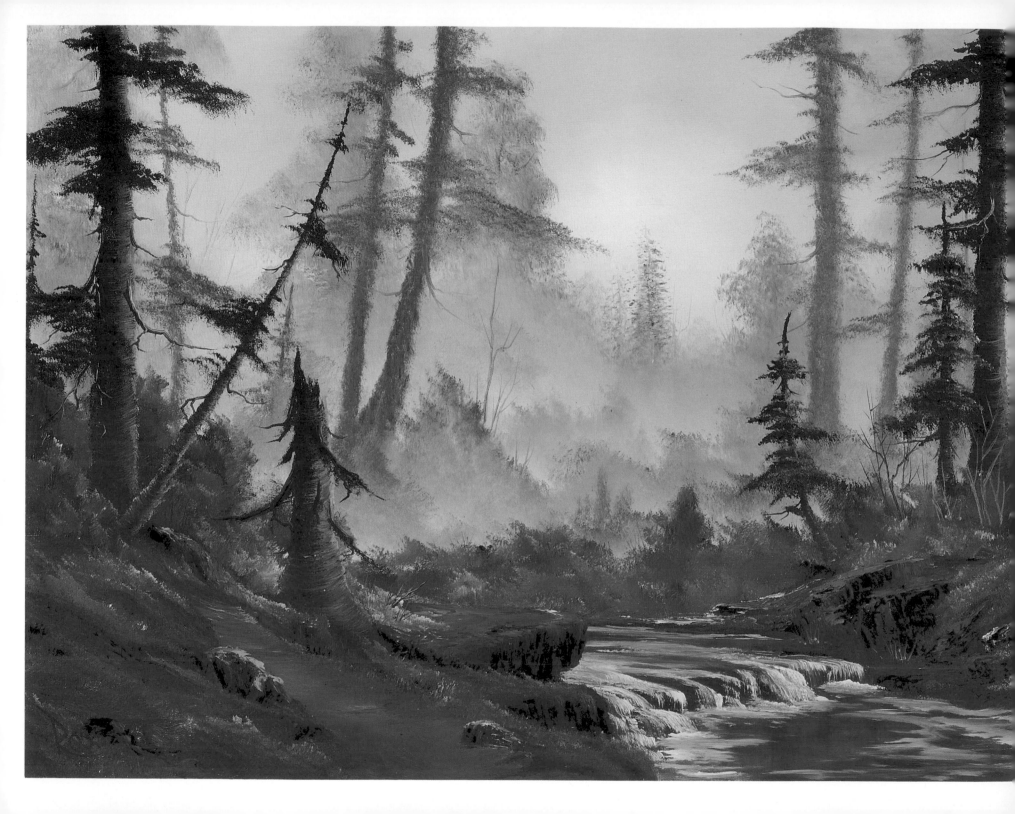

MATERIALS

2″ Brush	Midnight Black
1″ Brush	Dark Sienna
#6 Fan Brush	Van Dyke Brown
#2 Script Liner Brush	Alizarin Crimson
Large Knife	Sap Green
Liquid White	Cadmium Yellow
Titanium White	Yellow Ochre
Phthalo Blue	Bright Red

Start by covering the entire canvas with a thin, even coat of Liquid White. Do NOT allow the Liquid White to dry before you begin.

SKY

Use a mixture of Dark Sienna and Yellow Ochre on the 2″ brush and with criss-cross strokes, begin by applying this color to the center of the sky. *(Photo 1.)* Add a small amount of Sap Green to the mixture and extend the color out to the upper edges of the canvas. Blend the entire sky. With Titanium White on a clean, dry 2″ brush, use criss-cross strokes to add the lightest area to the center of the sky and again blend the entire sky. *(Photo 2.)*

BACKGROUND

The misty background trees are made with various mixtures of Dark Sienna, Yellow Ochre and Sap Green on the 2″ brush. Press each side of the brush against the canvas *(Photo 3)* or tap downward with just the top corner *(Photo 4)* to shape the tiny trees. Diffuse the base of the trees by firmly tapping downward with the top corner of the 2″ brush *(Photo 5)* creating the illusion of mist *(Photo 6).*

Moving forward in the painting, load the fan brush with a Blue-Lavender mixture made with Bright Red, Titanium White and Phthalo Blue. Use the corner of the brush to scrub in the indication of some darker trees. *(Photo 7.)* Again, firmly tap the base of the trees with the corner of the 2″ brush *(Photo 8)* to create the misty appearance. Shape tiny ever-greens with the same mixture using just one corner of the fan brush *(Photo 9).*

The large, misty tree trunks in the background are made by adding a bit more Phthalo Blue to the Lavender mixture. Load the fan brush and starting at the top of the canvas, firmly tap downward to create the fuzzy trunks. *(Photo 10.)* Use the same brush to add leaves to some of the trunks *(Photo 11)* and small growth to the base of the trees. Again, tap to mist the base of the trees. Use the same mixture, thinned with paint thinner, on the liner brush to add small limbs and branches *(Photo 12)* to the background trees.

Continuing to move forward in the painting, use the fan brush with various mixtures of Sap Green, Alizarin Crimson and Titanium White to scrub in the darker undergrowth at the base of the trees. *(Photo 13.)*

MIDDLEGROUND

Use long horizontal strokes with Van Dyke Brown on the 2″ brush *(Photo 14)* to underpaint the foreground *(Photo 15).* The land at the base of the trees is made with Van Dyke Brown on the knife and then highlighted with a mixture of Titanium White, Dark Sienna and Midnight Black. *(Photo 16.)* Use push-up strokes with the fan brush to add little grasses to the land area.

WATERFALL

With the small knife, use Van Dyke Brown to build the rock ledge under the waterfall *(Photo 17)* in the foreground *(Photo 18).* Use a mixture of Liquid White and Titanium White with a very small amount of Phthalo Blue on the fan brush to add the water. Make a series of short, sweeping horizontal strokes and then pull straight down to bring the water over the rocks and stones. *(Photo 19.)* Use tiny push-up strokes and swirling strokes for the water action at the base of the falls. *(Photo 20.)*

FOREGROUND

The large rock projections in the foreground are shaped with Van Dyke Brown on the knife. *(Photo 21.)* Use a Van Dyke Brown-Dark Sienna-Titanium White mixture on the fan brush to scrub in the growth above the rocks. *(Photo 22.)* Highlight the rocks with the same light mixture on the knife. *(Photo 23.)*

Use short, sweeping, horizontal strokes with the fan brush for the path and then highlight with a small amount of Titanium White. *(Photo 24.)* Watch the perspective here, the path becomes wider as it moves forward and nears the bottom of the canvas. Use Van Dyke Brown on the knife to add small stones to the edges of the path, then highlight with the Brown-White mixture.

LARGE TREES

The large tree trunks are made with Van Dyke Brown on the fan brush. Starting at the top of the canvas, tap downward to create the fuzzy bark appearance. *(Photo 25.)* Tap Titanium White along the right sides of the trunks *(Photo 26)* and then pull the White paint towards the left sides of the trunks *(Photo 27)*. The leaves are made with Van Dyke Brown on the fan brush. *(Photo 28.)*

FINISHING TOUCHES

Use a thin mixture of paint thinner and Van Dyke Brown on the liner brush to add small limbs and branches *(Photo 29)*, sticks and twigs and other small details. Your painting is finished *(Photo 30)* and ready for the most important part, your signature.

Deep Woods

1. Use criss-cross strokes . . .

2. . . . to paint the sky.

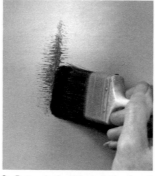

3. Press both sides of the brush against the canvas . . .

4. . . . or tap down to paint small background trees.

5. Firmly tap with the corner of the brush . . .

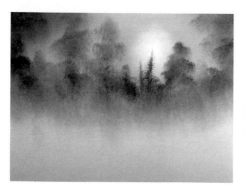

6. . . . to create the misty appearance.

7. Scrub in trees . . .

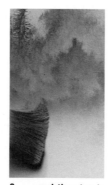

8. . . . and then tap to mist.

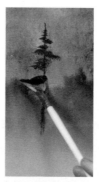

9. Use the fan brush for evergreens . . .

10. . . . tree trunks . . .

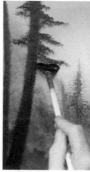

11. . . . and foliage.

12. Add limbs and branches . . .

Deep Woods

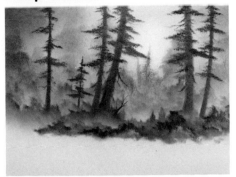

13. . . . to complete the background trees.

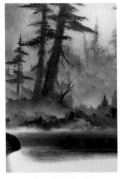

14. Use the 2" brush . . .

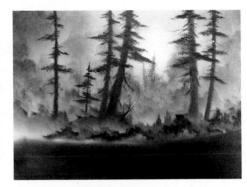

15. . . . to underpaint the foreground.

16. The land is made with the knife.

17. Use the knife . . .

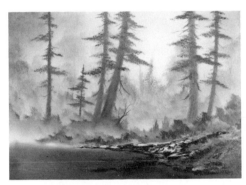

18. . . . to shape the rocky ledge.

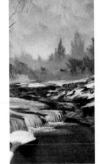

19. Use the fan brush. . .

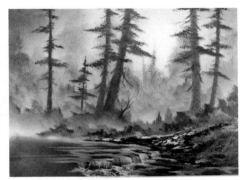

20. . . . to pull the water over the rocks.

21. Add more rocks with the knife . . .

22. . . . and bushes with the fan brush.

23. Highlight the rocks . . .

24. . . . and the path.

25. Tap down trunks . . .

26. . . . and highlight . . .

27. . . . with the fan brush.

28. Add foliage . . .

29. . . . and branches . . .

30. . . . and your painting is finished.

8. ROYAL MAJESTY

MATERIALS

2" Brush	Prussian Blue
1" Brush	Midnight Black
#6 Fan Brush	Dark Sienna
Script Liner Brush	Van Dyke Brown
Large Knife	Alizarin Crimson
Small Knife	Sap Green
Liquid White	Cadmium Yellow
Liquid Clear	Yellow Ochre
Titanium White	Indian Yellow
Phthalo Blue	Bright Red

Use a foam applicator with Black Gesso to block in the basic dark shapes on the lower portion of the canvas. Allow the Black Gesso to DRY COMPLETELY. (Photo 1.)

With the 2" brush, cover the dry Black Gesso with a VERY THIN coat of Liquid Clear.

Still using the 2" brush, cover the Liquid Clear with a very thin, even coat of a Lavender mixture made with Alizarin Crimson and Phthalo Blue.

Cover the dry, White unpainted area of the canvas with a thin, even coat of Liquid White. Do NOT allow the canvas to dry before you begin.

SKY

Load the 2" brush with a small amount of a mixture of Midnight Black and Prussian Blue. Starting at the top of the canvas and working down towards the horizon, use criss-cross strokes to paint the sky in the light portion of the canvas.

With Titanium White on the fan brush, use circular strokes to push in the cloud shapes. (Photo 2.) Use the top corner of a clean, dry 2" brush and circular strokes to blend the base of the clouds (Photo 3) then lightly lift upward to "fluff".

MOUNTAINS

The mountains are painted with the large knife and a mixture of Midnight Black, Phthalo Blue and Alizarin Crimson.

(To load the knife, pull the mixture out very flat on your palette and just cut across, loading the long edge of the knife with a small roll of paint.) With firm pressure, shape just the top edge of the mountain. (Photo 4.)

Add Titanium White to the mountain mixture when shaping the smaller, distant mountain top.

Use the knife to remove any excess paint and then with the 2" brush, blend the paint down to the base of the mountain to mist and complete the entire mountain shape. The mountain should be much more distinct at the top than at the bottom.

Highlight the mountain with a mixture of Titanium White with a very small amount of Alizarin Crimson. Again, load the knife with a small roll of paint. In this painting, the light is coming from the right. Starting at the top of the mountain (and paying close attention to angles) apply the snowy highlights to the right side of each peak, using so little pressure that the paint "breaks". (Photo 5.)

Use a mixture of Titanium White with a small amount of Phthalo Blue for the shadow sides of the peaks. Again, use so little pressure that the paint "breaks".

Carefully following the angles, diffuse the base of the mountain by tapping with the 2" brush then use upward strokes to mist.

Working in layers, add the small peaks at the base of the mountain with Titanium White; the shadows with Titanium White and Phthalo Blue. Again, tap and lift upward to diffuse and mist. (Photo 6.)

BACKGROUND

Load the fan brush with the mountain mixture (Midnight Black, Phthalo Blue and Alizarin Crimson), Titanium White and Sap Green. Holding the brush vertically, just tap downward to indicate the small evergreens at the base of the mountain. (Photo 7.)

Use just the corner of the fan brush to add tiny branches to the more distinct trees. Diffuse the base of the trees by

firmly tapping with the top corner of a clean, dry 2" brush then use upward strokes to create the illusion of mist (Photo 8).

EVERGREENS

To paint the larger evergreens, load the fan brush to a chiseled edge with a mixture of Midnight Black, Prussian Blue, Van Dyke Brown, Alizarin Crimson and Sap Green. Holding the brush vertically, touch the canvas to create the center line of each tree. Use just the corner of the brush to begin adding the small top branches. Working from side to side, as you move down each tree, apply more pressure to the brush, forcing the bristles to bend downward (Photo 9) and automatically the branches will become larger as you near the base of each tree.

Use a mixture of all of the Yellows with the dark tree color on the fan brush to lightly touch highlights to the right sides of the large evergreens. Don't over-do, these trees should remain quite dark.

LARGE ROCKS

Shape the large rocks with the fan brush and a mixture of Van Dyke Brown and Dark Sienna.

Highlight the rocks with various mixtures of Dark Sienna, Titanium White and Phthalo Blue on the small knife, again using so little pressure that the paint "breaks". (Photo 10.)

Very lightly blend the rocks with a clean, dry 2" brush paying close attention to the shape and contour of the rocks (Photo 11).

With a very small amount of Titanium White on the 2" brush, firmly tap the base of the rocks to create the illusion of mist.

FOREGROUND

Shape the rocks and stones in the foreground with a mixture of Van Dyke Brown and Dark Sienna on the knife. Highlight by adding Titanium White to the mixture. Again, use so little pressure that the paint "breaks".

Use various mixtures of all of the Yellows, Bright Red and Sap Green on the 2" brush to tap in the soft grassy area at the top of the rocks. Load the 2" brush by holding it at a 45-degree angle and tapping the bristles into the various paint mixtures. Allow the brush to "slide" slightly forward in the paint each time you tap (this assures that the very tips of the bristles are fully loaded with paint). Hold the brush horizontally and gently tap downward.

To add the path, make short horizontal strokes with a mixture of the Browns and Titanium White on the fan brush.

Working in layers, continue adding the soft grassy areas (Photo 12) curving over the tops of the rocks.

WATERFALL

Load the 1" brush to a chiseled edge with a mixture of Liquid Clear, Titanium White and a very small amount of Phthalo Blue to paint the waterfall. Starting at the top of the falls, make a short horizontal stroke and then pull straight down. (Photo 13.) Change the direction of the falls by reversing the direction of the strokes. (Photo 14.)

Add the large rock on the right side of the falls with Van Dyke Brown on the knife then highlight with a mixture of Van Dyke Brown and Titanium White. (Photo 15.) Lightly graze the highlights with the 2" brush to soften and blend.

Paint the small bushes at the base of this rock with the Yellow highlight mixtures using just the corner of the 2" brush. (Photo 16.)

Use Liquid Clear and Titanium White on the fan brush and push-up strokes to add the foaming action at the base of the falls (Photo 17) then continue moving the water forward with swirling, horizontal strokes. (Photo 18.)

FINISHING TOUCHES

Complete your painting with small tree trunks. Load the liner brush with thinned Van Dyke Brown and then pull one side of the bristles through a mixture of Liquid White and Dark Sienna, to double-load the brush. With single strokes (Photo 19) you can add the trunks and branches with highlights (Photo 20).

Royal Majesty

1. Pre-paint the canvas with Black Gesso.

2. Use circular strokes to paint the clouds . . .

3. . . . then blend with the 2" brush.

4. Shape the mountain . . .

5. . . . and apply highlights with the knife.

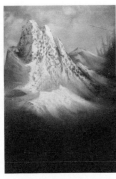
6. Add small peaks to the base of the mountain.

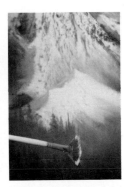
7. Use the fan brush to paint the tiny evergreens . . .

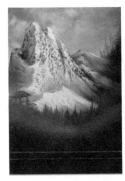
8. . . . at the base of the mountain.

9. Paint large evergreens with the fan brush.

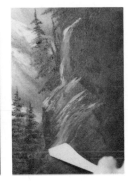
10. Use the knife . . .

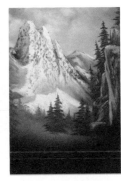
11. . . . to highlight the rocks.

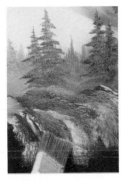
12. Extend the soft grasses over the rocks.

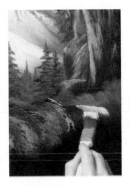
13. Pull down with the 1" brush . . .

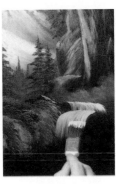
14. . . . to add the waterfall.

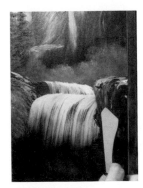
15. Use the knife . . .

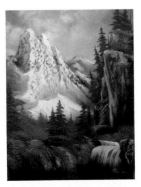
16. . . . to continue adding rocks and stones.

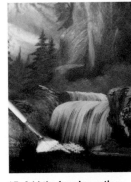
17. Add the foaming action . . .

18. . . . then bring the water forward.

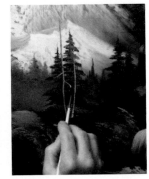
19. Tiny trees with the liner brush . . .

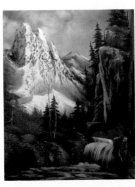
20. . . . will complete the painting.

45

9. AT DAWN'S LIGHT

MATERIALS

2" Brush	Prussian Blue
1" Round Brush	Midnight Black
Small Round Brush	Dark Sienna
#6 Fan Brush	Van Dyke Brown
#2 Script Liner Brush	Alizarin Crimson
Large Knife	Cadmium Yellow
Liquid White	Yellow Ochre
Liquid Clear	Bright Red
Titanium White	

Use the 2" brush to cover the entire canvas with a thin, even coat of Liquid White. With long horizontal and vertical strokes, work back and forth to ensure an even distribution of paint on the canvas. Do NOT allow the Liquid White to dry before you begin.

SKY AND WATER

Load the 2" brush by tapping the bristles into a mixture of Bright Red and Cadmium Yellow. Use criss-cross strokes to create an Orange glow in the center of the sky. *(Photo 1.)* Use long, vertical strokes to reflect the Orange into the center of the water.

Reload the 2" brush by tapping the bristles into a mixture of Yellow Ochre and Bright Red and continue working outward with criss-cross strokes. Again, reflect the color into the water.

Reload the brush with Alizarin Crimson and continue working outward with criss-cross strokes. *(Photo 2.)*

Still working outward from the center, use a mixture of Alizarin Crimson and Prussian Blue, then use a mixture of Alizarin Crimson, Prussian Blue and Midnight Black at the edges of the canvas; reflecting each color into the water. Use a clean, very dry 2" brush to blend the entire sky.

With Titanium White on the 2" brush, use criss-cross strokes to add the light area in the center of the sky. *(Photo 3.)* Blend the entire canvas. *(Photo 4.)*

BACKGROUND

Use the knife to make a dark Lavender mixture on your palette with Midnight Black, Alizarin Crimson and a small amount of Prussian Blue. Add Titanium White to a small portion of the mixture to make a light Lavender color.

To paint the misty, background evergreens, load the fan brush to a chiseled edge with the light Lavender mixture. Holding the brush vertically, touch the canvas to create the center line of each tree. Use just the corner of the brush to begin adding the small top branches. Working from side to side, as you move down each tree, apply more pressure to the brush, forcing the bristles to bend downward *(Photo 5)* and automatically the branches will become larger as you near the base of each tree.

Use the light Lavender mixture on the small round brush to tap in the indication of background leafy trees. *(Photo 6.)*

Use the 2" brush to extend this Lavender color into the water for reflections *(Photo 7)* then tap downward to underpaint the dark land area at the base of the trees.

Add snow to the land area by tapping downward with a mixture of Liquid White and Titanium White on the 2" brush, carefully creating the lay-of-the-land. Load the 2" brush by holding it at a 45-degree angle and tapping the bristles into the mixture. Allow the brush to "slide" slightly forward in the paint each time you tap (this assures that the very tips of the bristles are fully loaded with paint). Hold the brush horizontally and gently tap downward. Work in layers, carefully creating the lay-of-the-land. *(Photo 8.)*

Use a mixture of Liquid White with a very small amount of Bright Red on the edge of the knife to "cut" in the water lines *(Photo 9)* completing the background *(Photo 10)*.

FOREGROUND

Moving forward in the painting, underpaint the leaf trees and bushes with a darker Lavender mixture on the round brush. *(Photo 11.)* Again, use the 2" brush to extend the color into the water for reflections. *(Photo 12.)*

Add the tree trunks with the dark Lavender mixture and the liner brush. (To load the liner brush, thin the Lavender mixture to an ink-like consistency by first dipping the liner brush into paint thinner. Slowly turn the brush as you pull the bristles through the mixture, forcing them to a sharp point.) Apply very little pressure to the brush, as you shape the trunks. By turning and wiggling the brush, you can give your trunks a gnarled appearance. (Photo 13.)

Use the Lavender mixture with Titanium White on the small round brush to tap snowy highlights on the leaf trees and bushes. (Photo 14.)

Add the banks along the water's edge with Titanium White on the knife. (Photo 15.) Again, use Liquid White on the edge of the knife to cut in the water lines.

Use a mixture of Van Dyke Brown and Dark Sienna on the fan brush to paint the tree trunks (Photo 16) then highlight with Titanium White on the knife (Photo 17). Use thinned Brown mixture on the liner brush to add limbs and branches to the trees. (Photo 18.) Load the small brush with the dark Lavender mixture, then dip just the tips of the bristles into a thin mixture of Liquid Clear and Titanium White. Tap downward to add the snowy foliage to the trees, carefully forming individual leaf clusters. (Photo 19.)

Use the dark Lavender mixture on the fan brush to paint the large evergreen tree. (Photo 20.)

LARGE TREES

Again, use the Van Dyke Brown mixture on the fan brush to paint the large tree trunks. (Photo 21.) Highlight the trunks with Titanium White on the knife (Photo 22) then use thinned Brown on the liner brush to add the limbs and branches (Photo 23).

Load the round brush with the Lavender color, dip the tips of the bristles into the Liquid Clear-Titanium White mixture and tap downward to add leaf clusters to the large trees and the foliage at the base of the trees (Photo 24).

FINISHING TOUCHES

With Titanium White on the knife, use short horizontal strokes to paint the path. Paying close attention to perspective, starting in the distance, allow the path to become wider as you work forward (Photo 25) and your painting is complete (Photo 26).

Don't forget to sign your name with pride: Again, load the liner brush with thinned color of your choice. Sign just your initials, first name, last name or all of your names. Sign in the left corner, the right corner or one artist signs right in the middle of the canvas! The choice is yours. You might also consider including the date when you sign your painting. Whatever your choices, have fun, for hopefully with this painting you have truly experienced THE JOY OF PAINTING!

At Dawn's Light

1. Begin painting the sky with criss-cross strokes . . .

2. . . . then add reflections to the water.

3. Add the light area with the 2" brush . . .

4. . . . then blend the entire canvas.

5. Paint evergreens with the fan brush . . .

6. . . . and leafy trees with the round brush.

At Dawn's Light

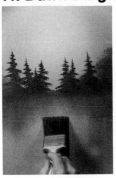

7. Pull down reflections . . .

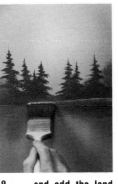

8. . . . and add the land area with the 2" brush.

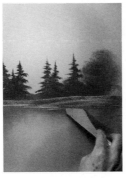

9. Cut in water lines with the knife . . .

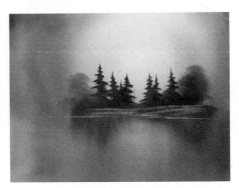

10. . . . to complete the background.

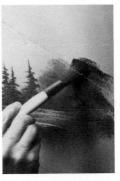

11. Underpaint leaf trees with the round brush . . .

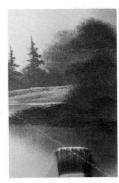

12. . . . add reflections with the 2" brush . . .

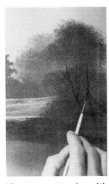

13. . . . tree trunks with the liner brush . . .

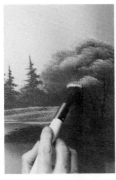

14. . . . then highlight with the round brush.

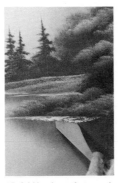

15. Add banks to the water's edge with the knife.

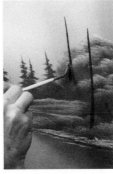

16. Pull down trunks with the fan brush . . .

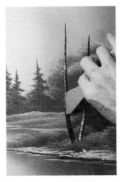

17. . . . then highlight with the knife.

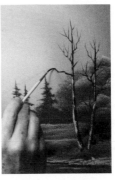

18. Add limbs and branches with the liner brush . . .

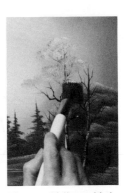

19. . . . and foliage with the round brush.

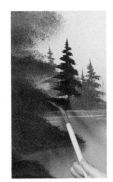

20. Use the fan brush to paint the evergreen . . .

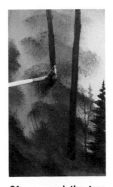

21. . . . and the tree trunks.

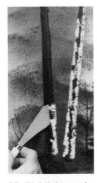

22. Highlight trunks with the knife . . .

23. . . . add branches with the liner brush . . .

24. . . . and foliage with the round brush.

25. Use the knife to add a path . . .

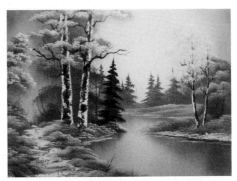

26. . . . and your painting is ready for a signature.

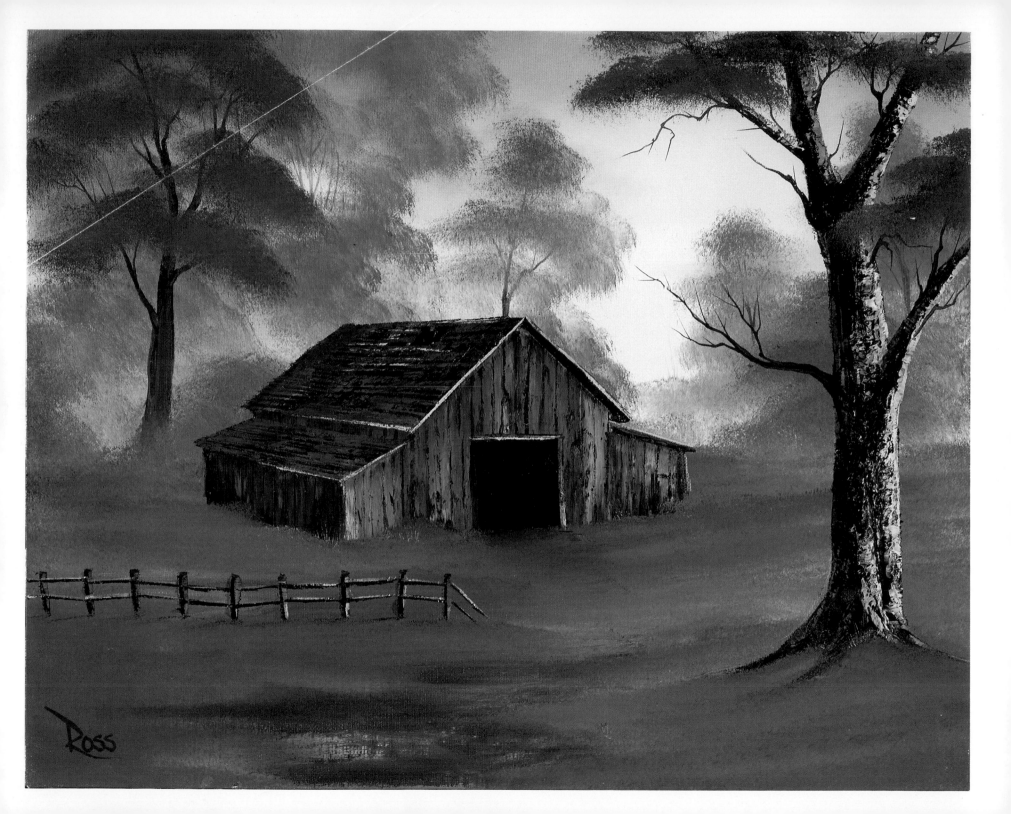

At Dawn's Light

7. Pull down reflections . . .

8. . . . and add the land area with the 2" brush.

9. Cut in water lines with the knife . . .

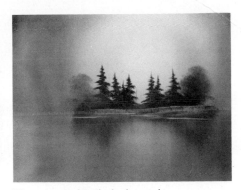

10. . . . to complete the background.

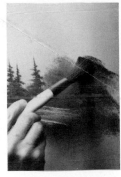

11. Underpaint leaf trees with the round brush . . .

12. . . . add reflections with the 2" brush . . .

13. . . . tree trunks with the liner brush . . .

14. . . . then highlight with the round brush.

15. Add banks to the water's edge with the knife.

16. Pull down trunks with the fan brush . . .

17. . . . then highlight with the knife.

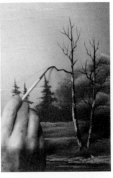

18. Add limbs and branches with the liner brush . . .

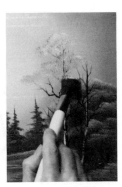

19. . . . and foliage with the round brush.

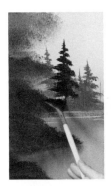

20. Use the fan brush to paint the evergreen . . .

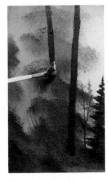

21. . . . and the tree trunks.

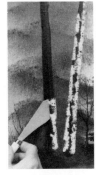

22. Highlight trunks with the knife . . .

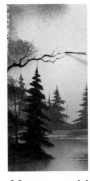

2 3. . . . a d d branches with the liner brush . . .

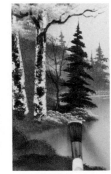

24. . . . and foliage with the round brush.

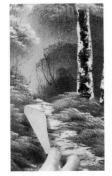

25. Use the knife to add a path . . .

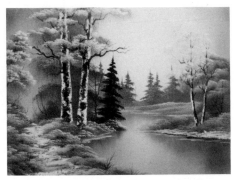

26. . . . and your painting is ready for a signature.

10. GRANDPA'S BARN

MATERIALS

2" Brush	Dark Sienna
#2 Script Liner Brush	Van Dyke Brown
Large Knife	Alizarin Crimson
Small Knife	Sap Green
Liquid White	Cadmium Yellow
Titanium White	Yellow Ochre
Prussian Blue	Indian Yellow
Midnight Black	Bright Red

Start by covering the entire canvas with a thin, even coat of Liquid White, using the 2" brush. With long, horizontal and vertical strokes, work back and forth to ensure an even distribution of paint on the canvas. Do NOT allow the Liquid White to dry before you begin.

SKY

Load the 2" brush by tapping the bristles firmly into a very small amount of Yellow Ochre. Create the Yellow areas in the sky by making criss-cross strokes just above the horizon, allowing some of the color to extend up towards the top of the canvas. (Photo 1.) Without cleaning the brush, reload by tapping the bristles into a small amount of Alizarin Crimson and Prussian Blue, to make a Lavender. Still using criss-cross strokes, cover the remainder of the sky. As the Lavender color mixes with the Yellow on the canvas, it should still remain quite "pure" and not turn into a Green color. (Photo 2.)

BACKGROUND

Load the 2" brush by tapping the bristles into a mixture of Midnight Black, Yellow Ochre, Titanium White and Alizarin Crimson. Starting at the base of the trees and working upward, tap downward with the corner of the brush to paint the distant trees and bushes along the horizon. (Photo 3.) Add Van Dyke Brown to the same mixture and use the liner brush to indicate the small tree trunks and branches. To fully load the liner brush, thin the paint mixture with paint thinner and slowly turn the handle as you pull the brush through the paint, forcing the bristles to form a sharp point. Use very little pressure on the brush as you paint the tree trunks. (Photo 4.)

Add highlights to the large trees and bushes with a mixture of Yellow Ochre and small amounts of Midnight Black and Alizarin Crimson, to make a Green. Again just tap downward, still using the 2" brush. (To load the 2" brush, hold it at a 45-degree angle and tap the bristles into the various paint mixtures. Allow the brush to "slide" slightly forward in the paint each time you tap (this assures that the very tips of the bristles are fully loaded with paint). Try not to just hit at random, this is where you form the individual tree and bush shapes. (Photo 5.)

MIDDLEGROUND

Underpaint the larger leaf tree on the left side of your painting with a darker base mixture of Midnight Black, Yellow Ochre and Alizarin Crimson on the 2" brush. (Photo 6.) Just tap downward to shape the tree (Photo 7) and then use Van Dyke Brown thinned with paint thinner on the liner brush to add the tree trunk and branches (Photo 8). Highlight the right side of the trunk with a small amount of thinned Bright Red on the liner brush.

Load the 2" brush by tapping the bristles into the same Green mixture of Midnight Black, Yellow Ochre and Alizarin Crimson. Highlight the leaf tree by tapping with just one corner of the brush. (Photo 9.) Try not to just hit at random, "think like a tree", form individual limbs and branches. (Photo 10.)

Use a mixture of Van Dyke Brown and Midnight Black on the 2" brush to underpaint the ground area. Load the 2" brush (which still has the dark mixture on it) by tapping the bristles into various mixtures of all the Yellows and Sap Green. Highlight the grass-covered ground area by holding the brush horizontally and tapping downward. (Photo 11.) Starting at the base of the background trees, work in layers as you move forward, creating the lay-of-the-land. Be very

careful not to destroy all of the dark base color already on the canvas. *(Photo 12.)*

BARN

Use a clean knife to remove paint from the canvas in the basic shape of the barn. Load the long edge of the knife with a small roll of Van Dyke Brown by pulling the paint out very flat on your palette and just cutting across. Paying close attention to angles, paint the back edge of the roof and then the front of the roof. Pull down to add the front and side of the barn.

Use a mixture of Bright Red, Dark Sienna, Van Dyke Brown and Titanium White to "bounce" highlights onto the roof. Very lightly highlight the front of the barn with a mixture of Dark Sienna and Titanium White on the knife, using so little pressure that the paint "breaks". Add Van Dyke Brown to the mixture to highlight the side of the barn and then use Van Dyke Brown on the knife to add the door. Use the knife to remove excess paint from the base of the barn. (Again, pay close attention to angles). Create the indication of boards using Van Dyke Brown on the long edge of the knife. *(Photo 13.)*

FOREGROUND

Tap the bristles of the 2″ brush into various mixtures of Midnight Black, Van Dyke Brown, all the Yellows and Bright Red to continue adding the grassy areas around the base of the barn, working in layers. The path is made with short, horizontal strokes using the knife and Van Dyke Brown.

Load the long edge of the small knife with a roll of Van Dyke Brown to add the fence and highlight with a mixture of Van Dyke Brown and Titanium White. Use the large knife with Van Dyke Brown for the rails.

The large tree in the foreground is made with Van Dyke Brown on the knife. Starting at the very top of the canvas, pull down allowing the trunk to become wider as you near the base. *(Photo 14.)* Highlight the right side with Titanium White and Dark Sienna on the knife, using very little pressure, allowing the paint to "break". *(Photos 15 & 16.)* Use a dark mixture of Midnight Black and Yellow Ochre on the 2″ brush to underpaint the leaf clusters on the tree *(Photo 17)* and then highlight with a lighter mixture of Midnight Black and Yellow Ochre *(Photo 18)*.

FINAL TOUCHES

Use a very thinned paint on your liner brush to add any small, final details and then sign your new masterpiece!

Grandpa's Barn

1. Use criss-cross strokes . . .

2. . . . to paint the sky.

3. Tap down with the 2″ brush . . .

4. . . . then add trunks with the liner brush . . .

5. . . . to add the background trees.

6. Use the 2″ brush . . .

Grandpa's Barn

 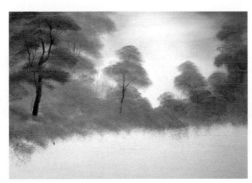 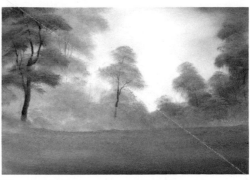

7. . . . to under-paint the larger leaf tree.

8. Add trunks with the liner brush . . .

9. . . . and high-lights with the 2" brush . . .

10. . . . to complete the background trees.

11. Tap down with the 2" brush . . .

12. . . . to add the grassy area to the background.

13. Progressional steps used to paint Grandpa's barn.

14. Pull down the trunk . . .

15. . . . and then high-light with the knife . . .

16. . . . to add the large tree in the foreground.

17. Use the 2" brush to add the foliage . . .

18. . . . and your painting is finished!

53

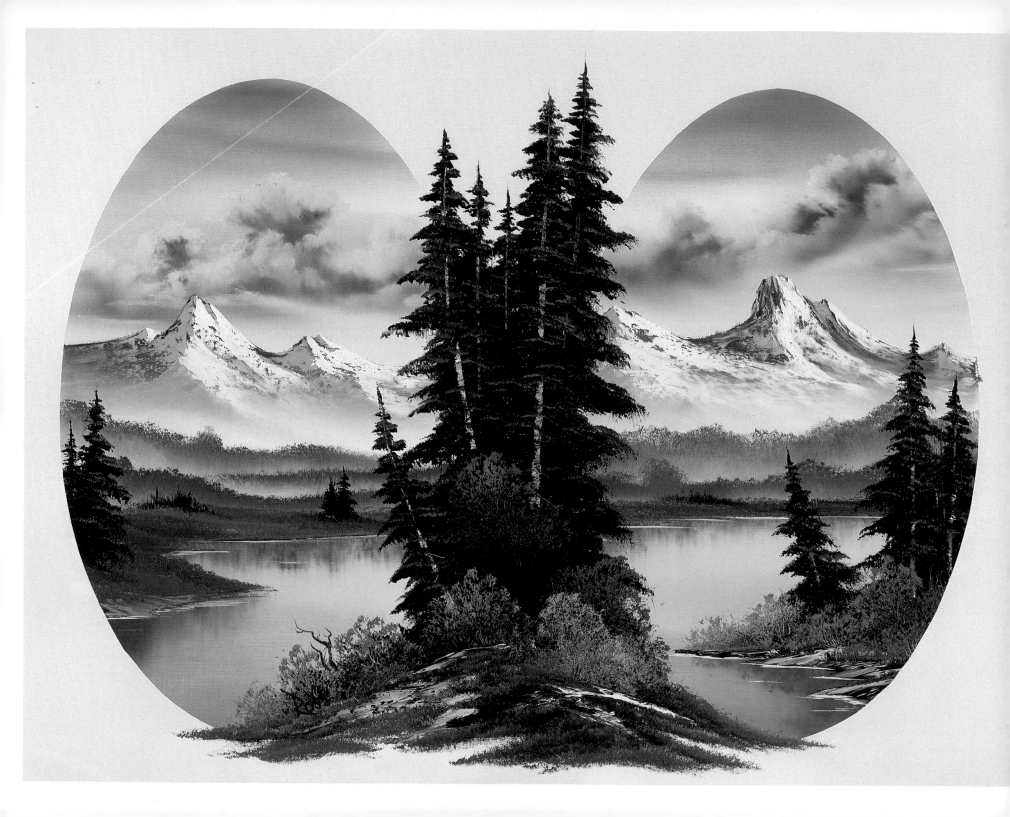

11. DOUBLE OVAL FANTASY

MATERIALS

2″ Brush
1″ Brush
#6 Fan Brush
#2 Script Liner Brush
Large Knife
Adhesive-Backed Plastic
Liquid White
Titanium White
Phthalo Green
Phthalo Blue

Prussian Blue
Midnight Black
Dark Sienna
Van Dyke Brown
Alizarin Crimson
Sap Green
Cadmium Yellow
Yellow Ochre
Indian Yellow
Bright Red

Cover the entire canvas with a piece of adhesive-backed plastic (Con-tact Paper) from which you have removed two ovals. *(Photo 1.)* Cover the exposed areas of the canvas with a thin, even coat of Liquid White. Do NOT allow the Liquid White to dry before you begin.

SKY

With Indian Yellow on the 2″ brush, create a Golden glow in the sky (in both ovals) just above the horizon. Without cleaning the brush, add Yellow Ochre above the Indian Yellow. With a clean, dry 2″ brush, use criss-cross strokes to add Phthalo Blue to the top of the ovals. Add the water to the lower portion of the ovals with a mixture of Phthalo Blue and Phthalo Green.

Blend the entire sky with a clean, dry 2″ brush and then with a small amount of Midnight Black and Prussian Blue on the brush, create subtle cloud effects by just tapping. The more distinct clouds are made with a mixture of Alizarin Crimson, Phthalo Blue, Midnight Black and Titanium White (to make a Lavender) on the fan brush. Use just one corner of the brush and small circular strokes to shape the clouds then use the 2″ brush to blend the clouds. Highlight just the top edges of the clouds with a mixture of Titanium White and a very small amount of Bright Red on the fan brush. Blend with the top corner of the 2″ brush then lift upward to "fluff" *(Photo 2)*.

MOUNTAINS

The mountains are made using the knife and a mixture of Midnight Black, Prussian Blue, Van Dyke Brown and Alizarin Crimson. Use firm pressure to shape just the top edge of the mountain. Pull the paint down to the base of the mountains to blend with the 2″ brush.

Highlight the mountains with Titanium White (to which you can add a very small amount of Bright Red). Load the knife with a small roll of paint and starting at the top, glide the knife down the right side of each peak, using so little pressure that the paint "breaks." *(Photo 3.)*

The shadow sides of the peaks are a mixture of Titanium White and Phthalo Blue, applied in the opposing direction; again, using so little pressure that the paint "breaks."

Use a clean, dry 2″ brush to tap to diffuse the base of the mountain (carefully following the angles) and then gently lift upward to create the illusion of mist *(Photo 4)*.

FOOTHILLS

Load the 2″ brush with the same Lavender mixture (Alizarin Crimson, Phthalo Blue, Midnight Black and Titanium White). Use just one corner of the brush and tap downward to shape the foothills at the base of the mountain. *(Photo 5.)* Hold a clean, dry 2″ brush vertically and use the top corner to tap the base of the hills, to diffuse and then lightly lift upward, to create the illusion of mist.

Continuing the foothills through both ovals, add several darker ranges of hills, by using less Titanium White in the mixture. Extend some of the color into the water area, for reflections. Pull the reflections straight down, with the 2″ brush *(Photo 6)* and then gently brush across to give the reflections a watery appearance.

With various mixtures of Midnight Black, all of the Yellows and Bright Red on the fan brush, you can highlight the closer hills with little push-up strokes. Use a small roll of Liquid White on the very edge of the knife to cut in the water lines. *(Photo 7.)*

EVERGREENS

You can add the tiny background trees using the dark Lavender mixture on the fan brush. For the larger evergreens, load the fan brush to a chiseled edge with a mixture of Midnight Black, Prussian Blue, Van Dyke Brown, Alizarin Crimson and Phthalo Green. Holding the brush vertically, touch the canvas to create the center line of each tree. Use just the corner of the brush to begin adding the small top branches. Working from side to side, as you move down the tree, apply more pressure to the brush, forcing the bristles to bend downward *(Photo 8)* and automatically the branches will become larger as you near the base of each tree. Allow this color to extend right into the water for reflections; pull down with the 2" brush *(Photo 9)* and lightly brush across.

With a mixture of Midnight Black and Cadmium Yellow (to make Green) lightly highlight the right sides of the branches, still using the fan brush. Pull the 1" brush in one direction through the same mixture, to round one corner. With the rounded corner up, force the bristles to bend upward as you highlight the individual bushes at the base of the evergreens. *(Photo 10.)* Reverse the brush and reflect the bushes into the water. Pull down with the 2" brush and then very lightly (two hairs and some air) brush across.

The land at the water's edge is Van Dyke Brown, applied with the knife and highlighted with a mixture of Dark Sienna and Titanium White. *(Photo 11.)* Cut in the water lines with a small amount of Liquid White on the knife and your painting is ready for the foreground.

FOREGROUND

Remove the Con-tact Paper from the canvas to expose the two painted ovals *(Photo 12)*.

Add several large evergreens to the exposed area between the ovals, using the fan brush and the dark evergreen mixture. *(Photo 13.)* Use the 2" brush and the same dark mixture to add the small trees and bushes *(Photo 14)* to the base of the evergreens. Again, highlight the bushes with the 1" brush and the Yellow highlight mixtures. *(Photo 15.)* The tree trunks are a mixture of Dark Sienna and Titanium White, applied with the knife. *(Photo 16.)*

You can use Van Dyke Brown on the knife to add the land masses to the base of the trees and then highlight with a mixture of Dark Sienna and Titanium White on the knife. *(Photo. 17.)* Use push-up strokes with the fan brush and the Yellow highlight colors to create little grassy areas. *(Photo 18.)*

FINISHING TOUCHES

With the point of the knife *(Photo 19)* or a thinned paint on the liner brush *(Photo 20)* add sticks, twigs and other small details and your double oval is finished! *(Photo 21)*.

Double Oval Fantasy

1. Cover the canvas with ovals from Con-Tact Paper.

2. Paint the sky, clouds and water in both ovals.

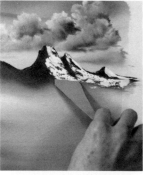

3. Use the knife to paint a mountain . . .

4. . . . in each oval.

Double Oval Fantasy

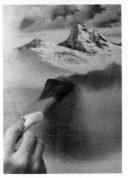

5. Use the 2" brush to tap in the foothills . . .

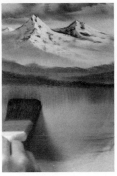

6. . . . and to reflect them into the water.

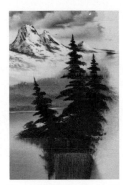

7. Cut in water lines with Liquid White.

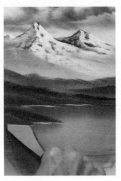

8. Paint evergreens with the fan brush . . .

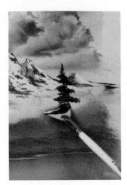

9. . . . and their reflections with the 2" brush.

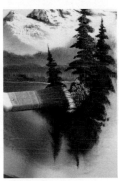

10. Highlight the bushes . . .

11. . . . and add land to the base of the evergreens.

12. Remove the Con-Tact paper, exposing the painted ovals.

13. Add evergreens . . .

14. . . . and bushes between the ovals.

15. Highlight the bushes with the 1" brush.

16. Use the knife for tree trunks . . .

17. . . . and to add rocks and stones.

18. Grassy areas are made with the fan brush.

19. Add sticks and twigs with the knife . . .

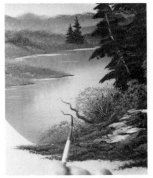

20. . . . or the liner brush . . .

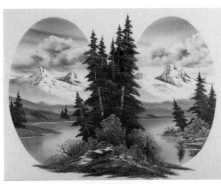

21. . . . and your double-oval is finished.

12. WATERFALL WONDER

MATERIALS

2″ Brush	Midnight Black
1″ Brush	Dark Sienna
#6 Fan Brush	Van Dyke Brown
#2 Script Liner Brush	Alizarin Crimson
Black Gesso	Sap Green
Liquid White	Cadmium Yellow
Titanium White	Yellow Ochre
Phthalo Blue	Indian Yellow

With a foam applicator, cover your entire canvas with a thin, even coat of Black Gesso and allow it to dry completely before you begin your painting.

When the Black Gesso is dry, use the 2″ brush to cover the entire canvas with a thin, even coat of a mixture of Phthalo Blue and Sap Green. Do NOT allow this paint to dry before you begin.

SKY

The sky in this painting is very simple. Just make criss-cross strokes in the light area of the sky, with Titanium White on the 2″ brush. (Photo 1.) Because of the color already on the canvas, your sky should look Bluish. (Photo 2.)

BACKGROUND

The background trees are made with a mixture of Phthalo Blue, Van Dyke Brown, Midnight Black and Alizarin Crimson. Load the 1″ or 2″ brush, hold it vertically and tap downward to indicate the distant trees. (Photo 3.) Firmly tap the base of the trees with the top corner of a clean, dry 2″ brush, to diffuse and create the illusion of mist. (Photo 4.) Use the same mixture with paint thinner and Titanium White on the liner brush to add the tiny, distant tree trunks. (Photo 5.)

WATERFALL

The waterfall is made with Titanium White on the 2″ brush. Holding the brush horizontally, decide where you want your waterfall to be, touch the canvas with the brush and pull straight down. (Photo 6.) Repeat this stroke as many times

as necessary for the desired effect. (Photo 7.)

The mist at the base of the falls is made with Titanium White on the fan brush. Crush the brush into the canvas and use circular and twirling motions to create the mist. (Photo 8.) Use the top corner of a clean, dry 2″ brush and tapping and circular strokes (Photo 9) to blend and diffuse the mist. You can add several layers of mist. (Photo 10.)

TREES

Moving forward in the painting, use various mixtures of Phthalo Blue and Sap Green on the 2″ brush to add the larger trees, in front of the waterfall. Hold the brush vertically and just tap downward to create basic tree shapes. (Photo 11.) The tiny tree trunks are made using a very thin, dark mixture on the liner brush. Working in layers, use mixtures of the Yellows on the top corner of the brush, again just tapping downward (Photo 12) to lightly highlight and more clearly define the individual tree shapes (Photo 13).

ROCKS AND STONES

Use a mixture of Van Dyke Brown, Dark Sienna and Midnight Black on the fan brush for the large rocks and stones. (Photo 14.) Shape and contour the rocks also using various mixtures of Dark Sienna and Titanium White for highlights. The mist at the base of the rocks is again made with Titanium White on the fan brush (Photo 15) and then blended with the 2″ brush (Photo 16).

STREAM

With the mixture of Liquid White and Titanium White on the fan brush, begin adding the stream at the base of the mist. (Photo 17.) Use swirling, horizontal strokes to start the stream. Pull straight down with short vertical strokes for the tiny falls and push-up strokes for the bubbling foam. (Photo 18.) Add small rocks and stones to the churning stream with Van Dyke Brown on the fan brush. (Photo 19.) Be careful of perspective, the stream should get progressively wider as it moves forward, near the bottom of the canvas. (Photo 20.)

FOREGROUND

The foreground rocks are shaped with Van Dyke Brown on the fan brush. (Photo 21.) Use a mixture of all of the Yellows, Phthalo Blue and Midnight Black on the fan brush and push-up strokes to add grassy areas to the large rocks. (Photo 22.) The foreground trees are made by tapping downward with the 2" brush using various mixtures of all of the Yellows.

FINISHING TOUCHES

Use light-colored mixtures on the liner brush to add small final details. Thin the paints to a water consistency by adding paint thinner. Load the brush full of paint by turning the handle of the brush as you pull the bristles through the mixtures, forcing the bristles to a sharp point. Use very little pressure on the brush to add tiny strokes, twigs and tree trunks. You could even add long grasses at the base of the rocks. (Photo 23.) I think we'll call this one finished. Hopefully, you have truly experienced THE JOY OF PAINTING. (Photo 24.)

Waterfall Wonder

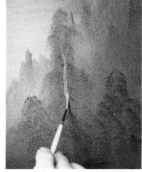

1. Use criss-cross strokes . . .

2. . . . to create the light sky.

3. Tap down trees with the 1" brush . . .

4. . . . then mist the base with the 2" brush.

5. Use the liner brush for the trunks.

6. Pull straight down with the 2" brush . . .

Waterfall Wonder

7.... to paint the waterfall.

8. Twirl in mist with the fan brush . . .

9. . . . and blend with the 2" brush . . .

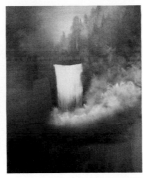

10.... to complete the waterfall.

11. Tap in the larger trees . . .

12.... and highlight with the 2" brush . . .

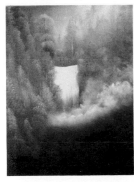

13.... to move forward in the painting.

14. Shape rocks with the fan brush . . .

15.... twirl in the mist . . .

16.... and then blend with the 2" brush.

17. Pull down tiny waterfalls . . .

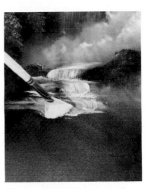

18. . . . and then use push-up foam strokes.

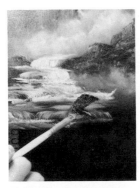

19. Working forward, add more rocks . . .

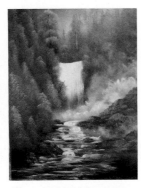

20.... and bubbling water.

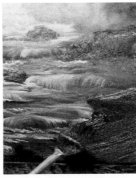

21. Shape the foreground rocks . . .

22. . . . and add grass with the fan brush.

23. Use thinned paint on the liner brush . . .

24.... to add final details.

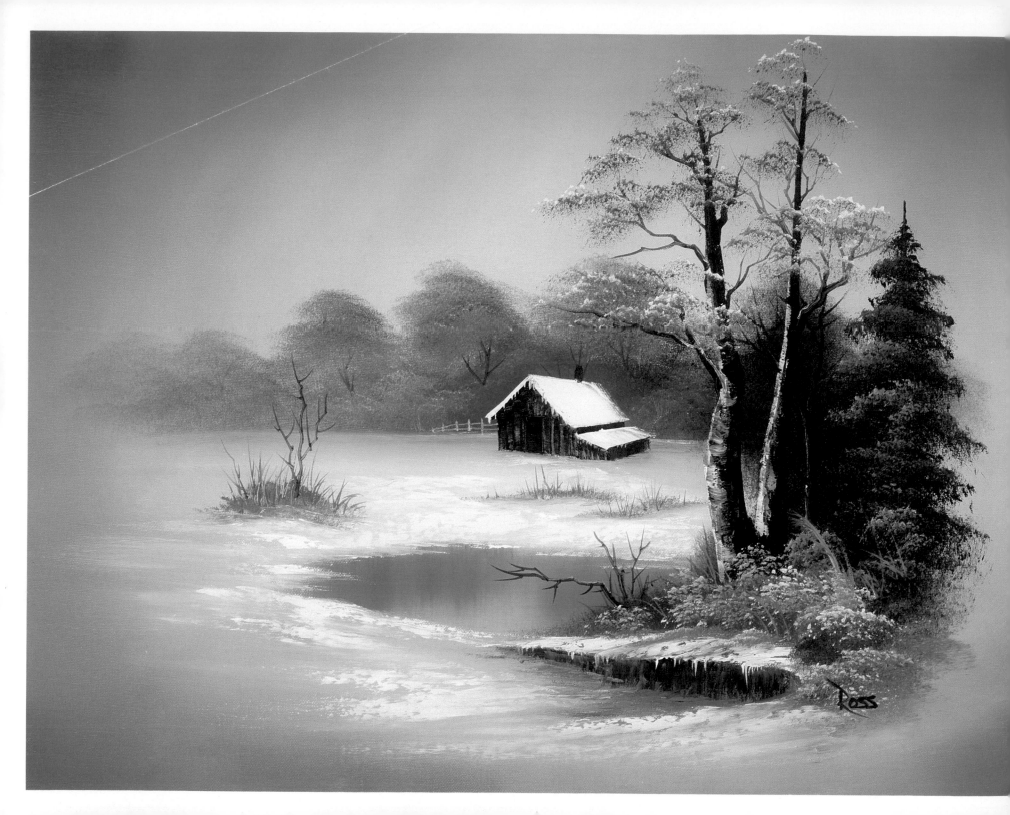

13. FROZEN BEAUTY IN VIGNETTE

MATERIALS

2" Brush	Phthalo Green
Small Round Brush	Phthalo Blue
#6 Fan Brush	Prussian Blue
#2 Script Liner Brush	Midnight Black
Large Knife	Dark Sienna
Liquid White	Van Dyke Brown
Liquid Clear	Yellow Ochre
Titanium White	Bright Red

Use the 2" brush to cover the entire canvas with a thin, even coat of Liquid White. With long horizontal and vertical strokes, work back and forth to ensure an even distribution of paint on the canvas. Do NOT allow the Liquid White to dry before you begin.

BACKGROUND

Load the 2" brush with a mixture of Phthalo Blue, Midnight Black and a very small amount of Phthalo Green, tapping the bristles firmly against the palette to evenly distribute the paint throughout the bristles. Paint the entire canvas, using criss-cross strokes. Reload the brush with Prussian Blue and continue using criss-cross strokes to darken the corners of the canvas. Blend the entire canvas with a clean, dry 2" brush. (Photo 1.)

BACKGROUND TREES

Load the small round brush with a mixture of Midnight Black, Phthalo Blue and a very small amount of Phthalo Green. Starting at the tops of the trees, tap downward with the brush to shape the small trees along the horizon. (Photo 2.) Because this painting is a vignette, do not extend the trees to the edges of the canvas; allow them to fade away to nothing.

Add the background tree trunks with Van Dyke Brown and the liner brush. (To load the liner brush, thin the paint to an ink-like consistency by first dipping the liner brush into paint thinner. Slowly turn the brush as you pull the bristles through the paint, forcing them to a sharp point.) Apply very little pressure to the brush, as you shape the trunks. (Photo 3.) By turning and wiggling the brush, you can give your trunks a gnarled appearance.

Add Titanium White to the tree mixture and use the small round brush to apply very subtle highlights to the background trees. (Photo 4.)

Lay in the snow at the base of the trees with Titanium White on the 2" brush. Use long horizontal strokes (Photo 5) paying close attention to the lay-of-the-land (Photo 6). Again, allow the snow to fade to nothing near the edges of the canvas.

CABIN

Use a clean knife to remove paint from the canvas in the basic shape of the cabin. Load the long edge of the knife with a small roll of Van Dyke Brown by pulling the paint out very flat on your palette and just cutting across.

Paint the back edge of the roof, then use a mixture of Van Dyke Brown and Dark Sienna to paint the front of the cabin. Add the front of the cabin roof and the roof on the shed with Titanium White. Paint the sides of the cabin and shed with the Van Dyke Brown-Dark Sienna mixture.

Use the small knife to graze the front of the cabin and the shed with a mixture of Yellow Ochre and Dark Sienna. Use Van Dyke Brown for the door, the chimney and to cut in the indication of boards. Use the knife to remove excess paint from the bottom of the cabin, then use Titanium White on the 2" brush to add snow to the base of the cabin. You can also use Titanium White on the knife to add snow to the base of the cabin; don't forget the lay-of-the-land. (Photo 7.)

POND

Load the 2" brush with the Midnight Black-Phthalo Blue-Phthalo Green mixture, decide where the pond will be, touch the brush to the canvas and pull straight down then lightly brush across. (Photo 8.)

Use the Black-Blue-Green mixture on the fan brush to "punch" in the small patches of grass in the snow. (Photo 9.) Thin the mixture and use the liner brush to pull up long grasses, sticks and twigs. (Photo 10.) Use the fan brush to pull dark color from the base of the grassy patches into the snow, for shadows.

Use Titanium White on the knife to add snow (Photo 11) then use Liquid White to cut in the edges of the water (Photo 12) and the pond is complete.

Working forward, continue adding snow with Titanium White on the 2" brush (Photo 13) then add the textured snow with the knife (Photo 14).

EVERGREENS

To paint the evergreen, load the small round brush to a chiseled edge with the Midnight Black-Phthalo Blue-Phthalo Green mixture. Holding the brush vertically, touch the canvas to create the center line of the tree. Use just the corner of the brush to begin adding the small top branches. Working from side to side, as you move down the tree, apply more pressure to the brush, forcing the bristles to bend downward and automatically the branches will become larger as you near the base of the tree. (Photo 15.)

Continue using the small round brush to underpaint the bushes at the base of the evergreen. Add Titanium White to the dark mixture already in the brush and very lightly touch highlights to the evergreen.

Load the small round brush with a thin mixture of Liquid

Clear and Titanium White to highlight the snow-covered bushes. (Photo 16.) Add snow to the base of the bushes with Titanium White on the knife. (Photo 17.)

LARGE TREES

Use the dark Blue mixture with Van Dyke Brown on the fan brush to paint the large tree trunks. Thin the mixture and use the liner brush to add limbs and branches. (Photo 18.) Add the snow-covered foliage to the tree with the small round brush: Load the round brush with the dark Blue mixture, then dip just the tips of the bristles into the Liquid Clear-Titanium White mixture; tap downward, carefully forming individual leaf clusters. (Photo 19.) By double-loading the brush, you can paint both the snowy highlights and shadows.

Highlight the large tree trunks with Titanium White and the knife. (Photo 20.)

FINISHING TOUCHES

Continue adding snowy highlights with the small round brush and small details with thinned paint on the liner brush and your masterpiece is ready for a signature. (Photo 21.)

Sign your name with pride: Again, load the liner brush with thinned color of your choice. Sign just your initials, first name, last name or all of your names. Sign in the left corner, the right corner or one artist signs right in the middle of the canvas! The choice is yours. You might also consider including the date when you sign your painting. Whatever your choices, have fun, for hopefully with this painting you have truly experienced THE JOY OF PAINTING!

Frozen Beauty in Vignette

1. Use the 2" brush to paint the entire canvas.

2. Paint background trees with the small round brush.

3. Add trunks with the liner brush . . .

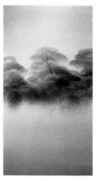

4. . . . then highlight with the small round brush.

5. Use the 2" brush to lay in the snow . . .

6. . . . paying close attention to the lay-of-the-land.

Frozen Beauty in Vignette

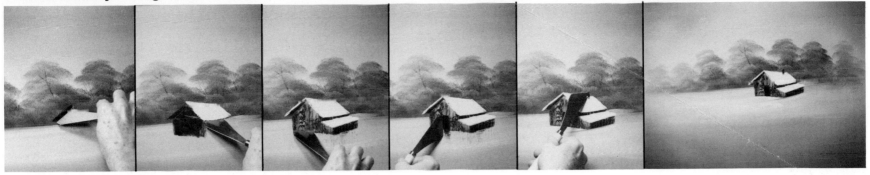

7. Progressional steps used to paint the cabin.

8. Pull down the water with the 2" brush.

9. Add grassy patches with the fan brush . . .

10. . . . then pull up sticks and twigs with the liner brush.

11. Use the knife to add snow . . .

12. . . . and water lines.

13. Use the 2" brush to continue adding snow . . .

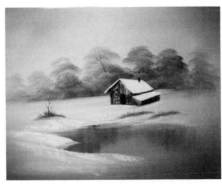

14. . . . to the foreground.

15. Use the small round brush to paint the evergreens . . .

16. . . . and to highlight small bushes.

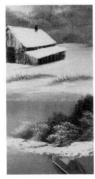

17. Use the knife to add snow to the base of the bushes.

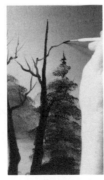

18. Trunks are made with the fan brush. Then add limbs and branches with the liner brush . . .

19. . . . and foliage with the round brush . . .

20. . . . highlights with the knife . . .

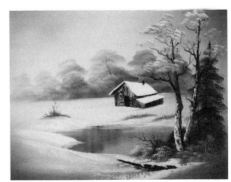

21. . . . and the painting is complete.

MATERIALS

2" Brush	Midnight Black
1" Oval Brush	Dark Sienna
Large Knife	Van Dyke Brown
Script Liner Brush	Alizarin Crimson
Black Gesso	Sap Green
Liquid White	Cadmium Yellow
Liquid Clear	Yellow Ochre
Titanium White	Indian Yellow
Prussian Blue	Bright Red

Use a foam applicator to prepaint the dark areas of the canvas with Black Gesso and allow to DRY COMPLETELY. (Photo 1.)

When the Black Gesso is dry, use the 2" brush to cover the darkened areas with a thin even coat of a mixture of Midnight Black, Dark Sienna, and a small amount of Prussian Blue. Cover the light area of the canvas with a thin, even coat of Liquid White. Do NOT allow these colors to dry before you begin.

SKY

Load the 2" brush with a small amount of the Midnight Black-Dark Sienna-Prussian Blue mixture, tapping the bristles firmly against the palette to ensure even distribution of paint. Starting at the top of the canvas, in the light area, use criss-cross strokes to paint the sky. (Photo 2.) As you work downward, notice how the color blends with the Liquid White already on the canvas and automatically the sky becomes lighter as it nears the horizon.

BACKGROUND

Load the oval brush with a mixture of Midnight Black, Dark Sienna, Prussian Blue and Van Dyke Brown and tap in the basic shape of the most distant, subtle, background trees. (Photo 3.)

Add a very small amount of Titanium White to the mixture to add the trees in the lighter area of the canvas.

Without cleaning the brush, tap the bristles into various mixtures of all of the Yellows and Sap Green to highlight the distant trees. Proper loading of the oval brush is essential to achieve these lacy highlights: Hold the brush at a 45-degree angle and tap the tips of the bristles into the various paint mixtures. Allow the brush to "slide" slightly forward in the paint each time you tap (this assures that the very tips of the bristles are fully loaded with paint). Holding the brush horizontally and working in layers, carefully shape individual leaf clusters by tapping downward with just the bristle tips. Be careful not to destroy all of the dark color already on the canvas, you can use it to separate the individual tree and bush shapes. (Photo 4.)

Use the liner brush and the same background-tree mixtures to paint the background tree trunks. (To load the liner brush, thin the mixture to an ink-like consistency by first dipping the liner brush into paint thinner. Slowly turn the brush as you pull the bristles through the mixture, forcing them to a sharp point.) Apply very little pressure to the brush, as you shape the trunks. (Photo 5.) By turning and wiggling the brush, you can give your trunks a gnarled appearance. (Photo 6.)

Working forward in layers, continue using the Yellow highlight mixtures with a very small amount of Bright Red on the oval brush to highlight the closer trees and bushes. Pay close attention to shape and form. Tap in leaf clusters, forming individual trees and bushes. Be very careful not to completely cover all of the dark undercolor. (Photo 7.)

LARGE EVERGREENS

To paint the larger evergreens, load the oval brush to a chiseled edge with the Midnight Black-Sienna-Prussian Blue mixture. Holding the brush vertically, start at the top of the canvas and tap in the center of each tree. Use just the tips of the bristles to begin adding the small top branches. Working from side to side, as you move down each tree, apply more pressure to the brush, forcing the bristles to bend downward (Photo 8) and automatically the branches will become larger as you near the base of each tree.

Add the evergreen trunks with a small roll of a mixture of Titanium White and Dark Sienna on the knife. (Photo 9.) Use

the oval brush to very lightly touch highlights to the branches with mixtures of all of the Yellows, Sap Green and Bright Red. *(Photo 10.)* You can thin these mixtures by first dipping the oval brush into Liquid Clear.

Continue using the oval brush and the Yellow highlight mixtures with Alizarin Crimson and Dark Sienna to add the bushes at the base of the large evergreens. *(Photo 11.)* Add Titanium White to the mixtures, for the lightest areas, where the light would strike. *(Photo 12.)*

LARGE TREE TRUNK

Use a mixture of Van Dyke Brown and Dark Sienna on the knife to shape the large foreground tree trunk. *(Photo 13.)* Re-load the knife with a small roll of a mixture of Titanium White and Dark Sienna. Highlight the left side of the trunk *(Photo 14)* with so little pressure that the paint "breaks" *(Photo 15).*

Use the Van Dyke Brown-Dark Sienna on the knife to shape the sections of old tree trunks on the ground. *(Photo 16.)* Highlight these sections by tapping with a mixture of Titanium White, Dark Sienna, and Yellow Ochre on the knife. *(Photo 17.)*

FOREGROUND

Use the various Yellow highlight mixtures on the oval brush to add the small bushes and ferns at the base of the tree trunks.

With a thinned mixture of Van Dyke Brown and Dark Sienna on the liner brush, add limbs and branches to the large tree trunk. By turning and twisting the brush, you can give the branches a gnarled appearance. *(Photo 18.)* You can also highlight the top edges of the branches with a thinned mixture of Titanium White and Dark Sienna on the liner brush.

FINISHING TOUCHES

With thinned mixtures of the Yellows and Sap Green on the liner brush, add long grasses *(Photo 19)* then use thinned Titanium White and Dark Sienna to add small tree trunks *(Photo 20)* and your painting is ready for your signature *(Photo 21).*

To sign your painting, again load the liner brush with thinned color of your choice. Sign just your initials, first name, last name or all of your names. Sign in the left corner, the right corner or one artist signs right in the middle of the canvas! The choice is yours. You might also consider including the date when you sign your painting. Whatever your choices, have fun, for hopefully with this painting you have truly experienced THE JOY OF PAINTING!

Indian Summer

1. Pre-paint the dark areas of the canvas with Black Gesso.

2. Paint the sky with criss-cross strokes.

3. Tap down with the oval brush to underpaint . . .

4. . . . and highlight background trees.

5. Use the liner brush . . .

Indian Summer

6. . . . to add background tree trunks.

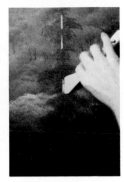

7. Use the oval brush to tap in bushes . . .

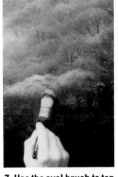

8. . . . and large evergreens.

9. Add evergreen trunks with the knife . . .

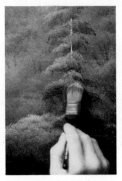

10. . . . then highlight with the oval brush.

11. Continue using the oval brush . . .

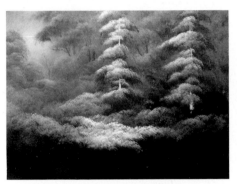

12. . . . to tap in small trees and bushes.

13. Use the knife to shape . . .

14. . . . and highlight . . .

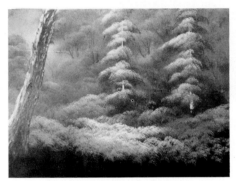

15. . . . the large foreground tree trunk.

16. Continue using the knife . . .

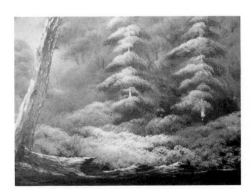

17. . . . to add fallen sections of trunks.

18. Use the liner brush to paint limbs and branches . . .

19. . . . add long grasses . . .

20. . . . and tiny tree trunks . . .

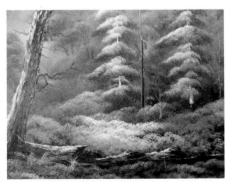

21. . . . to complete the painting.

69

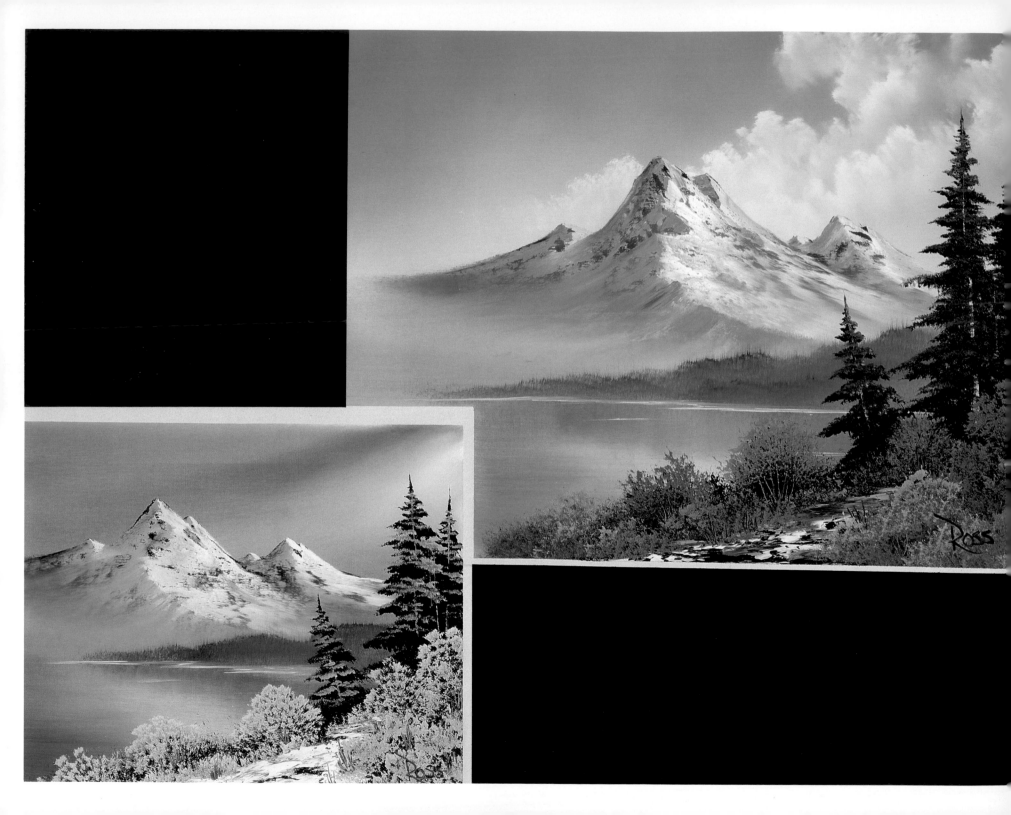

MATERIALS

2″ Brush	Phthalo Blue
1″ Brush	Prussian Blue
#6 Fan Brush	Midnight Black
#2 Script Liner Brush	Dark Sienna
Large Knife	Van Dyke Brown
Masking Tape	Alizarin Crimson
Adhesive-Backed Plastic	Sap Green
Black Gesso	Cadmium Yellow
Liquid White	Yellow Ochre
Titanium White	Indian Yellow
Phthalo Green	Bright Red

Prepare the canvas by using masking tape to apply borders to two over lapping rectangles. The SUMMER scene, (in the upper right-hand corner) is 16x12½ inches; the WINTER scene (in the lower left-hand corner) is 10½x8½ inches.

Use a foam applicator to apply Black Gesso to the remainder of the canvas. Allow the Black Gesso to DRY COMPLETELY. Cover the Black areas of the canvas with adhesive-backed plastic (such as Con-Tact Paper) for protection. *(Photo 1.)*

Use the 2″ brush to cover the over lapping, White areas of the canvas with a thin, even coat of Liquid White. Do NOT allow to dry before you begin the paintings.

SKY

Load the 2″ brush with a small amount of Phthalo Blue and use criss-cross strokes to paint the sky in the larger, SUMMER rectangle. *(Photo 2.)*

Add Phthalo Green to the brush and use horizontal strokes to add the water to the lower portion of the SUMMER rectangle. *(Photo 3.)*

For the WINTER picture, use Indian Yellow on a clean, dry 2″ brush and begin by painting the top corner of the sky with criss-cross strokes. As you work outward from the corner, add Bright Red to the brush, then a mixture of Alizarin Crimson and Phthalo Blue and finally use Phthalo Blue on the outside edge of the sky. Still with Phthalo Blue on the brush, use long, horizontal strokes to add the water to the lower portion of the WINTER rectangle. Blend the entire WINTER sky, then with a clean brush, add Titanium White to the lightest area of the sky, blending outward.

Use Titanium White on the 1″ brush, and circular strokes to shape the clouds in the SUMMER rectangle. *(Photo 4.)* Blend the base of the clouds with the top corner of a clean, dry 2″ brush. *(Photo 5.)*

MOUNTAINS

The mountains are made with the knife and a mixture of Midnight Black, Prussian Blue and Alizarin Crimson. Load the long edge of the knife with a small roll of paint and use firm pressure to shape just the top edge of each mountain. *(Photo 6.)* Use the knife to remove any excess paint, then with the 2″ brush, blend the paint down to the base of each mountain. *(Photo 7.)* The mountain tops should be much more distinct than the bottoms. *(Photo 8.)*

To highlight the SUMMER mountain, use a mixture of Titanium White with a very small amount of Midnight Black and Dark Sienna. Again, load the knife with a small roll of paint. Starting at the top of the mountain (and paying close attention to angles) apply the snowy highlights to the right side of each peak, using so little pressure that the paint "breaks". *(Photo 9.)*

Use a mixture of Titanium White with a small amount of Prussian Blue and Midnight Black for the shadow sides of the peaks. Again, use so little pressure that the paint "breaks".

Carefully following the angles, diffuse the base of the mountain by tapping with the 2″ brush *(Photo 10)* then use upward strokes to mist.

Highlight the WINTER mountain with a mixture of Titanium White and a very small amount of Bright Red; the shadows are Titanium White with a small amount of Prussian Blue. *(Photo 11.)*

FOOTHILLS

Load the 2″ brush with Titanium White, Sap Green and Dark Sienna. Tap downward to add the foothills at the base of the SUMMER mountain. *(Photo 12.)* Extend the color into the water, pull straight down *(Photo 13)* then lightly brush across to create reflections. Use a small roll of Liquid White on the knife to cut in the water lines and ripples. *(Photo 14.)*

The foothill at the base of the WINTER mountain is made with a mixture of the mountain color and Titanium White. Again, reflect the foothills into the water, then cut in the water lines and ripples. *(Photo 15.)*

EVERGREENS

To paint the WINTER evergreens, load the fan brush to a chiseled edge with a mixture of Midnight Black, Prussian Blue and Alizarin Crimson. Holding the brush vertically, touch the canvas to create the center line of each tree. Use just the corner of the brush to begin adding the small top branches. Working from side to side, as you move down each tree, apply more pressure to the brush, forcing the bristles to bend downward and automatically the branches will become larger as you near the base of each tree. *(Photo 16.)* Underpaint the small bushes at the base of the evergreens with the same dark mixture on the 1″ brush. *(Photo 17.)*

Add a small amount of Phthalo Green to the mixture for the SUMMER evergreens. Again, use the 1″ brush to add the bushes at the base of the trees.

Add the evergreen trunks with a mixture of Titanium White and Dark Sienna on the knife. *(Photo 18.)* Use the point of the knife to scratch in just the indication of small sticks and twigs. *(Photo 19.)*

FOREGROUND

In the SUMMER scene, use various mixtures of Sap Green, all of the Yellows and Bright Red to highlight the small bushes at the base of the evergreens, carefully creating *individual* bush shapes. *(Photo 20.)*

Use Van Dyke Brown on the knife to add the path and then highlight with a mixture of Titanium White and Van Dyke Brown, using so little pressure on the knife that the paint "breaks". *(Photo 21.)*

Highlight the bushes in the WINTER, painting with a mixture of Liquid White, Titanium White and a very small amount of Alizarin Crimson on the 1″ brush. The path is added with Titanium White on the knife.

Touch highlights to the right sides of the evergreen branches: use Liquid White with Titanium White for the WINTER painting, Sap Green and Yellow for the SUMMER painting. *(Photo 22.)*

FINISHING TOUCHES

Carefully remove the Con-Tact Paper from the canvas *(Photos 23 & 24)* to expose your finished SUMMER and WINTER scenes *(Photo 25)*.

Double Take

1. Protect the Black areas of the canvas with Con-Tact Paper . . .

2. . . . use criss-cross strokes to paint the skies . . .

3. . . . and horizontal strokes for the water.

4. Shape clouds with the 1″ brush . . .

5. . . . then blend with the 2″ brush.

6. Use the knife to paint the mountain tops . . .

7. . . . then blend the paint down with the 2″ brush . . .

Double Take

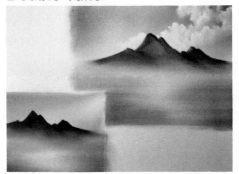 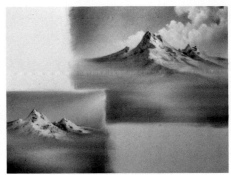 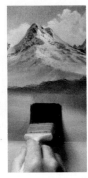

8. . . . to diffuse and mist.

9. Highlight the peaks . . .

10. . . . then tap the base with the 2" brush . . .

11. . . . to create the illusion of mist.

12. Tap in foothills with the 2" brush . . .

13. . . . then pull down their reflections.

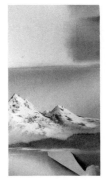 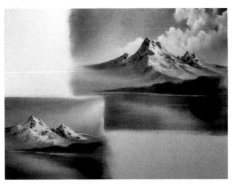 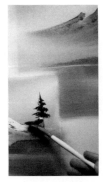 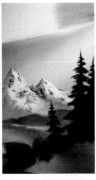 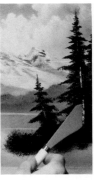 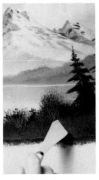 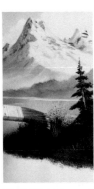

14. Use the knife and Liquid White . . .

15. . . . to add water lines and ripples to both paintings.

16. Add evergreens with the fan brush . . .

17. . . . and bushes with the 1" brush.

18. Use the knife to add trunks . . .

19. . . . and sticks and twigs.

20. Highlight the small bushes . . .

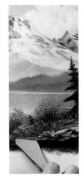 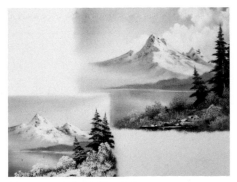

21. . . . then use the knife to add the paths . . .

22. . . . completing both paintings.

23. Carefully remove the Con-Tact Paper . . .

24. . . . from both rectangles . . .

25. . . . to expose two finished paintings. Sign both!

MATERIALS

2" Brush	Midnight Black
#6 Fan Brush	Dark Sienna
#3 Fan Brush	Van Dyke Brown
#2 Script Liner Brush	Alizarin Crimson
Large Knife	Sap Green
Small Knife	Cadmium Yellow
Black Gesso	Yellow Ochre
Masking Tape	Indian Yellow
Titanium White	Bright Red
Phthalo Blue	

Before starting your painting, use a foam applicator to cover your canvas completely with a thin, even coat of the Black Gesso and allow it to dry completely. When the Black Gesso is dry, use a piece of masking tape to mark the horizon, just above center.

With the 2" brush, cover the entire canvas with transparent color: Indian Yellow just above the horizon and above that a Lavender mixture made with Alizarin Crimson and Phthalo Blue; the top of the canvas is just Phthalo Blue. Below the horizon, in the center of the canvas is Indian Yellow, then the Lavender and then Phthalo Blue. Paint the bottom of the canvas with Dark Sienna and use the Lavender (Alizarin Crimson and Phthalo Blue) on each side of the lower portion of the canvas. Do NOT allow these colors to dry before you begin. (Photo 1.)

SKY

Load the 2" brush with Titanium White and begin by making criss-cross strokes just above the horizon. (Photo 2.) Clean and dry the brush and again load it with Titanium White to continue making criss-cross strokes at the top of the canvas. As the White mixes with the colors already on the canvas, you should have a Golden glow just above the horizon, then Lavender and then Blue at the very top.

The stringy clouds at the top of the canvas are made with a mixture of Midnight Black and Alizarin Crimson on the fan brush. Use short, rocking horizontal strokes and then blend with the 2" brush. Use a mixture of Titanium White and Alizarin Crimson on the fan brush to lightly highlight the bottoms of the clouds. Use long, horizontal strokes with a clean, dry 2" brush to blend the entire sky.

Use a Titanium White-Yellow Ochre-Alizarin Crimson mixture on the fan brush and tiny circular strokes to shape the puffy clouds just above the horizon. This time, with Titanium White on the fan brush, highlight the top edges of the clouds. Use circular strokes with the top corner of a clean, dry 2" brush to lightly blend. (Photo 3.)

When you are satisfied with your sky, remove the masking tape from the canvas (Photo 4) to expose a nice, straight, horizon line. Be sure to add Indian Yellow to the center and Lavender on the edges of the tiny, exposed dry area of the canvas (left by the masking tape).

BACKGROUND WATER

Use Titanium White on the fan brush to roughly sketch the large, foreground wave. (Photo 5.) With the White still on the fan brush, use small rocking strokes to begin adding color to the water just under the horizon.

Create the background swells with long, horizontal strokes, still using Titanium White and the fan brush. With a clean fan brush, use short, rocking strokes to pull the top edge of the swells back to blend. (Photo 6.) Be very careful not to destroy the dark color that separates the individual swells (or background waves).

LARGE WAVES

Use a mixture of Titanium White and Phthalo Blue with a very small amount of Cadmium Yellow on the fan brush to pull the water over the crashing wave. (Photo 7.) Be very careful of your angles here!

The "eye" of the wave is made with a mixture of Titanium

White, Cadmium Yellow and a small amount of Phthalo Blue. Use the corner of the fan brush to scrub in the color *(Photo 8)* and then blend with circular strokes using the top corner of a clean, dry 2" brush *(Photo 9)*. Again, pay close attention to the shape of your wave. *(Photo 10.)*

Use a mixture of Phthalo Blue, Alizarin Crimson and Titanium White on the #3 fan brush and small, circular strokes to scrub in the foam shadows along the edges of the large wave. *(Photo 11.)* Clean the fan brush and with Titanium White, make small, circular push-up strokes to highlight the top edges of the foam. *(Photo 12.)* Again, use circular strokes with the top corner of the 2" brush *(Photo 13)* to lightly blend the foam highlights into the shadows *(Photo 14)*.

FOREGROUND

In the lightest area of the foreground, make long, vertical strokes with Titanium White on the fan brush. *(Photo 15.)* Pull down with the 2" brush then lightly brush across *(Photo 16)* to create the reflected light in the foreground *(Photo 17)*.

Load the long edge of the small knife with a very small roll of Titanium White. Hold the knife flat against the canvas and use firm pressure and long horizontal strokes to add the foamy water action on the beach. *(Photo 18.)* Use a clean fan brush to pull the top edge of the paint back towards the large wave creating swirling foam patterns. *(Photo 19.)*

Use various thinned mixtures of the Lavender, Phthalo Blue and Titanium White on the liner brush to add tiny foam details to the large wave and the foreground water. *(Photo 20.)*

Continue using the small knife and Titanium White to add the long, horizontal water lines on the beach and the fan brush for the foam action. Use thinned paint on the liner brush to add small details to all of the water.

PALM TREES

With a mixture of Midnight Black and Van Dyke Brown on the fan brush, start at the top of each tree and pull down *(Photo 21)* to paint the tree trunks. Use push-up strokes at the base of the trees for the land projection. Add Titanium White, Cadmium Yellow and Sap Green to the brush to highlight the grassy area at the base of the trees. Use Van Dyke Brown on the knife to add the land area along the water's edge. *(Photo 22.)* Highlight the right sides of the tree trunks with a small amount of Titanium White on the fan brush. Use thinned Midnight Black on the liner brush to paint the palm limbs *(Photo 23)* and then use the same mixture on the fan brush to add the leaves *(Photo 24)*.

FINISHING TOUCHES

Add Sap Green to your fan brush to very lightly highlight the palm leaves and your painting is finished! *(Photo 25.)* Sign and enjoy!

High Tide

 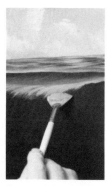

1. Place tape at the horizon.

2. Paint the sky with criss-cross strokes . . .

3. . . . and the clouds with circular strokes.

4. Remove the tape from the horizon.

5. Sketch the large wave.

6. Paint the background swells . . .

7. . . . and the crest of the wave with the fan brush.

High Tide

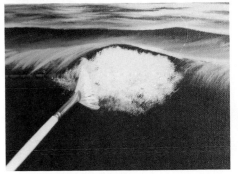

8. Add the "eye" of the wave . . .

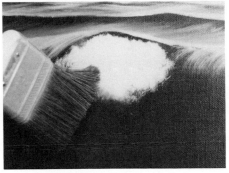

9. . . . and then use the 2" brush . . .

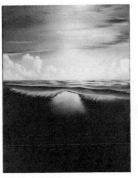

10. . . . to blend.

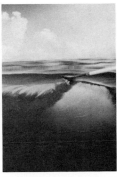

11. With the fan brush, add the foam . . .

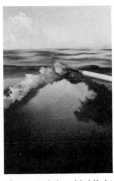

12. . . . and then highlight.

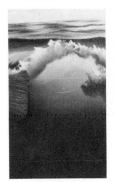

13. Use the 2" brush . . .

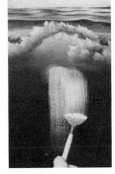

14. . . . to blend the foam.

15. Pull down the foreground light . . .

16. . . . then brush across . . .

17. . . . to blend.

18. Foreground water is made with the knife . . .

19. . . . then pulled back with the fan brush.

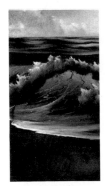

20. Add foam details with the liner brush.

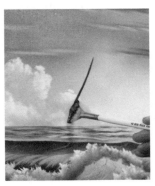

21. Paint the palm-tree trunks with the fan brush.

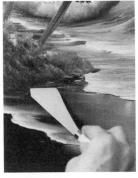

22. Add the land area to the water's edge.

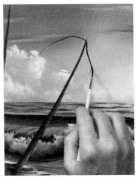

23. Add limbs with the liner brush . . .

24. . . . leaves with the fan brush . . .

25. . . . and your seascape is complete.

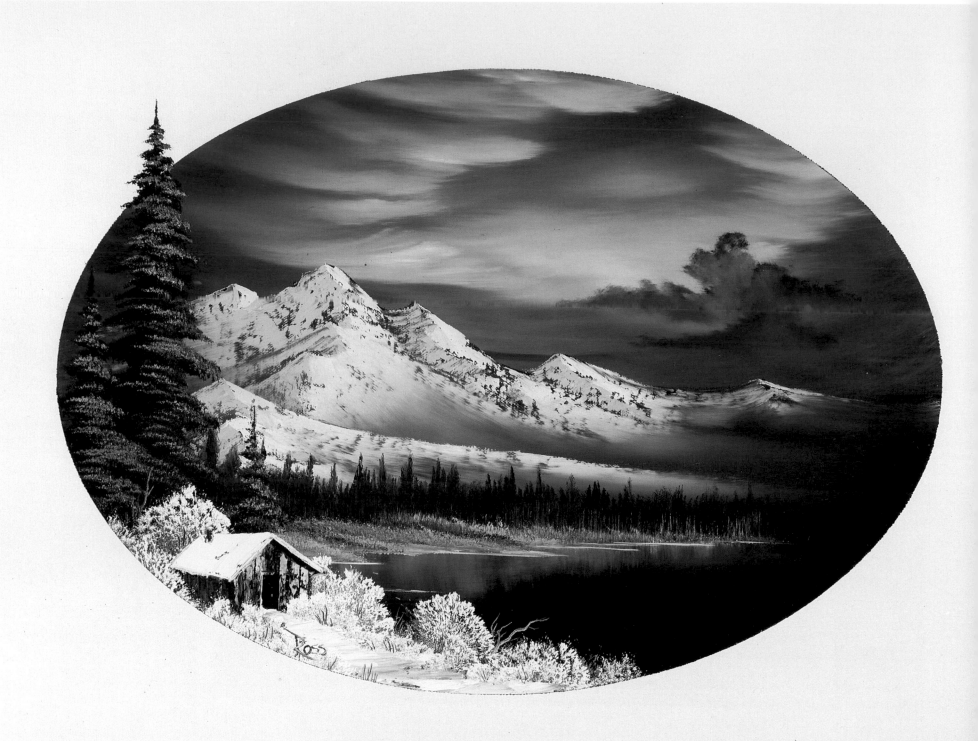

17. HIDDEN WINTER MOON OVAL

MATERIALS

2" Brush	Liquid White
1" Brush	Titanium White
#6 Fan Brush	Phthalo Blue
#2 Script Liner Brush	Prussian Blue
Large Knife	Midnight Black
Small Knife	Dark Sienna
Adhesive-Backed Plastic	Van Dyke Brown
Black Gesso	Alizarin Crimson

Start by covering the entire canvas with adhesive-backed plastic (such as Con-Tact Paper) from which you have removed a 14x20 center oval. Cover the exposed area of the canvas with a thin, even coat of Black Gesso and allow it to dry completely. (Photo 1.)

With a clean, dry 2" brush, cover the exposed Black area of the canvas with a thin, even coat of a mixture of Alizarin Crimson and Phthalo Blue. Because these colors are transparent, you will find your canvas still looks quite dark. As you work out from the center of the canvas, add more Phthalo Blue to the mixture so that the paint becomes progressively Bluer and darker. DO NOT allow this paint to dry before you begin.

SKY

With Titanium White on the 1" brush, use criss-cross strokes (Photo 2) to paint the sky. Automatically the White will blend with the Alizarin Crimson-Phthalo Blue mixture already on the canvas. Create a very light area (most likely where the moon is). With a clean, VERY dry 2" brush, again use criss-cross strokes (Photo 3) to blend the sky.

With Titanium White on the 1" brush, make short, horizontal, "rocking" strokes to add cloud indications throughout the sky. (Photo 4.) Blend with long, horizontal strokes. (Photo 5.) With a mixture of Midnight Black, Phthalo Blue and Alizarin Crimson on the fan brush, use tiny, circular strokes to add the small dark cloud shapes. (Photo 6.) Use the top corner of a clean, dry 2" brush to blend the clouds (Photo 7), then use VERY light horizontal strokes to blend the entire sky.

MOUNTAIN

Using the same dark paint mixture of Midnight Black, Phthalo Blue and Alizarin Crimson, load the long edge of the knife with a small roll of paint. Use firm pressure on the canvas to shape just the top edge of the mountain. (Photo 8.) Use the 2" brush to pull the paint down to the base of the mountain. (Photo 9.)

To highlight the mountain, load the long edge of the knife with a small roll of a mixture of Titanium White and a small amount of Midnight Black. In this painting, the light is coming from the right. So, starting at the top of the mountain, glide the knife down the right side of each peak, using so little pressure that the paint "breaks". (Photo 10.) Add the shadows to the left sides of the peaks with a mixture of Titanium White and Prussian Blue on the knife, pulling the paint in the opposite direction. With a clean, dry 2" brush, carefully following the angles, tap to diffuse the base of the mountain and then gently lift upward to create the illusion of mist.

Moving forward in the painting, repeat the same procedure to add the closer range of mountains. (Photo 11.)

BACKGROUND

Load the fan brush with a mixture of Midnight Black, Prussian Blue, Alizarin Crimson and Van Dyke Brown. Holding the brush vertically, tap downward to indicate the small evergreens at the base of the mountain. (Photo 12.) You can indicate tiny tree trunks with a small amount of Titanium White on a clean fan brush. Hold the brush horizontally (at the base of the trees) and use short, upward strokes. (Photo 13.)

Use Titanium White on the fan brush to add the snow-covered grassy area at the base of the trees. Working in layers, hold the brush horizontally and force the bristles to bend upward. (Photo 14.) With Titanium White on the 2" brush, pull straight down to add reflections to the water.

(Photo 15.) (Notice how the Titanium White blends with the color already on the canvas.) Very lightly brush across. Cut in the water lines with a tiny roll of a mixture of Liquid White and Phthalo Blue on the long edge of the knife *(Photo 16)* and the background is complete *(Photo 17)*.

EVERGREEN TREES

The large evergreens are made with the fan brush and the same dark mixture of Prussian Blue, Midnight Black, Van Dyke Brown and Alizarin Crimson. Holding the brush vertically, touch the canvas to form the center line of the tree. Turn the brush horizontally and starting at the top of the tree, use one corner of the brush to just touch the canvas to begin adding the branches. Working from side to side, as you move down the tree, use more pressure on the brush (forcing the bristles to bend downward) and automatically the branches will become larger as you near the base of each tree. *(Photo 18.)* Use a mixture of Titanium White and Phthalo Blue to very lightly highlight the right sides of the branches.

FOREGROUND

Load the 1″ brush with a dark mixture of Titanium White and Phthalo Blue. Moving forward in the painting, underpaint the leafy trees and bushes.

Add the snowy highlights to the trees and bushes by dipping the 1″ brush into Liquid White and pulling it in one direction through Titanium White, to round one corner. With the rounded corner up, force the bristles to bend upward as you form the individual trees and bushes. *(Photo 19.)* Don't just hit at random, make distinct tree and bush shapes. Be very careful not to "kill" all of your dark underpaint.

CABIN

Use the knife to remove the paint from the canvas in the basic shape of the cabin. With a small roll of Van Dyke Brown on the edge of the knife, and paying close attention to angles, lay in the back edge of the roof. Use Titanium White on the knife for the front of the roof. With a mixture of Dark Sienna and Van Dyke Brown on the small knife, add the front and side of the cabin. Very lightly highlight the front of the cabin with a mixture of Dark Sienna and Titanium White on the small knife. The door and chimney are Van Dyke Brown. You can scratch in the indication of boards using just the point of the knife. With a clean knife, remove the excess paint from the bottom edges of the cabin.

Use short, horizontal strokes with Titanium White on the knife to add the path and then continue using the Liquid White-Titanium White mixture and the 1″ brush to add bushes to the front of the cabin and along the path.

FINISHING TOUCHES

Remove the adhesive-backed plastic from the canvas to expose your painting. *(Photo 20.)* Extend the large evergreen tree beyond the border *(Photo 21)* and then use the liner brush to add any small final details and your painting is finished *(Photo 22)*.

Hidden Winter Moon Oval

1. Cover the center oval with Black Gesso.

2. Use criss-cross strokes to paint . . .

3. . . . and blend the sky.

4. Use "rocking" strokes . . .

5. . . . to paint cloud shapes.

Hidden Winter Moon Oval

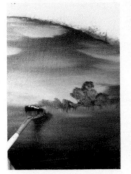

6. Add dark clouds with the fan brush . . .

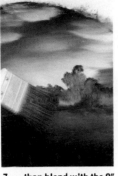

7. . . . then blend with the 2" brush.

8. Shape the mountain top . . .

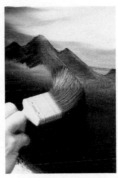

9. . . . then blend downward with the 2" brush.

10. Use the knife to highlight . . .

11. . . . and shadow the mountains.

12. Tap down to indicate distant trees . . .

13. . . . then pull up tree trunks.

14. Add snow to the base of the trees.

15. Pull down with the 2" brush for reflections.

16. Use the knife to cut in water lines . . .

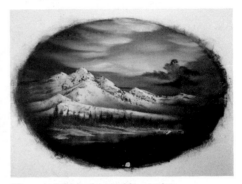

17. . . . and the background is complete.

18. Make evergreens with the fan brush.

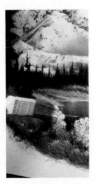

19. Paint leafy trees and bushes with the 1" brush.

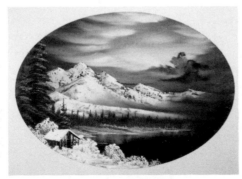

20. After removing the Con-Tact Paper . . .

21. . . . extend the evergreen with the fan brush . . .

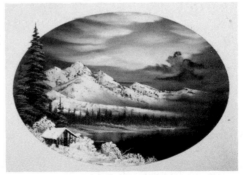

22. . . . and your painting is ready for a signature.

18. DEEP WILDERNESS HOME

MATERIALS

2" Brush	Prussian Blue
#6 Fan Brush	Midnight Black
#2 Script Liner Brush	Dark Sienna
Large Knife	Van Dyke Brown
Small Knife	Alizarin Crimson
Black Gesso	Sap Green
Liquid White	Cadmium Yellow
Liquid Clear	Yellow Ochre
Titanium White	Indian Yellow
Phthalo Blue	Bright Red

Start by using a foam applicator to apply a thin, even coat of Black Gesso to the lower portion of your canvas. Allow the Black Gesso to DRY COMPLETELY. (Photo 1.)

When the Black Gesso is dry, use the 2" brush to cover the entire canvas with a VERY THIN coat of Liquid Clear. (It is important to stress that the Liquid Clear should be applied VERY, VERY sparingly and really scrubbed into the canvas! The Liquid Clear will not only ease with the application of the firmer paint, but will allow you to apply very little color, creating a glazed effect.) Do NOT allow the Liquid Clear to dry.

Still using the 2" brush, cover the Black Gesso-area of the canvas with a thin even coat of a mixture of Midnight Black and Sap Green. (The mixture should contain proportionately much more Black than Green.) Apply a thin, even coat of Liquid White to the light area of the canvas. Do NOT allow the canvas to dry before you begin.

SKY

Load the 2" brush with various mixtures of Midnight Black with a small amount of Sap Green. (Just brush-mix these colors by firmly tapping the bristles into a small amount of the Midnight Black, then a smaller amount of Sap Green.)

Starting at the top of the canvas, begin painting the sky with small circular strokes, using just the top corner of the brush. As you work down towards the horizon, re-load the brush by also tapping the bristles into various mixtures of Van Dyke Brown, Dark Sienna and Alizarin Crimson. (Photo 2.)

Vary the coverage, allow some areas of the sky to remain quite light. Lightly blend the entire sky. (Photo 3.)

BACKGROUND

Add the background tree trunks with a mixture of Midnight Black and Sap Green on the liner brush. (To load the liner brush, thin the mixture to an ink-like consistency by first dipping the liner brush into paint thinner. Slowly turn the brush as you pull the bristles through the mixture, forcing them to a sharp point.) By turning and wiggling the brush, you can give your trunks a gnarled appearance. (Photo 4.)

Re-load the 2" brush by tapping the bristles into various mixtures of Sap Green, all of the Yellows and Bright Red to add foliage to the background trees. Proper loading of the brush is very important to the success of these lacy trees. Load the brush by holding it at a 45-degree angle and tapping the bristles into the various mixtures. Allow the brush to "slide" slightly forward in the paint each time you tap (this assures that the very tips of the bristles are fully loaded with paint). To paint the trees, hold the brush horizontally and gently tap downward with one corner of the brush. (Photo 5.)

As you work forward, carefully create individual tree and bush shapes. (Photo 6.) Try not to just hit at random, think about shape and form. (Photo 7.)

CLIFF

Use Van Dyke Brown on the knife and long, downward strokes to underpaint the cliff. Highlight the cliff with a marbled-mixture of Titanium White, Dark Sienna and Van Dyke Brown on the knife. (Photo 8.)

To add the soft grassy area at the top of the cliff, again fully load the bristle tips of the 2" brush by tapping into various mixtures of all of the Yellows, Bright Red and Sap Green. Apply the grassy highlights by holding the brush

horizontally and gently tapping downward. Working in layers and carefully creating the lay-of-the-land, allow the soft grass to extend right over the edge of the cliff. *(Photo 9.)* If you are also careful not to destroy all of the dark color already on the canvas, you can create grassy highlights that look almost like velvet. *(Photo 10.)*

WATERFALL

Load the fan brush with a mixture of Liquid White, Titanium White and a small amount of Phthalo Blue. To paint the waterfall, hold the brush horizontally, begin with a short, horizontal stroke, then pull straight down. *(Photo 11.)*

Hold the brush horizontally and use tiny push-up strokes to create the foaming water action at the base of the falls. *(Photo 12.)*

To add the reflections at the base of the waterfall, pull straight down with Titanium White on the 2" brush, then lightly brush across. Notice how the White mixes with the color already on the canvas. *(Photo 13.)*

Continue using the thin White mixture on the fan brush to add the water's edge and ripples. *(Photo 14.)*

Use Van Dyke Brown on the knife to add the rock projections *(Photo 15)* then highlight with the Titanium White-Dark Sienna-Van Dyke Brown mixture. *(Photo 16.)*

FOREGROUND

Working forward in layers, add the foreground rocks.

(Photo 17.) Use a mixture of Midnight Black, Prussian Blue and Alizarin Crimson on the 2" brush to underpaint the foreground foliage then again use the Yellow mixtures on the 2" brush to highlight. *(Photo 18.)*

HOUSE

With a small roll of Van Dyke Brown on the edge of the knife, and paying close attention to angles, paint the back edge of the roof—then pull down the front of the roof. Add the front and then the side of the house.

Load the knife with a small roll of the Titanium White-Dark Sienna-Van Dyke Brown mixture. Hold the knife horizontally and lightly touch "boards" to the front of the house. Use horizontal strokes to very lightly blend with a clean, dry 2" brush.

You can paint the boards on the side of the house by adding Van Dyke Brown to the mixture and by holding the knife vertically.

Use a mixture of Midnight Black and Titanium White on the short edge of the knife to add shingles to the roof.

Finish the house with Midnight Black on the small knife to add the door and the windows and the porch. *(Photo 19.)*

FINISHING TOUCHES

Use the Yellow highlight mixtures on the 2" brush to add soft grass to the base of the house and your painting is complete. *(Photo 20.)*

Deep Wilderness Home

1. Prepaint the lower portion of the canvas with Black Gesso.

2. Use the 2" brush and circular strokes . . .

3. . . . to paint the sky.

4. Add tree trunks with the liner brush . . .

5. . . . then tap downward with the 2" brush . . .

6. . . . to add foliage . . .

84

Deep Wilderness Home

7. . . . to the background trees.

8. Use the knife to paint the cliff.

9. Tap downward with the 2" brush . . .

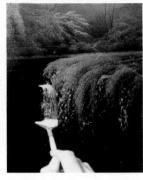

10. . . . to hang soft grass over the cliffs.

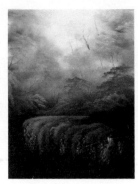

11. Pull down the waterfall with the fan brush . . .

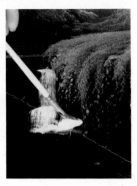

12. . . . then push up foamy water action.

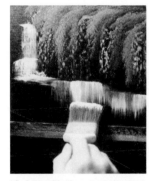

13. Add reflections to the base of the falls with the 2" brush . . .

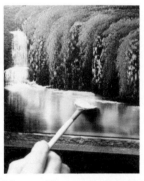

14. . . . and the water's edge with the fan brush.

15. Use the knife to paint rocks . . .

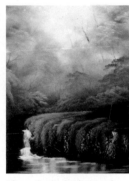

16. . . . in the background . . .

17. . . . then add the large rocks . . .

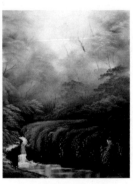

18. . . . in the foreground.

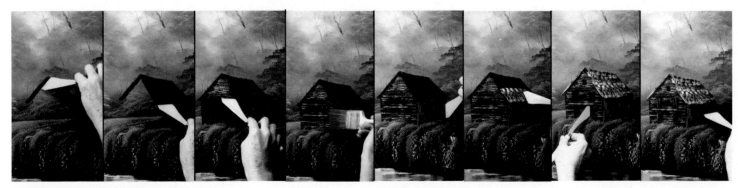

19. Progressional steps used to paint the house.

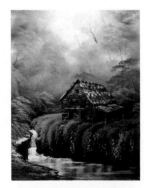

20. The painting is complete.

19. SOUTHWEST SERENITY

MATERIALS

2" Brush
1" Brush
#6 Fan Brush
#2 Script Liner Brush
Liquid White
Titanium White
Phthalo Blue
Midnight Black

Dark Sienna
Van Dyke Brown
Alizarin Crimson
Sap Green
Cadmium Yellow
Yellow Ochre
Bright Red

Start by covering the entire canvas with a thin, even coat of Liquid White. With long horizontal and vertical strokes, work back and forth to ensure an even distribution of paint on the canvas. Do NOT allow the Liquid White to dry before you begin.

SKY

Load the 2" brush with a very small amount of Cadmium Yellow, tapping the bristles firmly against the palette to ensure an even distribution of paint throughout the bristles. Begin by making criss-cross strokes near the top of the canvas. Vary the color by re-loading the brush with Yellow Ochre and continue making criss-cross strokes in the upper portion of the sky.

Combine some Alizarin Crimson with a small amount of Phthalo Blue on your palette, to make a Reddish-Lavender mixture. The mixture will look quite dark, but you can test it by adding a small amount of Titanium White. (Add more Alizarin Crimson or Phthalo Blue to achieve the desired color.)

To a small amount of this Lavender mixture, add some Bright Red; to a small portion of this new mixture, add some Yellow Ochre. (You should now have three mixtures on your palette: Lavender, Lavender-Red and Lavender-Red-Ochre.)

Load the 2" brush with a small amount of the first Lavender mixture and shape the clouds with circular strokes, using just one corner of the brush. (Photo 1.) Vary the color of the clouds by using the other Lavender mixtures; vary the shape by tapping downward with the brush. (Photo 2.)

Make circular strokes with the top corner of a clean, dry 2" brush (Photo 3) to blend the clouds (Photo 4). Add the lightest area of the sky with Titanium White on the fan brush (Photo 5) and again, blend (Photo 6) with the 2" brush.

MOUNTAINS

Load the fan brush with the first Alizarin Crimson-Phthalo Blue-Titanium White mixture to shape the top edge of the distant mountain. (Photo 7.) Blend the color down to the base of the mountain with the 2" brush (Photo 8) and then, holding the brush vertically, firmly tap the base of the mountain (Photo 9) to create the illusion of mist (Photo 10).

As you work forward in layers, add Phthalo Blue to the Lavender mixture for the darker ridges of mountains. Use the fan brush to add more detail (Photo 11) to the closer mountains (Photo 12). Again, blend with the 2" brush (Photo 13) and firmly tap the base of the mountain to mist (Photo 14). Notice how with just brush strokes, you can create highlights and shadows. (Photo 15.)

Underpaint the lower portion of the canvas with a mixture of equal amounts of Alizarin Crimson and Sap Green on the 2" brush, using long, horizontal strokes. (Photo 16.)

Add the road with Van Dyke Brown on the fan brush, using sweeping, horizontal strokes. Watch your perspective here, notice how the road is wider near the foreground. (Photo 17.) Use rocking strokes with the 2" brush, to blend. (Photo 18.)

BACKGROUND

Load the 1" brush with a mixture of Midnight Black, Van Dyke Brown and Alizarin Crimson to tap in (Photo 19) the basic shape of the small trees (Photo 20).

To highlight the trees, dip a clean 1" brush into Liquid White and then tap the bristles into a mixture of Titanium White and Phthalo Blue. Highlight the trees by just tapping downward (Photo 21), carefully creating the individual shapes. You can vary the highlight colors by using some of the Lavender mixtures.

Use the fan brush with a small amount of Titanium White to smooth out *(Photo 22)* and blend the base of the trees *(Photo 23).*

LARGE TREES

Use Midnight Black on the fan brush to tap in the large yucca-tree trunks. *(Photo 24.)* Use a very thin mixture of Midnight Black, Sap Green and the Yellows on the liner brush to add the spikes and leaves to the trunks. *(Photo 25.)* (To load the liner brush, thin the mixture to an ink-like consistency by first dipping the liner brush into paint thinner. Slowly turn the brush as you pull the bristles through the mixture, forcing them to a sharp point.) Apply very little pressure to the brush, as you shape the leaves.

FINISHING TOUCHES

Use the liner brush and thinned Van Dyke Brown to add the smaller trees *(Photo 26)* and your painting is finished— ready for the most important part—your signature! *(Photo 27.)*

Southwest Serenity

1. Use circular strokes . . .

2. . . . and tapping strokes to shape the clouds.

3. Use the top corner of the 2″ brush . . .

4. . . . to blend the cloud shapes.

5. Highlight the clouds with the fan brush . . .

6. . . . then blend the entire sky.

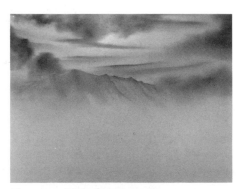

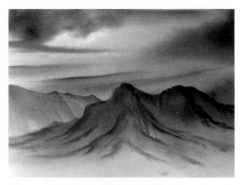

7. Shape mountain tops with the fan brush . . .

8. . . . then blend downward with the 2″ brush.

9. Tap the base of the mountain with the 2″ brush . . .

10. . . . to create the illusion of mist.

11. Use the fan brush . . .

12. . . . to contour the larger mountains . . .

Southwest Serenity

13. . . . and again tap the base . . .

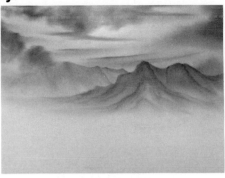

14. . . . to create the illusion of mist.

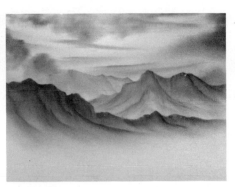

15. Continue working forward in layers . . .

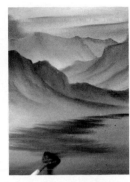

16. . . . then underpaint the lower portion of the canvas.

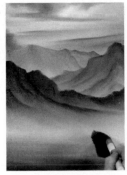

17. Paint the road with the fan brush . . .

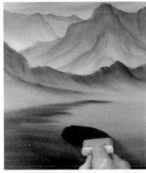

18. . . . then blend with the 2" brush.

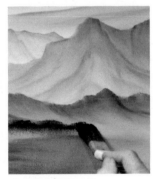

19. Use the 1" brush . . .

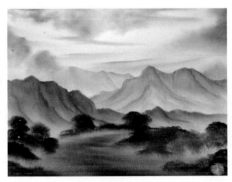

20. . . . to tap in the small trees.

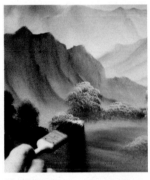

21. Highlights are painted with the 1" brush . . .

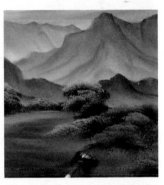

22. . . . then the bottoms are "cleaned up" . . .

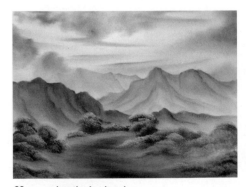

23. . . . using the fan brush.

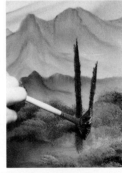

24. Tap down with the fan brush to add the yucca-tree trunks . . .

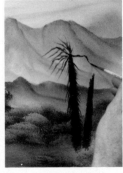

25. . . . then use the liner brush for the leaves.

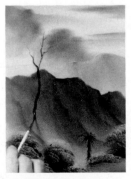

26. Add small tree trunks with the liner brush . . .

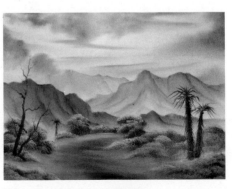

27. . . . to complete your painting.

89

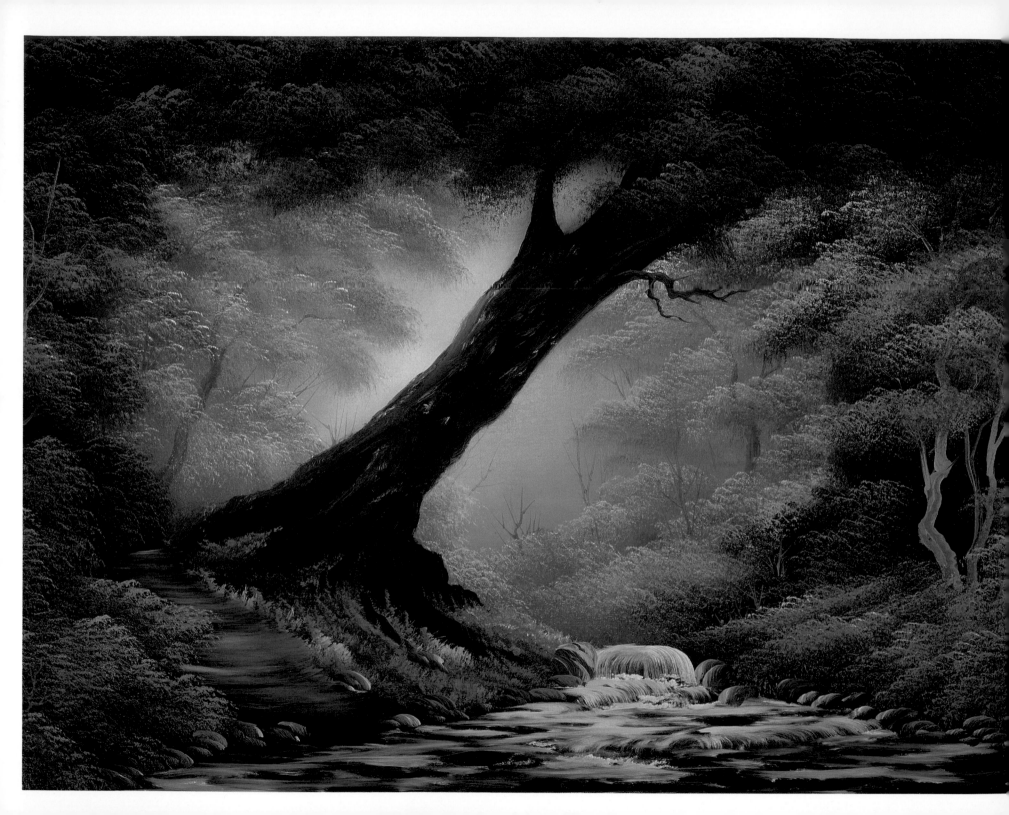

MATERIALS

2" Brush	Dark Sienna
Filbert Brush	Van Dyke Brown
#6 Fan Brush	Alizarin Crimson
Script Liner Brush	Sap Green
Black Gesso	Cadmium Yellow
Liquid Clear	Yellow Ochre
Titanium White	Indian Yellow
Phthalo Blue	Bright Red
Midnight Black	

Use a foam applicator and Black Gesso to prepaint the basic dark shapes, including the large tree trunk, on the canvas and allow to DRY COMPLETELY before you begin. (Photo 1.)

When the Black Gesso is dry, use the 2" brush to cover the entire canvas with a VERY THIN coat of Liquid Clear. Still using the 2" brush, cover the entire canvas with a very small amount of Lavender mixture made with Alizarin Crimson and Phthalo Blue.

BACKGROUND

Begin by lighting the background. With Titanium White on a clean, dry 2" brush, make criss-cross strokes in the light area of the canvas, behind the large tree trunk. (Photo 2.) (Notice how the White blends with the Lavender mixture already on the canvas.) Repeat until you achieve the desired amount of backlighting then lightly blend with long, horizontal strokes. (Photo 3.)

BACKGROUND TREES

Re-load the 2" brush with the Alizarin Crimson-Phthalo Blue mixture and just tap downward with one corner of the brush to shape the subtle background trees. (Photo 4.)

Add the background tree trunks using the same Lavender mixture and the liner brush. (To load the liner brush, thin the Lavender mixture to an ink-like consistency by first dipping the liner brush into paint thinner. Slowly turn the brush as you pull the bristles through the mixture, forcing them to a sharp point.) Apply very little pressure to the brush, as you shape the trunks. (Photo 5.)

Use various mixtures of Titanium White, Alizarin Crimson, Phthalo Blue and a small amount of Bright Red on the 2" brush to add foliage to the background trees. Load the 2" brush by holding it at a 45-degree angle and tapping the bristles into the various paint mixtures. Allow the brush to "slide" slightly forward in the paint each time you tap (this assures that the very tips of the bristles are fully loaded with paint). Starting in the lightest area of the background, tap downward with one corner of the brush to paint the leafy highlights. (Photo 6.) Work in layers, carefully creating individual trees. (Photo 7.)

As you work outward from the light area, underpaint the darker, closer trees with the Alizarin Crimson-Phthalo Blue mixture on the 2" brush.

Add tree trunks with a thin mixture of Alizarin Crimson, Phthalo Blue, Dark Sienna and Titanium White on the liner brush. (Photo 8.) By turning and wiggling the brush, you can give the trees a gnarled appearance. (Photo 9.)

Highlight these closer trees with various mixtures of the Lavender (Alizarin Crimson-Phthalo Blue), Titanium White, Sap Green, all of the Yellows and a very small amount of Bright Red. (Add a small amount of Midnight Black to the mixtures for the foliage in shadow.) Again, form individual leaf clusters by tapping downward with just one corner of the 2" brush. (Photo 10.)

Use the same highlight mixtures to add the soft grassy area at the base of the trees. Again, fully load the bristle tips of the 2" brush, hold the brush horizontally and gently tap downward. Work in layers, carefully creating the lay-of-the-land. (Photo 11.) If you are also careful not to destroy all of the dark color already on the canvas, you can create grassy highlights that look almost like velvet. (Photo 12.)

LARGE TREE TRUNK

Shape and contour the large Black Gesso tree trunk with a mixture of Van Dyke Brown, Dark Sienna and Midnight Black

on the fan brush. Be sure to give the tree a bumpy or gnarled appearance and be sure to include the large gnarled roots. *(Photo 13.)*

You can highlight and further contour the trunk with a very small amount of Titanium White on the fan brush, but the tree should remain very dark.

Use various mixtures of all of the Yellows, Sap Green and Midnight Black on the fan brush to add the grassy patches at the base of the large tree. *(Photo 14.)* Again, pay close attention to the lay-of-the-land. *(Photo 15.)*

WATER

Load the fan brush with a mixture of Liquid White, Titanium White and a very small amount of Phthalo Blue. To paint the tiny waterfall, hold the brush horizontally, start with a short horizontal stroke, then pull straight down. *(Photo 16.)*

Use push-up strokes at the base of the falls for the foaming water action *(Photo 17)* and swirling, horizontal strokes to bring the water forward. Pay close attention to perspective here; the stream should get progressively wider as it nears the foreground. *(Photo 18.)*

Add the rocks and stones along the water's edge with the filbert brush. Load the brush with a mixture of Van Dyke Brown and Dark Sienna, then pull one side of the bristles

through a thin mixture of Liquid White and Dark Sienna (to double-load the brush). With the light side of the brush facing upward, you can shape and highlight each rock and stone with a single, curved stroke. *(Photo 19.)* Use Titanium White on the fan brush and short horizontal strokes to indicate the path at the base of the large tree. *(Photo 20.)*

LARGE TREE FOLIAGE

Underpaint the foliage for the large tree with a mixture of Midnight Black and Sap Green on the 2″ brush. *(Photo 21.)* Highlight the foliage by adding Cadmium Yellow to the brush. Tap downward with one corner of the brush carefully forming individual leaf clusters—try not to just hit at random. *(Photo 22.)*

FINISHING TOUCHES

And now, the finished painting is ready for a signature! *(Photo 23.)* Again, load the liner brush with thinned color of your choice. Sign just your initials, first name, last name or all of your names. Sign in the left corner, the right corner or one artist signs right in the middle of the canvas! The choice is yours. You might also consider including the date when you sign your painting. Whatever your choices, have fun, for hopefully with this painting you have truly experienced THE JOY OF PAINTING!

Serenity

1. Pre-paint the canvas with Black Gesso.

2. Use criss-cross strokes . . .

3. . . . to paint the light area.

4. Tap down subtle background trees . . .

5. . . . then add trunks with the liner brush.

6. Use the 2″ brush . . .

Serenity

7. . . . to highlight the foliage.

8. Use thinned paint on the liner brush . . .

9. . . . to paint tree trunks.

10. Add the foliage . . .

11. . . . and soft grassy areas . . .

12. . . . by tapping downward with the 2" brush.

13. Shape the tree trunk . . .

14. . . . and add grassy patches . . .

15. . . . to the base of the tree with the fan brush.

16. Pull down the waterfall . . .

17. . . . push up the foaming action . . .

18. . . . and bring the water forward with the fan brush.

19. Use the filbert brush to paint rocks . . .

20. . . . and the fan brush to add the path . . .

21. . . . at the base of the tree.

22. Add foliage to the large tree . . .

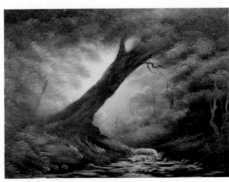

23. . . . to complete the painting.

93

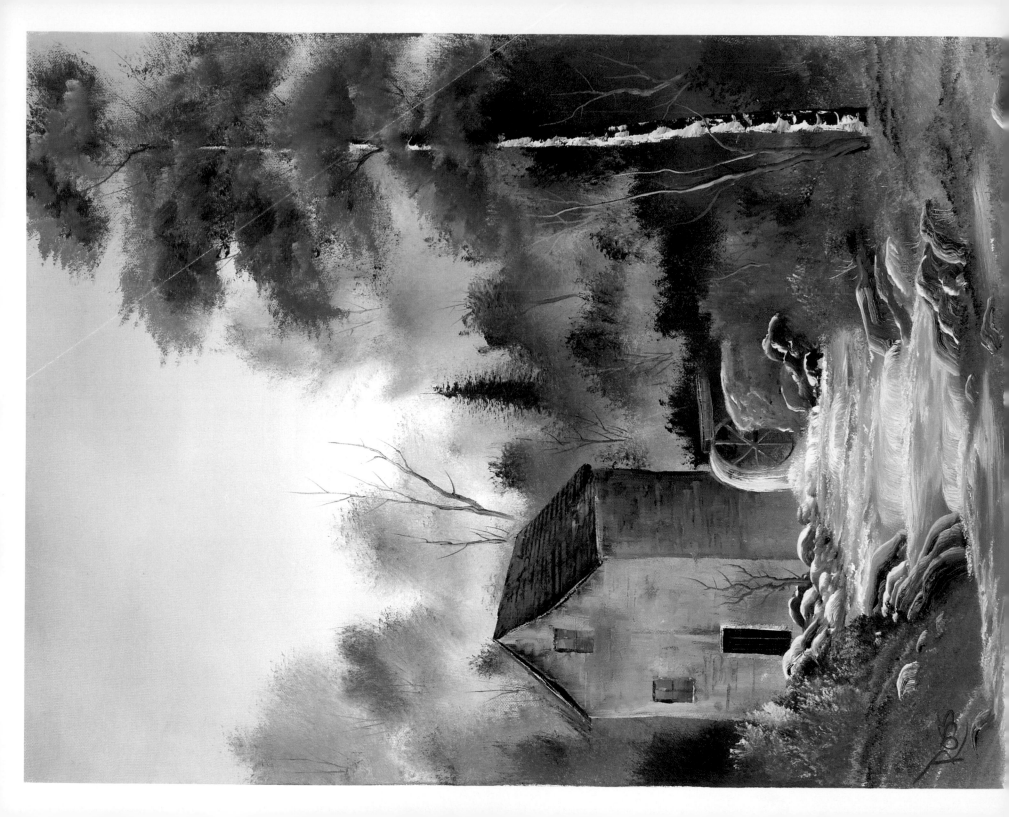

MATERIALS

2″ Brush	Midnight Black
1″ Brush	Dark Sienna
#6 Filbert Brush	Van Dyke Brown
#6 Fan Brush	Alizarin Crimson
#2 Script Liner Brush	Sap Green
Large Knife	Cadmium Yellow
Small Knife	Yellow Ochre
Liquid White	Indian Yellow
Titanium White	Bright Red
Phthalo Blue	

Start by covering the entire canvas with a thin, even coat of Liquid White. With long horizontal and vertical strokes, work back and forth to ensure an even distribution of paint on the canvas. Do NOT allow the Liquid White to dry before you begin.

SKY

Load the 2″ brush with a mixture of Dark Sienna and Alizarin Crimson, tapping the bristles firmly against the palette to ensure an even distribution of paint throughout the bristles. Starting at the top of the canvas, use criss-cross strokes to paint the sky. (Photo 1.) As you work down the canvas, notice how the color blends with the Liquid White, and automatically the sky becomes lighter as you near the horizon. Use a clean, dry 2″ brush to very lightly blend the entire sky, "three hairs and some air".

BACKGROUND

Again, load the 2″ brush by tapping the bristles into Dark Sienna and Alizarin Crimson. Use scrubbing strokes with one corner of brush to shape the distant tree tops.

With one corner of a clean, dry 2″ brush, firmly tap the base of the trees (Photo 2) and lift upward, to create the illusion of mist.

Re-load the 2″ brush with Midnight Black, Van Dyke Brown, Sap Green and Phthalo Blue for the closer trees, and again tap to create the illusion of mist.

The evergreens are made by holding the brush vertically and just pressing to slightly bend the bristles against the canvas. (Photo 3.) Use the knife to cut in the indication of tree trunks. (Photo 4.) Continuing to work forward in layers, you can begin adding varying amounts of all of the Yellows and Bright Red to your mixtures. Use thinned Van Dyke Brown or Dark Sienna or Titanium White on the liner brush to add tree trunks, limbs and branches and the background is complete. (Photo 5.)

WATERMILL

Use the knife to remove paint from the canvas in the basic shape of the building. Paying close attention to angles, add the roof and the back edge of the roof with Van Dyke Brown. Highlight the roof with a mixture of Van Dyke Brown, Bright Red and Titanium White.

Use a mixture of Dark Sienna, Titanium White and Yellow Ochre for the side of the mill and then lighten the mixture with Titanium White for the front of the mill. Lightly over-paint with a darker mixture of Dark Sienna, Van Dyke Brown and Titanium White.

Use the small knife with a mixture of Dark Sienna and Titanium White for the windows and then outline them with a very small roll of Van Dyke Brown on the knife. The door is Van Dyke Brown outlined with a lighter mixture.

Use the liner brush with a thinned mixture of Dark Sienna and Titanium White to paint the flume (on the back-side of the mill) and the water wheel. (Notice that the wheel is an oval-shape.) Highlight the wheel with a lighter mixture of Liquid White and Dark Sienna on the liner brush. (Photo 6.)

STREAM

Load the filbert brush with Midnight Black and then pull one side of the brush through a very thin mixture of Liquid White, Dark Sienna, and Yellow Ochre. With single strokes (Photo 7) you can shape the rocks and their highlights near the base of the water wheel (Photo 8).

Use the foliage mixtures on the 2" brush to underpaint the stream and entire lower portion of the canvas *(Photo 9)* and then continue by adding bushes to the base of the large rocks and the building, using just the corner of the brush *(Photo 10)*.

Load the fan brush with a mixture of Liquid White, Titanium White and Phthalo Blue, then use a single downward stroke to bring the water over the wheel. *(Photo 11.)* Create the foaming actions with tiny push-up strokes and swirling, horizontal strokes to bring the water forward. Continue to use the double-loaded filbert brush to add the rocks and stones along the water's edge. *(Photo 12.)*

Load the 2" brush with various mixtures of all the Yellows and Sap Green. Hold the brush vertically and tap downward *(Photo 13)* to add the grassy areas over the stones *(Photo 14)*.

TREE

Load the 2" brush with a dark mixture of Midnight Black, Van Dyke Brown and Dark Sienna to underpaint the large foreground tree. *(Photo 15.)*

Add the tree trunk with a double-loaded fan brush (Van Dyke Brown and the thinned light mixture). Hold the brush vertically, start at the top of the canvas and pull down. *(Photo 16.)* Increase pressure on the brush, forcing the base of the trunk to become wider.

Add limbs and branches to the tree using thinned Van Dyke Brown on the liner brush and then highlight the foliage using Yellow Ochre on the fan brush and push-up strokes. *(Photo 17.)*

FINISHING TOUCHES

You can add additional rocks with the double-loaded filbert brush and small sticks and twigs with a thinned paint on the liner brush to finish your painting. *(Photo 18.)*

Don't forget the most important part, your signature! Sign your painting with a mixture of paint and paint thinner mixed to an ink-like consistency. Slowly turn the handle of the liner brush as you pull its bristles through the mixture, fully loading them and forcing them to a sharp point. Use very little pressure and re-load the brush as necessary to sign your name. Stand back and admire your masterpiece with pride!

Old Country Mill

1. Use criss-cross strokes to paint the sky.

2. Paint the leafy trees . . .

3. . . . and evergreens with the 2" brush . . .

4. . . . then add trunks with the knife . . .

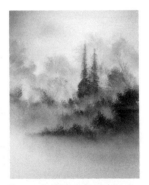

5. . . . to complete the background trees.

Old Country Mill

6. Progressional steps used to paint the mill.

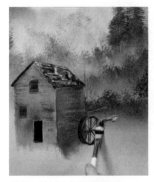

7. Double-load the filbert brush . . .

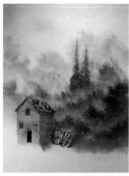

8. . . . to add rocks and stones.

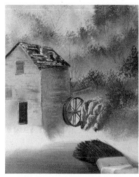

9. Use the 2" brush . . .

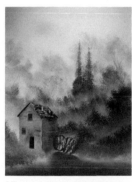

10. . . . to underpaint the foreground.

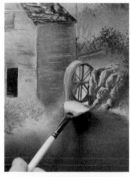

11. Add water with the fan brush . . .

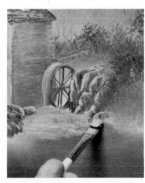

12. . . . and rocks and stones with the filbert brush.

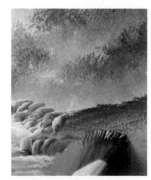

13. Tap down with the 2" brush . . .

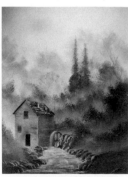

14. . . . to add the grassy areas.

15. Underpaint the large trees with the 2" brush . . .

16. . . . add the trunks . . .

17. . . . and foliage with the fan brush . . .

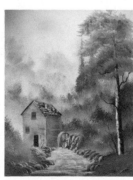

18. . . . and the painting is finished.

97

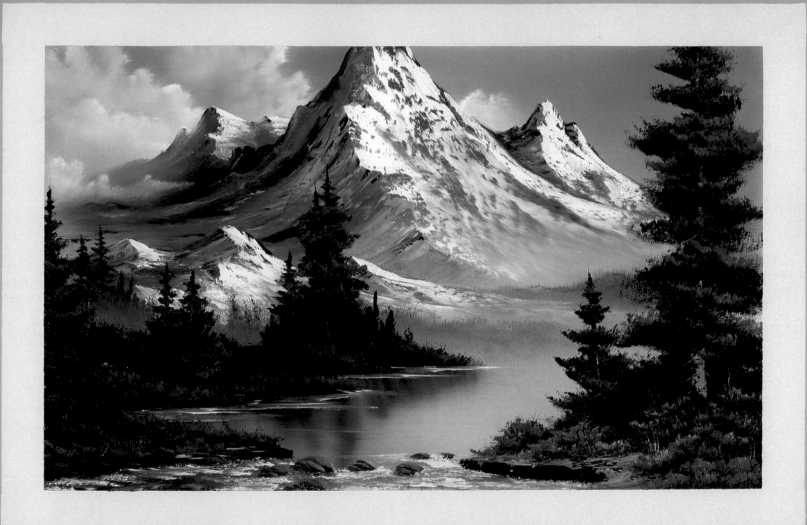

22. DIVINE ELEGANCE

MATERIALS

2" Brush	Prussian Blue
#6 Filbert Brush	Midnight Black
#6 Fan Brush	Dark Sienna
#2 Script Liner Brush	Van Dyke Brown
Large Knife	Alizarin Crimson
Masking Tape	Sap Green
Acrylic Spray Paint	Cadmium Yellow
Liquid White	Yellow Ochre
Titanium White	Indian Yellow
Phthalo Green	Bright Red
Phthalo Blue	

Prepare the canvas by placing strips of masking tape about four inches from the outside edges of an 18x24 canvas. Spray the border of the canvas with an acrylic spray paint, color of your choice. I used Blue for my border. (Photo 1.) Do not remove the masking tape.

Use the 2" brush to cover the center area of the canvas with a thin, even coat of Liquid White. Do NOT allow the Liquid White to dry before you begin.

SKY AND WATER

Load the 2" brush with Phthalo Blue. Starting at the top of the canvas, use criss-cross strokes to paint the sky. (Photo 2.)

Use a mixture of Phthalo Blue and a small amount of Phthalo Green to paint the water on the lower portion of the canvas.

Load the fan brush with Titanium White and use one corner of the brush and tight, circular strokes to shape the clouds. (Photo 3.) With the top corner of a clean, dry 2" brush, continue using circular strokes (Photo 4) to blend the clouds (Photo 5).

MOUNTAIN

The mountain is made with the knife and a mixture of Midnight Black, Prussian Blue, Alizarin Crimson and Van Dyke Brown. (Load the long edge of the knife with a small roll of paint.) With firm pressure, shape just the top edge of the mountain. (Photo 6.) Notice how the very top of the mountain extends right out of the picture. Use the knife to remove any excess paint and then with the 2" brush, pull the paint down to the base of the mountain to blend and mist. (Photo 7.)

To highlight the mountain, load the knife with a small roll of Titanium White. Starting with the most distant peaks and paying close attention to angles, apply the snowy highlights to the right side of each far away peak, using so little pressure that the paint "breaks".

Use a mixture of Titanium White with Phthalo Blue and Midnight Black for the shadow sides of the peaks. Again, use so little pressure that the paint "breaks".

Before moving forward to the larger, closer peaks, use a mixture of Liquid White and Titanium White on the fan brush and circular strokes to swirl clouds around the base of the small distant portion of the mountain. (Photo 8.) Use circular strokes with the top corner of a clean, dry 2" brush to lightly blend the clouds.

Moving forward and paying close attention to angles, apply highlights and shadows to the larger, closer mountain peaks. (Photo 9.) Carefully following the angles, tap the base of the mountain with a clean, dry 2" brush (Photo 10) and lift upward to create the impression of mist.

Working forward in the painting, use the same Midnight Black-Phthalo Blue-Alizarin Crimson-Van Dyke Brown mixture on the knife to add the small mountain at the base of the larger mountain. Again, apply highlights and shadows then tap with the 2" brush to mist the base of the small mountain.

FOOTHILLS

Use the shadow mixture (Titanium White, Phthalo Blue and Midnight Black) on the 2" brush and tap downward with just the corner of the brush to shape the foothill at the base of the large mountain.

Continuing to work in layers, with Titanium White on the knife, you can extend the small mountain peaks forward;

bring them right in front of the foothills. Again, tap the base of the peaks with the 2″ brush to mist. *(Photo 11.)*

BACKGROUND

Use the knife to make a Lavender mixture with Alizarin Crimson and a small amount of Phthalo Blue. Load the fan brush with a mixture of Titanium White and the Lavender color. Holding the brush vertically, just tap downward to add the indication of small evergreen trees at the base of the mountains. *(Photo 12.)* You can add branches to the more distinct trees with just the corner of the fan brush. Firmly tap the base of the trees with the top corner of a clean, dry 2″ brush *(Photo 13)* to diffuse and mist *(Photo 14)*.

EVERGREENS

For the large evergreens, load the fan brush to a chiseled edge with a mixture of Midnight Black, Phthalo Blue, Van Dyke Brown, Alizarin Crimson, Phthalo Green and Sap Green. Holding the brush vertically, touch the canvas to create the center line of each tree. Use just the corner of the brush to begin adding the small top branches. Working from side to side, as you move down each tree, apply more pressure to the brush, forcing the bristles to bend UPWARD and automatically the branches will become larger as you near the base of each tree. *(Photo 15.)*

Hold the brush horizontally and force the bristles to bend upward to add the grassy area at the base of the trees. *(Photo 16.)* Use a 2″ brush to extend the color into the water for reflections; hold the brush flat against the canvas and just pull straight down *(Photo 17)* then lightly brush across to give the reflections a watery appearance. Working forward in layers, continue adding land projections and reflections. *(Photo 18.)* Add the tree trunks with a small roll of a mixture of Titanium White and Dark Sienna on the knife. *(Photo 19.)* Highlight the trees by using the fan brush to very lightly touch the right sides of the branches with a mixture of the tree color and Cadmium Yellow. Highlight the grassy areas at the base of the trees.

Use a small roll of Liquid White on the edge of the knife to cut in water lines and ripples. *(Photo 20.)* Add the banks to the water's edge with Van Dyke Brown on the knife, then highlight with a mixture of Titanium White and Van Dyke Brown. *(Photo 21.)*

ROCKS AND STONES

Load the filbert brush with a mixture of Dark Sienna and Van Dyke Brown, then pull ONE side of the bristles through a thin mixture of Liquid White and Dark Sienna. With the light side of the brush UP, use single, curved strokes to shape the rocks and stones in the water. *(Photo 22.)* Use a small roll of Liquid White on the knife to add water lines to the base of the stones. With a mixture of Liquid White, Titanium White and a small amount of Phthalo Blue on the fan brush *(Photo 23)*, continue swirling water around the base of the rocks.

FINISHING TOUCHES

Remove the masking tape to expose your finished picture with its own border *(Photo 24)*.

Divine Elegance

1. Apply a border to the canvas with masking tape . . .

2. . . . then use criss-cross strokes to paint the sky.

3. Shape clouds with the fan brush . . .

4. . . . then use the top corner of the 2″ brush . . .

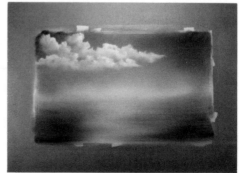

5. . . . to blend the clouds.

6. Shape the mountain top with the knife.

Divine Elegance

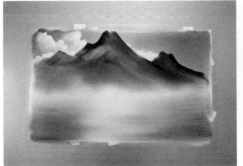

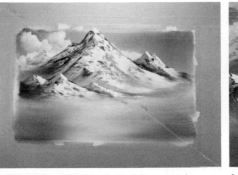

7. Diffuse the base of the mountain.

8. Add clouds to the base with the fan brush.

9. Highlight the larger peaks . . .

10. . . . then tap the base with the 2" brush.

11. Paint the foothill at the base of the mountains.

12. Tap down evergreens with the fan brush . . .

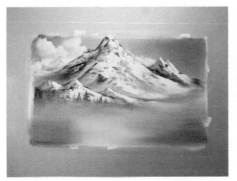

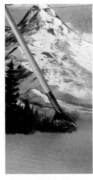
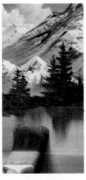
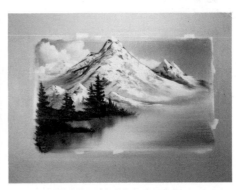

13. . . . then firmly tap the base with the 2" brush . . .

14. . . . to create the illusion of mist.

15. Larger evergreens . . .

16. . . . and the grassy areas are painted with the fan brush.

17. Pull straight down with the 2" brush . . .

18. . . . to reflect the trees into the water.

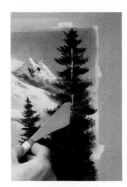
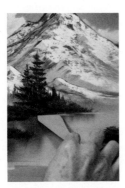
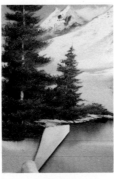
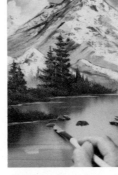
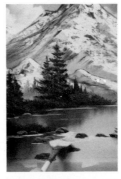
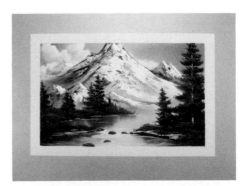

19. Use the knife to add tree trunks.

20. Use the knife for water lines . . .

21. . . . and to add banks to the water's edge.

22. Paint the rocks and stones with the filbert brush . . .

23. . . . then add water with the fan brush.

24. Remove the masking tape to expose the finished painting with its own border.

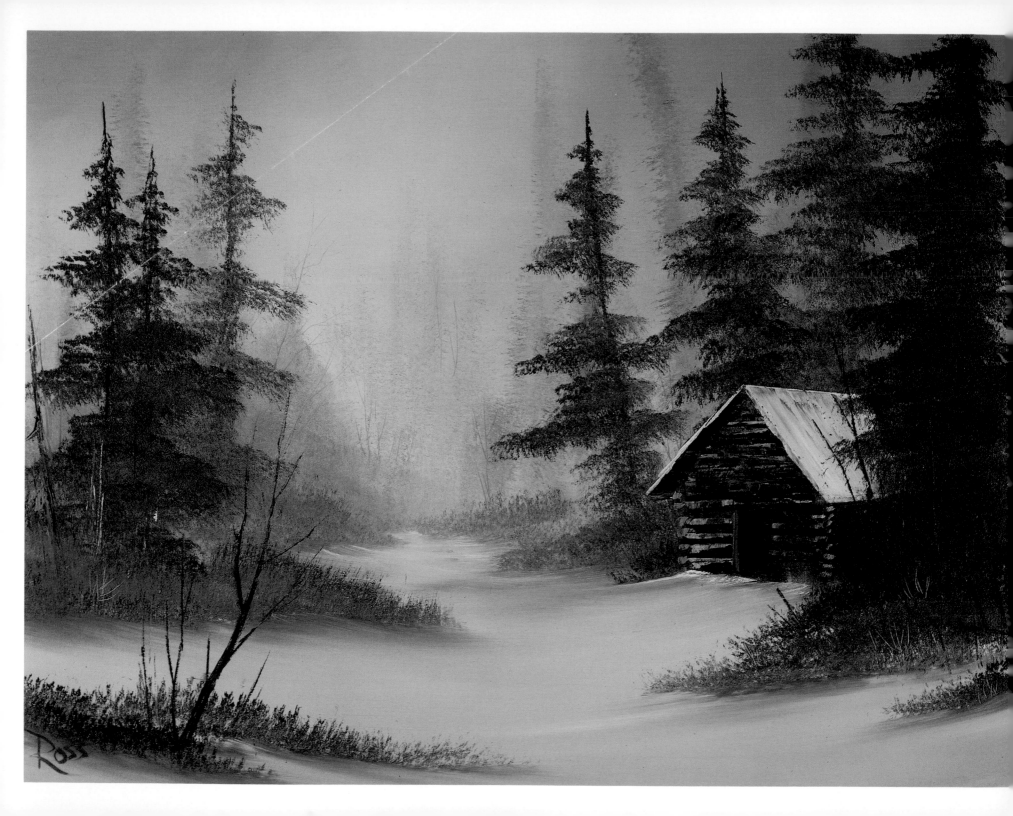

23. SNOWY MORN

MATERIALS

2" Brush	Midnight Black
#2 Script Liner Brush	Dark Sienna
Large Knife	Van Dyke Brown
Liquid White	Alizarin Crimson
Titanium White	Yellow Ochre
Prussian Blue	

SKY

Use the 2" brush to cover the entire canvas with a thin, even coat of Liquid White. With long horizontal and vertical strokes, work back and forth to ensure an even distribution of paint on the canvas. Do NOT allow the Liquid White to dry before you begin.

Without cleaning the 2" brush, load it with a mixture of Yellow Ochre and a small amount of Midnight Black; just brush-mix, tapping the bristles firmly against the palette to ensure an even distribution of paint throughout the bristles. Begin painting the sky by making criss-cross strokes near the top of the canvas, add a very small amount of Prussian Blue to the brush, as you complete the sky, always using criss-cross strokes. Use long, horizontal strokes to blend the entire sky. (Photo 2.)

BACKGROUND

The indication of the tall, misty, background evergreens is made still using the various sky mixtures and the 2" brush. To load the brush, pull both sides of the bristles through the mixtures, forcing them to a chiseled edge. Starting at the base of each tree, simply hold the brush vertically and press the side of the brush against the canvas. (Photo 3.) As you work upward, apply less pressure on the brush, creating the tapered tree top. Complete first one side and then the other of each tree. (Photo 4.)

Tap downward with just the top corner of the brush (still using the same colors) (Photo 5) to shape the small trees and bushes at the base of the tall evergreens (Photo 6).

Re-load the 2" brush with Midnight Black, Van Dyke Brown, Prussian Blue and Dark Sienna. Hold the brush horizontally and force the bristles to bend upward (Photo 7) to add the grassy area at the base of the background trees (Photo 8).

With Titanium White on a clean, dry 2" brush, use long, horizontal strokes to lay in the snow-covered ground area. (Photo 9.) Work in layers, concentrating on the lay-of-the-land. Add the background tree trunks (Photo 10) using the same tree-mixture and the liner brush. (To load the liner brush, thin the mixture to an ink-like consistency by first dipping the liner brush into paint thinner.) Apply very little pressure to the brush when painting the trunks. (Photo 11.)

LARGE TREES

For the larger evergreens, load the 2" brush to a chiseled edge with Prussian Blue, Midnight Black, Van Dyke Brown, Dark Sienna, Alizarin Crimson and Titanium White. Holding the brush vertically, touch the canvas to create the center line of each tree. (Photo 12.) Use just the corner of the brush to begin adding the small top branches. Working from side to side, as you move down each tree, apply more pressure to the brush, forcing the bristles to bend downward (Photo 13) and automatically the branches will become larger as you near the base of each tree (Photo 14).

As you work forward in the painting, the trees should become progressively darker by adding less Titanium White and more Prussian Blue and Van Dyke Brown to the mixture. (Photo 15.)

Use a small roll of the tree-mixture on the long edge of the knife to add the indication of the evergreen trunks. (Photo 16.) Then, use the 2" brush with Titanium White and long, horizontal strokes to add the snow-covered ground area to the base of the trees.

LOG CABIN

Use a clean knife to remove paint from the canvas in the

basic shape of the cabin. Load the long edge of the knife with a small roll of a mixture of Van Dyke Brown and Dark Sienna. Shape the back under-roof, then pull straight down to add the front and side of the cabin.

Touch Titanium White to the front and side of the cabin to indicate logs and add the door with Van Dyke Brown. Use Titanium White on the knife for the snow-covered roof (*Photo 17*) and the cabin is completed (*Photo 18*).

Use the dark evergreen mixture on the 2″ brush to add the large evergreen at the back of the cabin. (*Photo 19.*) Then, use long horizontal strokes with Titanium White (*Photo 20*) to add the snow to the base of the cabin. Continue using the dark tree-mixture on the 2″ brush (*Photo 21*) to add the grassy areas (*Photo 22*).

FOREGROUND

Working forward in layers, continue adding grassy areas and snow-covered land areas. The small foreground tree trunk is painted with Van Dyke Brown and the knife. (*Photo 23.*)

FINISHING TOUCHES

Use the point of the knife to scratch in small sticks and twigs and we'll call this one finished! (*Photo 24.*) Sign with pride.

Snowy Morn

1. Use criss-cross strokes . . .

2. . . . to paint the sky, then blend.

3. Press the side of the 2″ brush on the canvas . . .

4. . . . to paint the evergreens.

5. Tap down with the corner of the 2″ brush . . .

6. . . . for small bushes at the base of the evergreens.

7. Push up to add grassy areas . . .

8. . . . at the base of the trees and bushes.

9. Use long horizontal strokes to paint the snow.

10. With very thin paint on the liner brush . . .

11. . . . add background tree trunks.

Snowy Morn

12. Paint the center of the evergreen . . .

13. . . . then the branches . . .

14. . . . with the 2" brush.

15. Add darker evergreens with the 2" brush . . .

16. . . . and trunks with the knife.

17. Progressional steps used to paint the log cabin.

18. Use the 2" brush to paint the large tree . . .

19. . . . behind the cabin . . .

20. . . . the snow . . .

21. . . . and the grassy areas . . .

22. . . . paying close attention to the lay-of-the-land.

23. Add the small foreground tree . . .

24. . . . to complete the painting.

24. SEASCAPE FANTASY

MATERIALS

2" Brush	Midnight Black
#6 Filbert Brush	Dark Sienna
#6 Fan Brush	Van Dyke Brown
#2 Script Liner Brush	Alizarin Crimson
Small Knife	Sap Green
Black Gesso	Cadmium Yellow
Liquid White	Yellow Ochre
Titanium White	Indian Yellow
Phthalo Blue	

Before starting your painting, mark the horizon with a strip of masking tape. Use a foam applicator to cover the area below the horizon with a thin, even coat of Black Gesso. At the same time, you can add a basic cloud shape to the upper portion of the canvas. Allow the Black Gesso to DRY COMPLETELY. (Photo 1.)

Use the 2" brush to cover the Black Gesso, just below the horizon, with a mixture of Sap Green and Van Dyke Brown. Cover the lower portion of the canvas with Indian Yellow and then the lower left corner with a thin coat of Dark Sienna.

Cover the entire area above the horizon with a thin, even coat of Liquid White. Do NOT allow these paints to dry before you begin.

SKY

Load the 2" brush with a mixture of Yellow Ochre and Cadmium Yellow, tapping the bristles firmly against the palette to evenly distribute the paint throughout the bristles. Start by making criss-cross strokes just above the horizon and working upward. (Photo 2.) Without cleaning the brush, add a small amount of Alizarin Crimson above the Yellows.

With a Lavender mixture of Alizarin Crimson and Phthalo Blue on the fan brush, use rocking strokes to shape the clouds in the upper portion of the sky. (Photo 3.) Use small circular strokes to add the clouds just above the horizon. (Photo 4.)

Use Titanium White on the 2" brush for the light area in the center of the sky. (Photo 5.) You could even use your fingertip with Titanium White and a circular stroke to add a sun to the lightest area. (Photo 6.) Blend the entire sky with a clean, dry 2" brush.

Working in layers, use Titanium White on the fan brush and small circular strokes to highlight the individual cloud shapes (Photo 7), then blend with a clean, dry 2" brush and circular strokes (Photo 8).

When you are satisfied with your sky, remove the masking tape from the canvas (Photo 9) to expose a nice, straight, horizon line (Photo 10).

Cover the small area (left dry by the masking tape) with a mixture of Sap Green and Van Dyke Brown. Then, use Titanium White on the filbert brush to roughly sketch the basic shape of the large wave. (Photo 11.)

BACKGROUND WATER

Create the background swells with long, horizontal strokes, using Titanium White and the fan brush. With a clean fan brush, use short, rocking strokes to pull the top edge of the swells back, to blend. (Photo 12.) (Notice how the White paint mixes with the color already on the canvas, and you have Green water.) Be very careful not to destroy this dark undercolor that separates the individual swells (or background waves).

LARGE WAVE

Use the filbert brush and a mixture of Titanium White and Cadmium Yellow to scrub in the "eye" of the large wave. (Photo 13.) Blend with circular strokes using the top corner of a clean, dry 2" brush. (Photo 14.) Pay close attention to the shape of your wave.

With Titanium White on the fan brush, pull the water over the top of the crashing wave. (Photo 15.) Be very careful of your angles here!

Use the Alizarin Crimson-Phthalo Blue mixture on the filbert brush and make small circular strokes to scrub in the

foam shadows along the edges of the large wave. *(Photo 16.)* Clean the brush and with Titanium White, make small, circular push-up strokes to highlight the top edges of the foam, where the light would strike. *(Photo 17.)* Use circular strokes with the top corner of the 2" brush to lightly blend the base of the foam highlights into the shadow areas. *(Photo 18.)*

Use a very thin mixture of Titanium White with paint thinner on the liner brush to highlight the top edges of the waves *(Photo 19)* and to add small details *(Photo 20)* and foam patterns to the water *(Photo 21)*. (To load the liner brush, thin the paint to an ink-like consistency by first dipping the liner brush into paint thinner. Slowly turn the brush as you pull the bristles through the mixture, forcing them to a sharp point. Use very little pressure when applying the highlights. If you have trouble making the paint flow, you probably have not fully loaded the brush.)

FOREGROUND

In the lighest area of the foreground, make long, vertical strokes with Titanium White on the 2" brush. *(Photo 22.)* Lightly brush across to create the reflected light on the beach. *(Photo 23.)*

Load the long edge of the small knife with a very small roll of Titanium White, by pulling the paint out flat on your palette and just cutting across. Hold the knife flat against the canvas and use firm pressure and long horizontal strokes to add the foamy water action on the beach. *(Photo 24.)* Use a clean fan brush to pull the top edge of the paint back towards the large wave *(Photo 25)* creating swirling foam patterns.

With thinned Titanium White on the liner brush, add the water line on the beach *(Photo 26)*, then use thinned Van Dyke Brown on the liner brush and small "M" strokes to add the tiny birds *(Photo 27)*.

ROCKS AND STONES

Load both sides of the filbert brush with Van Dyke Brown and then pull one side of the bristles through a mixture of Liquid White, Dark Sienna and Yellow Ochre (to double-load the brush). With the light side of the brush towards the top, use a series of single strokes to both shape and highlight the rocks in the left corner of the painting. *(Photo 28.)*

FINISHING TOUCHES

Use thinned Titanium White on the liner brush to add the water lines to the base of the rocks and your painting is finished. *(Photo 29.)* Sign and enjoy!

Seascape Fantasy

1. Apply Black Gesso to the canvas.

2. Use criss-cross strokes to paint the sky.

3. Use rocking strokes ...

4. ... and circular strokes to paint clouds.

5. Add the light area with the 2" brush ...

6. ... and the sun with your finger.

7. Highlight clouds with the fan brush ...

Seascape Fantasy

 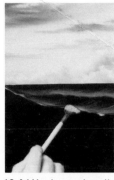 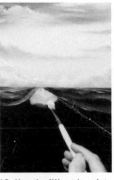 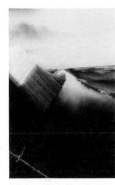

8. . . . then blend with the 2" brush.

9. Remove the tape from the canvas . . .

10. . . . to expose the horizon line.

11. Sketch the large wave.

12. Add background swells with the fan brush.

13. Use the filbert brush to scrub in the "eye" of the wave . . .

14. . . . then blend with the 2" brush.

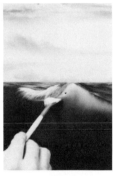 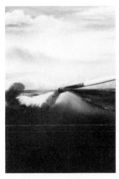 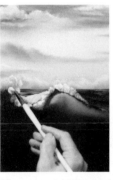 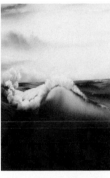 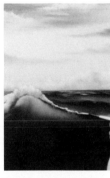 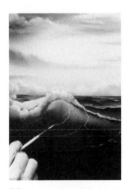 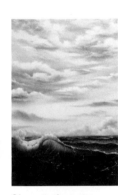

15. Pull water over the top of the wave.

16. Foam is made . . .

17. . . . and highlighted with the filbert brush . . .

18. . . . then blended with the 2" brush.

19. Use the liner brush . . .

20. . . . to add small details . . .

21. . . . to the water.

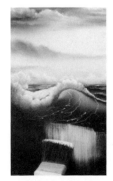 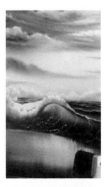 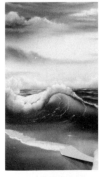 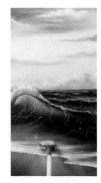 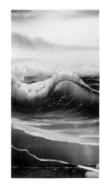

22. Pull down reflections with the 2" brush . . .

23. . . . then lightly brush across.

24. Use the knife to add water on the beach . . .

25. . . . then pull back with the fan brush.

26. Use the liner brush to add water lines . . .

27. . . . and birds.

28. Add rocks and stones with the filbert brush . . .

29. . . . to complete your seascape.

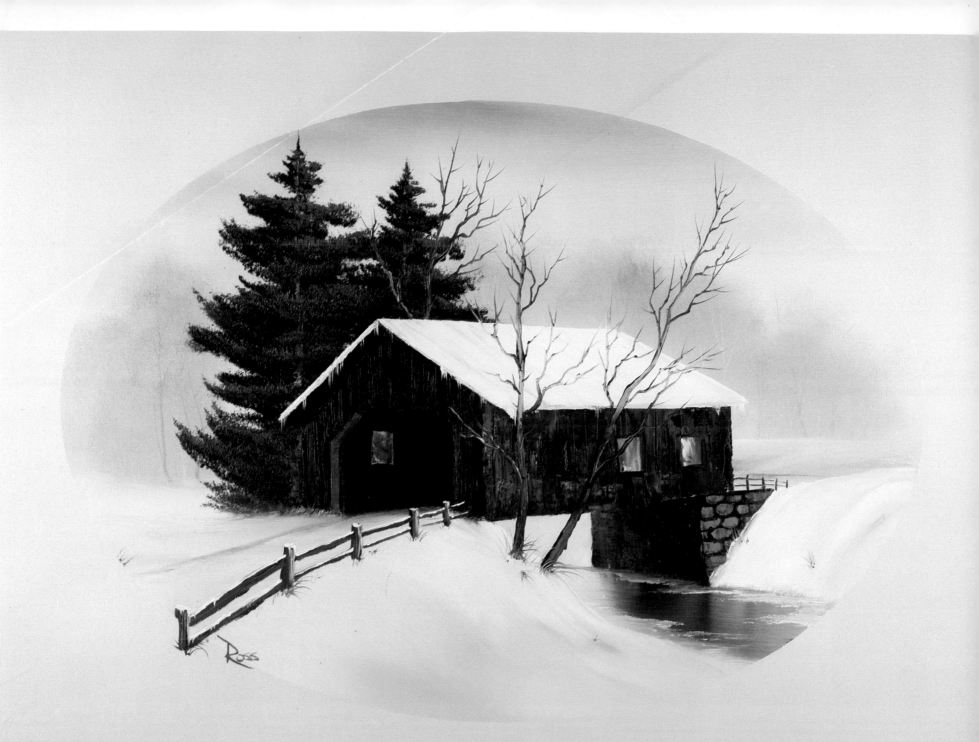

MATERIALS

2" Brush
#6 Fan Brush
#2 Script Liner Brush
Large Knife
Small Knife
Adhesive-Backed Plastic
Liquid White
Titanium White
Phthalo Blue

Prussian Blue
Midnight Black
Dark Sienna
Van Dyke Brown
Alizarin Crimson
Cadmium Yellow
Yellow Ochre
Bright Red

Start by covering the entire canvas with a piece of adhesive-backed plastic (such as Con-Tact Paper) from which you have removed a center oval shape. (A 16 x 20 oval for an 18 x 24 canvas.) *(Photo 1.)*

Use the 2" brush to cover the entire exposed oval-area of the canvas with a thin, even coat of Liquid White. Do NOT allow the Liquid White to dry before you begin.

SKY

Load the 2" brush with Cadmium Yellow and a small amount of Yellow Ochre. Use criss-cross strokes to create the Golden glow near the upper portion of the sky.

Without cleaning the brush, re-load it with Midnight Black and continue with criss-cross strokes at the very top of the oval *(Photo 2)* blending downward into the Yellows *(Photo 3)*.

BACKGROUND

Still with Midnight Black, tap downward with the top corner of the brush to indicate the small background tree shapes along the horizon. *(Photo 4.)*

Add the background tree trunks with Dark Sienna and the liner brush. *(Photo 5.)* To load the liner brush, thin the Dark Sienna to an ink-like consistency by first dipping the liner brush into paint thinner. Apply very little pressure to the brush as you shape the trunks. *(Photo 6.)*

Re-load the same 2" brush with Titanium White and use long, sweeping strokes to add the snow to the base of the background trees. *(Photo 7.)* Pay close attention to the lay-of-the-land; because there is a stream in this painting, the snow should slope down towards the water.

EVERGREENS

Before painting the evergreens, use the knife to remove paint from the canvas in the basic shape of the bridge. *(Photo 8.)* Try to avoid this bridge shape when painting the evergreens—we don't want Green snow on the bridge.

To paint the evergreens, load the fan brush to a chiseled edge with a mixture of Midnight Black, Prussian Blue, Van Dyke Brown and Alizarin Crimson. Holding the brush vertically, and carefully avoiding the covered bridge shape, touch the canvas to create the center line of each tree. Use just the corner of the brush to begin adding the small top branches. Working from side to side, as you move down each tree, apply more pressure to the brush, forcing the bristles to bend upward and automatically the branches will become larger as you near the base of each tree. Again, be very careful to work around the bridge. *(Photo 9.)*

The trunks are painted with a small roll of a mixture of Titanium White and Dark Sienna on the long edge of the knife. *(Photo 10.)* Add a very small amount of Yellow Ochre and Cadmium Yellow to the dark tree mixture already on the fan brush and very lightly touch highlights to the branches.

Use Titanium White on the 2" brush to add snow to the base of the trees, allowing the brush to pick up the dark tree color for the shadowed areas. *(Photo 11.)*

COVERED BRIDGE

Load the long edge of the knife with a small roll of a mixture of Van Dyke Brown and Dark Sienna. Paying close attention to angles, paint the underside of the back of the roof. Pull straight down to add the front of the bridge and then paint the side of the bridge by pulling from the bottom upward.

With Van Dyke Brown on the knife, pull straight down to

add the wall under the bridge, allowing the color to extend into the water. Use the 2″ brush to continue pulling the color into the water and then lightly brush across to create the reflection under the bridge.

Use a mixture of Bright Red, Dark Sienna, Yellow Ochre and Titanium White on the knife to apply highlights to the side of the cabin, with so little pressure on the knife that the paint "breaks". Add Van Dyke Brown to the mixture to highlight the darker front of the cabin.

Use the small knife and Van Dyke Brown to shape the entrance-way into the bridge. Highlight the edges of the opening with a tiny roll of a mixture of Yellow Ochre, Van Dyke Brown and Titanium White on the very edge of the knife.

Use the small edge of the blade to just scrape out the window shape inside the bridge. Add the vertical board indications and the dark window on the side of the bridge with Van Dyke Brown. The light windows are made with Titanium White.

Still carefully following the angles, add snow to the roof with Titanium White on the knife.

Use a mixture of Midnight Black, Titanium White and a small amount of Phthalo Blue on the small edge of the knife to form the stone wall under the bridge. Carefully outline, to further define, the individual stones with a thinned mixture of Titanium White, Dark Sienna and Midnight Black on the liner brush.

STREAM

Still with Titanium White on the 2″ brush and long sweep-

ing strokes, continue moving forward with the snow-covered banks. *(Photo 12.)* Concentrating on the lay-of-the-land, you can use very small amounts of Phthalo Blue on the brush for the shadowed areas. *(Photo 13.)*

Use a small roll of Titanium White on the long edge of the knife *(Photo 14)* to cut in the frozen water's edge *(Photo 15)*.

FENCE

Add the distant fence posts with thinned Van Dyke Brown on the liner brush. *(Photo 16.)* To paint the closer posts, double-load the liner brush by pulling one side of the bristles through thinned Van Dyke Brown and the other side through thinned Titanium White. Pay close attention to perspective, the fence posts should be larger and further apart as you move forward in the painting. *(Photo 17.)* At the same time, you can pull up the long grasses at the base of the fence posts.

TREES

Add the trees with thinned Van Dyke Brown on the liner brush. *(Photo 18.)* Applying very little pressure, by turning and wiggling the brush, you can give the trees a gnarled appearance. *(Photo 19.)*

FINISHING TOUCHES

Remove the Con-Tact Paper from the canvas *(Photo 20)* to expose your finished painting. As a final touch, you can extend the fence posts just outside the oval. *(Photo 21.)*

Covered Bridge Oval

 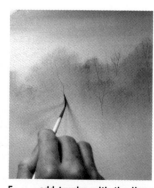

1. Cover the canvas with an oval-removed Con-Tact Paper.

2. Make criss-cross strokes in the sky . . .

3. . . . then blend, all with the 2″ brush.

4. Tap down with the 2″ brush . . .

5. . . . add trunks with the liner brush . . .

Covered Bridge Oval

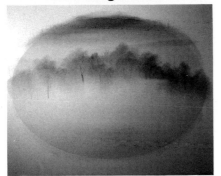

6. . . . to paint the background trees.

7. Lay in the snow with the 2" brush.

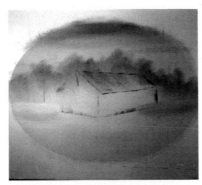

8. Scrape out the bridge shape . . .

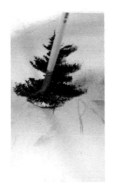

9. . . . before painting the evergreens.

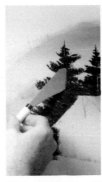

10. Use the knife to add trunks . . .

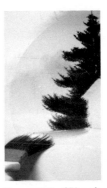

11. . . . and the 2" brush to add snow.

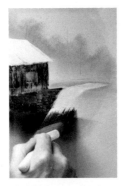

12. Add the snow banks . . .

13. . . . with the 2" brush.

14. Use White on the knife . . .

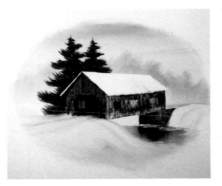

15. . . . to cut in the water's edge.

16. Use the liner brush . . .

17. . . . to add fence posts . . .

18. . . . and the trees . . .

19. . . . and the painting is almost complete.

20. Remove the Con-Tact Paper from the canvas . . .

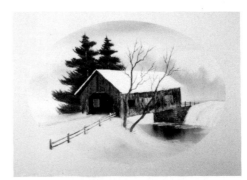

21. . . . extend the fence outside the oval to complete the painting.

MATERIALS

2" Brush	Midnight Black
#6 Fan Brush	Dark Sienna
#2 Script Liner Brush	Van Dyke Brown
Large Knife	Alizarin Crimson
Black Gesso	Sap Green
Liquid White	Cadmium Yellow
Liquid Clear	Yellow Ochre
Titanium White	Indian Yellow
Phthalo Blue	Bright Red

Start by using a foam applicator to apply a thin, even coat of Black Gesso to the dark areas of the painting, "swirling" it around a light area that remains unpainted. Allow the Black Gesso to DRY COMPLETELY. (Photo 1.)

When the Black Gesso is dry, use the 2" brush to completely cover the canvas with a VERY THIN coat of Liquid Clear. (It is important to stress that the Liquid Clear should be applied VERY, VERY sparingly and really scrubbed into the canvas! The Liquid Clear will not only ease with the application of the firmer paint, but will allow you to apply very little color, creating a glazed effect.)

Still using the 2" brush, cover the Liquid Clear with a very thin, even coat of a mixture of Sap Green, Phthalo Blue and Van Dyke Brown.

SKY

Load the 2" brush with a mixture of Titanium White and a small amount of Cadmium Yellow. Begin by making criss-cross strokes in the lightest area of the sky. (Photo 2.)

BACKGROUND

Load a clean, dry 2" brush with both the original Sap Green-Phthalo Blue-Van Dyke Brown mixture and the Titanium White and Cadmium Yellow mixture, to make a pale Blue-Green. Tap downward with the corner of the brush to underpaint subtle background trees. (Photo 3.) Do not clean the brush.

Add the background tree trunks using the same Blue-Green mixture and the liner brush. (To load the liner brush, thin the mixture to an ink-like consistency by first dipping the liner brush into paint thinner. Slowly turn the brush as you pull the bristles through the mixture, forcing them to a sharp point.) Apply very little pressure to the brush as you shape the trunks. By turning and wiggling the brush, you can give your trunks a gnarled appearance. (Photo 4.)

Highlights are made by adding Titanium White to the 2" brush which still contains the pale Blue-Green mixture. Proper loading of the brush is very important to the success of these lacy highlights. Load the brush by holding it at a 45-degree angle and tapping the bristles into the various mixtures. Allow the brush to "slide" slightly forward in the paint each time you tap (this assures that the very tips of the bristles are fully loaded with paint). To apply the highlights, hold the brush horizontally and gently tap downward (Photo 5) carefully creating the individual tree shapes (Photo 6).

Load a clean, dry 2" brush with the original, dark Sap Green-Phthalo Blue-Van Dyke Brown mixture. Moving forward in the painting, and still tapping downward (Photo 7) underpaint the larger, closer trees. Highlight these trees with various mixtures of Midnight Black, Cadmium Yellow and Sap Green. Try not to just hit at random. Working in layers, carefully create individual leaf clusters (Photo 8) by not completely covering all of the dark undercolor (Photo 9).

PATH

Load the long edge of the knife with a mixture of Van Dyke Brown and Dark Sienna. Starting in the distance and working forward, begin adding the path with short horizontal strokes. Watch the perspective, the path should become wider as it moves forward. Highlight the path with a mixture of Dark Sienna and Titanium White on the knife, again using horizontal strokes and so little pressure that the paint "breaks". (Photo 10.)

To make the puddles in the path, load the 2" brush with a small amount of Titanium White. Holding the brush horizontally, press the bristles against the canvas and just pull straight down. *(Photo 11.)* Lightly brush across. Working forward in layers, continue using the Browns and White on the knife to paint the path and the 2" brush to add the puddles. You can also add bushes and grassy areas to the edges of the path with the Yellow highlight colors on the 2" brush. *(Photo 12.)*

FOREGROUND

Under paint the large foreground trees with the Sap Green-Phthalo Blue-Van Dyke Brown mixture on the 2" brush. *(Photo 13.)* Highlight with the various mixtures of all of the Yellows, Midnight Black and Sap Green. Try not to just "hit" at random, carefully form individual leaf-clusters. *(Photo 14.)*

Continue using Titanium White on the 2" brush to add the foreground puddles. (Notice how the White picks up the Blue-Green color already on the canvas.) *(Photo 15.)* Still working in layers, extend the path to the bottom of the canvas.

LARGE TREES

Indicate a larger tree trunk with a mixture of Van Dyke

Brown and Titanium White on the fan brush. Hold the brush vertically, start at the top of the canvas, and just pull down. *(Photo 16.)* The leaf clusters are added with the Yellow highlight mixtures on the 2" brush. *(Photo 17.)*

Use Van Dyke Brown on the knife to underpaint the large tree trunk in the foreground. Highlight the trunk with a mixture of Titanium White, Van Dyke Brown and Dark Sienna on the knife, using so little pressure that the paint "breaks". *(Photo 18.)* Again, use the highlight mixtures on the 2" brush to add the foreground leaf-clusters. *(Photo 19.)*

Use thinned Van Dyke Brown on the liner brush to add the limbs and branches. *(Photo 20.)*

FINISHING TOUCHES

Use thinned paint on the liner brush or just the point of the knife to add small final details, sticks, twigs, etc., and your masterpiece is complete. *(Photo 21.)*

Don't forget to sign your name with pride: Again, load the liner brush with thinned color of your choice. Sign just your initials, first name, last name or all of your names. Sign in the left corner, the right corner or one artist signs right in the middle of the canvas! The choice is yours. You might also consider including the date when you sign your painting. Whatever your choices, have fun, for hopefully with this painting you have truly experienced THE JOY OF PAINTING!

After The Rain

1. Under-paint dark shapes with Black Gesso.

2. Use criss-cross strokes to paint the sky.

3. Tap in background trees with the 2" brush . . .

4. . . . then add trunks with the liner brush.

5. Again, tap down with the 2" brush . . .

6. . . . to add highlights to the trees.

After The Rain

7. Under-paint . . .

8. . . . and highlight . . .

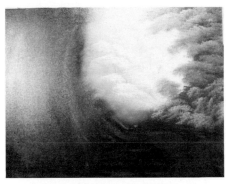

9. . . . the large dark trees with the 2" brush.

10. Paint the path with the knife . . .

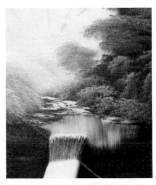

11. . . . make puddles with the 2" brush . . .

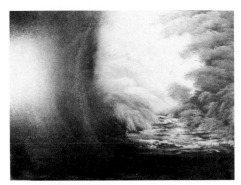

12. . . . as you work forward in layers.

13. Continue adding large trees . . .

14. . . . highlights . . .

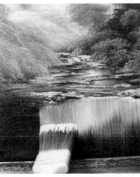

15. . . . and puddles with the 2" brush.

16. Pull down with the fan brush . . .

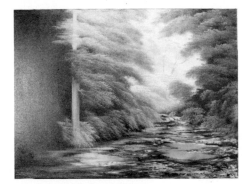

17. . . . to paint the tree trunk.

18. The large trunk is made with the knife.

19. Add foliage with the 2" brush . . .

20. . . . limbs and branches with the liner brush . . .

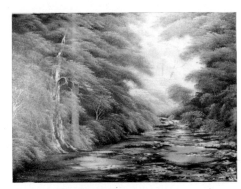

21. . . . to complete the painting.

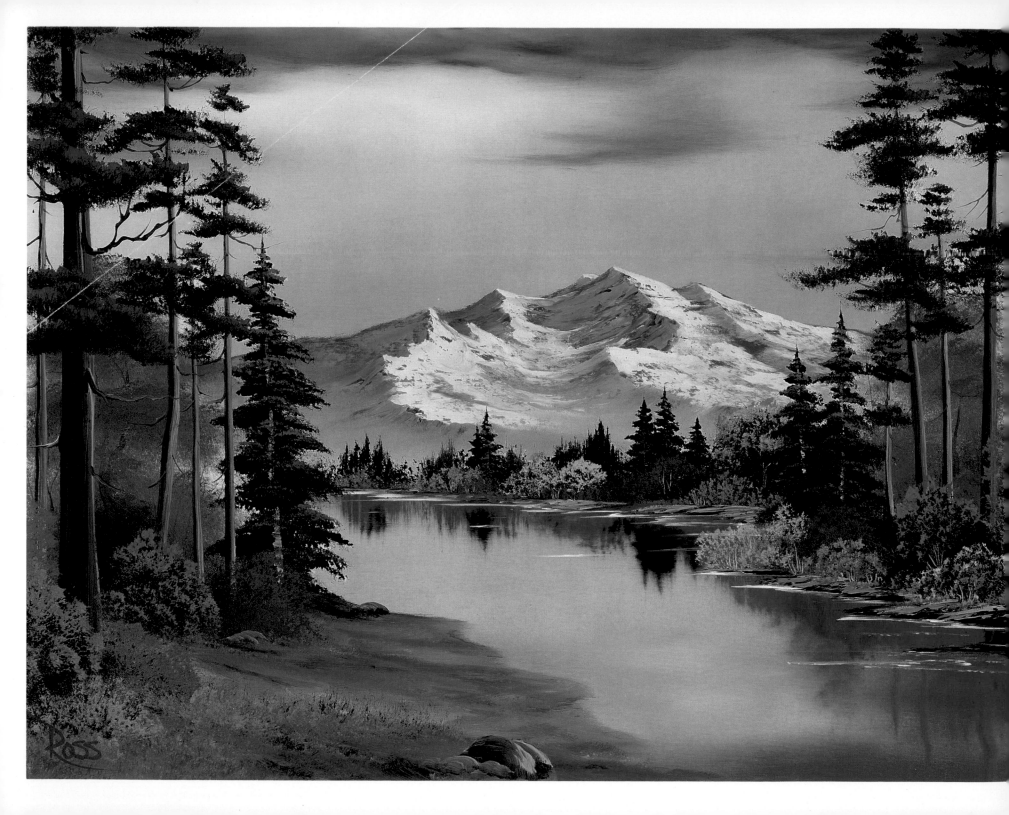

27. AUTUMN FANTASY

MATERIALS

2" Brush	Dark Sienna
1" Brush	Van Dyke Brown
#6 Fan Brush	Alizarin Crimson
#2 Script Liner Brush	Sap Green
Large Knife	Cadmium Yellow
Liquid White	Yellow Ochre
Titanium White	Indian Yellow
Phthalo Blue	Bright Red
Midnight Black	

Start by using the 2" brush to cover the entire canvas with a thin, even coat of Liquid White. Do NOT allow the Liquid White to dry before you begin.

SKY AND WATER

Load the 2" brush with a small amount of Bright Red. Create the Pink glow in the sky by making criss-cross strokes just above the horizon. *(Photo 1.)* Reflect the color into the water with horizontal strokes on the lower portion of the canvas. *(Photo 2.)* Use a mixture of Van Dyke Brown and Dark Sienna on the 2" brush and horizontal, rocking strokes to add the cloud shapes at the top of the canvas. *(Photo 3.)* The bright area in the sky is made with Titanium White on the 2" brush—again, use horizontal, rocking strokes. Blend the entire canvas. *(Photo 4.)*

MOUNTAIN

The mountain is painted with the knife and a mixture of Alizarin Crimson and Sap Green. With firm pressure, shape just the top edge of the mountain. *(Photo 5.)* When you are satisfied with the basic shape of the mountain top, use the knife to remove any excess paint. Then, with the 2" brush, blend the paint down to the base of the mountain to mist. *(Photo 6.)* The mountain should be much more distinct at the top than at the bottom.

Highlight the mountain with Titanium White to which you have added a very small amount of Bright Red. Starting at the top (and paying close attention to angles) glide the knife down the right side of each peak, using so little pressure that the paint "breaks". *(Photo 7.)* Use a mixture of Titanium White with a small amount of Phthalo Blue, Midnight Black and Alizarin Crimson, applied in the opposing direction, for the shadowed sides of the peaks.

Diffuse the base of the mountain by tapping with a clean, dry 2" brush (carefully following the angles) *(Photo 8)* then use upward strokes to create the illusion of mist *(Photo 9)*.

BACKGROUND

The small evergreens at the base of the mountain are made with the fan brush and the Alizarin Crimson-Sap Green mixture. Holding the brush vertically, touch the canvas to create the center line of each tiny tree, then use the corner of the brush to add small branches. *(Photo 10.)*

By holding the brush vertically and just tapping downward, you can create the indication of small, indistinct trees. *(Photo 11.)* Reverse the brush to reflect the color into the water.

To underpaint the small trees and bushes at the base of the evergreens, use the 1" brush and the same Alizarin Crimson-Sap Green mixture. *(Photo 12.)*

Again, extend this color into the water. Pull the reflected color straight down with a 2" brush held flat against the canvas *(Photo 13)* and lightly brush across to give the reflections a watery appearance.

To highlight the trees and bushes, dip the 1" brush into Liquid White, then pull the brush several times in one direction through various mixtures of all of the Yellows and Sap Green (to round one corner of the brush). With the rounded corner of the brush up, lightly touch the canvas, forcing the bristles to bend upward, to highlight and shape the individual trees and bushes. *(Photo 14.)* Reflect some of these highlight colors into the water and again very lightly pull down and brush across with the 2" brush.

Use a very small roll of Van Dyke Brown on the long edge of the knife to add the land at the base of the small trees, then

highlight with a mixture of Titanium White and Dark Sienna on the knife, using so little pressure that the paint "breaks". *(Photo 15.)* Add small, grassy patches to the land area with the Yellow-Red highlight mixtures on the fan brush, then use a small roll of Liquid White on the knife *(Photo 16)* to cut in the water lines and ripples *(Photo 17)*.

FOREGROUND

Load the 2″ brush with the Alizarin Crimson-Sap Green mixture and tap downward with one corner of the brush to indicate the large leafy tree-shapes in the foreground. *(Photo 18.)* Extend this dark, undercolor to the lower edge of the canvas on the left side. *(Photo 19.)*

The large evergreens are made by loading the fan brush to a chiseled edge with a mixture of Sap Green, Midnight Black, Phthalo Blue and Alizarin Crimson. Holding the brush vertically, touch the canvas to create the center line of each tree. Use just the corner of the brush to begin adding the small top branches. Working from side to side, as you move down each tree, apply more pressure to the brush, forcing the bristles to bend downward, and automatically the branches will become larger as you near the base of each tree. *(Photo 20.)*

Use a mixture of Titanium White and Dark Sienna on the knife *(Photo 21)* to add trunks to the evergreens.

Use the 1″ brush and the Alizarin Crimson-Sap Green mixture to underpaint the small bushes at the base of the large evergreens. Again, extend this dark color into the water. Highlight the bushes with the Yellow highlight mixtures on the 1″ brush.

LARGE TREES

Double-load the fan brush by filling it with the Alizarin Crimson-Sap Green mixture. Then, pull ONE side of the bristles through a very thin mixture of Liquid White, Dark Sienna and Bright Red. Holding the brush vertically, with the light side of the bristles to the right, pull down to paint the large tree trunks. *(Photo 22.)* With just one stroke, you can paint each trunk and its highlight. Extend the trunks right into the water *(Photo 23)* then pull down with the 2″ brush and lightly brush across the reflections *(Photo 24)*.

Add foliage to the large trees with the Alizarin Crimson-Sap Green mixture on the fan brush, forcing the bristles to bend UPWARD. Highlight the foliage with the Yellow highlight mixtures on the fan brush.

The banks along the right side of the water's edge are added with Van Dyke Brown on the knife, highlighted with a mixture of Titanium White and Van Dyke Brown. *(Photo 25.)*

Use various mixtures of all of the Yellows and Bright Red to highlight the small trees and bushes at the base of the large tree trunks. *(Photo 26.)* Cut in the foreground water lines and ripples with a small roll of Liquid White on the knife.

FINISHING TOUCHES

With Van Dyke Brown on the fan brush, you can scrub in the land area along the water's edge on the left side to complete the painting. *(Photo 27.)*

Autumn Fantasy

1. Use criss-cross strokes to paint the sky . . .

2. . . . horizontal strokes to paint the water . . .

3. . . . and horizontal rocking strokes . . .

4. . . . to paint the clouds.

5. Add the mountain top with the knife . . .

6. . . . then use the 2″ brush to blend the paint down to the base.

7. Highlight the mountain with the knife . . .

Autumn Fantasy

8. . . . then tap the base with the 2" brush . . .

9. . . . to diffuse and mist.

10. To paint tiny evergreens, use the corner of the fan brush . . .

11. . . . or just tap downward.

12. Use the 1" brush to paint leaf trees.

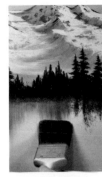

13. Pull straight down to reflect the trees . . .

14. . . . then highlight with the 1" brush.

15. Use the knife to add banks . . .

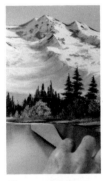

16. . . . and water lines . . .

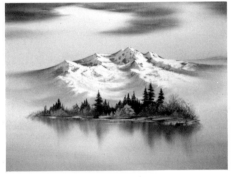

17. . . . to complete the background.

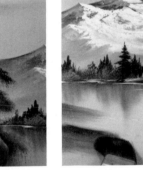

18. Under-paint large trees with the 2" brush . . .

19. . . . then extend the dark color to the bottom of the canvas.

20. Paint the larger evergreens with the fan brush . . .

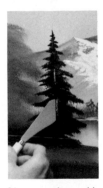

21. . . . then add trunks with the knife.

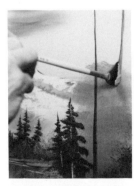

22. Pull down tree trunks with the fan brush.

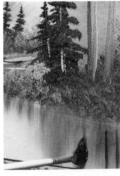

23. Reflect the trunks into the water . . .

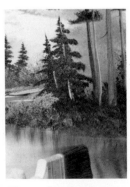

24. . . . then brush across with the 2" brush.

25. Add banks with the knife . . .

26. . . . and highlights with the 1" brush.

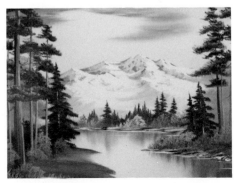

27. Your masterpiece is ready for you to sign!

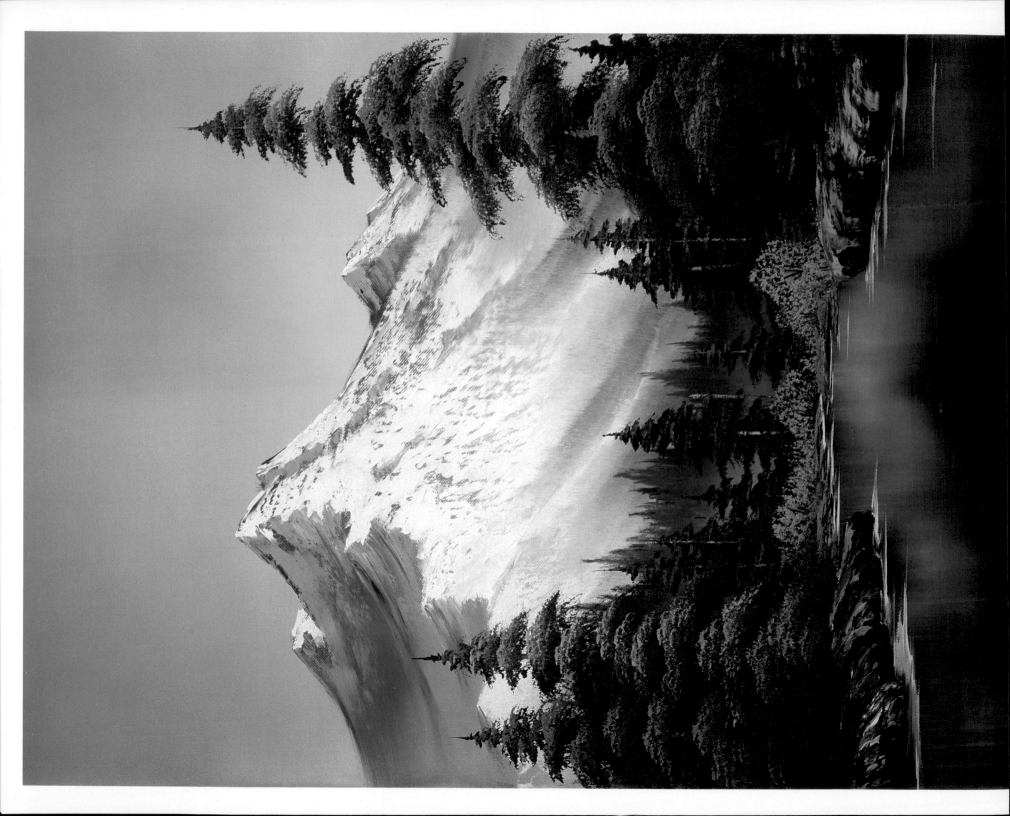

MATERIALS

2″ Brush	Prussian Blue
1″ Brush	Midnight Black
1″ Oval Brush	Dark Sienna
#6 Fan Brush	Van Dyke Brown
Large Knife	Alizarin Crimson
Black Gesso	Sap Green
Liquid Clear	Cadmium Yellow
Liquid White	Yellow Ochre
Titanium White	Indian Yellow
Phthalo Blue	Bright Red

Use a foam applicator with Black Gesso to block in the basic dark shapes on the lower portion of the canvas. Allow the Black Gesso to DRY COMPLETELY before you begin. *(Photo 1.)*

When the Black Gesso is dry, use the 2″ brush to cover the White, unpainted area of the canvas with a thin, even coat of Liquid White. With a clean, dry 2″ brush, cover the Black Gesso area with a thin, even coat of a mixture of Sap Green and Van Dyke Brown. Do NOT allow these colors to dry before you begin.

SKY

Load a clean, dry 2″ brush with a very small amount of Phthalo Blue. Starting at the top of the canvas, use criss-cross strokes to paint the sky. *(Photo 2.)* Use a clean, very dry 2″ brush to blend the entire sky. *(Photo 3.)*

MOUNTAIN

The mountain is made using the knife and a mixture of Midnight Black, Prussian Blue, Alizarin Crimson and Van Dyke Brown. Pull the mixture out very flat on your palette, hold the knife straight up and "cut" across the mixture to load the long edge of the blade with a small roll of paint. (Holding the knife *straight up* will force the small roll of paint to the very edge of the blade.) With firm pressure, shape just the top edge of the mountain. *(Photo 4.)*

When you are satisfied with the basic shape of the mountain top, use the knife to remove any excess paint. Then, with the 2″ brush, pull the paint down to the base of the mountain, to blend *(Photo 5)* and complete the entire mountain shape.

Highlight the mountain with various mixtures of Titanium White, Dark Sienna and a very small amount of Bright Red. Again, load the long edge of the blade with a small roll of paint. Starting at the top (and paying close attention to angles) glide the knife down the right side of each peak, using so little pressure that the paint "breaks". *(Photo 6.)*

Use the mountain-mixture, Titanium White and a very small amount of Phthalo Blue, applied in the opposing direction, for the shadow sides of the peaks. Again, use so little pressure that the paint "breaks".

With a clean, dry 2″ brush, tap to diffuse the base of the mountain (carefully following the angles) *(Photo 7)* and then gently lift upward to create the illusion of mist *(Photo 8)*.

Use various mixtures of all of the Yellows, Sap Green and a small amount of the mountain color on the same 2″ brush to add the Green area, or tree line at the base of the mountain. Carefully following the angles, just tap downward with the brush. *(Photo 9.)*

Use a clean, dry 1″ brush and very short upward strokes *(Photo 10)* to indicate tiny tree tops *(Photo 11)*, still carefully following the angles of the mountain.

BACKGROUND

Load the fan brush with a mixture of Prussian Blue, Van Dyke Brown, Midnight Black and Sap Green. Holding the brush vertically, just tap downward to indicate the small trees at the base of the mountain. *(Photo 12.)*

Use a clean, dry 2″ brush to firmly tap the base of the small evergreens *(Photo 13)* then, lift upward *(Photo 14)* to create the illusion of mist *(Photo 15)*.

Use just the corner of the brush to touch tiny branches to the more distinct trees. *(Photo 16.)*

Add the trunks with a small roll of a mixture of Titanium White, Dark Sienna and a very small amount of Phthalo Blue on the knife. (Photo 17.) Use the fan brush to very lightly touch highlights to the branches with a mixture of the dark tree color and the Yellows. (Photo 18.)

LARGE EVERGREENS

Moving forward in the painting, use the oval brush to add the large evergreens. Load the brush to a chiseled edge by pulling both sides of the bristles through the same dark tree mixture. Holding the brush vertically, touch the canvas to create the center line of each tree. Turn the brush horizontally and just touch the end of the bristles to the canvas to begin adding the small top branches. Working from side to side, as you move down each tree, apply more pressure to the brush, forcing the bristles to bend downward (Photo 19) and automatically the branches will become larger as you near the base of each tree.

Add the trunks with a small roll of the Titanium White-Dark Sienna-Phthalo Blue mixture on the knife. (Photo 20.)

Still using the oval brush, highlight the evergreens by just brush-mixing the dark-tree color with all of the Yellows. Hold the brush horizontally and lightly touch highlights to the branches with just the top bristles of the brush. (Photo 21.)

The brightest highlights are added by first dipping the brush into Liquid Clear, to thin a lighter Yellow-highlight mixture. (Use less of the dark tree-color in this mixture.)

Don't overdo here, apply these thinner, brighter highlights very sparingly. (Photo 22.)

FOREGROUND WATER

With Titanium White on the 2" brush, pull straight down to add the water on the lower portion of the canvas. Notice how the White mixes with the wet Sap Green-Van Dyke Brown mixture already on the canvas, adding instant reflections. (Photo 23.) Lightly brush across to give the reflections a watery appearance.

To highlight the small trees and bushes at the base of the evergreens, first dip the 1" brush into Liquid White. Then, with the handle straight up, pull the brush (several times in one direction, to round one corner of the bristles) through the various Yellow-highlight mixtures.

With the rounded corner of the brush up, force the bristles to bend upward to highlight individual small trees and bushes. (Photo 24.)

Use a mixture of Van Dyke Brown and Dark Sienna on the knife to add the banks to the water's edge. Add Titanium White to the mixture to highlight (Photo 25), again using so little pressure that the paint "breaks" (Photo 26).

FINISHING TOUCHES

Use a small roll of Liquid White on the edge of the knife to cut in water lines and ripples (Photo 27) and your painting is complete (Photo 28).

Valley View

1. Use Black Gesso to pre-paint the canvas.

2. With criss-cross strokes . . .

3. . . . paint the sky.

4. Shape the mountain top with the knife . . .

5. . . . then pull down to blend with the 2" brush.

6. Highlight the mountain . . .

7. . . . then firmly tap with the 2" brush . . .

Valley View

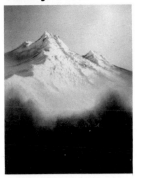
8. . . . to create the illusion of mist.

9. Tap in the Green base of the mountain . . .

10. . . . then use short upward strokes with the 1" brush . . .

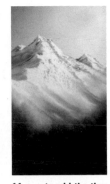
11. . . . to add the tiny tree tops.

12. Tap down evergreens with the fan brush . . .

13. . . . then firmly tap . . .

14. . . . and lift upward . . .

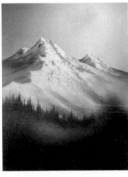
15. . . . with the 2" brush to create mist.

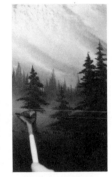
16. Add more distinct trees . . .

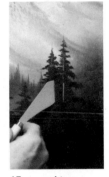
17. . . . and tree trunks . . .

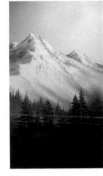
18. . . . to the background.

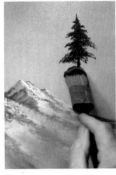
19. Large evergreens are painted with the oval brush . . .

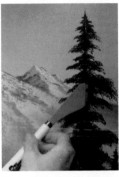
20. . . . then trunks are added with the knife.

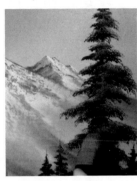
21. Again, use the oval brush . . .

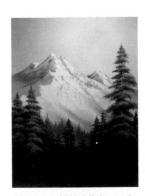
22. . . . to add highlights to the large evergreens.

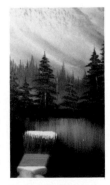
23. Pull down the water with the 2" brush.

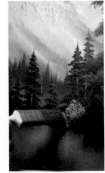
24. Add bushes and small trees with the 1" brush.

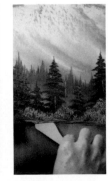
25. The banks along the water's edge . . .

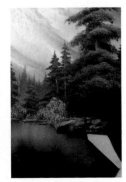
26. . . . are painted with the knife.

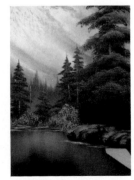
27. The knife is also used to add water lines . . .

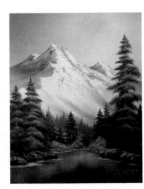
28. . . . to your finished painting.

29. FLORIDA'S GLORY

MATERIALS

2" Brush	Titanium White
#6 Fan Brush	Phthalo Blue
#3 Fan Brush	Prussian Blue
Script Liner Brush	Midnight Black
Large Knife	Dark Sienna
Small Knife	Van Dyke Brown
Adhesive-Backed Plastic	Alizarin Crimson
Acrylic Spray Paint	Sap Green
Liquid White	Cadmium Yellow
Liquid Clear	Yellow Ochre

Prepaint the entire canvas with a thin coat of light Blue (or color of your choice) acrylic spray paint, and allow to DRY COMPLETELY.

When the acrylic paint is dry, cover the canvas with adhesive-backed plastic, such as Con-tact Paper, from which a center design (in this case the state of Florida) has been removed. (Photo 1.)

Use the 2" brush to cover the upper portion of the exposed canvas (above the horizon) with a thin, even coat of Liquid White. Below the horizon, apply a VERY THIN coat of Liquid Clear.

With a small amount of Phthalo Blue on the 2" brush, use horizontal strokes to underpaint just the large wave. (Photo 2.) Establish the horizon, above the wave, with the Alizarin Crimson-Phthalo Blue (Lavender) mixture and then apply a small amount of the Lavender just below the wave. Do NOT allow these colors to dry before you begin.

SKY

Load the 2" brush with a very small amount of Yellow Ochre, and begin painting the lower portion of the sky with criss-cross strokes, blending upward. Re-load the brush with a very small amount of Alizarin Crimson, and continue to the top of the sky with criss-cross strokes. (Photo 3.) Use the Alizarin Crimson-Phthalo Blue (Lavender) mixture just above the horizon. Blend the entire sky.

Use the Lavender mixture on the fan brush and small rocking strokes to shape clouds. The darker clouds are made by adding Phthalo Blue to the Lavender mixture. (Photo 4.) Use long sweeping strokes with a clean, dry 2" brush (Photo 5) to carefully blend the clouds (Photo 6).

WAVE

Sketch the basic shape of the wave with Titanium White on the small fan brush. (Photo 7.)

Define the top edge of the wave with thinned Titanium White on the liner brush. (To load the liner brush, thin the Titanium White to an ink-like consistency by first dipping the liner brush into paint thinner. Slowly turn the brush as you pull the bristles through the paint, forcing them to a sharp point.) With very little pressure on the brush, use a long, horizontal stroke to shape the top edge of the wave, rolling and wiggling the brush to give the wave a foam appearance. Use the fan brush to blend out the bottom of this line of foam, creating a light area in the wave.

Re-load the small fan brush with a very small amount of Titanium White to pull the water over the top of the breaker. Pay close attention to the angle of the water. (Photo 8.)

Again, use thinned Titanium White on the liner brush to define the foamy edge of the wave (Photo 9) and to add the tiny background swells and waves (Photo 10). Be very careful not to completely cover all of the dark color already on the canvas.

FOREGROUND

Use Dark Sienna with a very small amount of Van Dyke Brown on the 2" brush and long, horizontal strokes (Photo 11) to underpaint the sandy beach.

Use the small knife and a mixture of Titanium White that has been tinted with a very small amount of Phthalo Blue to add the water on the beach. Pull the mixture out flat on your palette and just cut across to load the long edge of the knife with a small roll of paint. Hold the knife flat against the canvas and with firm pressure, scrub in the foaming water action on the beach. (Photo 12.)

Use horizontal strokes with a clean fan brush to blend back the top edges of the foam. *(Photo 13.)* To keep the water flat on the beach, be sure these strokes are parallel to the top and bottom edges of the canvas.

With a thinned mixture of Titanium White and Phthalo Blue on the liner brush, add tiny foam details to the large wave and the foreground water.

Continue using the knife to add the water on the beach *(Photo 14)* and again blend back with the fan brush. Touch the base of this water line with the fan brush and pull straight down for reflected light on the beach. Lightly brush across to create the glistening wet-sand appearance. *(Photo 15.)* With thinned Lavender on the liner brush, add a very thin line of shadow under the water on the beach.

Shape the foreground sand dunes with a mixture of Titanium White and Dark Sienna on the large fan brush. Use a mixture of Sap Green, Prussian Blue and Midnight Black (dark Green) on the small fan brush and push-up strokes to add grass to the top of the dunes. *(Photo 16.)* Blend the base of the grass downward with the fan brush to shadow and contour the dunes.

Use thinned Green mixture on the liner brush to add the tall grasses and sea oats *(Photo 17)* then highlight with various mixtures of thinned Yellows.

Load the liner brush with thinned Midnight Black, then pull one side of the brush through Titanium White to paint and highlight the tiny "M" birds. *(Photo 18.)*

Carefully remove the Con-Tact Paper to expose the painted design *(Photo 19)*.

PALM TREES

With a mixture of Van Dyke Brown and Dark Sienna on the fan brush, hold the brush vertically and just pull down to paint the palm tree trunks. *(Photo 20.)*

Because this portion of the canvas is dry, use a very thin mixture of paint thinner and Midnight Black on the fan brush to tap in the curving palm tree branches *(Photo 21)* then pull out the feathery leaves *(Photo 22)*. You can highlight these leaves with a very small amount of Titanium White.

Use a mixture of Titanium White and Midnight Black on the knife to lightly highlight the trunks. *(Photo 23.)*

Add the land at the base of the palm trees with Dark Sienna on the knife and highlight with a mixture of Titanium White and Dark Sienna. *(Photo 24.)* Punch in short grasses with the Green mixture on the fan brush. *(Photo 25.)*

FINISHING TOUCHES

Use thinned mixtures on the liner brush to lift up long grasses *(Photo 26)* and your painting is complete *(Photo 27)*.

Try this painting by prepainting the canvas with a color of your choice, using your state as the cut-out design!

Florida's Glory

1. Cover the canvas with Con-Tact Paper from which a design has been removed.

2. Underpaint the large wave.

3. Use criss-cross strokes to paint the sky.

4. Paint clouds with rocking strokes . . .

5. . . . then use the 2" brush . . .

6. . . . to blend the entire sky.

Florida's Glory

7. Sketch the large wave . . .

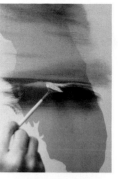

8. . . . then add the breaker with the fan brush.

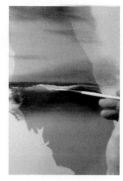

9. Use the liner brush to add the foamy edges . . .

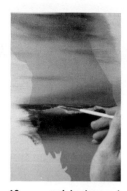

10. . . . and background water.

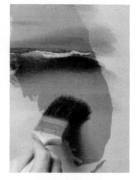

11. Paint the beach with the 2" brush.

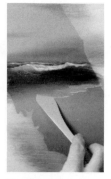

12. Add water to the beach with the knife . . .

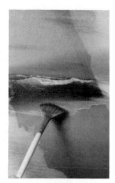

13. . . . then blend back with the fan brush.

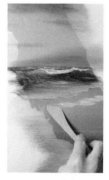

14. Continue adding water . . .

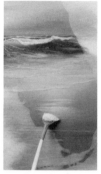

15. . . . and reflections to the beach.

16. Push up short grasses with the fan brush . . .

17. . . . and pull up long grasses with the liner brush.

18. Add tiny birds with the liner brush.

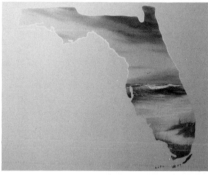

19. Remove the Con-Tact Paper from the canvas.

20. Pull down palm tree trunks . . .

21. . . . then tap in the branches . . .

22. . . . and add feathery leaves.

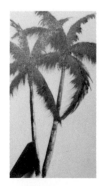

23. Use the knife to highlight the trunks . . .

24. . . . and to add the land area.

25. Push up short grasses with the fan brush . . .

26. . . . and pull up long grasses with the liner brush . . .

27. . . . to complete the painting.

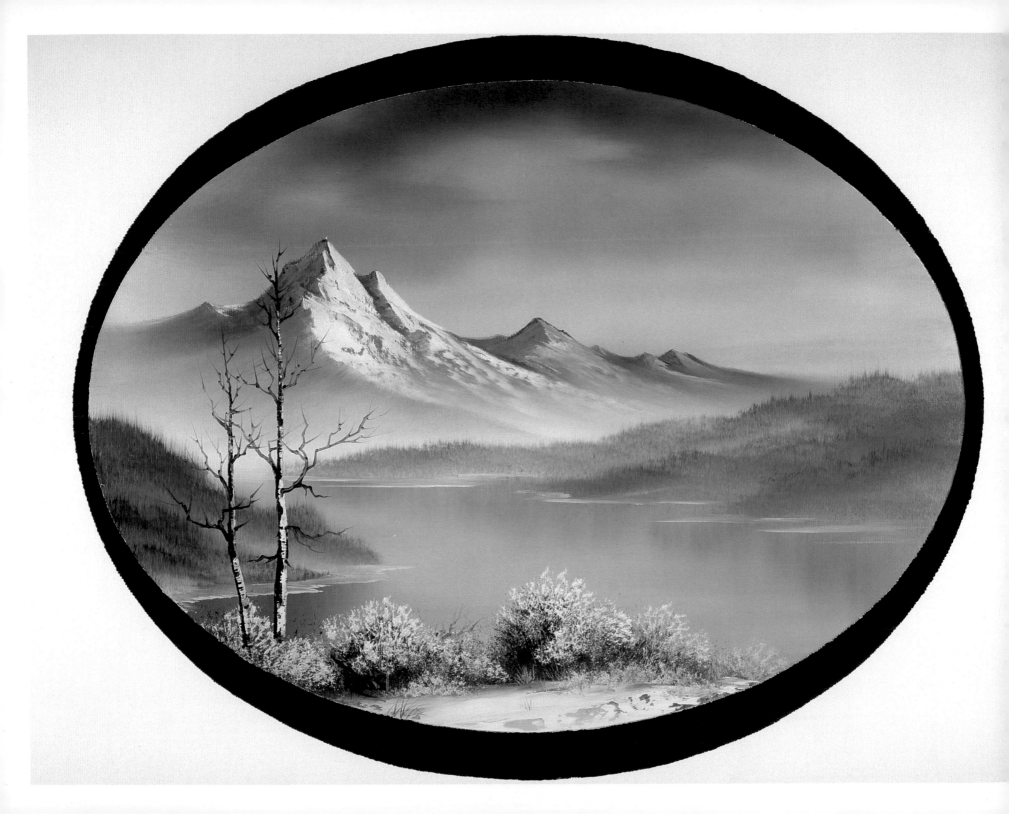

MATERIALS

2" Brush
1" Brush
#6 Fan Brush
#2 Script Liner Brush
Large Knife
Adhesive-Backed Plastic
Black Gesso
Liquid White

Titanium White
Phthalo Blue
Prussian Blue
Midnight Black
Dark Sienna
Van Dyke Brown
Alizarin Crimson

Prepare the canvas by first painting the Black border with a foam applicator and Black Gesso. (You can protect the edges by covering the canvas with adhesive-backed plastic, such as Con-Tact Paper, from which you have removed a border-shaped oval.) Allow the Black Gesso to DRY COMPLETELY, then remove the Con-Tact Paper.

Cover the entire canvas, including the Black border, with Con-Tact Paper from which you have removed a center oval. (A 16 x 20 oval for an 18 x 24 canvas.)

Use the 2" brush to cover the entire exposed area of the canvas with a thin, even coat of Liquid White. Do NOT allow the Liquid White to dry before you begin.

SKY

Load the 2" brush with a very small amount of Alizarin Crimson and use criss-cross strokes to create a Pink glow in the center of the sky. (Photo 1.) You can reflect this color into the water with horizontal strokes.

Reload the brush with a mixture of Alizarin Crimson and Phthalo Blue and use circular strokes (Photo 2) to paint the clouds (Photo 3). Add Midnight Black to the mixture and continue with circular strokes to paint the dark clouds at the top of the sky. (Photo 4.) While this color is still in the brush, use long horizontal strokes to underpaint the water on the lower portion of the canvas. Blend the entire sky with a clean, dry 2" brush. (Photo 5.)

MOUNTAIN

Paint the mountain with the knife and a mixture of Midnight Black, Alizarin Crimson, Prussian Blue and Van Dyke Brown. Pull the mixture out very flat on your palette, hold the knife straight up and "cut" across the mixture to load the long edge of the blade with a small roll of paint. (Holding the knife straight up will force the small roll of paint to the very edge of the blade.)

With firm pressure, shape just the top edge of the mountain. (Photo 6.) When you are satisfied with the basic shape of the mountain top, use the knife to remove any excess paint. Then, with the 2" brush, blend the paint down to the base of the mountain, creating the illusion of mist. (Photo 7.) The mountain should be much more distinct at the top than at the bottom.

Highlight the mountain with Titanium White. Again, load the long edge of the knife blade with a small roll of paint. Starting at the top (and paying close attention to angles) glide the knife down the right side of each peak, using so little pressure that the paint "breaks". (Photo 8.) Use a mixture of Titanium White with a small amount of Phthalo Blue and Midnight Black, applied in the opposing direction, for the shadowed sides of the peaks. Again, use so little pressure that the paint "breaks".

Diffuse the base of the mountain by tapping with a clean, dry 2" brush, carefully following the angles then gently lift upward to create the illusion of mist. (Photo 9.)

FOOTHILLS

Load the 2" brush with a mixture of the mountain color, Titanium White, and Phthalo Blue. Shape the foothills at the base of the mountain by tapping downward with one corner of the brush. (Photo 10.) Tap the base of the hills to diffuse, creating the illusion of mist.

With the same foothill color, hold the 2" brush flat against the canvas and pull straight down to reflect the foothills into the water (Photo 11) then lightly brush across. Cut in the water lines with a small roll of a mixture of Titanium White and Alizarin Crimson on the knife. To load the knife with a

small roll of paint, pull the mixture out very flat on your palette and just cut across. *(Photo 12.)*

Working forward in layers, use a darker foothill mixture (less Titanium White) to paint the closer hills. *(Photo 13.)* Again, reflect the hills into the water and cut in water lines and ripples *(Photo 14)* to complete the background *(Photo 15)*.

FOREGROUND

Use Titanium White on the 2″ brush and long horizontal strokes to paint the foreground snow. *(Photo 16.)*

Underpaint the small bushes in the foreground with the 1″ brush and a mixture of the dark foothill color, Prussian Blue and Alizarin Crimson.

To add the snowy highlights to the bushes, dip the 1″ brush into Liquid White (to thin the paint). Then, with the handle straight up, pull the brush (several times in one direction, to round one corner of the bristles) through a mixture of Titanium White with a small amount of Alizarin Crimson. With the rounded corner of the brush up, force the bristles to bend upward to create the lacy highlights. Try not to just "hit" at random, carefully shape each individual bush. *(Photo 17.)* If you are careful to not completely destroy all of the dark under-color, you can use it to separate the individual bush shapes.

Use Titanium White on the knife to add the snow to the base of the foreground bushes. Drag the paint, allowing it to

"break". *(Photo 18.)*

TREES

Use a mixture of Van Dyke Brown and Dark Sienna on the knife to paint the tree trunks. *(Photo 19.)* Highlight the trunks with a small roll of Titanium White on the knife.

Use the liner brush with Van Dyke Brown and Dark Sienna to add the limbs and branches. (To load the liner brush, thin the mixture to an ink-like consistency by first dipping the liner brush into paint thinner. Slowly turn the brush as you pull the bristles through the mixture, forcing them to a sharp point.) Apply very little pressure to the brush, as you shape the limbs and branches. By turning and wiggling the brush, you can give the trees a gnarled appearance *(Photos 20 & 21.)*

FINISHING TOUCHES

When you are satisfied with your painting, carefully remove the Con-Tact Paper *(Photo 22)* to expose your finished painting with its own Black border *(Photo 23)*!

Don't forget to sign your name with pride: Again, load the liner brush with thinned color of your choice. Sign just your initials, first name, last name or all of your names. Sign in the left corner, the right corner or one artist signs right in the middle of the canvas! The choice is yours. You might also consider including the date when you sign your painting. Whatever your choices, have fun, for hopefully with this painting you have truly experienced THE JOY OF PAINTING!

Winter Bliss

1. Use criss-cross strokes to paint the sky.

2. Make circular strokes with the 2″ brush . . .

3. . . to begin adding the clouds.

4. Add darker clouds . . .

5. . . . at the top of the sky.

Winter Bliss

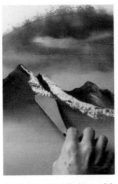
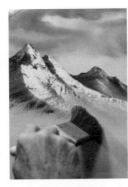
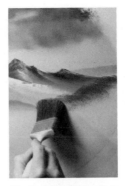
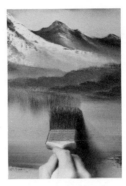

6. Shape the mountain top with the knife . . .

7. . . . then blend the paint down to the base with the 2" brush.

8. Apply highlights with the knife . . .

9. . . . then tap the base of the mountain to mist.

10. Use the 2" brush to paint the foothills . . .

11. . . . and to reflect them into the water.

12. Add water lines and ripples with the knife.

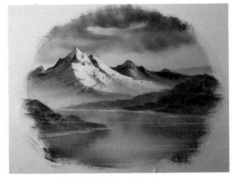
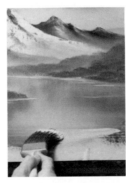
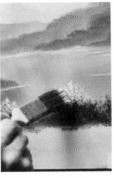
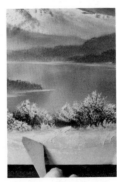

13. Working forward in layers add closer foothills . . .

14. . . . reflections and water lines and ripples . . .

15. . . . to complete the background.

16. Use the 2" brush to under-paint the foreground snow.

17. Add lacy highlights to bushes with the 1" brush.

18. Use the knife to add textured snow in the foreground.

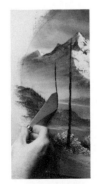

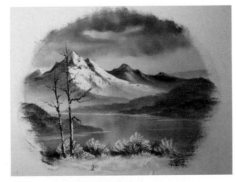

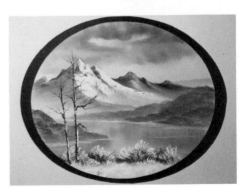

19. Paint and highlight trunks with the knife.

20. Add limbs and branches with the liner brush . . .

21. . . . to complete the painting.

22. Remove the Con-Tact Paper . . .

23. . . . to expose your bordered painting.

133

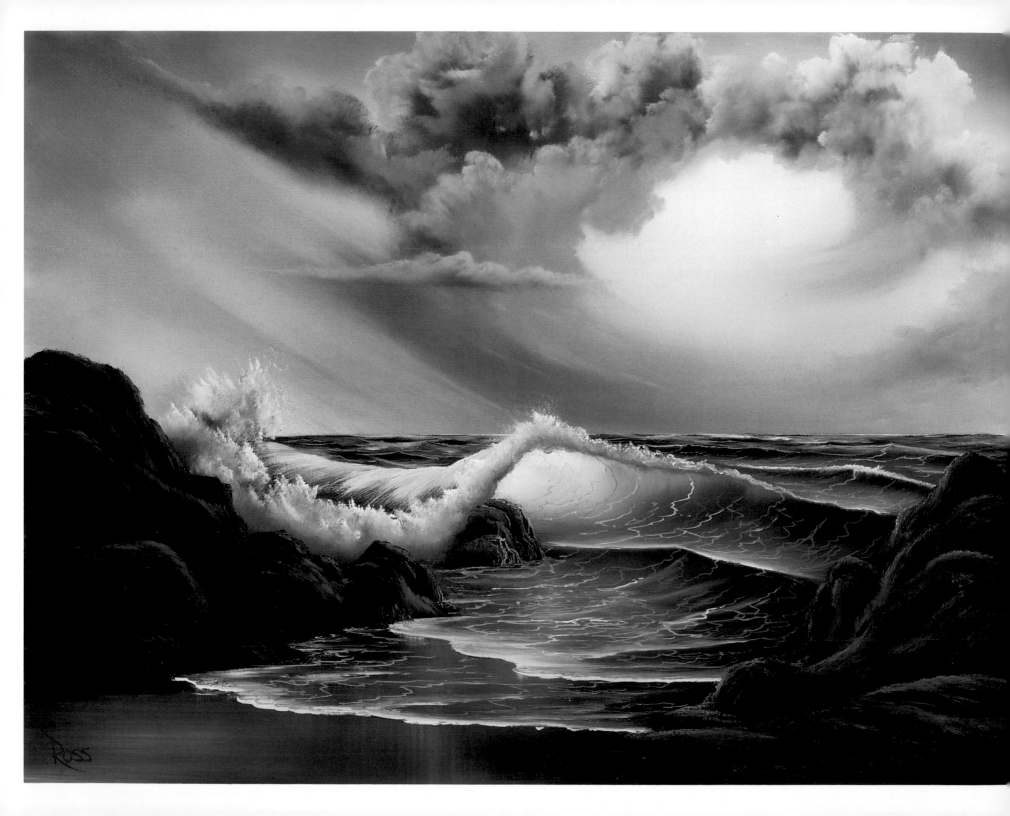

MATERIALS

2" Brush	Phthalo Blue
#6 Fan Brush	Midnight Black
#3 Fan Brush	Dark Sienna
#2 Script Liner Brush	Van Dyke Brown
Small Knife	Alizarin Crimson
Black Gesso	Cadmium Yellow
Liquid White	Yellow Ochre
Titanium White	Bright Red

Before starting your painting, mark the horizon with a strip of masking tape, just below the center of the canvas. Use a foam applicator to cover the lower portion of the canvas with a thin, even coat of Black Gesso. Allow the lightest areas of the seascape to remain unpainted: the "eye" of the wave, the foam, etc. Allow the Black Gesso to dry completely. *(Photo 1.)*

Reposition the masking tape across the top edge of the dry Black Gesso.

Use the 2" brush to cover the Black Gesso area with Alizarin Crimson in the center, a mixture of Alizarin Crimson and Phthalo Blue on each side and a mixture of Van Dyke Brown and Dark Sienna across the bottom of the canvas.

Use a clean, dry 2" brush to cover the top portion of the canvas with a thin, even coat of Liquid White. With long horizontal and vertical strokes, work back and forth to ensure an even distribution of paint on the canvas. Do NOT allow these paints to dry before you begin.

SKY

Load the 2" brush with Cadmium Yellow, tapping the bristles firmly against the palette to evenly distribute the paint throughout the bristles. Start by making criss-cross strokes in the center of the sky. Without cleaning the brush, add Yellow Ochre below the Cadmium Yellow and then Bright Red below the Yellow Ochre, just above the horizon.

Lighten the very center of the sky by making criss-cross strokes with Titanium White on a clean, dry 2" brush. Use a mixture of Phthalo Blue and Midnight Black across the top and along the side of the sky area of the canvas, still using criss-cross strokes. Blend the entire sky with a clean, dry 2" brush.

Use a mixture of Alizarin Crimson and Phthalo Blue on the 1" brush and circular strokes to shape the clouds. *(Photo 2.)* Blend the base of the clouds with the top corner of a clean, dry 2" brush. *(Photo 3.)*

Still using circular strokes, use a mixture of Titanium White with a small amount of Bright Red on the 1" brush to highlight the clouds. *(Photo 4.)* Again, blend with the 2" brush.

When you are satisfied with your sky, remove the masking tape from the canvas *(Photo 5)* to expose a nice, straight, horizon line. Cover the area of the canvas, left dry by the masking tape, with a small amount of Alizarin Crimson.

BACKGROUND WATER

With the Titanium White on the fan brush, use small rocking strokes to begin adding the water just under the horizon.

Create the background swells with long, horizontal strokes, still using Titanium White and the fan brush. With a clean fan brush, use short, rocking strokes to pull the top edge of the swells back to blend. Be very careful not to destroy the dark color that separates the individual swells (or background waves).

LARGE WAVE

The "eye" of the wave is made with a mixture of Titanium White and Cadmium Yellow. Use the corner of the fan brush to scrub in the color and then blend with circular strokes using the top corner of a clean, dry 2" brush *(Photo 6)*. Pay close attention to the shape of your wave. *(Photo 7.)*

Use a mixture of Titanium White with a very small amount of Cadmium Yellow on the fan brush to pull the water over the top of the crashing wave. *(Photo 8.)* Be very careful of your angles here!

Use a mixture of Phthalo Blue, Alizarin Crimson and Titanium White on the #3 fan brush and small, circular strokes to scrub in the foam shadows along the edges of the large wave. Clean the fan brush with Titanium White, make small, circular push-up strokes to highlight the top edges of the foam, where the light would strike. *(Photo 9.)* Again, use circular strokes with the top corner of the 2" brush to lightly blend the foam highlights into the shadows. *(Photo 10.)*

FOREGROUND

In the lightest area of the foreground, make long, vertical strokes with Titanium White on the 1" brush. *(Photo 11.)* Pull down with the 2" brush and lightly brush across to create the reflected light in the foreground.

Add the swell in front of the large wave with a long, horizontal stroke of Titanium White, still using the fan brush. *(Photo 12.)* Again, use small rocking strokes to pull the top edge of the paint back to blend.

Load the long edge of the small knife with a very small roll of a mixture of Titanium White and Phthalo Blue, by pulling the paint out very flat on your palette and just cutting across. Hold the knife flat against the canvas and use firm pressure and long horizontal strokes to add the foamy water action on the beach. *(Photo 13.)* Use a clean fan brush to pull the

top edge of the paint back towards the large wave *(Photo 14)* creating swirling foam patterns *(Photo 15)*.

ROCKS

The rocks are shaped with the fan brush using various mixtures of Van Dyke Brown, Dark Sienna and Midnight Black. *(Photo 16.)*

Add the beach with long horizontal strokes, using a very small amount of Titanium White on the 2" brush. *(Photo 17.)* To make the beach look wet, pull straight down and lightly brush across.

Use mixtures of Titanium White, Alizarin Crimson and Phthalo Blue to shape, contour and highlight the rocks, still using the fan brush. *(Photo 18.)* Following the angles, use a clean, dry brush to very lightly blend the rock-highlights. *(Photo 19.)*

Again, use a mixture of Titanium White and Phthalo Blue on the small knife to add the water on the beach. *(Photo 20.)*

FINISHING TOUCHES

Use a very thin mixture of Titanium White, Alizarin Crimson and Phthalo Blue on the liner brush to add the tiny foam details to the water *(Photo 21)* and your painting is finished *(Photo 22)*. Sign and enjoy!

Stormy Seas

1. Underpaint the dark areas of the seascape with Black Gesso.

2. Paint the clouds with the 1" brush . . .

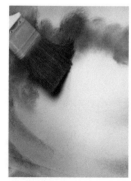

3. . . . then blend with the 2" brush.

4. Highlight the clouds with the 1" brush.

5. When the sky is complete, remove the masking tape.

Stormy Seas

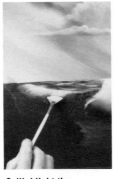

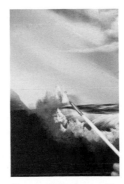

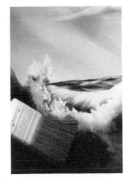

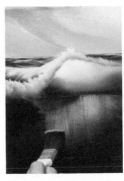

6. Use circular strokes with the 2" brush . . .

7. . . . to blend the "eye" of the wave.

8. Highlight the breaker . . .

9. . . . and the foam with the fan brush.

10. Then blend the foam with the 2" brush.

11. Pull straight down for reflections.

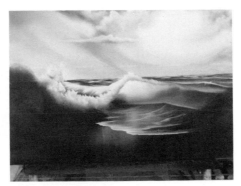

12. Add the swell in front of the wave with the fan brush.

13. Add the water on the beach with the knife . . .

14. . . . then use the fan brush to pull back . . .

15. . . . to blend the water.

16. Shape the rocks with the fan brush . . .

17. . . . then underpaint the beach with the 2" brush.

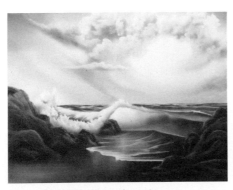

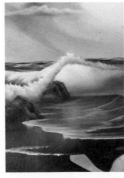

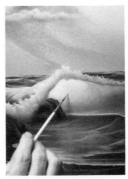

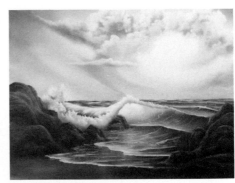

18. Use the fan brush to highlight . . .

19 . . . shape and contour the rocks.

20. Add foam to the beach with the knife . . .

21. . . . and foam details to the water with the liner brush . . .

22. . . . to complete the painting.

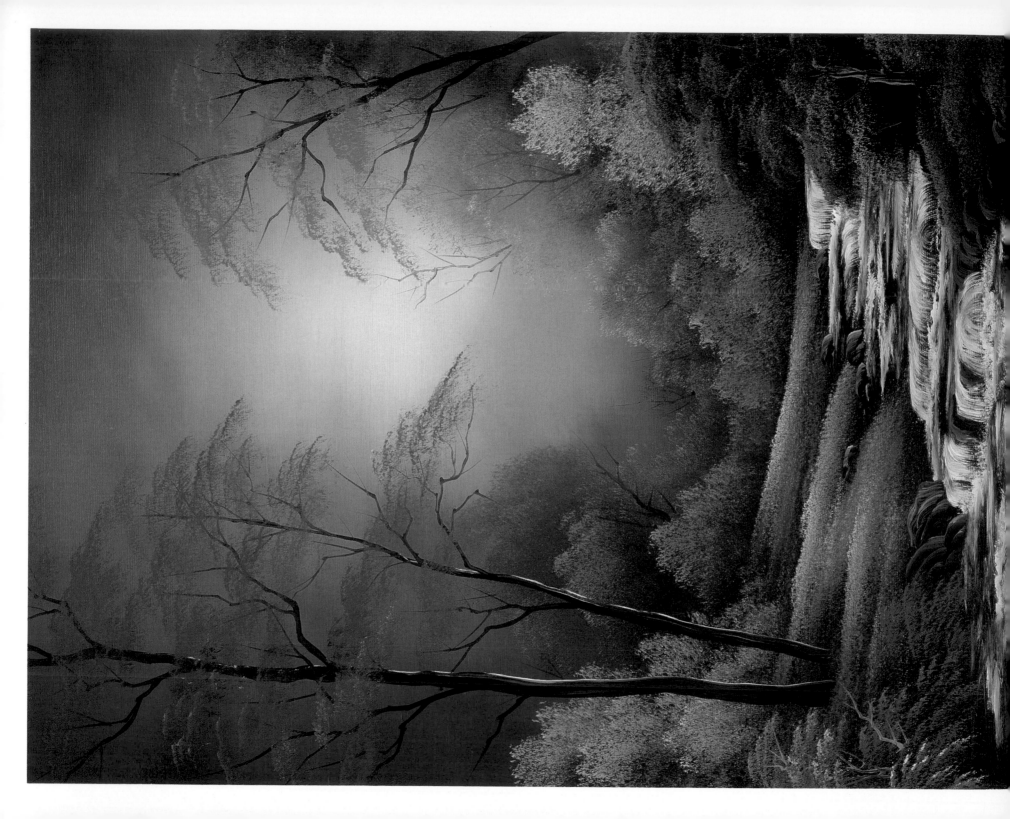

32. PURPLE HAZE

MATERIALS

2" Brush	Phthalo Blue
1" Round Brush	Midnight Black
#6 Filbert Brush	Dark Sienna
#6 Fan Brush	Van Dyke Brown
#2 Script Liner Brush	Alizarin Crimson
Large Knife	Sap Green
Black Gesso	Cadmium Yellow
Liquid White	Yellow Ochre
Liquid Clear	Indian Yellow
Titanium White	Bright Red

Start by using a foam applicator to apply a thin, even coat of Black Gesso to your canvas, "swirling" it around a center area that remains unpainted. Allow the Black Gesso to DRY COMPLETELY. (Photo 1.)

When the Black Gesso is dry, use the 2" brush to cover the entire canvas with a VERY THIN coat of Liquid Clear. (It is important to stress that the Liquid Clear should be applied VERY, VERY sparingly and really scrubbed into the canvas! The Liquid Clear will not only ease with the application of the firmer paint, but will allow you to apply very little color, creating a glazed effect.) Do NOT allow the Liquid Clear to dry.

Still using the 2" brush, cover the Liquid Clear with a very thin, even coat of a Lavender mixture made with Alizarin Crimson and Phthalo Blue. (The mixture should contain proportionately much more Crimson than Blue.) Do NOT allow the canvas to dry before you begin.

SKY

Load the 2" brush with Titanium White and begin painting the sky with criss-cross strokes in the lightest area of the canvas. (Photo 2.) As you work away from the center, notice how the White blends with the Lavender mixture already on the canvas. You can repeat this process, always starting with a clean brush, until you achieve the desired amount of lightness in the sky. Use a clean, dry 2" brush to blend the entire sky with long, horizontal strokes. (Photo 3.)

BACKGROUND

Use the knife to make a Lavender mixture on your palette by adding a small amount of Phthalo Blue to some Alizarin Crimson. (The mixture will look quite dark; you can test the color by adding a small amount of the mixture to some Titanium White. Adjust the color if necessary by adding more Phthalo Blue or Alizarin Crimson to the mixture.)

Load the round brush by tapping the bristles into the Lavender mixture. Tap downward with the top edge of the brush to add the indication of subtle background trees along the horizon. (Photo 4.)

Use various mixtures of all of the Yellows, Titanium White, Alizarin Crimson, Bright Red, Phthalo Blue and Sap Green on the round brush to highlight some of the background trees. Again, tap downward with the top edge of the brush to create individual tree and bush shapes. Pay close attention to shape and form, try not to just hit at random. (Photo 5.)

Add the background tree trunks with the Lavender mixture on the liner brush. (To load the liner brush, thin the Lavender mixture to an ink-like consistency by first dipping the liner brush into paint thinner. Slowly turn the brush as you pull the bristles through the mixture, forcing them to a sharp point.) Apply very little pressure to the brush as you shape the trunks. (Photo 6.) By turning and wiggling the brush, you can give your trunks a gnarled appearance. (Photo 7.)

Use various mixtures of the Lavender, all of the Yellows, Bright Red and Titanium White to add the soft grassy area at the base of the trees. Load the 2" brush by holding it at a 45-degree angle and tapping the bristles into the various paint mixtures. Allow the brush to "slide" slightly forward in the paint each time you tap (this assures that the very tips of the bristles are fully loaded with paint.) Hold the brush horizontally and gently tap downward. (Photo 8.) Work in layers, carefully creating the lay-of-the-land. If you are also careful not to destroy all of the dark color already on the canvas, you can create grassy highlights that look almost

like velvet. *(Photo 9.)*

STREAM

Load the fan brush with a mixture of Liquid White, Titanium White and a very small amount of Phthalo Blue to paint the stream. Starting in the distance and working forward, hold the brush horizontally, make a short horizontal stroke and then a downward stroke to paint the tiny waterfall. *(Photo 10.)* Make push-up strokes to add the foaming action at the base of the falls. *(Photo 11.)*

Continue "swirling" the water forward, adding small falls and foaming water action. *(Photo 12.)*

FOREGROUND

Use the Lavender mixture on the 2" brush to underpaint the foreground tree and bushes. *(Photo 13.)*

Add the trunk with a thinned mixture of Titanium White and Phthalo Blue on the liner brush. *(Photo 14.)*

With the Yellow highlight mixtures on the 2" brush, tap downward with one corner of the brush to highlight the foreground tree and bushes. Again, pay close attention to shape and form. *(Photo 15.)*

Working forward in layers, continue using the 2" brush to add the soft grassy areas—the filbert brush to add small rocks and stones—and the fan brush to paint the stream.

To paint small rocks and stones, load the filbert brush with a mixture of Van Dyke Brown and Dark Sienna, then pull one side of the bristles through a very thin mixture of Liquid White, Van Dyke Brown and Dark Sienna. With the light side of the brush UP, use a single, curved stroke to shape each of the small rocks and stones. *(Photo 16.)*

By double-loading the brush, you can highlight and shadow each rock with a single stroke. Continue using the Liquid White-Titanium White-Phthalo Blue mixture on the fan brush to swirl water around the base of the rocks, to add small falls and foaming water action. *(Photo 17.)*

LARGE TREES

Use a thinned mixture of Van Dyke Brown and Dark Sienna on the liner brush to add the large tree trunks, limbs and branches. *(Photo 18.)* Highlight the trunks with the thinned mixture of the Browns and Titanium White on the liner brush.

You can add foliage to the large trees with the various highlight mixtures on the corner of the 2" brush. *(Photo 19.)*

FINISHING TOUCHES

Sign your masterpiece, stand back and admire! *(Photo 20.)*

Purple Haze

1. Prepaint the canvas with Black Gesso.

2. Use the 2" brush with criss-cross strokes . . .

3. . . . to paint the sky.

4. Tap down with the round brush to paint . . .

5. . . . and to highlight the background trees.

Purple Haze

6. Use thinned paint on the liner brush . . .

7. . . . to add background tree trunks.

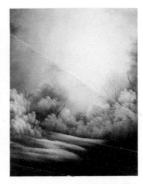

8. Tap down with the 2" brush to paint soft grass . . .

9. . . . that looks almost like velvet.

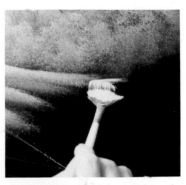

10. Use the fan brush to pull down the waterfall . . .

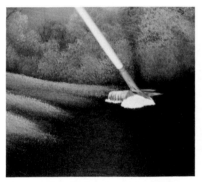

11. . . . push up the foamy water action . . .

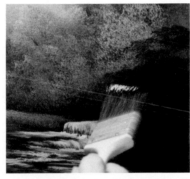

12. . . . and "swirl" the water forward.

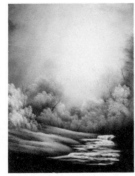

13. Underpaint foreground trees with the 2" brush.

14. Add trunks with the liner brush . . .

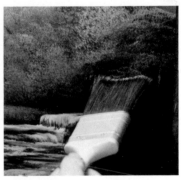

15. . . . then highlight the foliage with the 2" brush.

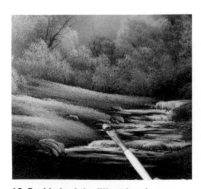

16. Double-load the filbert brush . . .

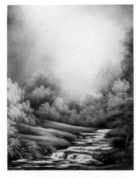

17. . . . to paint rock highlights and shadows.

18. Use the liner brush to add foreground trunks . . .

19. . . . the 2" brush to add the foliage . . .

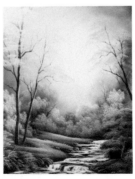

20. . . . and the painting is complete.

141

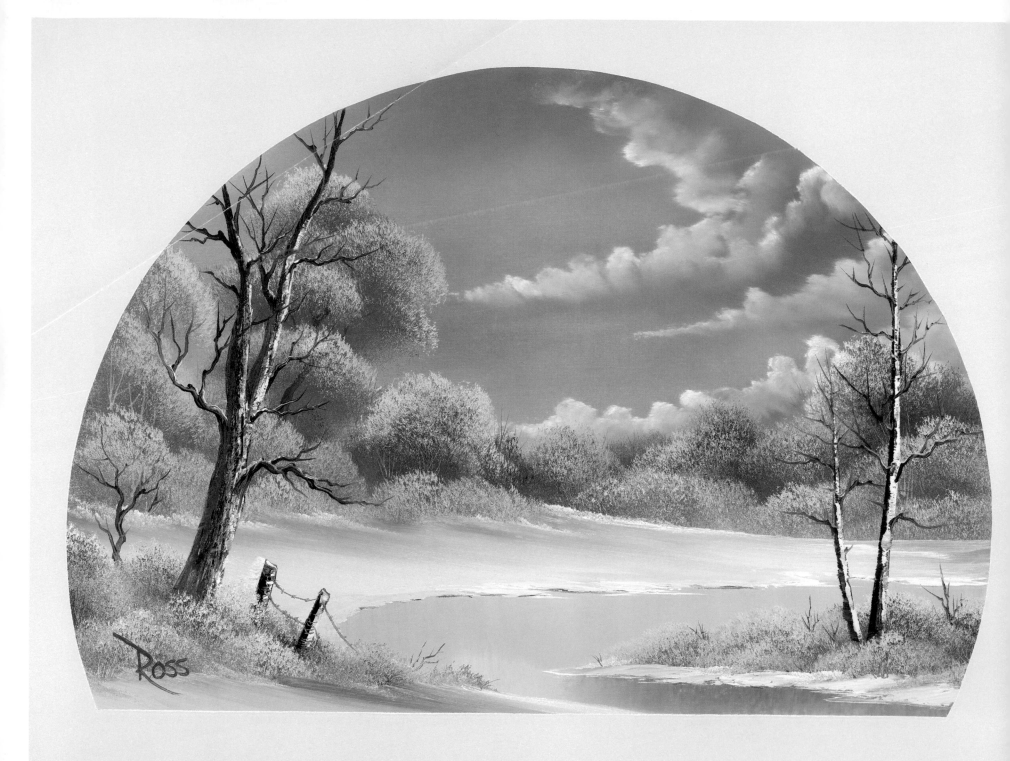

MATERIALS

2″ Brush
1″ Round Brush
#6 Fan Brush
#2 Script Liner Brush
Large Knife
Adhesive-Backed Plastic
Liquid White
Titanium White

Phthalo Blue
Prussian Blue
Midnight Black
Dark Sienna
Van Dyke Brown
Alizarin Crimson
Bright Red

Start by covering the entire canvas with a piece of adhesive-backed plastic, such as Con-Tact Paper, from which you have removed a center half-circle shape. *(Photo 1.)*

Use the 2″ brush to cover the entire exposed area of the canvas with a thin, even coat of Liquid White. Do NOT allow the Liquid White to dry before you begin.

SKY

Load the 2″ brush by tapping the bristles into a very small amount of Alizarin Crimson. Starting just above the horizon, begin painting the sky with criss-cross strokes. *(Photo 2.)* Use horizontal strokes to add this color to the lower portion of the canvas.

Without cleaning the brush, reload it with a mixture of Alizarin Crimson and a small amount of Phthalo Blue. Still using criss-cross strokes, add this Lavender color to the top of the sky, at the same time tapping in the indication of subtle cloud-shapes. *(Photo 3.)* Add this color to the edges of the lower portion of the canvas, again using horizontal strokes.

With Titanium White, use one corner of the fan brush and small circular strokes to shape the clouds. *(Photo 4.)* Blend the base of the clouds with the top corner of a clean, dry 2″ brush (still using circular strokes) *(Photo 5)* and then gently lift upward to "fluff" *(Photo 6)*.

BACKGROUND

Load the round brush by tapping the bristles into a

Lavender mixture made with Alizarin Crimson and a small amount of Phthalo Blue. Tap downward to underpaint the small background trees along the horizon. *(Photo 7.)* Use the liner brush *(Photo 8)* and the point of the knife *(Photo 9)* to add the tree trunks.

Load the round brush by first dipping it into Liquid White and then tapping the bristles into Titanium White with a very, very small amount of Bright Red (to make Pink). Again, just tap to add the snowy-highlights to the trees. *(Photo 10.)* If you are very careful not to destroy all of the dark undercolor, you can create very distinct and individual tree-shapes. *(Photo 11.)*

SNOW

Paying close attention to the lay-of-the-land, use Titanium White on the 2″ brush and long horizontal strokes to add the snow-covered ground area to the base of the background trees. *(Photo 12.)* Create additional shadows in the snow by adding a very small amount of Phthalo Blue to your brush.

Use a mixture of Liquid White with Titanium White and a very small amount of Bright Red on the fan brush and push-up strokes *(Photo 13)* to add the grassy areas to the base of the background trees *(Photo 14)*.

WATER

With a mixture of Phthalo Blue and Titanium White on the 2″ brush, decide where you want the water to be, touch the canvas and pull straight down *(Photo 15)* then use the 2″ brush to lightly brush across.

Use a small roll of a mixture of Liquid White, Titanium White and a very small amount of Bright Red on the long edge of the knife to add the water's edge *(Photo 16)* to complete the background *(Photo 17)*.

FOREGROUND

Again use the round brush with the Alizarin Crimson-

Phthalo Blue mixture to underpaint the foreground bushes. *(Photo 18.)* Use the 2″ brush to pull the color into the water for reflections then lightly brush across. *(Photo 19.)*

Highlight the bushes with Titanium White and a small amount of Bright Red on the round brush. The snow-covered ground area at the base of the bushes is added with a mixture of Liquid White and Titanium White on the knife. *(Photo 20.)* Use Van Dyke Brown on the knife to paint the tree trunks *(Photo 21)* then highlight with Titanium White. *(Photo 22.)*

With a thin mixture of Van Dyke Brown on the liner brush, add limbs and branches *(Photo 23)* to the trees *(Photo 24).*

On the left side of the painting, the tree trunks are made with Van Dyke Brown on the fan brush. Start at the top of the tree and just pull down. *(Photo 25.)* Apply the highlights to the trunk by just tapping with Titanium White on the knife.

(Photo 26.) Again, use the thin mixture on the liner brush to add limbs and branches *(Photo 27)* to the trees.

Use the dark Alizarin Crimson-Phthalo Blue mixture on the round brush to add the bushes to the base of the tree and highlight with a mixture of Liquid White, Titanium White and Bright Red.

Use Van Dyke Brown on the knife to add the small fence and highlight with Titanium White *(Photo 28)*. Add the fence wire with thinned Van Dyke Brown on the liner brush. You can "clean-up" the bottom of this area by adding snow with the 2″ brush and Titanium White. *(Photo 29.)*

FINISHING TOUCHES

When your painting is finished carefully remove the Contact-Paper to expose your finished masterpiece *(Photo 30)!*

Winter Lace

1. Cover the canvas with Con-Tact Paper.

2. Use criss-cross strokes to paint the sky.

3. Tap in clouds with the 2″ brush . . .

4. . . . highlight with the fan brush . . .

5. . . . and blend with the 2″ brush . . .

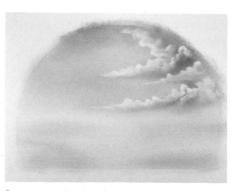

6. . . . to complete the sky.

7. Tap in background trees with the round brush . . .

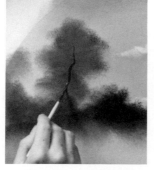

8. . . . then add trunks with the liner brush.

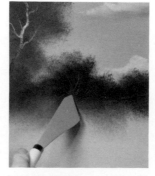

9. Scratch in sticks and twigs with the knife.

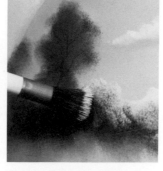

10. Apply highlights with the round brush . . .

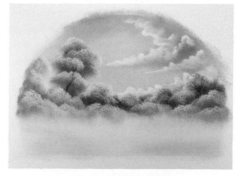

11. . . . to complete the background trees.

Winter Lace

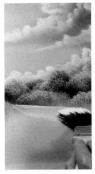 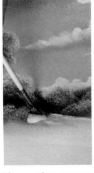 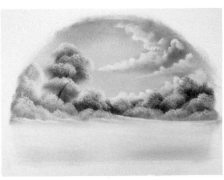 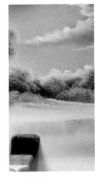 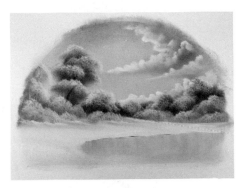

12. Add snow with the 2" brush . . .

13. . . . then grassy areas with the fan brush . . .

14. . . . to complete the background.

15. Pull down water with the 2" brush . . .

16. . . . then use the knife . . .

17. . . . to add the water's edge.

 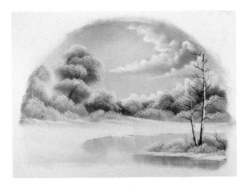

18. Paint foreground bushes with the round brush . . .

19. . . . then reflect them into the water.

20. Add snow to the base of the bushes.

21. Trunks are made . . .

22. . . . and highlighted with the knife.

23. Add limbs and branches with the liner brush . . .

24. . . . to complete the small tree.

25. Add the large trunk with the fan brush . . .

26. . . . then highlights with the knife.

27. Liner brush limbs and branches.

28. Paint a fence with the knife . . .

29. then add snow with the 2" brush . . .

30. to complete your painting.

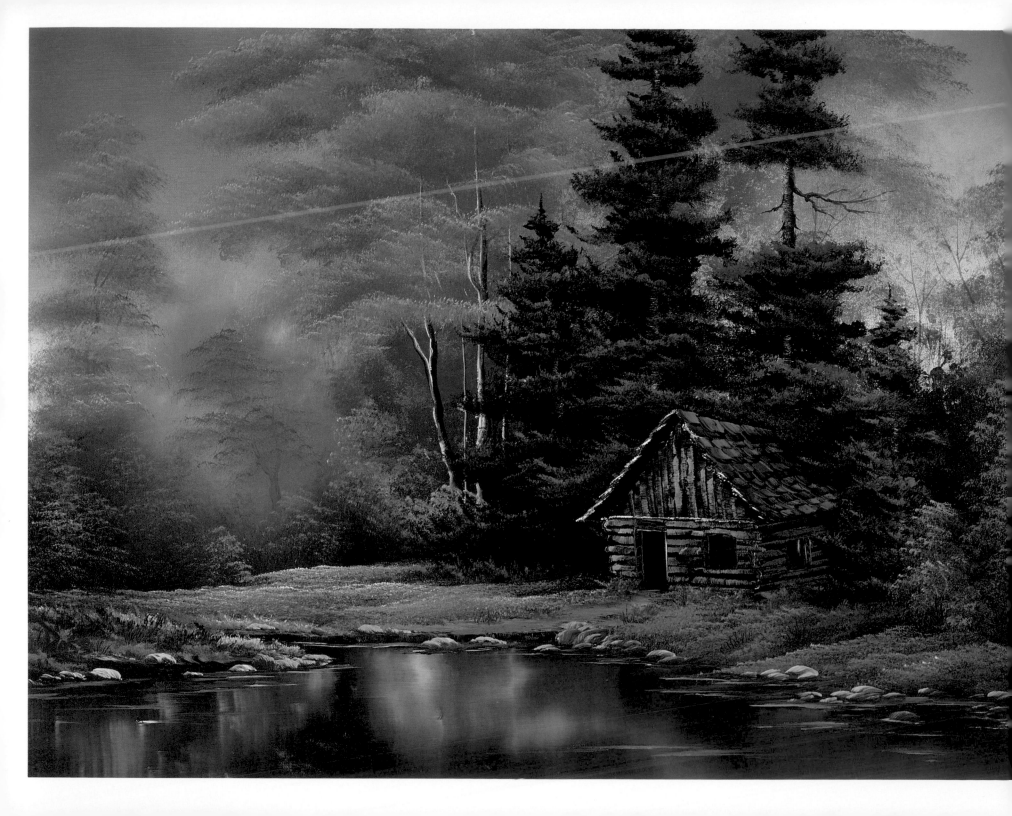

34. WILDERNESS CABIN

MATERIALS

2" Brush	Phthalo Blue
1" Oval Brush	Prussian Blue
#6 Fan Brush	Midnight Black
Filbert Brush	Dark Sienna
Script Liner Brush	Van Dyke Brown
Large Knife	Alizarin Crimson
Black Gesso	Sap Green
Liquid White	Cadmium Yellow
Liquid Clear	Yellow Ochre
Titanium White	Indian Yellow
Phthalo Green	Bright Red

Start by using a foam applicator and Black Gesso to just dab in the dark shapes on the lower portion of the canvas and allow to DRY COMPLETELY. *(Photo 1.)*

With the 2" brush, apply a VERY, VERY thin coat of Liquid Clear over the dry Black Gesso shapes. While the Liquid Clear is still wet, apply a thin, even coat of a mixture of Sap Green and Van Dyke Brown over the dark portion of the canvas.

Apply a thin, even coat of Liquid White to the White, unpainted upper portion of the canvas. Do NOT allow these colors to dry before you begin.

SKY

With a mixture of Phthalo Blue and Midnight Black on the 2" brush, use criss-cross strokes to paint the sky *(Photo 2)* and then blend with long, horizontal strokes *(Photo 3)*.

BACKGROUND

Use a Blue-Lavender mixture of Midnight Black, Phthalo Blue and Alizarin Crimson on the 2" brush to tap in the basic shapes of the background trees. *(Photo 4.)*

Double-load the liner brush to paint the background tree trunks. (To double-load the brush, fill the bristles with thinned Van Dyke Brown, then pull *one* side of the bristles through a very thin mixture of Liquid White and Dark

Sienna.) With single strokes you can paint highlights and shadows. *(Photo 5.)*

Re-load the 2" brush with a small amount of Titanium White to add foliage highlights to the background trees. Tap downward with one corner of the brush to shape individual leaf clusters. Use various mixtures of Midnight Black, all of the Yellows and a small amount of Bright Red on the brush to shape the small bushes at the base of the large background trees. *(Photo 6.)*

Use thinned dark color on the liner brush to add the tiny trunks, sticks and twigs *(Photo 7)* to the background trees *(Photo 8)*.

EVERGREEN TREES

To paint the evergreen trees load the fan brush to a chiseled edge with a mixture of Phthalo Green, Prussian Blue, Midnight Black, Alizarin Crimson and Van Dyke Brown. Hold the brush vertically and tap downward to create the trunk of each tree. Use just the corner of the brush to begin adding the small top branches. Working from side to side, as you move down each tree, apply more pressure to the brush, forcing the bristles to bend upward *(Photo 9)* and automatically the branches will become larger as you near the base of each tree.

Use Titanium White on the knife to very lightly touch highlights to the left side of any exposed portion of the tree trunks.

With a mixture of the dark tree color, Cadmium Yellow, Midnight Black and Van Dyke Brown (to make a dark Green) on the fan brush, lightly touch highlights to the evergreen branches, again forcing the bristles to bend upward. *(Photo 10.)* Don't over-do, these trees should remain quite dark. *(Photo 11.)*

Tap down with the 2" brush using the same Yellow highlight mixtures to add the soft grassy area at the base of the trees. Load the brush by holding it at a 45-degree angle and tapping the bristles into the various paint mixtures, allowing the brush to "slide" slightly forward in the paint each time you tap (this assures that the very tips of the bristles are fully

loaded with paint). Hold the brush horizontally and gently tap downward. Work in layers, carefully creating the lay-of-the-land. *(Photo 12.)*

CABIN

Use a clean knife to remove paint from the canvas in the basic shape of the cabin. Load the long edge of the knife with a small roll of Van Dyke Brown. Shape the right side of the roof and the back under-roof, then pull straight down to add the front and side of the cabin.

With a mixture of Titanium White and Midnight Black on the short edge of the knife, add the shingles to the roof.

Use a mixture of Titanium White, Van Dyke Brown, and Dark Sienna on the knife to add the logs to the front of the cabin. Use a darker mixture to add logs to the side of the cabin. Just scrape off the paint to shape the cabin windows and then add the door with Van Dyke Brown. Add Phthalo Blue or Prussian Blue to the windows for glass. Touch highlights to the ends of the logs and around the door and windows to complete the cabin.

Continue using the Yellow highlight mixtures on the 2″ brush to add the soft grassy areas to the base of the cabin *(Photo 13)* and then use the corner of the brush to tap in small trees and bushes near the cabin *(Photo 14)*.

With a mixture of Van Dyke Brown and Titanium White on the knife, use short horizontal strokes to scrub in the path. *(Photo 15.)* Be sure to extend the soft grass over the edges of the path.

POND

With Titanium White on a clean, dry 2″ brush, just pull straight down to paint the water. *(Photo 16.)* Lightly brush across to give the pond a watery appearance.

Add the banks to the water's edge with a mixture of Van Dyke Brown and Dark Sienna on the knife. Paying close attention to angles, use a mixture of the Browns and Titanium White to highlight the banks, with so little pressure on the knife that the paint "breaks". *(Photo 17.)*

To add the rocks and stones along the water's edge, load the filbert brush with a mixture of Van Dyke Brown and Dark Sienna; then pull one side of the bristles through a thin mixture of Liquid White, Van Dyke Brown and Dark Sienna, to double-load the brush. With the light side of the brush up, use a single, curved stroke to shape each of the rocks and stones. *(Photo 18.)*

Use the fan brush to pull paint from the bottoms of the rocks straight down into the water then lightly brush across to create reflections. *(Photo 19.)*

With a mixture of Liquid White and Midnight Black on the long edge of the knife, cut in water lines at the base of the rocks and along the water's edge. *(Photo 20.)*

FINISHING TOUCHES

Use the Yellow highlight mixtures on the fan brush to push in little grasses along the edge of the pond and the painting is complete. *(Photo 21.)*

Wilderness Cabin

1. Start by dabbing Black Gesso onto the canvas.

2. Use criss-cross strokes to paint the sky . . .

3. . . . then blend the sky with long, horizontal strokes.

4. Tap in background tree shapes.

5. Add tree trunks with the liner brush.

6. Foliage highlights are made with the 2″ brush.

Wilderness Cabin

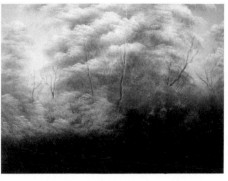

7. Use the liner brush to add small twigs and branches . . .

8. . . . to the background.

9. Use the fan brush to paint . . .

10. . . . and then highlight . . .

11. . . . the background evergreens.

12. Begin tapping in the soft grassy areas.

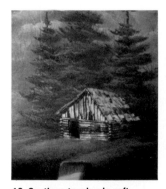

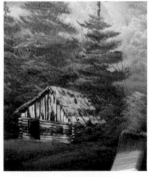

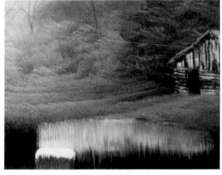

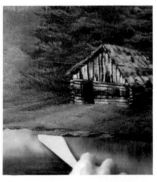

13. Continue tapping in soft grass . . .

14. . . . and small trees and bushes.

15. Add a path with the knife.

16. Pull down water with the 2" brush . . .

17. . . . then use the knife to add banks.

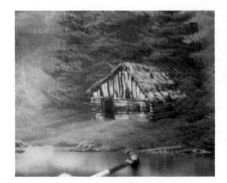

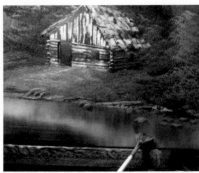

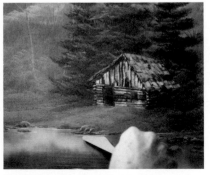

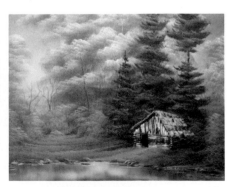

18. Shape rocks with the filbert brush . . .

19. . . . then add reflections with the fan brush.

20. Use the knife to cut in water lines . . .

21. . . . to complete the painting.

35. PASTEL SEASCAPE

MATERIALS

2" Brush	Midnight Black
1" Brush	Dark Sienna
#6 Filbert Brush	Van Dyke Brown
#6 Fan Brush	Alizarin Crimson
#2 Script Liner Brush	Sap Green
Small Knife	Cadmium Yellow
Adhesive-Backed Plastic	Yellow Ochre
Liquid White	Indian Yellow
Titanium White	Bright Red
Phthalo Blue	

Start by covering the entire canvas with a piece of adhesive-backed plastic (such as Con-Tact Paper) from which you have removed a center oval shape. (A 16 x 20 oval for an 18 x 24 canvas.) *(Photo 1.)*

Use the 2" brush to cover the exposed area of the canvas with a thin, even coat of Liquid White. With long horizontal and vertical strokes, work back and forth to ensure an even distribution of paint on the canvas. Do NOT allow the Liquid White to dry before you begin.

SKY

Load the 2" brush with a mixture of Cadmium Yellow and Indian Yellow, tapping the bristles firmly against the palette to ensure an even distribution of paint throughout the bristles.

Begin by creating a Golden glow in the center sky with criss-cross strokes. Without cleaning the brush, re-load it with Yellow Ochre and continue working outward with criss-cross strokes.

Load a clean, dry 2" brush with a small amount of Alizarin Crimson and starting at the outside edges of the sky, again use criss-cross strokes as you work in towards the Golden glow in the center of the sky. Use a mixture of Alizarin Crimson with a small amount of Phthalo Blue to make criss-cross strokes in the upper portion of the sky. (Notice how all of the colors are continually blending with Liquid White

already on the canvas.) Blend the entire sky with a clean, dry 2" brush.

With Titanium White on your fingertip, make a circular stroke to add the sun. *(Photo 2.)* Very lightly blend the sun with a clean, dry 2" brush.

Load the fan brush with a mixture of Cadmium Yellow and Alizarin Crimson. Make tight, circular strokes with one corner of the brush to drift a cloud right across the face of the sun. *(Photo 3.)* Use a mixture of Titanium White with a very small amount of Cadmium Yellow and Yellow Ochre on the fan brush to touch highlights to the top of the cloud *(Photo 4)* then blend with a clean, dry 2" brush.

Continue adding clouds with various mixtures of Titanium White, Cadmium Yellow, Yellow Ochre and Bright Red on the fan brush. Paint the clouds in layers, adding highlights and then blending with a clean, dry 2" brush.

Use a Lavender mixture of Alizarin Crimson with a small amount of Phthalo Blue on the 2" brush to add the dark clouds above the horizon. *(Photo 5.)* Very carefully blend the entire sky. *(Photo 6.)*

BACKGROUND WATER

Starting just below the horizon, use Phthalo Blue on the 2" brush to underpaint the water with long, horizontal strokes *(Photo 7)* on the lower portion of the oval. As you near the bottom of the oval, add a very small amount of Alizarin Crimson to the Phthalo Blue already in the brush. *(Photo 8.)*

Use Titanium White on the fan brush to sketch *(Photo 9)* just the basic shape of the large wave *(Photo 10)*.

Still with Titanium White on the fan brush, use rocking strokes to paint the background swells, then blend back the tops of the swells; be careful not to destroy all of the dark color on the canvas. *(Photo 11.)*

LARGE WAVE

Paying close attention to the angle of the water, use Titanium White on the fan brush to "pull" the water over the top

of the large wave. *(Photo 12.)*

With a mixture of Alizarin Crimson, Phthalo Blue and Midnight Black on the filbert brush, make tiny circular strokes to paint the foam shadows. *(Photo 13.)* Use Titanium White on the filbert brush and small, circular, push-up strokes to highlight the foam. *(Photo 14.)* Blend the bottom of the foam into the shadows with just the top corner of a clean, dry 1" brush. *(Photo 15.)*

Load the fan brush with a mixture of Titanium White and a very small amount of Cadmium Yellow. Again, use circular strokes to scrub in the "eye" or transparency of the wave. *(Photo 16.)* Make circular strokes with the top corner of a very clean, dry 2" brush *(Photo 17)* to lightly blend the "eye" of the wave *(Photo 18)*.

BEACH

With a small roll of Titanium White on the underside of the small knife, use firm pressure to add the water line to the beach. *(Photo 19.)* Blend the top edge of the water line back with a clean fan brush. *(Photo 20.)*

Use Titanium White on the fan brush to just pull down the reflected light on the beach *(Photo 21)* then lightly brush across with a clean, dry 2" brush to glisten the sand *(Photo 22)*.

Use the small knife to add the second water line to the beach and again blend back with the fan brush.

Use thinned Titanium White on the liner brush to add tiny foam details in the water. (To load the liner brush, thin the Titanium White to an ink-like consistency by first dipping the liner brush into paint thinner. Slowly turn the brush as you pull the bristles through the paint, forcing them to a sharp point.) *(Photo 23.)*

Use very little pressure and just the point of the bristles to add the final, small details to the water. *(Photo 24.)*

SAND DUNES

Underpaint the basic shape of the dunes with a dark mixture of Midnight Black, Van Dyke Brown, Dark Sienna, Alizarin Crimson and Titanium White on the fan brush. *(Photo 25.)*

Highlight the dunes with various mixtures of Titanium White, a small amount of Bright Red and the Lavender color on the knife, using so little pressure that the paint "breaks". *(Photo 26.)*

Use Sap Green and Van Dyke Brown on the fan brush and push-up strokes to add the base of the sea grass, carefully following the lay-of-the-land.

Pull up long grasses and sea oats with various mixtures of thinned Dark Sienna and Titanium White on the liner brush. *(Photo 27.)*

Use the fan brush with Titanium White to blend the base of the grass into the dunes and your seascape is complete.

FINISHING TOUCHES

Remove the Con-Tact Paper to expose your completed masterpiece *(Photo 28)*.

Pastel Seascape

1. Cover the canvas with Con-Tact Paper.

2. Add the sun with your fingertip.

3. Use the fan brush to add clouds . . .

4. . . . then highlights.

5. Make circular strokes with the 2" brush . . .

6. . . . to paint the large clouds.

7. Make long, horizontal strokes . . .

152

Pastel Seascape

8. . . . to underpaint the background water.

9. Use the fan brush . . .

10. . . . to roughly sketch the large wave.

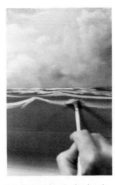

11. Blend back the background swells . . .

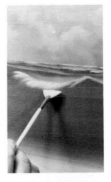

12. . . . and highlight the wave with the fan brush.

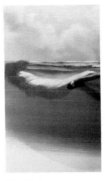

13. Paint the foam shadows . . .

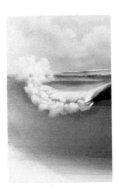

14. . . . then highlight with the filbert brush.

15. Blend the foam with the top corner of the 1" brush.

16. Scrub in the "eye" of the wave . . .

17. . . . then use the top corner of the 2" brush . . .

18. . . . to blend and shape the transparency.

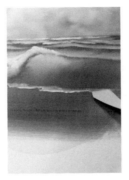

19. Add the water line with the small knife . . .

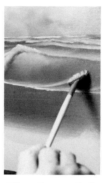

20. . . . then use the fan brush to blend the line back.

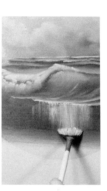

21. Create reflections on the beach . . .

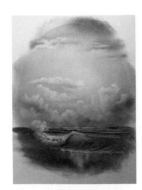

22. . . . to glisten the sand.

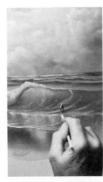

23. Add foam details to the water . . .

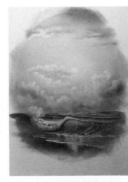

24. . . . to complete the sea.

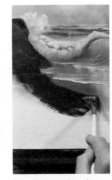

25. Underpaint dunes with fan brush.

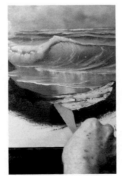

26. Highlight with the knife.

27. Use the liner brush to add long grasses.

28. Your completed, oval masterpiece.

153

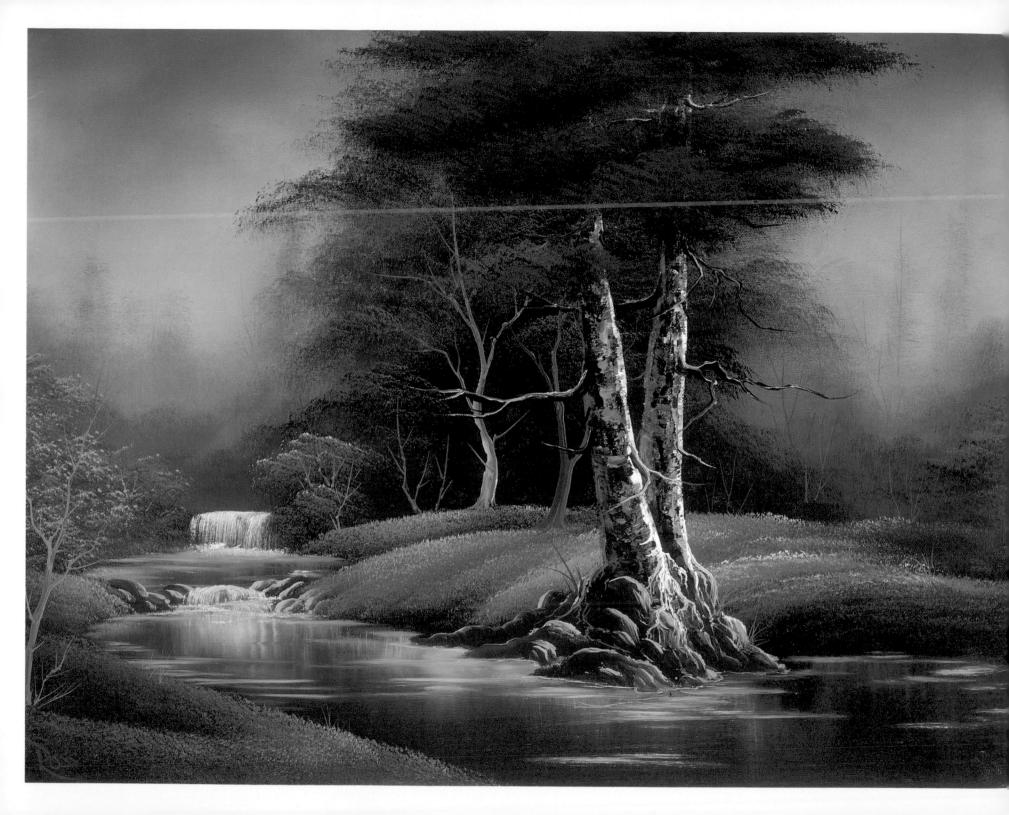

MATERIALS

2" Brush	Prussian Blue
#6 Filbert Brush	Midnight Black
#6 Fan Brush	Dark Sienna
#2 Script Liner Brush	Van Dyke Brown
Large Knife	Alizarin Crimson
Black Gesso	Sap Green
Liquid White	Cadmium Yellow
Liquid Clear	Yellow Ochre
Titanium White	Indian Yellow
Phthalo Blue	Bright Red

Start by using a crumpled paper towel to underpaint the basic dark foliage shapes with Black Gesso. (The bottom of the canvas should be dark; the top of the canvas should retain some light areas in the sky.) *(Photo 1.)* Allow the canvas to DRY COMPLETELY.

When the Black Gesso is dry, use the 2" brush to apply a thin, even coat of Liquid White to the light areas of the canvas. Use a clean, dry 2" brush to cover the dark portions of the canvas with a VERY THIN coat of Liquid Clear. (It is important to stress that the Liquid Clear should be applied VERY, VERY sparingly and really scrubbed into the canvas! The Liquid Clear will not only ease with the application of the firmer paint, but will allow you to apply very little color, creating a glazed effect.) Do NOT allow the Liquid White and Liquid Clear to dry.

Use the 2" brush to apply a mixture of Van Dyke Brown, Sap Green and a small amount of Prussian Blue over the Liquid Clear. Apply the paint very sparingly for a glazed effect.

SKY

Load the 2" brush with a very small amount of Phthalo Blue and use criss-cross strokes *(Photo 2)* to paint the light areas of the sky, over the Liquid White.

BACKGROUND

Reload the 2" brush with Dark Sienna, hold the brush vertically and tap downward to shape the subtle background trees. *(Photo 3.)*

To paint the indication of the tall, misty, background evergreens load the 2" brush to a chiseled edge. Starting at the base of each tree, simply hold the brush vertically and press the side of the brush against the canvas. As you work upward, apply less pressure on the brush, creating the tapered tree top. Complete first one side and then the other of each tree. *(Photo 4.)*

Use a very small amount of Titanium White on the 2" brush to tap the base of the trees, creating the illusion of mist. *(Photo 5.)*

With a mixture of Midnight Black, Prussian Blue, Van Dyke Brown and Sap Green on the 2" brush, tap downward with one corner of the brush to underpaint the cluster of trees in the center of the background. *(Photo 6.)*

Use a thinned mixture of Van Dyke Brown, Dark Sienna and Titanium White on the liner brush to add the small distant tree trunks. *(Photo 7.)* (To load the liner brush, thin the mixture to an ink-like consistency by first dipping the liner brush into paint thinner. Slowly turn the brush as you pull the bristles through the mixture, forcing them to a sharp point.) Apply very little pressure to the brush, as you shape the trunks. By turning and wiggling the brush, you can give your trunks a gnarled appearance.

Use various mixtures of Dark Sienna, all of the Yellows and Bright Red on the 2" brush to highlight the background foliage. Tap downward with one corner of the brush, keeping the highlights quite subtle. *(Photo 8.)* Pay close attention to shape and form, carefully creating individual tree and bush shapes. *(Photo 9.)*

Use the same Yellow mixtures to highlight the soft grassy area at the base of the trees. Load the 2" brush by holding it at a 45-degree angle and tapping the bristles into the various paint mixtures. Allow the brush to "slide" slightly forward in the paint each time you tap (this assures that the very tips of

the bristles are fully loaded with paint). Hold the brush horizontally and gently tap downward. Work in layers, carefully creating the lay-of-the-land. If you are also careful not to destroy all of the dark color already on the canvas, you can create grassy highlights that look almost like velvet. (Photo 10.)

WATERFALL

Load the fan brush with a mixture of Liquid White, Titanium White and a very small amount of Phthalo Blue. Hold the brush horizontally, start with a short horizontal stroke at the top of the falls, then pull down the falling water straight down. (Photo 11.) Use tiny push-up strokes to add the foaming water at the base of the falls. (Photo 12.)

Use the 2" brush to pull down paint from the base of the falls, for reflections. (Photo 13.) Continue using "swirling" horizontal strokes with the fan brush to bring the water forward. (Photo 14.)

To add rocks and stones to the water, load the filbert brush with a mixture of Midnight Black and Van Dyke Brown; then pull one side of the bristles through a thin mixture of Liquid White, Van Dyke Brown and Dark Sienna. With the light side of the brush UP, use a single, curved stroke to shape each of the small rocks and stones. (Photo 15.) By double-loading the brush, you can highlight and shadow each rock with a single stroke.

FOREGROUND

Working forward in layers, use the 2" brush to add reflections (Photo 16) the fan brush to "swirl" the water forward (Photo 17) and the Yellow highlight mixtures on the 2" brush

to tap in the foreground grassy areas. (Photo 18.)

LARGE TREES

Load the fan brush with a mixture of Van Dyke Brown, Midnight Black and Alizarin Crimson. Hold the brush vertically and pull down each large tree trunk. (Photo 19.)

Highlight the right side of each trunk with a mixture of Titanium White and Dark Sienna on the knife, using so little pressure that the paint "breaks". (Photo 20.) Use a mixture of Titanium White with a small amount of Prussian Blue on the knife to add the reflected light to the left sides of the trunks.

Again, use the filbert brush to add rocks and stones to the base of the large trees. (Photo 21.)

Thin the tree trunk mixture and use the liner brush to add small limbs and branches to the large trees. (Photo 22.) Use the corner of the 2" brush to underpaint the foliage (Photo 23) then add the Yellow highlights.

FINISHING TOUCHES

Use thinned mixtures on the liner brush to add small trees, the 2" brush to add the foliage and your painting is complete. (Photo 24.)

Don't forget to sign your name with pride: Again, load the liner brush with thinned color of your choice. Sign just your initials, first name, last name or all of your names. Sign in the left corner, the right corner or one artist signs right in the middle of the canvas! The choice is yours. You might also consider including the date when you sign your painting. Whatever your choices, have fun, for hopefully with this painting you have truly experienced THE JOY OF PAINTING!

River's Peace

1. Prepaint the canvas with Black Gesso and allow to dry.

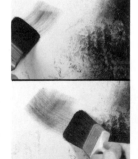

2. Use criss-cross strokes to paint the sky.

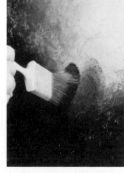

3. Tap down with the 2" brush to paint leafy trees . . .

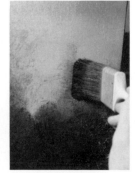

4. . . . then press the brush against the canvas . . .

5. . . . to paint tall, misty evergreens.

River's Peace

6. Underpaint foliage with the 2" brush . . .

7. . . . add trunks with the liner brush . . .

8. . . . then use the 2" brush to highlight . .

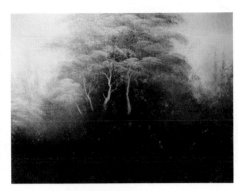

9. . . . the background trees.

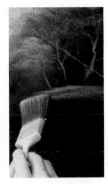

10. Tap down with the 2" brush to paint soft grass.

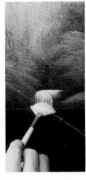

11. Pull down the waterfall . . .

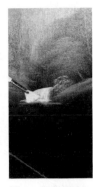

12. . . . then push up the foaming action.

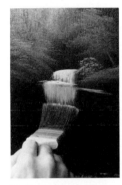

13. Use the 2" brush . . .

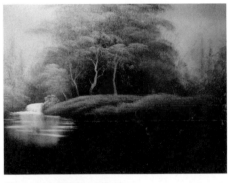

14. . . . to pull down reflections.

15. Shape the rocks with the filbert brush . . .

16. . . . then continue adding reflections . . .

17. . . . before "swirling" the water forward.

18. Tap in soft grassy areas.

19. Pull down trunks with the fan brush . . .

20. . . . then highlight with the knife.

21. Add rocks with the filbert brush . . .

22. . . . add limbs and branches with the liner brush.

23. Add foliage to the trees with the 2" brush . . .

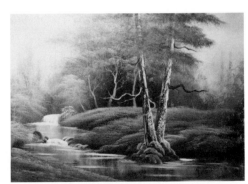

24. . . . and your painting is ready for a signature.

157

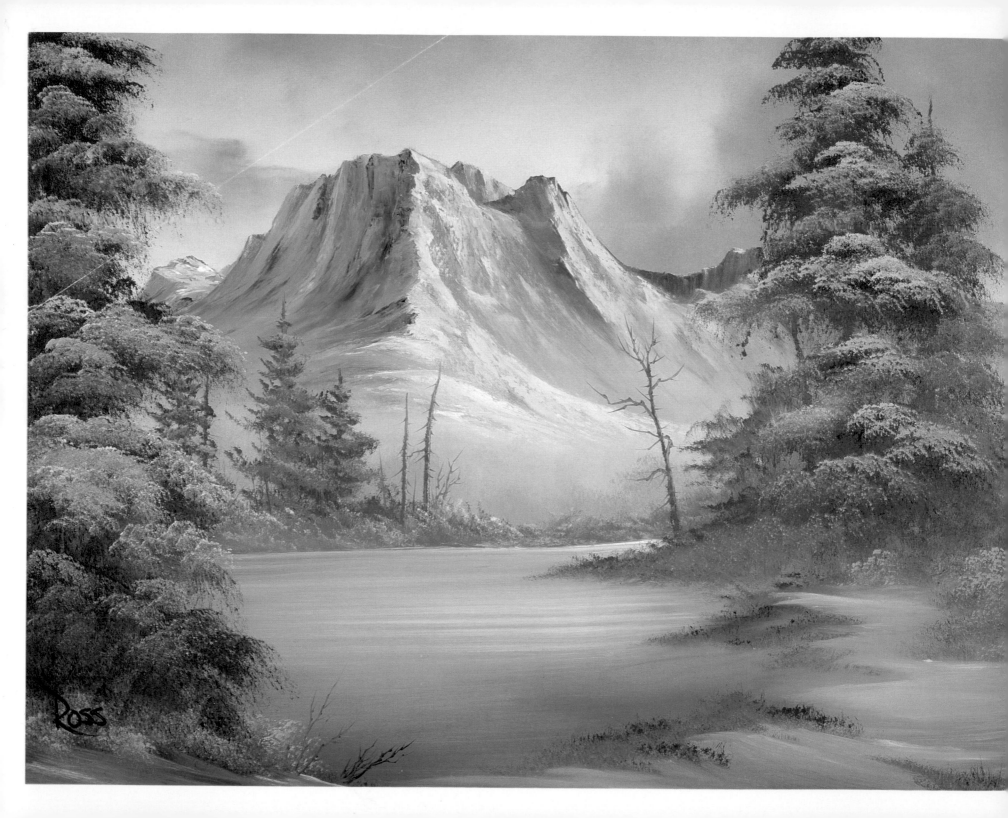

MATERIALS

2" Brush	Titanium White
1" Oval Brush	Phthalo Blue
#6 Fan Brush	Midnight Black
Script Liner Brush	Dark Sienna
Large Knife	Alizarin Crimson
Liquid White	Yellow Ochre
Liquid Clear	Indian Yellow

Start by using the 2" brush to cover the entire canvas with a thin, even coat of Liquid White. With long horizontal and vertical strokes, work back and forth to ensure an even distribution of paint on the canvas. Do NOT allow the Liquid White to dry before you begin.

SKY

Load a clean dry 2" brush with a mixture of Alizarin Crimson and Yellow Ochre, tapping the bristles firmly against the palette to ensure an even distribution of paint throughout the bristles.

Starting at the top of the canvas, begin painting the sky with criss-cross strokes. (Photo 1.) As you work downward, re-load the brush with Alizarin Crimson, Yellow Ochre and Dark Sienna. Make circular strokes with the top corner of the brush to shape the fluffy clouds (Photo 2); stringy clouds are made by just tapping the brush (Photo 3).

Blend out the base of the fluffy clouds with a clean, dry 2" brush, again using small circular strokes. (Photo 4.) Lightly brush across the stringy clouds to blend and soften, then use long horizontal strokes to blend the entire sky. (Photo 5.)

MOUNTAIN

The mountain is made with the knife and a mixture of Midnight Black, Alizarin Crimson, Dark Sienna and a small amount of Phthalo Blue. Pull the mixture out very flat on your palette, hold the knife straight up and "cut" across the mixture to load the long edge of the blade with a small roll of paint. (Holding the knife *straight up* will force the small roll of paint to the very edge of the blade.)

With firm pressure, shape just the top edge of the mountain. (Photo 6.) When you are satisfied with the basic shape of the mountain top, use the knife to remove any excess paint. Then, with the 2" brush, pull the paint down to the base of the mountain, to blend (Photo 7) and complete the entire mountain shape. The mountain should be much more distinct at the top than at the bottom. (With the dark mountain mixture on the 2" brush, make long, horizontal strokes on the lower portion of the canvas for shadows in the snow.)

Highlight the mountain with various mixtures of Titanium White, Indian Yellow and Yellow Ochre. Again, load the long edge of the knife blade with a small roll of paint. Starting at the top (and paying close attention to angles) glide the knife down the right side of each peak, using so little pressure that the paint "breaks". (Photo 8.)

Use a mixture of Titanium White, Midnight Black and a small amount of Phthalo Blue, applied in the opposing direction, for the shadowed sides of the peaks. Again, use so little pressure that the paint "breaks".

Carefully following the angles, diffuse the base of the mountain by firmly tapping with a clean, dry 2" brush (Photo 9) and then lightly brush upward to create the illusion of mist (Photo 10).

BACKGROUND

Begin by making a Lavender-Blue color with a mixture of Titanium White, Alizarin Crimson and Phthalo Blue.

Load the 2" brush with the Lavender mixture and tap downward with one corner of the brush to add the small bushes at the base of the mountain. (Photo 11.) (You can again add this color to the lower portion of the canvas.)

To paint the small background evergreens, load the fan brush to a chiseled edge with the same Lavender mixture. Holding the brush vertically, touch the canvas to create the center line of each tree. Use just the corner of the brush to begin adding the small top branches. Working from side to side, as you move down each tree, apply more pressure to

the brush, forcing the bristles to bend upward *(Photo 12)* and automatically the branches will become larger as you near the base of each tree.

Highlight the evergreens and bushes with a mixture of Titanium White, Phthalo Blue and a small amount of Midnight Black on the fan brush; again, force the bristles to bend upward. *(Photo 13.)*

Add tiny leafless trees with the Lavender mixture and the liner brush. (To load the liner brush, thin the Lavender mixture to an ink-like consistency by first dipping the liner brush into paint thinner. Slowly turn the brush as you pull the bristles through the mixture, forcing them to a sharp point.) Apply very little pressure to the brush *(Photo 14)* as you shape the trees *(Photo 15)*.

FOREGROUND

With Titanium White on the 2″ brush, make long, horizontal strokes to add the snow-covered ground area to the base of the small trees and bushes. *(Photo 16.)* Pay close attention to the lay-of-the-land. *(Photo 17.)*

LARGE EVERGREENS

Load the fan brush with a mixture of Midnight Black, Alizarin Crimson and Phthalo Blue. Hold the brush vertically and tap downward to paint the large evergreen trunks in the foreground. *(Photo 18.)*

Load the oval brush with the same mixture to add the limbs and branches to the large evergreens. Use just the tip of the brush to begin adding the small top branches. Working from side to side, as you move down each tree, apply more pressure to the brush, forcing the bristles to bend downward *(Photo 19)* and automatically the branches will become larger as you near the base of each tree *(Photo 20)*.

The smaller evergreen tree is very lightly highlighted with a "cool" mixture of Titanium White, Phthalo Blue and a small amount of Midnight Black on the oval brush.

Dip a clean, dry oval brush into Liquid Clear and with a "warm" mixture of Titanium White, Yellow Ochre and a small amount of Alizarin Crimson, highlight the larger evergreens. *(Photo 21.)*

Continue using the 2″ brush with Titanium White to add snow to the base of the large evergreens. Allow the brush to pull in some of the dark tree color for shadows. *(Photo 22.)*

With the dark tree mixture on the fan brush, hold the brush horizontally and force the bristles to bend upward to add the grassy patches in the snow. *(Photo 23.)* Again, use Titanium White on the 2″ brush to blend in the snow at the base of the grassy patches.

FINISHING TOUCHES

You can use thinned paint on the liner brush to add long grasses and other final details—especially your signature! *(Photo 24.)*

Rapture

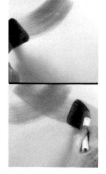

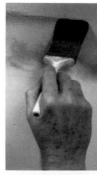

1. Use criss-cross strokes to paint the sky . . .

2. . . . and circular strokes to paint fluffy clouds.

3. Just tap in stringy clouds . . .

4. . . . then use circular strokes . . .

5. . . . to blend the entire sky.

6. Shape the mountain top with the knife . . .

7. . . . then blend the paint down to the base.

Rapture

8. Highlight the mountain with the knife . . .

9. . . . then use the 2" brush to tap the base . . .

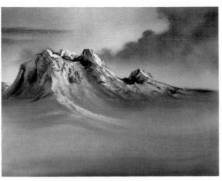

10. . . . creating the illusion of mist.

11. Tap down bushes at the base of the mountain.

12. Use the fan brush to paint tiny evergreens . . .

13. . . . and to highlight the bushes.

14. With thinned paint on the liner brush . . .

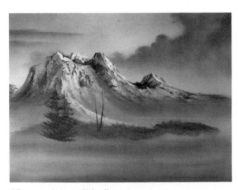

15. . . . paint small leafless trees.

16. Lay in the snow . . .

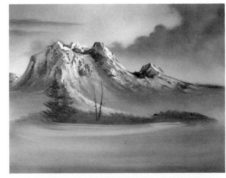

17. . . . paying close attention to the lay-of-the-land.

18. Paint the trunks with the fan brush . . .

19. . . . then use the oval brush to add branches . . .

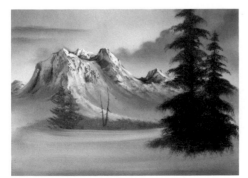

20. . . . to the large evergreens.

21. Highlight the evergreens with the oval brush.

22. Continue adding snow with the 2" brush . . .

23. . . . and grassy patches with the fan brush . . .

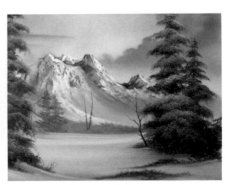

24. . . . to complete the painting.

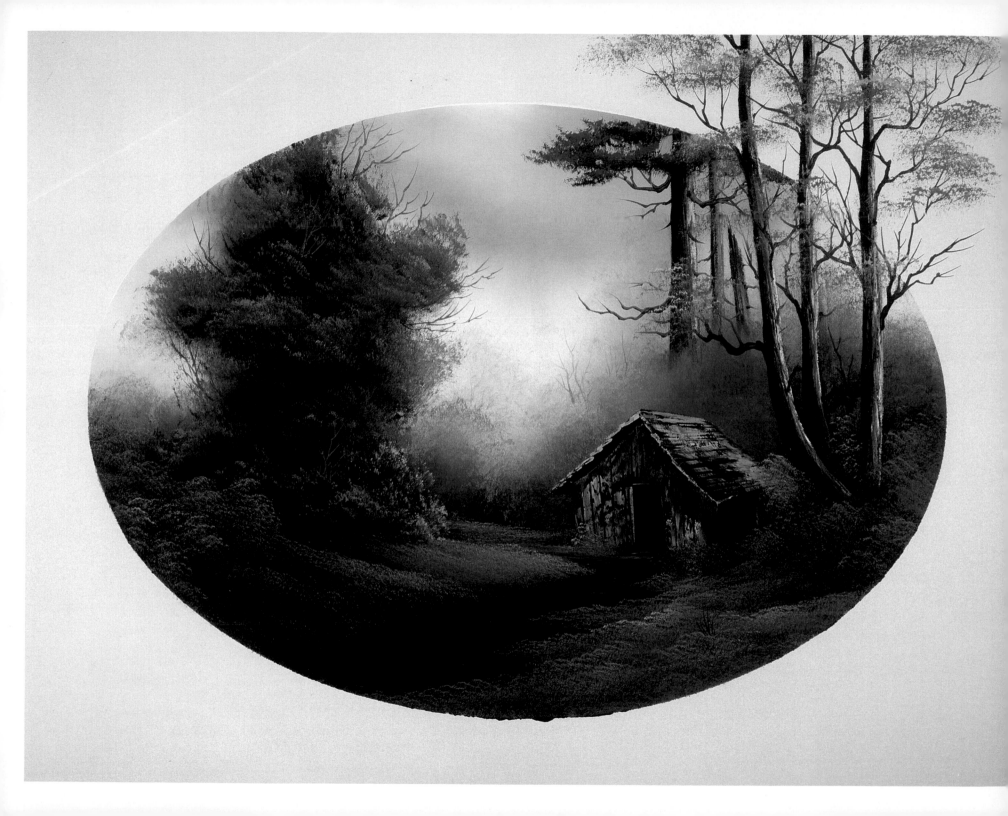

38. CABIN AT TRAIL'S END

MATERIALS

2" Brush	Phthalo Blue
1" Oval Brush	Midnight Black
#3 Fan Brush	Dark Sienna
#6 Fan Brush	Van Dyke Brown
Script Liner Brush	Alizarin Crimson
Large Knife	Sap Green
Adhesive-Backed Plastic	Cadmium Yellow
Black Gesso	Yellow Ochre
Liquid White	Indian Yellow
Liquid Clear	Bright Red
Titanium White	

Start by covering the entire canvas with a piece of adhesive-backed plastic (such as Con-Tact Paper) from which you have removed a center oval shape (a 16x20 oval for an 18x24 canvas).

Use a foam applicator and Black Gesso to prepaint the basic dark shapes on the exposed oval area of the canvas and allow to DRY COMPLETELY. (Photo 1.)

With the 2" brush, apply a VERY thin, even coat of Liquid Clear over the dry Black Gesso shapes. Apply a thin, even coat of a mixture of Sap Green and Van Dyke Brown over the Liquid Clear. Cover the White, unpainted area of the oval, above the Black Gesso, with a thin, even coat of Liquid White. Do NOT allow these colors to dry before you begin.

SKY

Load the 2" brush with a small amount of Indian Yellow and begin painting the sky with criss-cross strokes, just above the horizon. Without cleaning the brush, re-load it with a very small amount of Bright Red and continue using criss-cross strokes above the Yellow. Re-load the brush with a very small amount of Phthalo Blue and continue with criss-cross strokes at the top of the oval. Blend the entire sky with a clean, dry 2" brush.

BACKGROUND

Load the 2" brush with a small amount of a mixture of Sap Green and Van Dyke Brown. Tap downward with just the corner of the brush to shape the subtle background trees along the horizon.

Highlight the trees with the oval brush and various mixtures of all of the Yellows and Midnight Black. Proper loading of the brush is very important to the success of these lacy highlights. Load the brush by holding it at a 45-degree angle and tapping the bristles into the various paint mixtures. Allow the brush to "slide" slightly forward in the paint each time you tap (this assures that the very tips of the bristles are fully loaded with paint). Hold the brush horizontally and gently tap downward with the tip of the bristles.

Working in layers, carefully create individual leaf clusters; try not to just hit at random. Do not completely cover all of the dark color already on the canvas; use it to separate the individual trees and bush shapes.

EVERGREEN TREES

Reinforce the Black Gesso tree trunks with a mixture of Midnight Black and Dark Sienna on the large fan brush. Holding the brush vertically, start at the top and pull straight down over the previously painted trunks. (Photo 2.)

Highlight the trunks with a small roll of a mixture of Titanium White, Dark Sienna and Midnight Black on the knife. Holding the knife vertically, begin by tapping the right side of each trunk, working towards the center to give the appearance of roundness. (Photo 3.)

Add the limbs and branches with thinned Van Dyke Brown on the liner brush. (Photo 4.)

Use Midnight Black on the small fan brush to add foliage to the evergreen trees. Hold the brush horizontally and force the bristles to bend upward. (Photo 5.)

Lightly highlight the foliage with a mixture of Midnight Black and Cadmium Yellow on the fan brush. (Photo 6.) Don't overdo! These trees should remain quite dark. Continue using the Yellow highlight mixtures on the oval brush to add small trees and bushes to the base of the evergreens.

LEAFY TREE

Underpaint the large leafy tree with a mixture of Midnight Black, Sap Green and Alizarin Crimson, tapping downward with just the corner of the 2″ brush. *(Photo 7.)*

Highlight the tree with the fan brush and various mixtures of all the Yellows and Midnight Black (to make Green) and a very small amount of Bright Red. Hold the brush horizontally and just push upward with one corner of the brush *(Photo 8)* shaping individual leaf clusters.

CABIN

Load the long edge of the knife with a small roll of Van Dyke Brown by pulling the paint out flat on your palette and just cutting across. Paying close attention to angles, start with the back edge of the roof, then pull down the front of the roof. Add the front and side of the cabin.

Use a mixture of Titanium White, Midnight Black and Dark Sienna on the knife to bounce a little color down the front of the roof. Highlight just the edge of the back of the roof. Darken the mixture by adding more Dark Sienna and highlight the front of the cabin. Add Van Dyke Brown to the mixture to highlight the side of the cabin.

Paint the door with Van Dyke Brown and then use the short edge of the knife to remove the paint from the window; indicate light in the window with a mixture of Titanium White and Phthalo Blue. Use a small roll of Van Dyke Brown on the knife to vertically touch boards to the front of the cabin and to outline the door. Again, paying close attention to angles, use the knife to remove the excess paint from the base of the cabin.

Use the Yellow highlight mixtures on the 2″ brush to tap in small bushes and trees along the side of the cabin.

SOFT GRASS

Use the Yellow highlight mixtures on the 2″ brush to add the soft grassy areas at the base of the trees. Hold the brush horizontally and gently tap downward. Work in layers, carefully creating the lay-of-the-land. If you are also careful not to destroy all of the dark color already on the canvas, you can create grassy highlights that look almost like velvet. *(Photo 9.)* Be sure to leave an open area for the path to the cabin. *(Photo 10.)*

LARGE TREES

Paint the foreground tree trunks with the large fan brush and a mixture of Van Dyke Brown and Dark Sienna. *(Photo 11.)* Add limbs and branches with thinned Van Dyke Brown on the liner brush. Highlight the right sides of the trunks with a mixture of Titanium White and Dark Sienna on the knife. *(Photo 12.)*

PATH

With a mixture of Titanium White and Van Dyke Brown on the fan brush, use short, rocking, horizontal strokes to add the path. *(Photo 13.)* Continue adding grass to the edges of the path with the Yellow highlight mixtures on the 2″ brush.

FOREGROUND

Use various mixtures of thinned Titanium White and Van Dyke Brown on the liner brush to add small sticks and twigs, limbs and branches and other small details.

Carefully remove the Con-Tact Paper to expose the painted oval.

Use the fan brush to extend the foreground tree trunks outside the oval *(Photo 14)* then use thinned Van Dyke Brown on the liner brush to add limbs and branches *(Photo 15)*.

Load the oval brush with a dark Green mixture of Midnight Black and Cadmium Yellow; then, add Cadmium Yellow to just the tips of the bristles, double-loading the brush. Add foliage to the foreground trees by just tapping downward, carefully forming individual leaf clusters. By double-loading the brush you can paint shadows and highlights with single strokes *(Photo 16)* and your painting is complete *(Photo 17)*.

Cabin At Trail's End

1. Pre-paint the dark shapes with Black Gesso.

2. Pull down evergreen trunks with the fan brush . . .

3. . . . then highlight trunks with the knife.

4. Add branches with the liner brush . . .

5. . . . then use the fan brush . . .

6. . . . to add foliage to the evergreens.

7. Underpaint leafy trees with the 2" brush.

8. Add highlights with the fan brush.

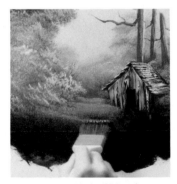

9. Tap down with the 2" brush . . .

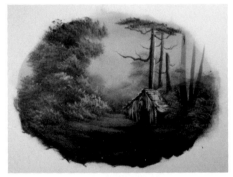

10. . . . to add the soft grassy areas.

11. Pull down foreground trunks . . .

12. . . . then highlight with the knife.

13. Paint the path with the fan brush.

14. Extend the trunks outside the oval . . .

15. . . . then add branches with the liner brush.

16. Add foliage with the oval brush . . .

17. . . . to complete the painting.

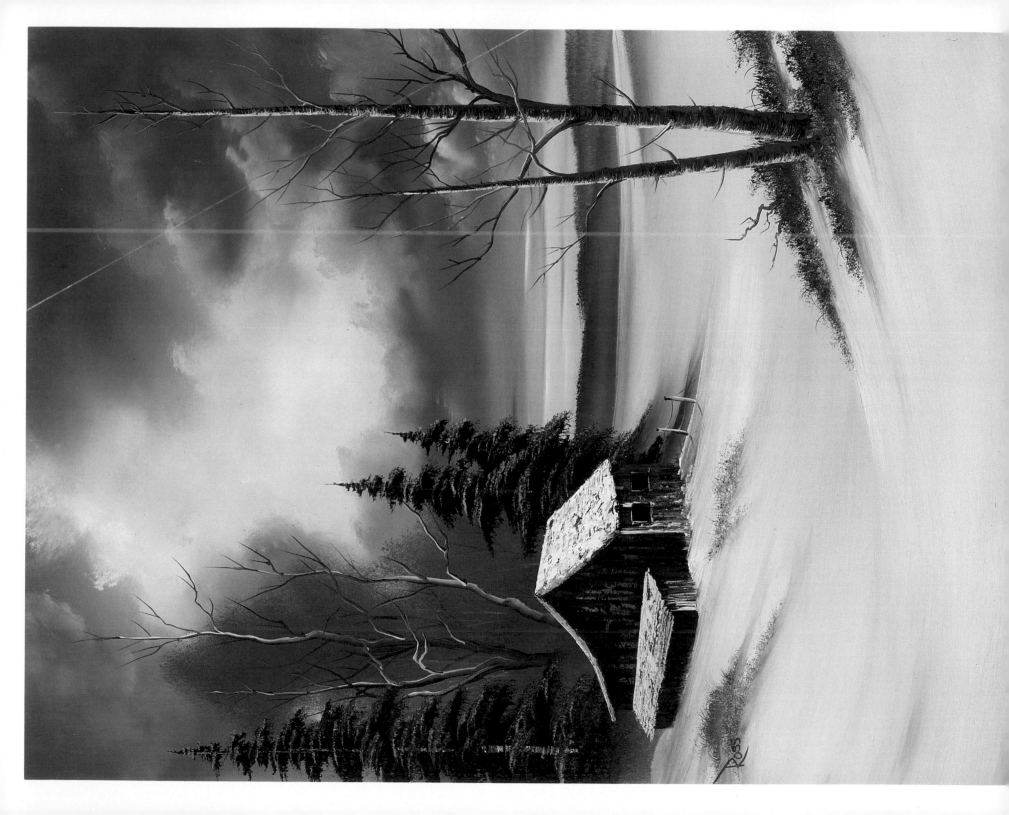

39. WINTERTIME DISCOVERY

MATERIALS

2" Brush	Midnight Black
1" Brush	Dark Sienna
#6 Fan Brush	Van Dyke Brown
#2 Script Liner Brush	Alizarin Crimson
Large Knife	Cadmium Yellow
Liquid White	Yellow Ochre
Titanium White	Indian Yellow
Phthalo Blue	Bright Red

Start by covering the entire canvas with a thin, even coat of Liquid White. With long horizontal and vertical strokes, work back and forth to ensure an even distribution of paint on the canvas. Do NOT allow the Liquid White to dry before you begin.

SKY

Load the 2" brush by tapping the bristles into Indian Yellow and then starting just above the horizon, begin by making small criss-cross strokes. (Photo 1.) Working up towards the top of the canvas and without cleaning the brush, add Cadmium Yellow to the brush, then Yellow Ochre and above that Bright Red.

Load a clean, dry 2" brush with a mixture of Phthalo Blue and Midnight Black. Starting at the top of the canvas, use criss-cross strokes to extend the color down towards the Bright Red. Blend the entire sky with a clean, very dry 2" brush. You can also add these sky colors to the lower portion of the canvas, creating reflections in the snow.

The tiny "floater" clouds above the horizon are added with a mixture of Cadmium Yellow and Yellow Ochre, using the knife. Blend with a clean, dry 2" brush. You can also use the 2" brush and a very small amount of Titanium White to lighten the sky just above the horizon.

The large clouds are made with Titanium White on the 2" brush. Use just one corner of the brush and small circular strokes to shape the clouds. With a clean, dry brush, again use circular strokes to blend the base of the clouds (Photo 2) and gently lift upward to "fluff".

The smaller dark clouds are made with Dark Sienna and Midnight Black on the 1" brush, using small circular strokes. Don't just hit at random, think about cloud shapes. (Photo 3.) Blend with the 2" brush and then highlight the top edges of the clouds with a mixture of Titanium White and Alizarin Crimson on the fan brush, still using tiny circular strokes. (Photo 4.) Use the 2" brush to soften the bottom of the highlights (Photo 5) and then blend the entire sky with a clean, dry 2" brush (Photo 6).

BACKGROUND

Use Dark Sienna, Midnight Black and Titanium White on the 2" brush and just tap downward to shape the tiny hills in the background. (Photo 7.) Tap the base of the hills with a clean, dry brush to create the illusion of mist. Add the snow to the base of the hills by making a long, horizontal stroke using Titanium White on the large brush. (Photo 8.)

Use Dark Sienna on the 2" brush and tap downward with the top corner of the brush to shape the small background trees. (Photo 9.) Add the tree trunks and limbs using various thinned mixtures of Van Dyke Brown, Yellow Ochre and Liquid White on the liner brush. (Photo 10.)

EVERGREEN TREES

Load the fan brush to a chiseled edge with a mixture of Midnight Black, Van Dyke Brown and Phthalo Blue. Holding the brush vertically, touch the canvas to create the center line of each tree. Use the corner of the brush to just touch the canvas and begin adding the small top branches. Working from side to side, as you move down the tree, apply more pressure to the brush, forcing the bristles to bend downward (Photo 11) and automatically the branches will become larger as you near the base of each tree. Use the point of the knife to scratch in the tree trunks and then use a mixture of Liquid White, Titanium White and Phthalo Blue on the fan brush to lightly highlight the branches.

With Titanium White on the 2″ brush, pull some of the dark color from the base of each evergreen to create the shadow areas in the snow, paying close attention to the lay-of-the-land. *(Photo 12.)*

CABIN

Use a clean knife to remove paint from the canvas in the basic shape of the cabin. Load the long edge of the knife with a small roll of a mixture of Van Dyke Brown and Dark Sienna by pulling the paint out very flat on your palette and just cutting across. Pull down to add the side and then the front of the cabin. Use a mixture of Bright Red, Yellow Ochre and Titanium White to highlight the side of the cabin, holding the knife vertically and using so little pressure that the paint "breaks." Use less Titanium White in the mixture to highlight the darker front of the cabin.

"Bounce" snow on the roof with thick Titanium White. Don't forget to add the shed with Van Dyke Brown, highlight and then add snow to the roof. Finish the cabin with Van Dyke Brown windows and then remove any excess paint from the base of the cabin with a clean knife. *(Photo 13.)*

Use Titanium White on the 2″ brush and long horizontal strokes to add the snow to the base of the cabin. Use tiny push-up strokes with Dark Sienna and Van Dyke Brown on the fan brush to add the little grassy things in the snow.

FOREGROUND

Continue adding the snow to the foreground using long horizontal strokes with Titanium White on the 2″ brush, paying close attention to the lay-of-the-land. *(Photo 14.)* Again, use the Brown mixture on the fan brush and push-up strokes to add the grasses. *(Photo 15.)* With Titanium White on the fan brush and sweeping, horizontal strokes, add the snow to the base of the grasses.

TREES

The large trees in the foreground are made by loading the fan brush with Van Dyke Brown and Dark Sienna. Starting at the top of each tree, just tap downward. Highlight each trunk by tapping the left side with Titanium White and then pulling the paint towards the right side of each trunk. *(Photo 16.)* Add the limbs and branches with a very thinned mixture of paint thinner and Van Dyke Brown on the liner brush. *(Photo 17.)*

FINISHING TOUCHES

You can also use thinned Van Dyke Brown on the liner brush to add fence posts to your cabin, and then highlight with Liquid White. *(Photo 18.)* Scratch in small sticks and twigs with the point of the knife, or again use thinned paint on the liner brush and your painting is completed *(Photo 19).*

Wintertime Discovery

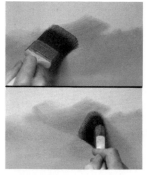 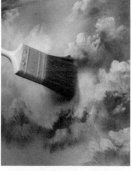

1. Paint the sky with criss-cross strokes.

2. Paint the clouds with the 2″ brush.

3. Add the dark clouds with the 1″ brush . . .

4. . . . then highlight with the fan brush . . .

5. . . . and blend with the 2″ brush . . .

6. . . . to complete the sky.

Wintertime Discovery

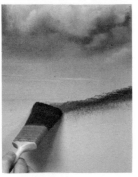

7. Shape the foothills with the 2" brush.

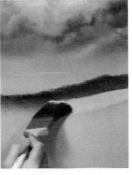

8. Add snow to the base of the foothills.

9. Shape leafy trees with the 2" brush . . .

10. . . . and add trunks with the liner brush.

11. Paint evergreens with the fan brush.

12. Add snow to the base of the trees with the 2" brush.

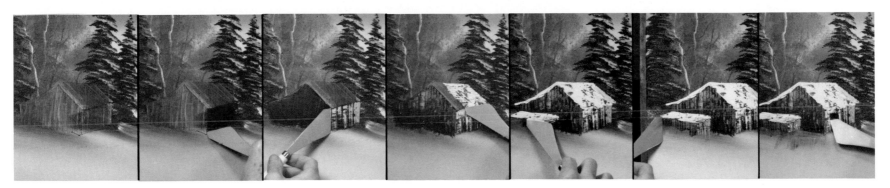

13. Progressional steps used to paint the cabin.

14. Add foreground snow with the 2" brush.

15. Push up grassy areas with the fan brush.

16. Paint the tree trunks with the fan brush . . .

17. . . . then add branches . . .

18. . . . and fence posts with the liner brush . . .

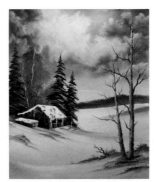

19. . . . and the painting is complete.

169

MATERIALS

2″ Brush	Liquid White
1″ Brush	Titanium White
#6 Fan Brush	Phthalo Blue
#2 Script Liner Brush	Midnight Black
Large Knife	Dark Sienna
Small Knife	Van Dyke Brown
Adhesive-Backed Plastic	Alizarin Crimson
Metal or Paper Design	Yellow Ochre
Spray Paint	

The border design of this painting was created by covering the canvas with a cut-out pattern, either metal or paper, and then spraying the canvas with a fast-drying paint (such as KRYLON). When the paint is completely dry, remove the pattern and cover the entire canvas with a piece of adhesive-backed plastic (Con-Tact Paper) from which you have removed a center oval. (Photo 1.)

Cover the entire exposed oval with a thin, even coat of Liquid White. Do NOT allow the Liquid White to dry before you begin.

SKY

Load the 2″ brush with a mixture of Alizarin Crimson and Phthalo Blue. Starting at the top of the oval, use criss-cross strokes to begin painting the sky. (Photo 2.)

Load the 1″ brush with Titanium White and just tap in the basic cloud shapes. (Photo 3.) Use long, horizontal strokes with a clean, dry 2″ brush (Photo 4) to blend the entire sky (Photo 5).

BACKGROUND

Load the 2″ brush by tapping the bristles into a mixture of Phthalo Blue, Alizarin Crimson, Dark Sienna and Titanium White. Hold the brush vertically and just tap downward, to shape the hazy, background trees along the horizon. (Photo 6.) With a clean, dry 2″ brush, firmly tap the base of the trees to create the illusion of mist. (Photo 7.)

BARN

Use a mixture of Van Dyke Brown and Dark Sienna on the knife to start the barn by shaping the silo (Photo 8) and then use the small knife to firmly rub the paint into the canvas, removing any excess paint as you work (Photo 9). Notice how soft and smooth the color becomes. Use Titanium White on the edge of the large knife to add the snow-covered roof (Photo 10) and then use the 1″ brush to pull the paint down, creating the illusion of old, smooth wood (Photo 11). Use Van Dyke Brown on the very edge of the knife to add board indications (Photo 12) and your silo is complete (Photo 13).

Use the knife with Van Dyke Brown to "sketch" the shape of the barn. (Photo 14.) Block in the color using various mixtures of Van Dyke Brown, Dark Sienna and Phthalo Blue. Again, firmly scrub the color into the canvas using a circular motion with the small knife, continually removing excess paint. At the same time, you can vary the color by adding small amounts of Yellow Ochre, Alizarin Crimson, Phthalo Blue, Dark Sienna and Titanium White. (Photo 15.) Again, pull the paint down, this time with the 2″ brush. (Photo 16.)

Use Van Dyke Brown to indicate the boards (Photo 17) and to add the windows (Photo 18) and the doors (Photo 19) to your barn. The porch roof and posts are made with Van Dyke Brown. (Photo 20.) You can use Titanium White for the snow on the porch roof and to outline the doors and windows.

EVERGREENS

To add the large evergreens behind the barn, load the fan brush to a chiseled edge with a mixture of Midnight Black, Alizarin Crimson, Phthalo Blue and Van Dyke Brown. Holding the brush vertically, touch the canvas to create the center line of each tree. Use the corner of the brush to begin adding the small top branches. Working from side to side, as you move down the tree, apply more pressure to the brush, forcing the bristles to bend downward (Photo 21) and auto-

matically the branches will become larger as you near the base of the tree. Use Titanium White and Phthalo Blue to add the trunks and to highlight the branches.

SNOW

With Titanium White on the knife, add the snow-covered roofs to your barn *(Photo 22)* using small amounts of Phthalo Blue for the shadowed areas. Use mixtures of Titanium White and Phthalo Blue on the fan brush to add the snow to the base of the barn.

TREES

Use thinned Van Dyke Brown on the liner brush *(Photo 23)* to paint the background trees *(Photo 24)*.

FOREGROUND

The fence is painted with the knife and Van Dyke Brown *(Photo 25)* and then highlighted with a mixture of Titanium White and Dark Sienna. Use the heel of the knife and Van Dyke Brown to firmly cut in the fence wire.

Use push-up strokes with Dark Sienna on the fan brush to add the grasses to the base of the fence posts and then use Titanium White to add the snow beneath the grass *(Photo 26)*. With the thinned Van Dyke Brown on the liner brush, you can add long grasses and other tiny details and your painting is almost finished. *(Photo 27.)*

FINISHING TOUCHES

Remove the Con-Tact Paper *(Photo 28)* to expose your finished masterpiece *(Photo 29)!*

Barn in Snow Oval

1. Cover the bordered canvas with an oval cut from Con-Tact Paper.

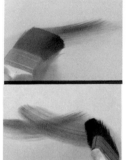
2. Paint the sky with criss-cross strokes . . .

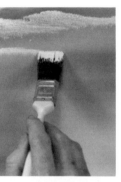
3. . . . then tap in clouds with the 1" brush.

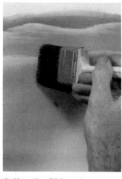
4. Use the 2" brush . . .

5. . . . to blend the clouds and sky.

6. Shape background trees with the 2" brush . . .

7. . . . then tap to create mist.

8. Block in the silo with the large knife . . .

9. . . . then scrub the paint with the small knife.

10. Add snow to the roof.

11. Smooth the paint with the 1" brush.

12. Use the knife . . .

Barn in Snow Oval

13. . . . to cut in board indications.

14. Use the knife . . .

15. . . . to outline and paint the entire barn shape.

16. Smooth the paint with the large brush.

17. Use the knife to cut in boards . . .

18. . . . add the windows . . .

19. . . . and the doors.

20. Add a porch . . .

21. . . . the evergreens . . .

22. . . . and snow on the roof.

23. Use the liner brush . . .

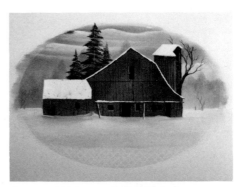

24. . . . to add the trees behind the barn.

25. Paint a fence with the knife . . .

26. . . . then add grass and more snow with the fan brush.

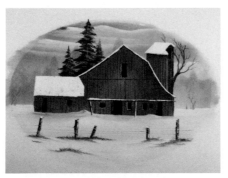

27. When you are satisfied with your painting . . .

28. . . . remove the Con-Tact Paper . . .

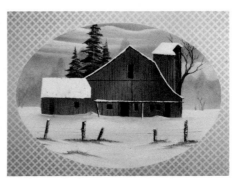

29. . . . to expose your finished masterpiece!

MATERIALS

2" Brush	Dark Sienna
#6 Fan Brush	Van Dyke Brown
#2 Script Liner Brush	Alizarin Crimson
Large Knife	Sap Green
Liquid White	Cadmium Yellow
Titanium White	Yellow Ochre
Phthalo Blue	Indian Yellow
Prussian Blue	Bright Red
Midnight Black	

Start by using the 2" brush to cover the entire canvas with a thin, even coat of Liquid White. Do NOT allow the Liquid White to dry before you begin.

SKY

Load the 2" brush with a very small amount of Phthalo Blue. Start by making sweeping, circular strokes in the center of the sky. (Photo 1.) Add a small amount of Prussian Blue to the brush and make criss-cross strokes (Photo 2) around the center. Then, use a mixture of Prussian Blue and Midnight Black on the outside edges of the canvas, still making criss-cross strokes.

Load a clean, dry 2" brush with Titanium White and use criss-cross strokes to add lightness to the center of the sky, blending outward. Blend the entire sky with a clean, dry 2" brush. (Photo 3.)

BACKGROUND

Load the fan brush with a Lavender mixture of Alizarin Crimson, Phthalo Blue and Titanium White. Hold the brush vertically and just tap downward to indicate tiny evergreen trees. (Photo 4.) Use just the corner of the brush to add branches to the more distinct trees. (Photo 5.)

Holding a clean, dry 2" brush vertically, firmly tap the base of the trees (Photo 6) then gently lift upward to create the illusion of soft mist (Photo 7).

With the Lavender mixture on the 2" brush, hold the brush vertically and tap downward to shape the leafy background trees. (Photo 8.)

Add the background tree trunks using the same dark mixture and the liner brush. Paint the trunks with very little pressure (Photo 9) turning and wiggling the brush to give the trunks a gnarled appearance (Photo 10).

As you work forward in layers, add Midnight Black to the Lavender mixture (Photo 11) and again tap the base of the trees to mist. Highlight the trees (still tapping with the 2" brush) with various mixtures of all of the Yellows and Bright Red. (Photo 12.) Use the point of the knife to scratch in the indication of tree trunks.

BARN

With a small roll of Van Dyke Brown on the knife and paying close attention to angles, paint the back edge of the roof, the front of the roof, the front and then the side of the barn.

Use a mixture of Titanium White, Dark Sienna, Van Dyke Brown and Phthalo Blue on the knife to highlight the front of the barn. Use less Titanium White on the dark side of the building.

To create the impression of old wood, make vertical slabs with Van Dyke Brown on the knife, then very lightly brush downward with a clean, dry 2" brush, to soften.

"Bounce" the highlights on the roof with a mixture of Titanium White and Midnight Black on the knife. The door and the window are both added with Van Dyke Brown (Photo 13) to complete the barn (Photo 14).

Use a mixture of the Lavender, Midnight Black and Van Dyke Brown on the 2" brush to tap in the tree and bush shapes around the barn. (Photo 15.) Again, use the Yellow mixtures to softly highlight these trees and bushes. Add tree trunks with thinned color on the liner brush. (Photo 16.)

FOREGROUND

The land area, or ravine, in the foreground is made with

Van Dyke Brown and the knife. *(Photo 17.)* Pay close attention to angles. *(Photo 18.)*

Working forward in layers, continue highlighting the trees and bushes in the foreground. *(Photo 19.)*

Under-paint the bridge and road, leading to the barn, with Van Dyke Brown and the knife. Apply highlights with a mixture of Dark Sienna, Titanium White and Yellow Ochre on the knife. Use so little pressure that the paint "breaks" and again, pay close attention to the angle. *(Photo 20.)*

Use the 2″ brush to under-paint the small bushes at the bottom of the painting then highlight with the Yellow mixtures. *(Photo 21.)*

The bridge railings are made with Van Dyke Brown on the knife and then highlighted with a mixture of Van Dyke Brown and Titanium White. *(Photo 22.)*

TREES

With a mixture of Van Dyke Brown and Dark Sienna on the fan brush, pull down the large trunks in the foreground. *(Photo 23.)*

Use thinned Van Dyke Brown on the liner brush to add limbs and branches to the trunks. *(Photo 24.)*

Push in the foliage on the large trees with a mixture of Midnight Black and Van Dyke Brown on the fan brush, forcing the bristles to bend *upward*. Without cleaning the brush, add Yellow Ochre to highlight. *(Photo 25.)*

FINISHING TOUCHES

Use the point of the knife to scratch in small sticks and twigs and your painting is ready for a signature. *(Photo 26.)*

Days Gone By

1. Use circular strokes . . .

2. . . . and criss-cross strokes . . .

3. . . . to paint the sky.

4. Tap down evergreen indications . . .

5. . . . then use the corner of the fan brush to add branches.

6. Firmly tap the base of the trees . . .

7. . . . to create the illusion of mist.

8. Use the 2″ brush to paint leaf trees . . .

9. . . . then add trunks with the liner brush . . .

10. . . . as you work forward in layers.

11. Continue with a darker mixture . . .

12. . . . then highlight with the corner of the 2″ brush.

Days Gone By

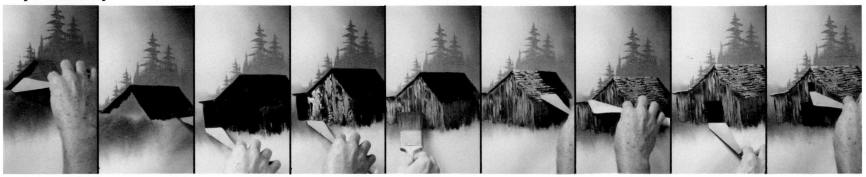

13. Progressional steps used to paint the barn.

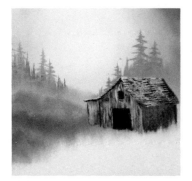

14. The barn is complete.

15. Tap down with the 2" brush . . .

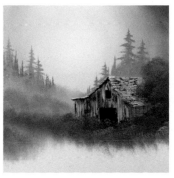

16. . . . to add trees near the barn.

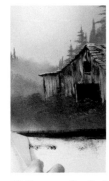

17. Use a small roll of paint on the knife . . .

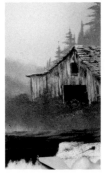

18. . . . to paint the ravine . . .

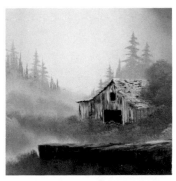

19. . . . paying close attention to angles.

20. Highlight the road with the knife . . .

21. . . . and the bushes with the 2" brush.

22. Paint the bridge railings with the knife.

23. Pull down trunks with the fan brush . . .

24. . . . then add branches with the liner brush . . .

25. . . . and foliage with the fan brush . . .

26. . . . and the painting is complete.

42. FALLS IN THE GLEN

MATERIALS

2″ Brush	Phthalo Blue
Small Round Brush	Prussian Blue
#6 Filbert Brush	Midnight Black
#6 Fan Brush	Dark Sienna
#3 Fan Brush	Van Dyke Brown
#2 Script Liner Brush	Alizarin Crimson
Large Knife	Sap Green
Black Gesso	Cadmium Yellow
Liquid White	Yellow Ochre
Liquid Clear	Indian Yellow
Titanium White	Bright Red

To prepare the canvas, use a foam applicator to pre-paint the dark portions of the painting with Black Gesso and allow to DRY COMPLETELY before proceeding. (Photo 1.)

When the Black Gesso is dry, use the 2″ brush to cover the White portion of the canvas with a thin, even coat of Liquid White. Cover the Black portion of the canvas with a VERY THIN coat of Liquid Clear. (It is important to stress that the Liquid Clear should be applied VERY, VERY sparingly and really scrubbed into the canvas! The Liquid Clear will not only ease with the application of the firmer paint, but will allow you to apply very little color, creating a glazed effect.) Do NOT allow the Liquid White and Liquid Clear to dry.

Still using the 2″ brush, cover the Black, Liquid Clear area of the canvas with a very thin, even coat of a mixture of Midnight Black, Phthalo Green and Van Dyke Brown. Do NOT allow the canvas to dry before you proceed.

SKY

Load the 2″ brush with a small amount of Indian Yellow and use criss-cross strokes to paint a Yellow glow in the center top of the sky.(Photo 2.) Reload the brush with a very small amount of Bright Red and working outward, continue using criss-cross strokes. Continue working outward with Phthalo Blue on a clean, dry 2″ brush and then use Prussian Blue at the very edges of the canvas. Blend the entire sky with a clean, dry 2″ brush.(Photo 3.)

MOUNTAIN

The mountain is made with the knife and a mixture of Prussian Blue and Alizarin Crimson. Pull the mixture out very flat on your palette, and "cut" across the paint to load the long edge of the knife with a small roll of paint.

With firm pressure, shape just the top edge of the mountain. (Photo 4.) Use the knife to remove any excess paint, then blend the paint down to the base of the mountain with the 2″ brush. (Photo 5.) The mountain should be much more distinct at the top than at the bottom.

Mist the base of the mountain by tapping with a small amount of Titanium White on a clean, dry 2″ brush. (Photo 6.)

BACKGROUND

Reload the 2″ brush with a mixture of Alizarin Crimson and Prussian Blue. Hold the brush vertically and tap downward to indicate the subtle tree shapes at the base of the mountain. (Photo 7.)

Use the Alizarin Crimson-Prussian Blue mixture on the fan brush to tap in the tiny background evergreens. You can vary the color by adding small amounts of Sap Green and Cadmium Yellow to the brush. (Photo 8.) Tap the base of the trees to mist.

BACKGROUND WATERFALL

To paint the waterfall, load the #3 fan brush with a thin mixture of Liquid White and Titanium White. Hold the brush horizontally, starting at the top of the waterfall, make a short horizontal stroke, then pull the brush straight down to the base of the falls. (Photo 9.)

With a very small amount of Titanium White on the 2″ brush, tap the base of the falls to create the illusion of mist. (Photo 10.)

FOREGROUND WATERFALL

Start by using Midnight Black on the knife to shape the

cliffs in the foreground. *(Photo 11.)*

To paint the waterfall, load the fan brush with a mixture of Liquid Clear with a very small amount of Phthalo Blue, Phthalo Green and Midnight Black. Again, starting at the top of the falls, pull straight down to paint the falling water. *(Photo 12.)*

Use Midnight Black on the knife to add stone to the waterfall then highlight with a mixture of Titanium White, Prussian Blue, Alizarin Crimson and Midnight Black. *(Photo 13.)*

Highlight, shape and contour the cliffs with a mixture of Titanium White, Midnight Black and Dark Sienna on the knife, using so little pressure that the paint "breaks." *(Photo 14.)*

Tap the base of the falls with a small amount of Titanium White on the 2" brush to create the illusion of mist. *(Photo 15.)*

EVERGREENS

To paint the larger evergreens, load the fan brush to a chiseled edge with a mixture of Midnight Black, Phthalo Green, Alizarin Crimson, Prussian Blue and Van Dyke Brown. Holding the brush vertically, touch the canvas to create the center line of each tree. Use just the corner of the brush to begin adding the small top branches. Working from side to side, as you move down each tree, apply more pressure to the brush, forcing the bristles to bend upward and automatically the branches will become larger as you near the base of each tree. *(Photo 16.)*

Add a small amount of Cadmium Yellow to the fan brush

and very lightly touch highlights to the evergreen branches. *(Photo 17.)*

FOREGROUND

To add reflections to the foreground water, use a small amount of Titanium White on the 2" brush and just pull straight down, then lightly brush across. *(Photo 18.)*

Use various mixtures of all of the Yellows and Bright Red on the 2" brush to tap in the soft grassy areas in the foreground. *(Photo 19.)* Use these same Yellow mixtures on the small round brush to shape foreground trees and bushes. *(Photo 20.)*

With thinned Titanium White on the liner brush, you can paint a small tree trunk *(Photo 21)* then again, use the Yellow mixtures on the small round brush to add foliage to the tree *(Photo 22)*.

FINISHING TOUCHES

If you would like to add small rocks and stones to the water, load the filbert brush with a mixture of Van Dyke Brown and Dark Sienna; then pull one side of the bristles through a thin mixture of Liquid White, Van Dyke Brown and Dark Sienna. With the light side of the brush UP, use a single, curved stroke to shape each of the small rocks and stones. By double-loading the brush, you can highlight and shadow each rock with a single stroke. *(Photo 23.)*

Add ripples and water lines to the base of the rocks with Liquid White on the fan brush and your painting is complete. *(Photo 24.)*

Falls in the Glen

1. Prepaint the canvas with Black Gesso . . .

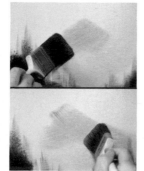

2. . . . then use criss-cross strokes to paint the sky.

3. Blend the entire sky.

4. Paint the mountain top with the knife . . .

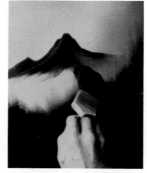

5. . . . then pull the paint down to the base with the 2" brush.

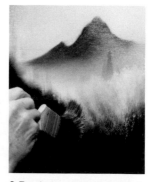

6. Tap the base of the mountain to mist.

Falls in the Glen

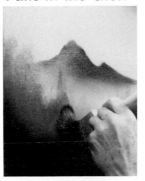

7. Use the 2" brush to paint background leaf trees . . .

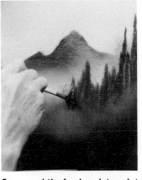

8. . . . and the fan brush to paint the evergreens.

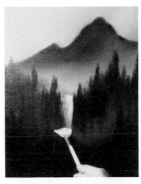

9. Pull down the background waterfall with the fan brush . . .

10. . . . then tap with the 2" brush to mist the base of the falls.

11. Shape the cliffs with the knife . . .

12. . . . then paint the large waterfall with the fan brush.

13. Use the knife to paint rocks and stones . . .

14. . . . and to highlight the cliffs.

15. Tap to mist the base of the falls.

16. Use the fan brush . . .

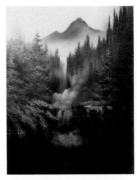

17. . . . to paint the large evergreens.

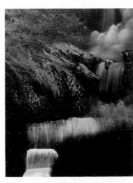

18. Use the 2" brush to pull down reflections . . .

19. . . . and to tap in soft grassy areas.

20. Paint foliage with the small round brush . . .

21. . . . then add trunks with the liner brush.

22. Highlight foliage with the small round brush.

23. Use the filbert brush to add rocks and stones . . .

24. . . . to the finished painting.

43. MIGHTY MOUNTAIN LAKE

MATERIALS

2" Brush	Midnight Black
1" Brush	Dark Sienna
#6 Fan Brush	Van Dyke Brown
#2 Script Liner Brush	Alizarin Crimson
Large Knife	Sap Green
Small Knife	Cadmium Yellow
Liquid White	Yellow Ochre
Titanium White	Indian Yellow
Prussian Blue	Bright Red

Start by covering the entire canvas with a thin, even coat of Liquid White. With long horizontal and vertical strokes, work back and forth to ensure an even distribution of paint on the canvas. Do NOT allow the Liquid White to dry before you begin.

SKY

Load the 2" brush with Prussian Blue, tapping the bristles firmly against the palette to ensure an even distribution of paint throughout the bristles. Start at the top of the sky and begin making criss-cross strokes. (Photo 1.) As you work down the canvas, notice how the paint mixes with the Liquid White and automatically the color becomes lighter as you near the horizon.

With the same color, add water to the lower portion of the canvas, pulling from the outside edges in towards the center.

The clouds are made with the 1" brush and Titanium White. Use small circular strokes to shape the clouds—don't just throw them in at random—think of what clouds look like. (Photo 2.) Blend the base of the clouds with the top corner of a clean, dry 2" brush (Photo 3) and then gently lift upward to "fluff" (Photo 4).

MOUNTAIN

The mountain is made with a mixture of Midnight Black and Van Dyke Brown. Pull the paint out very flat on your palette and just cut across to load the long edge of the knife with a small roll of paint. Use firm pressure to form just the basic shape of the top of the mountain. (Photo 5.) Pull the paint down to the base of the mountain with the 2" brush and automatically the color will mix with the Liquid White already on the surface, creating a misty appearance.

Highlight the mountain with various mixtures of Titanium White, Dark Sienna, Van Dyke Brown and a very small amount of Bright Red. Load the small knife with a small roll of paint by pulling the mixture out very flat on your palette and just cutting across. Since the light in this painting is coming from the right, start at the top of the right side of each peak and carefully following the angles, pull the highlight colors down, using so little pressure that the paint "breaks." (Photo 6.)

The left, or shadow sides, of the peaks are a mixture of Titanium White, Van Dyke Brown, Midnight Black and Prussian Blue. Again, pull down with so little pressure that the paint "breaks."

Moving forward, all the while working in layers, add additional peaks with Midnight Black on the knife.

The glacier, or lightest snow, is applied with a mixture of Titanium White with a small amount of Prussian Blue. Again, be very careful of angles and allow the paint to "break." (Photo 7.)

Use a clean, dry 2" brush and following the angles, tap the base of the mountain, to diffuse (Photo 8) and then gently lift upward to create the illusion of mist (Photo 9). (You can also add a very small amount of Yellow-Green to your brush and again, tap the base of the mountain.)

BACKGROUND

Load the fan brush with a very dark mixture of Midnight Black, Prussian Blue, Van Dyke Brown, Alizarin Crimson and Sap Green. Hold the brush vertically and just tap downward to make the small trees that live at the base of the mountain. (Photo 10.) Indicate tiny trunks with Titanium

White on the fan brush. Hold the brush horizontally and use short, upward strokes at the base of the trees. *(Photo 11.)*

Use the same dark mixture on the 2" brush to tap in the land area beneath the trees. *(Photo 12.)* Allow some of this dark color to extend into the water for reflections. Add various mixtures of all of the Yellows and Bright Red to the same 2" brush and tap downward to highlight the land area. This is where you begin concentrating on the lay-of-the-land. *(Photo 13.)*

Use a clean, dry 2" brush to pull the dark reflection color straight down *(Photo 14)* and then lightly brush across, to give the reflections a watery appearance. Add the banks to the water's edge with a very small amount of Van Dyke Brown on the knife *(Photo 15)* and then use a small roll of Liquid White on the edge of the knife to cut in water lines *(Photo 16)*.

EVERGREENS

You can add some larger evergreens to the background by loading the fan brush to a chiseled edge with the same dark mixture of Midnight Black, Prussian Blue, Van Dyke Brown, Alizarin Crimson and Sap Green. Holding the brush vertically, touch the canvas to create the center line of each tree. Use just the corner of the brush to begin adding the small top branches. Working from side to side, as you move down the tree, apply more pressure to the brush, forcing the bristles to bend downward *(Photo 17)* and automatically the branches will become larger as you near the base of each tree *(Photo 18)*.

FOREGROUND

Underpaint the foreground grassy area with the same dark mixture on the 2" brush *(Photo 19)* and then highlight by just tapping downward with mixtures of all of the Yellows on the same brush. Be very careful not to completely cover all of your dark undercolor.

Use the 1" brush to add the bushes in the foreground. Start by dipping the brush into Liquid White to thin the paint. Then, pull the brush in one direction, through various mixtures of all of the Yellows and Bright Red, to round one corner of the brush.

With the rounded corner up, force the bristles to bend upward as you shape each individual bush. *(Photo 20.)* Again, be careful not to "kill" all of the dark color, use it to separate the individual shapes. *(Photo 21.)*

Still using the same dark mixture add the large evergreens to the foreground. The tree trunks are made with a mixture of Titanium White and Dark Sienna on the knife. *(Photo 22.)* Lightly highlight the branches on the right sides of these closer trees with a Yellow-Green mixture on the fan brush.

FINISHING TOUCHES

Use the point of the knife or thinned paint on the liner brush to add sticks and twigs or other small details and your painting is finished! Sign and enjoy! *(Photo 23.)*

Mighty Mountain Lake

1. Use criss-cross strokes to start painting the sky.

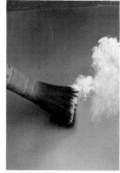

2. Add clouds with the 1" brush . . .

3. . . . then blend with the 2" brush . . .

4. . . . to complete the sky.

5. Use firm pressure to shape the mountain . . .

6. . . . and light pressure to highlight.

Mighty Mountain Lake

7. Continue adding peaks . . .

8. . . . then tap to blend . . .

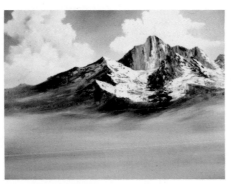

9. . . . and create the illusion of mist.

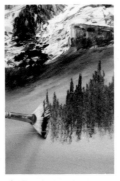

10. Tap down with the fan brush for tiny trees.

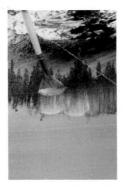

11. Lift up with the fan brush for tiny tree trunks.

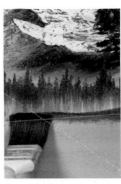

12. Use the 2" brush to underpaint . . .

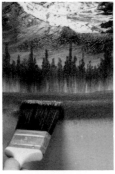

13. . . . and highlight the grass.

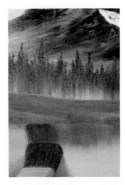

14. Pull reflections straight down.

15. Add land to the water's edge . . .

16. . . . and cut in water lines with the knife.

17. Use the fan brush . . .

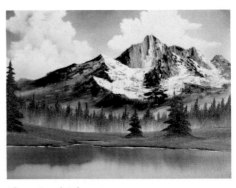

18. . . . to paint the evergreens.

19. Tap in the foreground . . .

20. . . . then use the 1" brush . . .

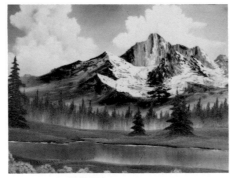

21. . . . for highlighting.

22. . . . Use the knife to add tree trunks . . .

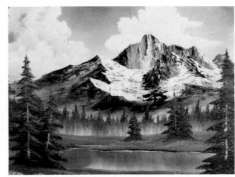

23. . . . to the finished painting.

MATERIALS

2" Brush	Titanium White
1" Brush	Phthalo Blue
#3 Fan Brush	Prussian Blue
#2 Script Liner Brush	Midnight Black
Large Knife	Dark Sienna
Adhesive-Backed Plastic	Alizarin Crimson
Liquid White	

Start by covering the entire canvas with a piece of adhesive-backed plastic (such as Con-Tact Paper) from which you have removed a center oval shape. (A 16x20 oval for an 18x24 canvas.) *(Photo 1.)*

Use the 2" brush to cover the entire exposed oval-area of the canvas with a thin, even coat of Liquid White. Do NOT allow the Liquid White to dry before you begin.

SKY

Load the 2" brush with a very small amount of Alizarin Crimson. Use criss-cross strokes to cover the center portion of the canvas with a Pink glow. *(Photo 2.)* Without cleaning the brush, tap the bristles into a small amount of Phthalo Blue and use criss-cross strokes at the top of the canvas to continue painting the sky. Use horizontal strokes on the bottom of the canvas to underpaint the water. Blend the entire canvas with a clean, dry 2" brush.

The clouds are painted with Titanium White and the fan brush. Use just one corner of the brush and tiny circular strokes to shape the clouds. *(Photo 3.)* Use a Lavender mixture of Alizarin Crimson and Phthalo Blue to add the shadowed areas of the clouds and then blend with one corner of the 2" brush, still using circular strokes. *(Photo 4.)* Use sweeping upward strokes to "fluff". *(Photo 5.)*

MOUNTAIN

The mountain is painted with the knife and a mixture of Midnight Black and Alizarin Crimson. With firm pressure, shape just the top edge of the mountain. *(Photo 6.)* With the 2" brush, blend the paint down to the base of the mountain to mist and complete the entire shape. *(Photo 7.)* The mountain should be much more distinct at the top than at the bottom.

Highlight the mountain with Titanium White. Again, load the long edge of the knife with a very small roll of paint. In this painting the light is coming from the right. Starting at the top (and paying close attention to angles) glide the knife down the right side of each peak, using so little pressure that the paint "breaks". *(Photo 8.)*

Use a mixture of Titanium White with Midnight Black and Phthalo Blue, applied in the opposing direction, for the shadowed sides of the peaks.

Carefully following the angles of the peaks, diffuse the base of the mountain by tapping with a clean, dry 2" brush *(Photo 9)* then use upward strokes to create the illusion of mist *(Photo 10)*.

FOOTHILLS

To paint the small evergreens at the base of the mountain, load the #3 fan brush to a chiseled edge with Alizarin Crimson, Phthalo Blue and Titanium White. Holding the brush vertically, touch the canvas to create the center of each tree, then use just the corner of the brush to add the small branches, forcing the bristles of the brush to bend *upward*. *(Photo 11.)*

The less distinct evergreens are made by holding the brush vertically and just tapping downward. *(Photo 12.)*

Use a clean, dry 2" brush to firmly tap the base of the evergreens, creating the illusion of mist. *(Photo 13.)*

WATER

To reflect the trees into the water, use the same Lavender mixture on the 2" brush and pull straight down, then lightly brush across. *(Photo 14.)* Cut in the water lines and ripples with Liquid White to which you have added a very small amount of Alizarin Crimson *(Photo 15)* to complete the background *(Photo 16)*.

EVERGREENS

Add the larger evergreens by loading the #3 fan brush to a chiseled edge with a mixture of Midnight Black, Prussian Blue and Alizarin Crimson. Holding the brush vertically, touch the canvas to create the center line of each tree. Touch the canvas with just the corner of the brush to begin adding the small top branches. Working from side to side, as you move down each tree, apply more pressure to the brush, forcing the bristles to bend *upward* and automatically the branches will become larger as you near the base of each tree. *(Photo 17.)*

Extend the color into the water area, pull down with the 2" brush and then lightly brush across to create reflections. *(Photo 18.)*

Underpaint the small bushes at the base of the evergreens with the same dark mixture on the 1" brush.

Use a mixture of Titanium White with a very small amount of Alizarin Crimson to add the snowy highlights to the small bushes at the base of the evergreens. Dip the 1" brush into Liquid White and then pull the brush several times through the mixture, to round one corner.

With the rounded corner up, touch the canvas and force the bristles to bend upward as you create the individual bush shapes. *(Photo 19.)*

Reverse the brush to reflect the highlights into the water, very lightly pull down and brush across with the 2" brush. *(Photo 20.)*

Paying close attention to angles and allowing the paint to "break", use Titanium White on the knife to add snow-covered ground area at the base of the bushes. *(Photo 21.)* Cut in the water lines and ripples with a small roll of Liquid White on the long edge of the knife. *(Photo 22.)*

FOREGROUND

Continue by removing the Con-Tact Paper *(Photo 23)* to expose the painted oval *(Photo 24)*.

Use the dark tree mixture on the fan brush to add the large foreground evergreens (on the right side of the painting) allowing them to extend beyond the borders of the oval. *(Photo 25.)*

Again, use the 1" brush with dark mixture to push in the bush shapes at the base of the large trees. *(Photo 26.)*

With a small roll of Titanium White and Dark Sienna on the knife, add trunks to the large evergreens. *(Photo 27.)*

Use a mixture of Titanium White and Phthalo Blue on the fan brush to add the snowy highlights to the large evergreen branches, always pushing upward with the brush and concentrating on shape and form.

Highlight bushes at the base of the large evergreens with the Titanium White-Alizarin Crimson mixture on the 1" brush. *(Photo 28.)*

The path is added with the knife, using Titanium White and so little pressure that the paint "breaks". *(Photo 29.)* Paint the bushes along the edges of the path with a mixture of Liquid White and Titanium White on the 1" brush.

FINISHING TOUCHES

Sign your completed painting with pride! *(Photo 30.)*

Winter Paradise

 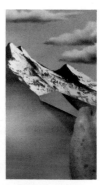

1. After applying Con-Tact Paper to the canvas . . .

2. . . . use criss-cross strokes to paint the sky.

3. Paint clouds with the fan brush . . .

4. . . . then use the 2" brush . . .

5. . . . to blend and "fluff" the clouds.

6. Shape the mountain top with the knife . . .

7. . . . then blend the paint down with the 2" brush.

8. After applying highlights with the knife . . .

Winter Paradise

9. . . . tap the base with the 2" brush . . .

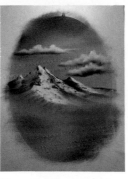

10. . . . to diffuse and mist.

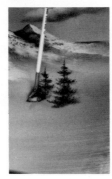

11. Shape distinct evergreens . . .

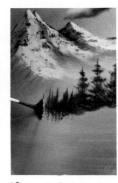

12. . . . or just tap down with the fan brush.

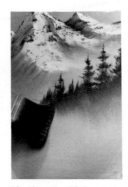

13. Use the 2" brush to firmly tap the base of the trees to mist . . .

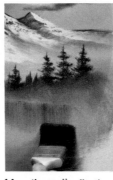

14. . . . then pull reflections straight down.

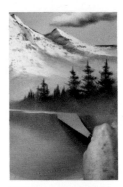

15. Use a small roll of Liquid White on the knife . . .

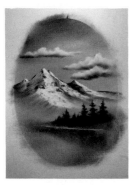

16. . . . to cut in water lines and ripples.

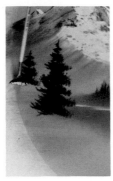

17. Add larger evergreens with the fan brush . . .

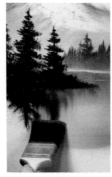

18. . . . and reflections with the 2" brush.

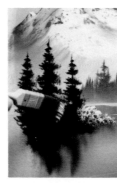

19. Highlight small bushes with the 1" brush . . .

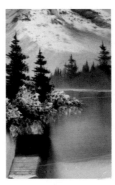

20. . . . and use the 2" brush to reflect them.

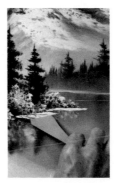

21. Use a small roll of paint on the knife . . .

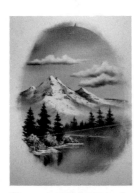

22. . . . to add banks to the water's edge.

23. Remove the Con-Tact Paper . . .

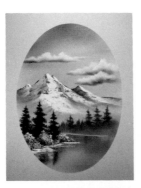

24. . . . to expose your painted oval.

25. Add the large evergreen with the fan brush . . .

26. . . . bushes with the 1" brush . . .

27. . . . the trunks with the knife.

28. Highlight the bushes with the 1" brush . . .

29. . . . then add a path . . .

30. . . . to your finished painting.

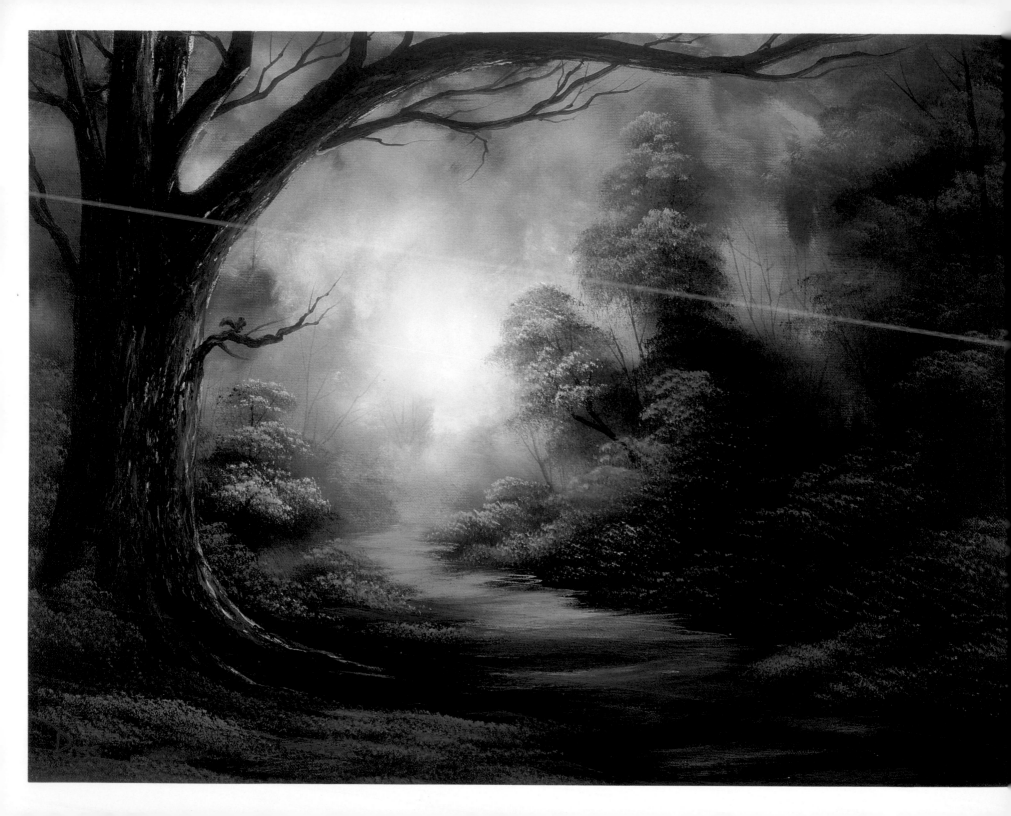

45. FOREST EDGE

MATERIALS

2" Brush	Midnight Black
Small Round Brush	Dark Sienna
#6 Fan Brush	Van Dyke Brown
#2 Script Liner Brush	Alizarin Crimson
Large Knife	Sap Green
Black Gesso	Cadmium Yellow
Liquid Clear	Yellow Ochre
Titanium White	Indian Yellow
Prussian Blue	Bright Red

Start by using a crumpled paper towel to underpaint the basic dark foliage shapes with Black Gesso. (Allow the canvas to remain much lighter near the top than at the bottom.) Use a foam applicator to underpaint the large tree trunk and then allow the canvas to DRY COMPLETELY. (Photo 1.)

When the Black Gesso is dry, use the 2" brush to cover the entire canvas with a VERY THIN coat of a thin mixture of Liquid Clear and Sap Green. (It is important to stress that the mixture should be applied VERY, VERY sparingly and really scrubbed into the canvas!) Do NOT allow the Liquid Clear-Sap Green mixture to dry before you begin. Clean and dry the 2" brush.

SKY

Load the 2" brush with Titanium White, tapping the bristles firmly against the palette to evenly distribute the paint throughout the bristles. Use circular strokes to paint the light sky-area of the canvas. (Photo 2.) The White is very opaque, try not to completely cover the sky; allow some of the transparent Green undercolor to show through, creating a mottled effect.

When you are satisfied with the color, again use circular strokes, this time with a clean, dry 2" brush (Photo 3) to carefully blend the sky (Photo 4).

BACKGROUND

Add the tiny, background tree trunks with the liner brush and a mixture of Sap Green and Midnight Black. (To load the liner brush, thin the mixture to an ink-like consistency by first dipping the liner brush into paint thinner. Slowly turn the brush as you pull the bristles through the mixture, forcing them to a sharp point.) Apply very little pressure to the brush, as you shape the trunks. By turning and wiggling the brush, you can give your trunks a gnarled appearance. (Photo 5.)

Load the small round brush by tapping the bristles into a mixture of Midnight Black, Sap Green and a small amount of Yellow Ochre. Starting at the top of each tree, tap downward to underpaint the foliage. (Photo 6.)

Use Liquid Clear with various mixtures of Titanium White, Sap Green, all of the Yellows and a very small amount of Bright Red on the small round brush to highlight the foliage. Again, tap downward (Photo 7) to apply the highlights. Try not to just hit at random. Pay close attention to shape and form, carefully creating individual leaf clusters, trees and bushes; at the same time, work in layers and be very careful not to completely cover the dark undercolor. (Photo 8.)

PATH

Use a mixture of Titanium White, Dark Sienna and Van Dyke Brown on the knife and scrubbing, horizontal strokes to add the path. Starting in the background and working forward, pay close attention to perspective here. The path should get progressively wider as you work into the foreground. (Photo 9.)

Use sweeping horizontal strokes with the fan brush to lightly soften the path. (Photo 10.)

With the small round brush, continue working forward in layers, shaping and highlighting small trees, bushes and grassy areas.

Use thinned paint on the liner brush to add small trunks, limbs, branches, sticks and twigs. (Photo 11.)

LARGE TREE

The basic shape of the large, foreground tree has been

prepainted with Black Gesso; now, use Midnight Black on the fan brush to redefine the shape of the tree. *(Photo 12.)* Wiggle the fan brush to give the tree a gnarled appearance and extend the roots of the tree into the path.

Add the small branches to the tree with thinned Midnight Black on the liner brush. *(Photo 13.)*

Highlight the right side of the trunk with a small roll of a mixture of Titanium White, Dark Sienna and Van Dyke Brown on the knife, using so little pressure that the paint "breaks". *(Photo 14.)* Use a mixture of Titanium White with Prussian Blue on the knife for the reflected light on the left side of the trunk.

Continue using the small round brush to add small bushes and grassy areas to the base of the tree. Extend these grassy areas into the path, to soften the edges.

FINISHING TOUCHES

Use a thinned mixture of the Brown and White on the liner brush to lightly highlight the small branches, or even add a squirrel *(Photo 15)* and your painting is complete *(Photo 16)*.

Don't forget to sign your name with pride: Again, load the liner brush with thinned color of your choice. Sign just your initials, first name, last name or all of your names. Sign in the left corner, the right corner or one artist signs right in the middle of the canvas! The choice is yours. You might also consider including the date when you sign your painting. Whatever your choices, have fun, for hopefully with this painting you have truly experienced THE JOY OF PAINTING!

Forest Edge

1. Underpaint the canvas with Black Gesso.

2. Use circular strokes with the 2" brush ...

3. ... to "swirl" in the sky ...

4. ... and to blend the canvas.

192

Forest Edge

5. Paint tree trunks with the liner brush . . .

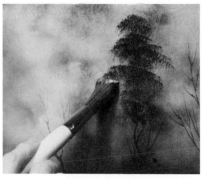

6. . . . then add foliage with the small round brush.

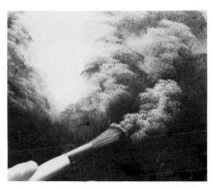

7. Tap downward with the small round brush . . .

8. . . . to highlight the foliage.

9. Use horizontal strokes with the knife to paint the path . . .

10. . . . then soften the path with the fan brush . . .

11. . . . paying close attention to perspective.

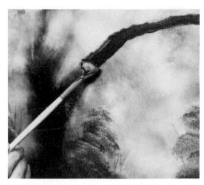

12. Redefine the tree trunk with the fan brush . . .

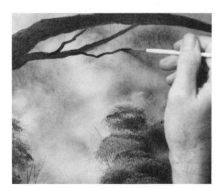

13. . . . then add small branches with the liner brush.

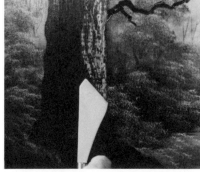

14. Use the knife to highlight the trunk with "breaking" paint.

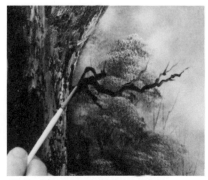

15. Don't forget to add a tiny squirrel . . .

16. . . . to complete your painting.

Steve Ross

Steve's appearances on Bob's programs have become a very popular addition to THE JOY OF PAINTING Series. Not only does he display an extraordinary ability to paint (having trained at the knee of the master) but his good looks, charm and wit have made him a favorite among students across the country. Having mastered this technique of painting at a very early age, it is no wonder that Steve has become one of the most popular Bob Ross Certified Instructors.

MATERIALS

2" Brush	Midnight Black
1" Brush	Dark Sienna
#6 Fan Brush	Van Dyke Brown
#3 Fan Brush	Alizarin Crimson
#2 Script Liner Brush	Sap Green
Large Knife	Cadmium Yellow
Liquid White	Yellow Ochre
Titanium White	Indian Yellow
Phthalo Blue	Bright Red
Prussian Blue	

Start by covering the entire canvas with a thin, even coat of Liquid White. With long horizontal and vertical strokes, work back and forth to ensure an even distribution of paint on the canvas. Do NOT allow the Liquid White to dry before you begin.

SKY

Load the 2" brush with a small amount of Phthalo Blue, tapping the bristles firmly against the palette to ensure an even distribution of paint throughout the bristles. Starting in the center of the canvas, use criss-cross strokes to paint the sky and water. *(Photo 1.)*

To achieve the vignette-effect in the background, allow the color to fade into the White edges of the canvas. *(Photo 2.)* Blend the entire canvas with a clean, dry 2" brush.

Shape the clouds with Titanium White on the fan brush, making small circular strokes with just the corner of the brush. *(Photo 3.)* Use the top corner of a clean, dry 2" brush to blend the base of the clouds, carefully not distorting the top edges of the clouds. *(Photo 4.)* Use sweeping upward strokes to blend and "fluff". *(Photo 5.)*

BACKGROUND

Load the fan brush with a mixture of Titanium White, Phthalo Blue and Midnight Black. Holding the brush vertically, tap downward to shape the tiny, distant evergreens. *(Photo 6.)* (Again, avoid the edges of the canvas.) With just the corner of the fan brush you can add small limbs and branches to some of the more detailed trees.

Use the top corner of the 2" brush to firmly tap the base of the trees *(Photo 7)* creating the illusion of mist.

The hills at the base of the trees are shaped with a darker value of the Titanium White-Phthalo Blue-Midnight Black mixture on the fan brush. This time, hold the brush horizontally and tap downward. *(Photo 8.)* Again, use the top corner of the 2" brush to tap the base of the hills *(Photo 9)* creating the misty effect.

Allowing the mist to separate the hills, add the closer range using an even darker value of the same mixture. Extend some of the color into the water area for reflections.

Use the 2" brush to pull the reflections straight down *(Photo 10)* and then lightly brush across to give the reflections a watery appearance. Cut in the water lines with a very small roll of Liquid White on the long edge of the knife *(Photo 11)* and the background is complete.

TREES

Underpaint the large foreground trees with the 2″ brush and a mixture of Midnight Black, Sap Green, Prussian Blue and Titanium White. Hold the brush horizontally and tap downward for the basic shape of the trees. *(Photo 12.)*

Use a mixture of paint thinner and Van Dyke Brown on the liner brush *(Photo 13)* to add the small tree trunk and branches.

Still using the same dark mixture on the 2″ brush, underpaint the small trees and bushes in the foreground *(Photo 14)*, then scratch in sticks and twigs with the point of the knife *(Photo 15)*. Be sure to allow the foreground to extend across the entire width of the canvas. *(Photo 16.)*

Add the two large birch-tree trunks with Van Dyke Brown on the knife, using a series of small sideways-strokes. Start at the top of the canvas and allow the trunks to become wider near the base.

Highlight the right sides of the trunks with Titanium White (again using small sideways-strokes) and so little pressure that the paint "breaks". *(Photo 17.)* Touch the left sides of the trunks with a small amount of a mixture of Phthalo Blue and Midnight Black.

The limbs and branches are added with thinned Midnight Black on the liner brush.

Underpaint the leaf-clusters with a mixture of Midnight Black and Sap Green, using the corner of the 2″ brush. *(Photo 18.)* Still using the dark, 2″ brush, pull down the reflections in the foreground water. *(Photo 19.)*

Use the 1″ brush to highlight the trees and bushes. Dip the brush into paint thinner and pull it in one direction (to round one corner) through various mixtures of all the Yellows, Sap Green and Bright Red. With the rounded corner up, touch the canvas and force the bristles to bend upward. Don't just hit at random. Form individual leaf clusters, think like a tree! *(Photo 20.)* Be very careful not to "kill" all of the dark undercolor. Allow it to separate the individual bush shapes. *(Photo 21.)*

With a very small roll of Liquid White on the long edge of the knife, cut in the water lines and ripples. *(Photo 22.)*

Again, use the dark mixture on the 2″ brush to underpaint the foliage across the bottom of the canvas then highlight with the Yellow-mixtures on the 1″ brush *(Photo 23)*.

FINISHING TOUCHES

Use horizontal strokes with Van Dyke Brown on the knife to add the path in the foreground. The highlights are a mixture of Titanium White, Dark Sienna and Van Dyke Brown. *(Photo 24.)*

Use the point of the knife, or thinned color on the liner brush to add final small details and your painting is ready for a signature! *(Photo 25.)*

Lake View

1. Use criss-cross strokes . . .

2. . . . to paint the sky and water.

3. Paint the clouds with the fan brush . . .

4. . . . then use the 2″ brush . . .

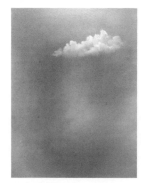

5. . . . to blend the clouds.

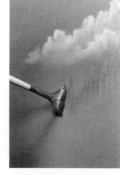

6. Tap in tiny evergreens with the fan brush . . .

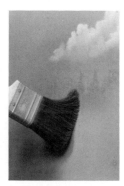

7. . . . then mist the base of the trees with the 2″ brush.

Lake View

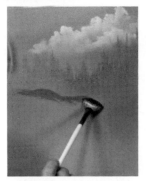

8. Add background hills with the fan brush . . .

9. . . . then use the 2" brush to mist . . .

10. . . . and reflect them into the water.

11. Cut in water lines with Liquid White.

12. Underpaint the large tree with the 2" brush . . .

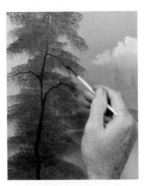

13. . . . then use the liner brush to add limbs and branches.

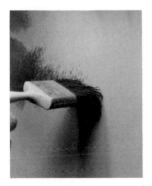

14. Underpaint the foreground with the 2" brush . . .

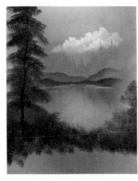

15. . . . then use the point of the knife . . .

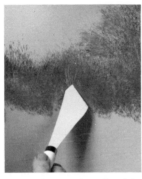

16. . . . to scratch in sticks and twigs.

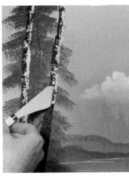

17. Paint trunks with the knife . . .

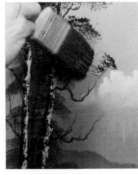

18. . . . and leaf clusters with the 2" brush.

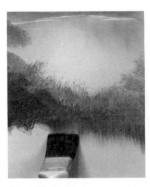

19. Add the foreground water with the 2" brush.

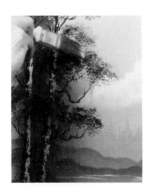

20. Highlight the leaf clusters . . .

21. . . . and bushes with the 1" brush.

22. Use the knife to cut in the water lines.

23. Highlight the foreground . . .

24. . . . add the land area . . .

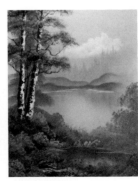

25. . . . and your painting is finished.

47. DOUBLE-OVAL STREAM

MATERIALS

2" Brush	Midnight Black
1" Brush	Dark Sienna
#6 Filbert Brush	Van Dyke Brown
#6 Fan Brush	Alizarin Crimson
#2 Script Liner Brush	Sap Green
Large Knife	Cadmium Yellow
Adhesive-Backed Plastic	Yellow Ochre
Liquid White	Indian Yellow
Titanium White	Bright Red
Phthalo Blue	

Start by covering the entire canvas with adhesive-backed plastic (such as Con-Tact Paper) from which you have removed two oval-shapes. *(Photo 1.)*

Cover the entire exposed area of the canvas (both ovals) with a thin, even coat of a mixture of Liquid Black and Liquid White. Do NOT allow the mixture to dry before you begin.

BACKGROUND

Load the 2" brush with a mixture of Midnight Black, Dark Sienna and Alizarin Crimson. Hold the brush horizontally and just tap downward to underpaint the background trees above the horizon in both ovals. *(Photo 2.)*

Load the liner brush with a very thin mixture of Van Dyke Brown and paint thinner. Slowly turn the brush as you pull the bristles through the mixture, forcing them to a sharp point. With very little pressure on the brush, indicate the small background tree trunks. *(Photo 3.)* Use thinned Titanium White for the light trunks. *(Photo 4.)*

To highlight the background trees, load the same 2" brush by tapping the bristles into various mixtures of Midnight Black, all of the Yellows, Sap Green and Bright Red. Again, hold the brush horizontally and tap downward with just one corner of the brush to apply the highlights. *(Photo 5.)* Try not to hit at random, work in layers, shaping individual trees and bushes. Be very careful not to completely "kill" all of the dark undercolor already on the canvas. *(Photo 6.)*

STREAM

Use a mixture of Liquid White, Titanium White and a very small amount of Phthalo Blue on the fan brush to add the stream. Starting in the distance and working forward, hold the brush horizontally and begin by making very short, horizontal strokes. *(Photo 7.)* Pull straight down with the brush for the tiny falls; push-up strokes for the foamy water splashes. *(Photo 8.)*

Load the 1" brush with various mixtures of Sap Green, Yellow Ochre and a small amount of Titanium White. Underpaint the foreground water with long vertical strokes *(Photo 9)* then, lightly brush across with a clean, dry 2" brush.

As you continue to move the water forward *(Photo 10)* add the rocks and stones with the filbert brush. Load both sides of the bristles with a mixture of Van Dyke Brown and Dark Sienna, then pull one side of the bristles through a mixture of the Liquid White, Dark Sienna and Yellow Ochre (to double-load the brush). By always keeping the light side of the brush facing upward, you can shape and highlight the stones in just one step. *(Photo 11.)* Use the 2" brush to pull some of the dark mixture straight down into the water and then lightly brush across to create reflections. *(Photo 12.)*

Use the fan brush to continue bringing the water forward (through both ovals) with swirling horizontal strokes and pull-down strokes for the falls around the rocks. *(Photo 13.)* Watch your perspective here, the stream should get wider as it moves forward through both ovals. *(Photo 14.)*

FOREGROUND

With a mixture of Midnight Black, Dark Sienna and Alizarin Crimson on the 2" brush, again tap downward to underpaint the foreground foliage in both ovals. *(Photo 15.)* Use the point of the knife to scratch in stems, sticks and twigs.

Highlight the foliage with various mixtures of all of the Yellows, Midnight Black, Sap Green and Bright Red on the same brush. Use just the corner of the brush to tap downward, shaping the individual bushes in the foreground. *(Photo 16.)*

At this point you should carefully remove the Con-Tact

Paper *(Photo 17)* to expose the painted double-oval *(Photo 18)*.

Use the Midnight Black-Dark Sienna-Alizarin Crimson mixture on the 2" brush to underpaint the continuation of the foliage between the two ovals. With the same highlight mixtures, again use one corner of the brush to shape the individual bushes. *(Photo 19.)*

Use Van Dyke Brown on the knife to add the ground area at the base of the bushes. Highlight with a mixture of Van Dyke Brown and Titanium White, applied with so little pressure on the knife that the paint "breaks". *(Photo 20.)* Use the Yellow and Green highlight mixtures on the fan brush and push-up strokes *(Photo 21)* to add the small grassy areas *(Photo 22)*.

LARGE TREES

The large tree trunks in the foreground are made with Van

Dyke Brown and Dark Sienna on the fan brush. *(Photo 23.)*

Highlight the trunks with a small roll of Titanium White on the long edge of the knife. *(Photo 24.)* The limbs and branches are added with thinned Van Dyke Brown on the liner brush. *(Photo 25.)*

Tap down with the corner of the 2" brush to add the foliage to the trees. Start with the dark Midnight Black-Dark Sienna-Alizarin Crimson mixture and then highlight with the Yellow and Green mixtures. *(Photo 26.)*

FINISHING TOUCHES

Use the liner brush with thinned paint mixtures to add the small final details. *(Photo 27.)*

Double-Oval Stream

1. Cover the canvas with Con-Tact Paper.

2. Use the 2" brush to tap in tree shapes . . .

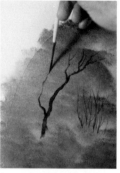
3. . . . and the liner brush to add trunks.

4. Tap downward . . .

5. . . . to highlight the background trees.

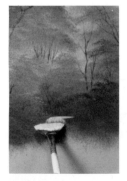
6. Pull down to paint the falls . . .

7. . . . then push up to add the splashes.

8. Use the 1" brush to underpaint the water.

9. Paint water with the fan brush . . .

10. . . . and rocks with the filbert brush . . .

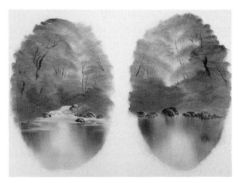
11. . . . to complete the background.

Double-Oval Stream

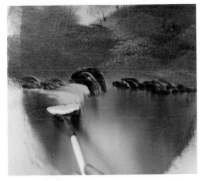

12. Use the fan brush . . .

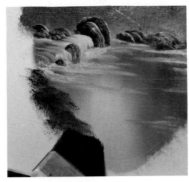

13. . . . to pull the water over the rocks.

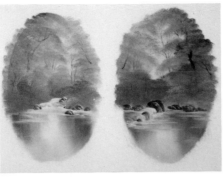

14. Use the 2" brush . . .

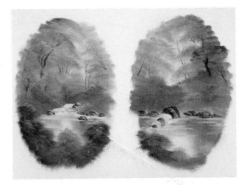

15. . . . to underpaint the foreground foliage.

16. Carefully remove the Con-Tact Paper . . .

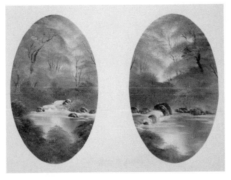

17. . . . to expose your painted ovals.

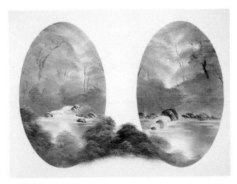

18. Add the foreground foliage . . .

19. . . . then use the knife to paint the path.

20. With the fan brush . . .

21. . . . push in small grassy areas.

22. Pull tree trunks down with the fan brush . . .

23. . . . then highlight with the knife . . .

24. . . . add limbs with the liner brush . . .

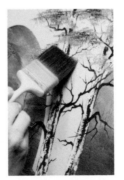

25. . . . and foliage with the 2" brush . . .

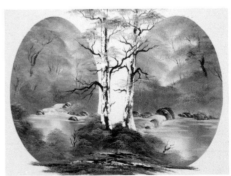

26. . . . and your painting is finished!

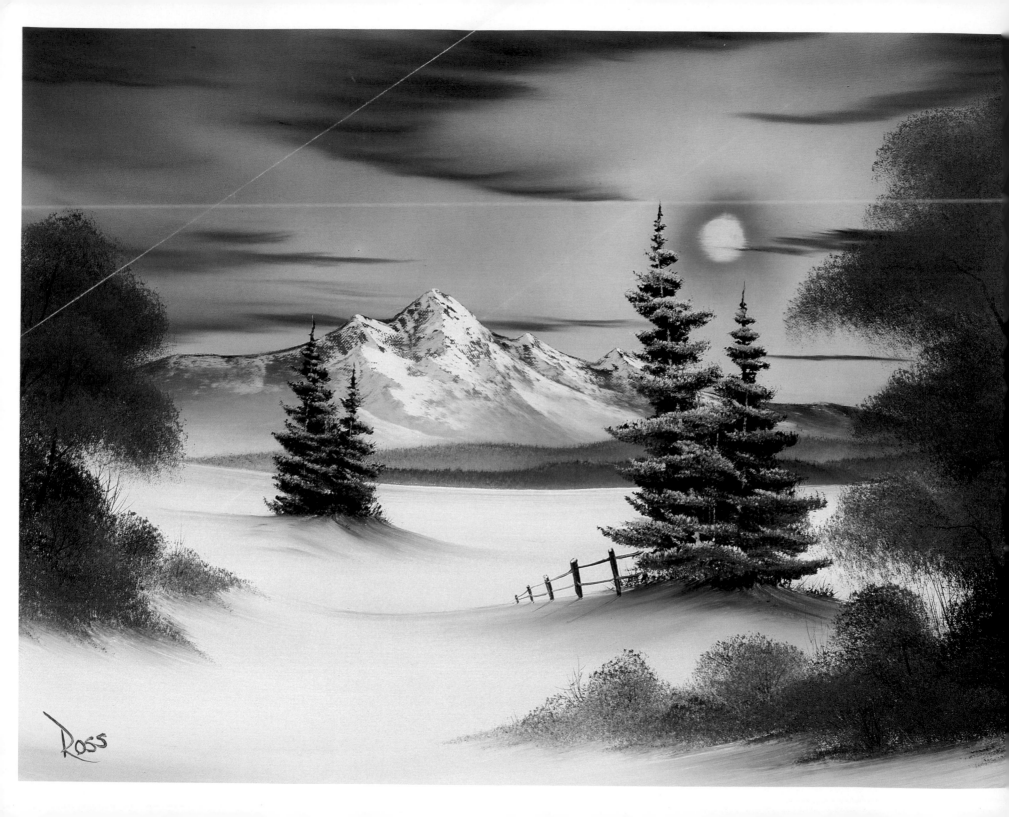

48. SPLENDOR OF WINTER

MATERIALS

2" Brush	Phthalo Blue
1" Brush	Prussian Blue
1" Round Brush	Midnight Black
#6 Fan Brush	Dark Sienna
#3 Fan Brush	Van Dyke Brown
#2 Script Liner Brush	Alizarin Crimson
Large Knife	Cadmium Yellow
Liquid White	Yellow Ochre
Titanium White	Bright Red

Start by covering the entire canvas with a thin, even coat of Liquid White, using the 2" brush. Use long horizontal and vertical strokes, working back and forth to ensure an even distribution of paint on the canvas. Do not allow the Liquid White to dry before you begin.

SKY AND WATER

Create an Orange circle in the sky (where the sun will be) using a mixture of Cadmium Yellow and Bright Red on the 1" brush. (Photo 1.) Clean and dry the brush. With a mixture of Titanium White and Alizarin Crimson, use criss-cross strokes to add a Pink glow around the Orange circle and out along the horizon. (Photo 2.) Add a small amount of Phthalo Blue to the Pink mixture on the palette to make a Lavender color. Still using criss-cross strokes, add the Lavender above the Pink in the sky. Add Midnight Black to the Lavender mixture and apply to the top corners, completely covering the sky portion of the canvas. Starting in the lightest portion of the sky, blend the sky using criss-cross strokes with a clean, dry 2" brush until there are no visible lines between colors.

Use a small amount of Titanium White on your finger to rub the sun in the center of the Orange glow. (Photo 3.) Remove any excess paint with the knife and blend very lightly with the 2" brush.

Load the fan brush with a mixture of Midnight Black and a small amount of Van Dyke Brown. Shape the clouds by holding the brush horizontally and using short, "rocking" strokes. You can pull a few small, thin clouds right across the sun. (Photo 4.) Blend lightly with a clean, dry 2" brush using horizontal strokes. (Photo 5.)

MOUNTAIN

Using a mixture of Midnight Black, Prussian Blue, Van Dyke Brown and Alizarin Crimson, load a small roll of paint on the long edge of the knife, by pulling the mixture out flat on your palette and just cutting across. With firm pressure, shape just the top edge of the distant mountain. (Photo 6.) Since this mountain is far away, you should keep it quite small. Use the knife to remove any excess paint and then with the 2" brush, pull the paint down to the base of the mountain.

Highlights are a mixture of Titanium White with a VERY SMALL amount of Bright Red. Again, load a small roll of paint on the long edge of the knife. Starting at the top of the mountain, glide the knife down the right side of each peak, using so little pressure that the paint "breaks". (Photo 7.)

The shadow color is a mixture of Titanium White and Phthalo Blue applied to the left sides of the peaks. Again, using very little pressure, pull the paint in the opposing direction. With a clean, dry 2" brush (and paying close attention to angles) tap to diffuse the base of the mountain, then gently lift upward to create the illusion of mist.

BACKGROUND

Use the 2" brush to add a small amount of Titanium White to your mountain mixture and then load the brush by tapping the bristles firmly against the palette. Holding the brush horizontally, use just the corner and gentle tapping strokes to shape the foothills at the base of the mountain. (Photo 8.) With the 1" brush and tiny, upward strokes, indicate distant trees on the foothills. Use the 2" brush to firmly tap to diffuse the base of the hills, creating the illusion of mist. Add a closer range of foothills, a little darker in color, using the same technique.

With Titanium White and a very small amount of Phthalo Blue on the 2" brush, add the snow-covered ground to the base of the foothills. Use long, horizontal strokes and pay close attention to the lay-of-the-land. *(Photo 9.)* As you move forward in the painting, add touches of Alizarin Crimson to the White for a warm glow in the snow. *(Photo 10.)*

EVERGREEN TREES

Working forward in layers, add the evergreen trees by loading the small fan brush with a mixture of Midnight Black, Prussian Blue, and Van Dyke Brown. Holding the brush vertically, just touch the canvas to form the center line of the tree. Turn the brush horizontally (using just one corner of the brush) and begin adding the small top branches. Working from side to side, as you move down the tree, use more pressure on the brush (forcing the bristles to bend UPWARD) and automatically the branches will become larger as you near the base of the tree. *(Photo 11.)* With Titanium White on the 2" brush, pull a small amount of the dark mixture from the base of the trees into the snow for shadows. You can add a bit of warmth to the snow by adding a very small amount of Alizarin Crimson to your brush. *(Photo 12.)*

Create just the indication of the evergreen tree trunks using a mixture of Dark Sienna and Titanium White on the long edge of the knife. *(Photo 13.)* Use Titanium White and Phthalo Blue on the fan brush to very lightly highlight the right sides of the evergreen branches, where the light would strike. Go easy, you don't want to "kill" all of the dark base color.

FOREGROUND

Underpaint the leaf-trees and bushes with a mixture of Van Dyke Brown and Dark Sienna. Use the 1" round brush to just tap in the basic shapes, starting at the base of the trees and working upward. *(Photo 14.)* Use thinned Van Dyke Brown on the liner brush to add the trunks, limbs and branches. *(Photo 15.)* With a clean, round brush, gently highlight the leaves using mixtures of Yellow Ochre and Bright Red. Think about form and shape, don't just hit at random.

Use Titanium White on the 2" brush to add snow to the base of the trees and bushes, following the basic lay-of-the-land. *(Photo 16.)* Pull a little of the dark tree color into the snow to create shadow areas. *(Photo 17.)* The small fence is made with thinned Van Dyke Brown on the liner brush and highlighted with Liquid White. *(Photo 18.)*

FINAL TOUCHES

Use thinned Van Dyke Brown on the liner brush to add long grasses, sticks, twigs and other final details. *(Photo 19.)* Also use thinned paint on the liner brush to sign your painting!

Splendor of Winter

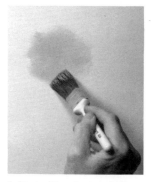 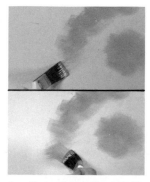 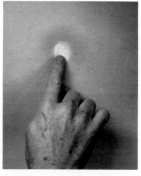 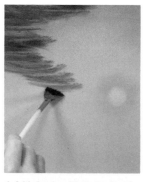 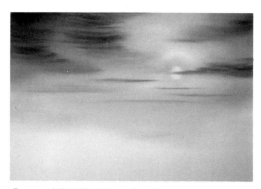

1. Start with an Orange circle...

2....then complete the sky with criss-cross strokes.

3. Use your finger to paint the sun.

4. Add clouds with the fan brush...

5.... and then blend the entire sky.

Splendor of Winter

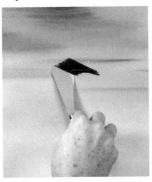

6. Use the knife to shape the mountain . . .

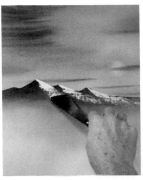

7. . . . and to add the highlights.

8. Tap down foothills with the 2" brush.

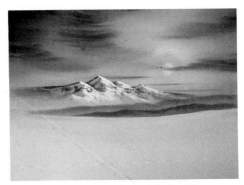

9. Use the 2" brush . . .

10. . . . to add snow to the base of the foothills.

11. Make evergreens with the fan brush . . .

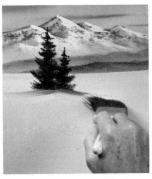

12. . . . add snow to the base with the 2" brush . . .

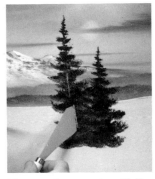

13. . . . and tree trunks with the knife.

14. Use the round brush to paint the large trees . . .

15. . . . then the liner brush . . .

16. . . . then use the 2" brush to add snow . . .

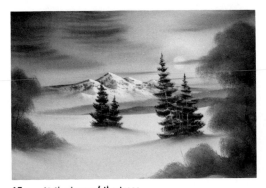

17. . . . to the base of the trees.

18. A small fence . . .

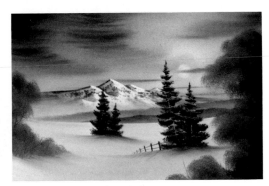

19. . . . will complete the painting.

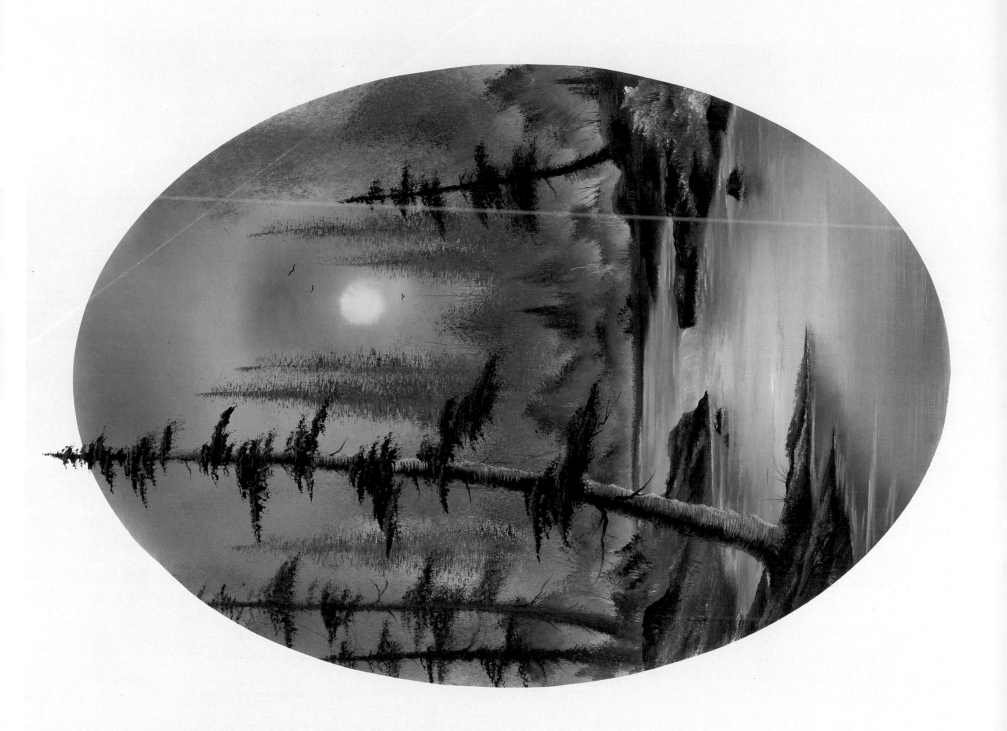

49. GOLDEN MIST OVAL

MATERIALS

2" Brush	Midnight Black
#6 Fan Brush	Dark Sienna
#2 Script Liner Brush	Van Dyke Brown
Large Knife	Alizarin Crimson
Liquid White	Cadmium Yellow
Titanium White	Yellow Ochre
Phthalo Blue	Bright Red

Start by covering the entire vertical canvas with Con-Tact Paper from which you have removed a center oval. (On an 18x24 canvas, I remove a 16x20 oval.) *(Photo 1.)*

Use the 2" brush to cover the exposed area of the canvas with a thin, even coat of Liquid White. With long horizontal and vertical strokes, work back and forth to ensure an even distribution of paint on the canvas. Do NOT allow the Liquid White to dry before you begin.

SKY

Load the 2" brush with a mixture of Dark Sienna and Yellow Ochre, tapping the bristles firmly against the palette to ensure an even distribution of paint throughout the bristles. Use criss-cross strokes to begin adding color to the center area of the sky. Without cleaning the brush, add a small amount of Alizarin Crimson to the outside edges of the sky, still using criss-cross strokes. *(Photo 2.)*

With Cadmium Yellow on the same brush, pull down long, vertical strokes for the bright center area of the water. Use Yellow Ochre and then Dark Sienna as you work towards the outside edges of the water. *(Photo 3.)* You can also add a small amount of Titanium White to the very lightest area in the center of the water. Use long, horizontal strokes to blend the entire canvas. *(Photo 4.)*

With Titanium White on your finger, use a circular motion to add the sun to the painting. *(Photo 5.)* Remove any excess paint with the knife *(Photo 6)* and then again, blend the sky.

BACKGROUND

The tall evergreens in the background are made with a mixture of Dark Sienna, Yellow Ochre and Alizarin Crimson on the 2" brush. Load the brush to a chiseled-edge by "wiggling" it as you pull both sides of the bristles through the mixture. Holding the brush vertically, just press the bristles to the canvas to paint each side of each tree. *(Photo 7.)* The leafy trees in the background are made with the same mixture, this time just tapping downward with the top corner of the 2" brush. *(Photo 8.)*

The distant tree trunks are made with the liner brush, still using the same paint mixture. Dip the brush into thinner and then turn the brush as you pull the bristles through the mixture, forcing them to a sharp point. With very little pressure on the brush, you can just indicate the tiny trunks, limbs and branches. *(Photo 9.)*

Load the fan brush with a Lavender mixture made with Phthalo Blue, Bright Red and Titanium White. With just one corner of the brush use small, circular, push-up strokes to shape the bushes at the base of the trees. *(Photo 10.)* Use the top corner of a clean, dry 2" brush to tap the base of the bushes to create the illusion of mist. *(Photo 11.)* Move forward with another layer of bushes and again mist the base. *(Photo 12.)* You can again use thinned paint on the liner brush to add small details, sticks and twigs.

The banks along the water's edge are made with Van Dyke Brown and Dark Sienna. Pull the mixture out very flat on your palette and just cut across to load the long edge of the knife with a small roll of paint. Pay close attention to angles as you add the land area to the base of the bushes. *(Photo 13.)*

Use the Lavender mixture on the 2" brush to pull down the reflections *(Photo 14)* and then lightly brush across, to give the reflections a watery apperance.

Load the fan brush with a mixture of Yellow Ochre, Bright Red, Cadmium Yellow and Dark Sienna. Hold the brush

horizontally and bend the bristles upward *(Photo 15)* to punch in some small grassy areas on the land *(Photo 16)*.

LARGE EVERGREENS

Use the Lavender mixture (Phthalo Blue, Bright Red and Titanium White) on the fan brush and a series of tap-down strokes to add the evergreen trunks. *(Photo 17.)* Re-load the brush and then use just the corner to begin adding the small top branches. Working from side to side, as you move down each tree, apply more pressure to the brush, forcing the bristles to bend downward *(Photo 18)* and automatically the branches will become larger as you near the base of each tree. Try not to paint too many branches, allow some of the trunk to show through.

Use a mixture of Liquid White, Titanium White and Phthalo Blue on the fan brush and short horizontal strokes to add the water's edge. *(Photo 19.)*

Working forward in layers, continue using Van Dyke Brown on the knife to add the land areas, then pull down reflections with the Lavender mixture on the 2" brush. Add the grassy areas with the Yellow mixtures on the fan brush *(Photo 20)* to the land projections *(Photo 21)*.

WATERFALL

Again, use a mixture of Liquid White, Titanium White and Phthalo Blue on the fan brush for the waterfall. Start with a short horizontal stroke and then pull straight down. *(Photo 22.)*

Use tiny push-up strokes to add the foam action at the base of the falls. Continue bringing the water forward with a series of short, swirling horizontal strokes. *(Photo 23.)*

FOREGROUND

Use the Lavender mixture on the fan brush to tap in the large evergreen trunks in the foreground. *(Photo 24.)* Turn the brush and use just one corner to add the branches. *(Photo 25.)* When you are satisfied with your trees *(Photo 26)* remove the Con-Tact Paper *(Photo 27)* from the canvas *(Photo 28)*.

With a mixture of Phthalo Blue, Bright Red and Midnight Black on the fan brush, tap in the large foreground tree trunk, allowing it to extend outside the oval into the top border. Use Titanium White on the brush and tap to highlight the right side of the large trunk. *(Photo 29.)* Still using the Lavender color, add the large branches with the corner of the fan brush.

FINISHING TOUCHES

Use a mixture of paint thinner and the Lavender color on the liner brush to add the tiny branches and other small details *(Photo 30)* and your finished painting is ready for a signature *(Photo 31)*.

To sign your masterpiece, thin the paint with paint thinner to a water-like consistency. Load the liner brush by slowly turning the handle as you pull the bristles through the mixture. Use very little pressure on the brush, and re-load as necessary, as you use just the point of the bristles to sign your painting.

Golden Mist Oval

1. Cover the canvas with Con-Tact Paper.

2. Paint the sky with criss-cross strokes.

3. Use long vertical strokes to add the water . . .

4. . . . then lightly brush across.

5. Add the sun with your finger . . .

6. . . . then remove excess paint with the knife.

7. Press the brush against the canvas to add evergreens.

8. Tap down with the corner for leafy trees.

Golden Mist Oval

 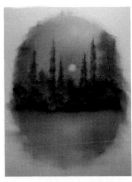 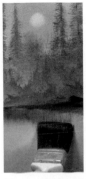 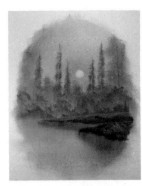

9. Add the trunks with the liner brush . . .

10. . . . and bushes with the fan brush.

11. Tap down with the corner of the 2″ brush . . .

12. . . . to create the illusion of mist.

13. Add the banks with the knife . . .

14. . . . then pull down reflections with the 2″ brush.

15. Use the fan brush to punch in . . .

16. . . . the grassy areas on the banks.

 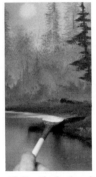 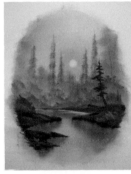 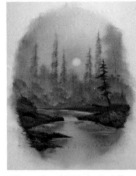

17. Use the fan brush to tap in the trunks . . .

18. . . . and add branches to the evergreens.

19. Use the fan brush to add the water's edge . . .

20. . . . and grassy areas to the banks . . .

21. . . . as you move forward in layers.

22. Pull straight down with the fan brush . . .

23. . . . to add the waterfall.

24. Hold the fan brush vertically to paint the trunks . . .

 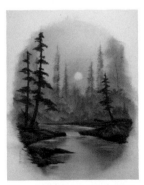 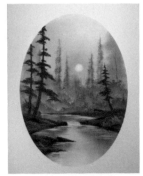 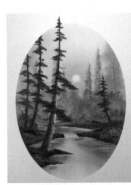

25. . . . and horizontally to add the branches . . .

26. . . . to the large evergreens.

27. Remove the Con-Tact Paper . . .

28. . . . from your canvas.

29. Use the fan brush to add the large trunk . . .

30. . . . and the liner brush to add branches . . .

31. . . . and your painting is finished.

209

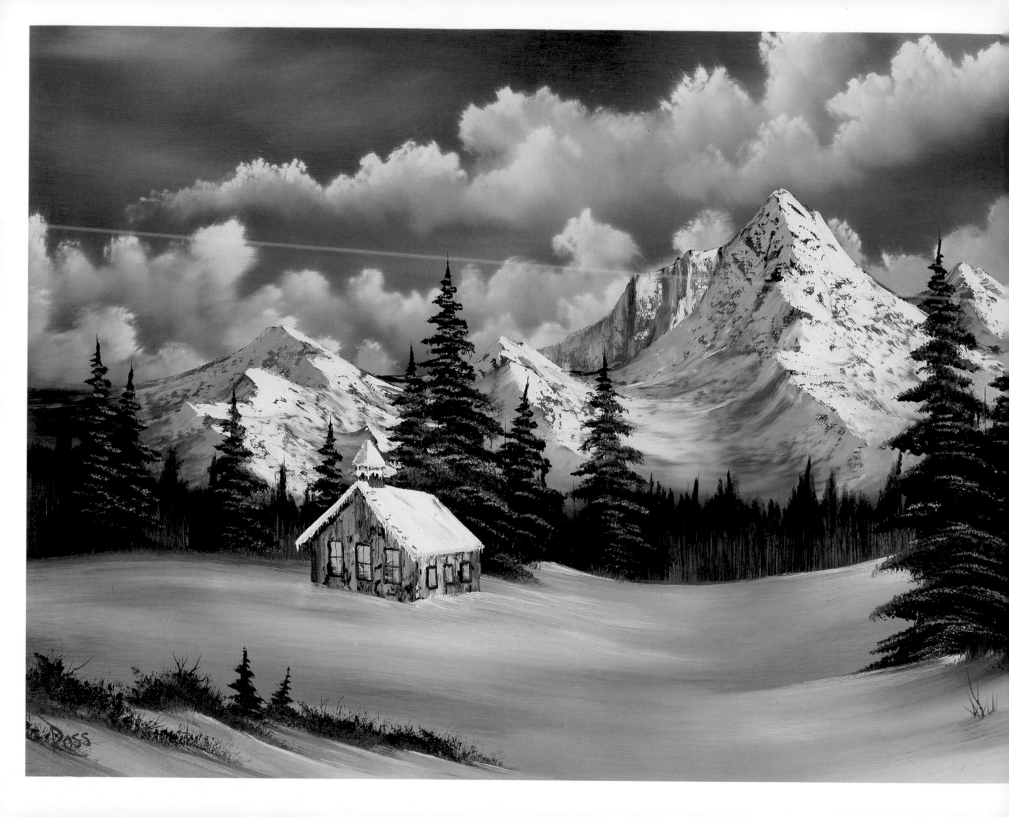

50. CHRISTMAS EVE SNOW

MATERIALS

2" Brush	Phthalo Blue
1" Brush	Prussian Blue
#6 Fan Brush	Midnight Black
#2 Script Liner Brush	Dark Sienna
Large Knife	Van Dyke Brown
Black Gesso	Alizarin Crimson
Titanium White	Cadmium Yellow

Start with a canvas that has been covered with a thin, even coat of Black Gesso and allowed to dry completely. When the canvas is thoroughly dry, use the 2" brush to cover it completely with a thin coat of a mixture of Midnight Black and a small amount of Prussian Blue. DO NOT allow these colors to dry before you begin your painting.

SKY

Load the 2" brush with Titanium White, tapping the bristles firmly against the palette to ensure an even distribution of paint throughout the bristles. Create the sky using very loose, sweeping, criss-cross strokes (Photo 1) and automatically the White will blend with the Midnight Black-Prussian Blue mixture already on the canvas. Blend with long, horizontal strokes.

Use Titanium White on the 1" brush for the clouds. With just one corner of the brush and tiny circular strokes, form the cloud shapes. (Photo 2.) With the top corner of the 2" brush and small circular strokes, blend out the base of the clouds, being very careful not to destroy the top edges. (Photo 3.) Use gentle, sweeping upward strokes to "fluff", then lightly blend the entire sky with long horizontal strokes. (Photo 4.)

MOUNTAIN

The mountains are made with a mixture of Midnight Black, Van Dyke Brown, Prussian Blue and Alizarin Crimson loaded on the long edge of the knife. Using very firm pressure, push the paint into the canvas forming the top edge of a basic mountain shape. (Photo 5.) Use the knife to remove any excess paint from the canvas. With the 2" brush, pull the color down towards the base of the mountain to complete the entire shape. (Photo 6.) Your mountain should be more distinct at the top than at the bottom.

Use a mixture of Titanium White and a small amount of Midnight Black to highlight the mountain. Load the long edge of the knife with a small roll of paint by pulling the mixture out very flat on your palette and just cutting across. Starting at the top of the mountain, glide the knife down the right sides of the peaks, using so little pressure that the paint "breaks". (Photo 7.)

The shadows on the left sides of the peaks are made with a mixture of Prussian Blue, Titanium White and Midnight Black on the knife, and pulled in the opposite direction. Leave some areas dark to create the deepest valleys and recesses.

With the 2" brush, tap to diffuse the base of the mountain, paying close attention to angles. (Photo 8.) Very gently (two hairs and some air!) lift upward with the brush to create a misty effect. (Photo 9.)

BACKGROUND

Load the fan brush with a dark mixture of Prussian Blue, Midnight Black, Van Dyke Brown, Dark Sienna and Alizarin Crimson. Hold the brush vertically and just tap downward for the range of distant evergreen trees along the base of the mountain. (Photo 10.) Create distant tree trunks with the mountain shadow mixture (Titanium White, Midnight Black and Prussian Blue) on the fan brush. Hold the brush horizontally, touch the canvas and gently lift upward. (Photos 11 & 12.)

The larger, more distinct evergreen trees are made by loading the fan brush with the same dark mixture. Holding the brush vertically and starting at the top of the tree, tap firmly downward for the tree trunk. Turn the brush horizontally and begin adding small branches at the top of the tree using just one corner of the brush. Working from side to side, as you move down the tree, use more pressure on the brush (forcing the bristles to bend downward) and automatically the branches will become larger as you near

the base of the tree. *(Photo 13.)* If you have trouble making your paint stick over the mountain mixture already on the canvas, add a little paint thinner to the tree mixture. *(Photo 14.)*

FOREGROUND

With a mixture of Titanium White and the mountain shadow color (Titanium White, Midnight Black and Prussian Blue) on the 2" brush, use horizontal strokes to add snow to the base of the trees and to the remainder of the lower portion of the canvas, allowing it to blend with the Midnight Black-Prussian Blue mixture already on the canvas. Pay close attention to the lay-of-the-land and allow the brush to pull some of the dark tree color into the snow for shadows.

Moving forward in the painting, use the dark mixture of Prussian Blue, Midnight Black, Van Dyke Brown, Dark Sienna and Alizarin Crimson on the fan brush to add the larger evergreen trees on the right side of the painting. Again, use Titanium White on the 2" brush to create the tree shadows in the snow, paying close attention to the lay-of-the-land. Use a Titanium White-Phthalo Blue mixture on the fan brush and short, sweeping, horizontal strokes to create the indication of a path in the snow.

CHURCH BUILDING

Use a clean knife to remove paint from the canvas in the basic shape of a church. With a small roll of Titanium White on the long edge of the knife, and paying close attention to angles, lay in the front of the roof and then the back edge of the roof.

Add the front and side of the church with Van Dyke Brown. Very lightly highlight the front of the church with a mixture of Dark Sienna and Titanium White on the knife, using so little pressure that the paint "breaks". Highlight the side with Van Dyke Brown, Dark Sienna and Titanium White.

The steeple is Van Dyke Brown and then Titanium White for snow. Add the windows with Van Dyke Brown and then Cadmium Yellow to indicate light shining inside the church. Remove excess paint from the base of the building and, with Titanium White on the fan brush, add snow to the base of the building and your church is complete *(Photo 15)*.

FINISHING TOUCHES

Use the dark tree mixture on the fan brush to "push in" small trees, bushes and grassy areas in the foreground *(Photo 16)* and then use the fan brush to add snow to the base of these small happenings *(Photo 17)*. Use the point of the knife to scratch in small details and finally the liner brush with thinned paint to sign your masterpiece! *(Photo 18.)*

Christmas Eve Snow

1. Paint the sky . . .

2. . . . and then add the clouds.

3. Use the 2" brush . . .

4. . . . to blend the cloud shapes.

5. Shape the mountain-top with the knife . . .

6. . . . then pull the paint down to the base with the 2" brush.

212

Christmas Eve Snow

7. Highlight the mountain . . .

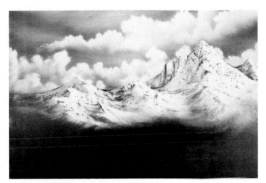

8. . . . then tap with the 2" brush to create mist . . .

9. . . . and the mountain is complete.

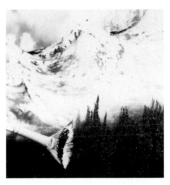

10. Tap down with the fan brush to indicate tiny trees . . .

11. . . . and then pull up the tree trunks . . .

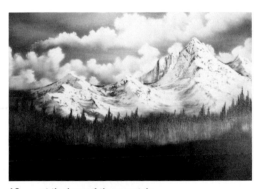

12. . . . at the base of the mountain.

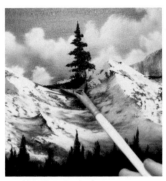

13. Use the fully loaded fan brush . . .

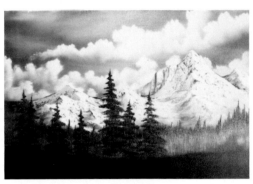

14. . . . to add the larger evergreens.

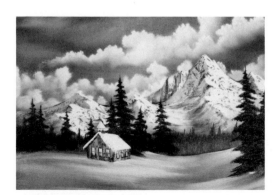

15. The background is complete.

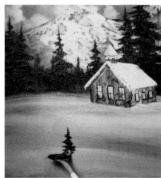

16. Add tiny trees . . .

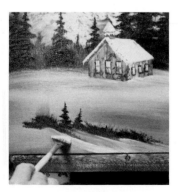

17. . . . and snow to the foreground . . .

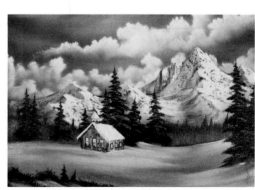

18. . . . and your painting is complete.

213

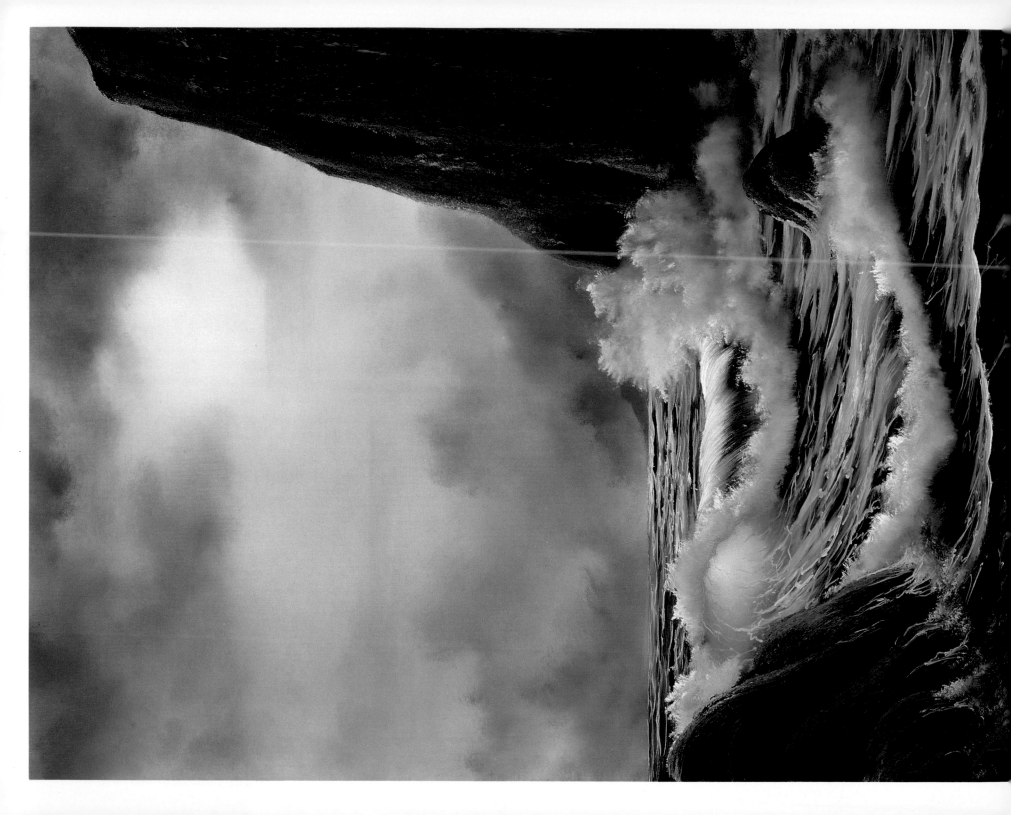

MATERIALS

2″ Brush	Midnight Black
#6 Fan Brush	Dark Sienna
#3 Fan Brush	Van Dyke Brown
#2 Script Liner Brush	Alizarin Crimson
Masking Tape	Sap Green
Black Gesso	Cadmium Yellow
Liquid White	Yellow Ochre
Titanium White	Indian Yellow
Phthalo Blue	Bright Red

After marking the horizon with a short strip of masking tape, use a foam applicator to underpaint the dark areas of the canvas (below the horizon and the cliff shape on the right side) with a thin even coat of Black Gesso *(Photo 1)* and allow to DRY COMPLETELY before you begin.

When the Black Gesso is dry, use the 2″ brush to apply a thin, even coat of a mixture of Alizarin Crimson and Dark Sienna just below the horizon and a mixture of Sap Green and Van Dyke Brown to the lower portion of the canvas. Cover the dark area on the side of the canvas with a thin, even coat of Van Dyke Brown.

Use a clean, dry 2″ brush to cover the light area of the canvas with a thin, even coat of Liquid White. Do NOT allow these colors to dry before you begin.

SKY

Load the 2″ brush with a small amount of Indian Yellow, tapping the bristles firmly against the palette to evenly distribute the paint. Start painting in the center of the sky by making criss-cross strokes near the top of the canvas. Working outward and down towards the horizon, add Cadmium Yellow to the brush, then Yellow Ochre and finally Bright Red just above the horizon. *(Photo 2.)* Lightly blend the entire sky. *(Photo 3.)*

Use a clean, dry brush with Titanium White to make criss-cross strokes in the lightest area of the sky, blending outward.

Load the 2″ brush by tapping the bristles into a Lavender mixture made with Alizarin Crimson and Phthalo Blue. Use small circular strokes, with one corner of the brush, to shape the clouds. *(Photo 4.)* With a clean, dry 2″ brush again, use circular strokes to blend the clouds.

WATER

Remove the masking tape from the canvas to expose a nice, straight horizon line. *(Photo 5.)* Carefully apply a small amount of a mixture of Alizarin Crimson and Dark Sienna to that area of the canvas left dry by the tape.

Use Titanium White on the #3 fan brush to roughly sketch the basic shape of the large wave. *(Photo 6.)*

BACKGROUND WATER

With Titanium White on the small fan brush, paint the background water, along the horizon, with short, horizontal rocking strokes. *(Photo 7.)* Add a small amount of Cadmium Yellow to the water directly under the bright area of the sky. *(Photo 8.)*

LARGE WAVE

Use a mixture of Titanium White and Cadmium Yellow on the fan brush to scrub in the "eye" of the wave. *(Photo 9.)* If necessary, remove the excess paint with the knife and then re-apply to achieve the desired amount of lightness.

Blend the "eye" of the wave with circular strokes using just the top corner of a clean, dry 2″ brush. *(Photo 10.)*

Paying very close attention to the angle of the water, use Titanium White on the large fan brush to pull the water over the top of the wave. *(Photo 11.)*

Re-load the small fan brush with Titanium White and the Lavender mixture (Alizarin Crimson-Phthalo Blue). With just one corner of the brush, use tiny, circular strokes to underpaint the foam at the base and along the edge of the large wave. *(Photo 12.)*

Use the Titanium White-Cadmium Yellow mixture on the small fan brush to highlight the top edges of the foam (where

the light would strike) using small, circular, push-up strokes. (Photo 13.) With the top corner of the 2″ brush and small circular strokes (Photo 14) blend the foam (Photo 15).

FOREGROUND

With a mixture of Titanium White and Phthalo Blue on the fan brush, bring the water forward at the base of the large wave. (Photo 16.) Again, pay close attention to the angle of the water. (Photo 17.) Use tight circular strokes to add the foam action. (Photo 18.) Again, blend with the top corner of a clean, dry 2″ brush.

SMALL DETAILS

Use the liner brush with Titanium White and the Lavender mixture to add the thin line of shadow at the base of the foam. (To load the liner brush, thin the mixture to an ink-like consistency by first dipping the liner brush into paint thinner. Slowly turn the brush as you pull the bristles through the mixture, forcing them to a sharp point.)

You can use a thinned mixture of Titanium White and Phthalo Blue on the liner brush (Photo 19) to add foam details in the "eye" of the wave (Photo 20).

CLIFF AND ROCKS

Load the fan brush with a mixture of Titanium White, Dark Sienna, Alizarin Crimson and Yellow Ochre. Hold the brush vertically and tap downward to shape and highlight the contours of the large dark cliff on the right side of the painting. (Photo 21.) Very lightly blend using vertical strokes with a clean,

dry 2″ brush. (Photo 22.) Be very careful not to completely cover all of the dark undercolor already on the canvas. (Photo 23.)

Use Van Dyke Brown on the fan brush to shape and contour the smaller rocks on the left side. Again, tap downward to highlight with the Titanium White-Dark Sienna-Alizarin Crimson-Yellow Ochre mixture; but, these rocks should remain quite dark.

Use the Titanium White-Phthalo Blue mixture on the fan brush to add the foaming water at the base of the rocks (Photo 24) and dripping water over the rocks (Photo 25). Continue by adding the water line on the beach (Photo 26) then blending it back with the fan brush (Photo 27).

FINISHING TOUCHES

Again, use thinned mixtures on the liner brush to add final small details to the water and your painting is finished. (Photo 28.)

And while you are using the liner brush, add the most important part of your painting, your signature! To sign your painting, again load the liner brush with thinned color of your choice. Sign just your initials, first name, last name or all of your names. Sign in the left corner, the right corner or one artist we know signs right in the middle of the canvas! The choice is yours. You might also consider including the date when you sign your painting. Whatever your choices, relax, have fun, for hopefully with this painting you have truly experienced THE JOY OF PAINTING.

Cliffside

 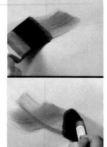 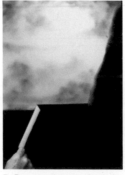 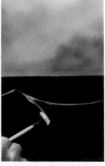 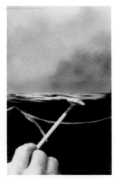

1. Pre-paint the canvas with Black Gesso . . .

2. . . . then use criss-cross strokes . . .

3. . . . to paint the sky.

4. Add clouds with the 2″ brush.

5. Remove the tape from the horizon.

6. Use the fan brush to sketch the large wave . . .

7. . . . then use rocking, horizontal strokes . . .

Cliffside

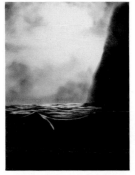

8. . . . to paint the background water.

9. Paint the "eye" of the wave with the fan brush . . .

10. . . . then blend with the 2" brush.

11. Use the fan brush to pull water over the wave . . .

12. . . . to underpaint the foam . . .

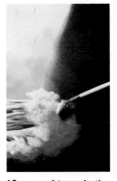

13. . . . and to apply the foamy highlights.

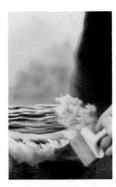

14. Use the 2" brush and circular strokes . . .

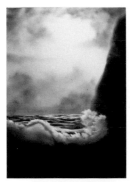

15. . . . to blend the foam.

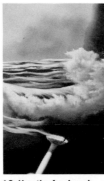

16. Use the fan brush . . .

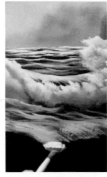

17. . . . to pull the water forward . . .

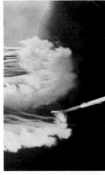

18. . . . and to add the foaming action.

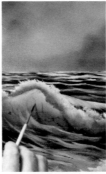

19. With thinned paint on the liner brush . . .

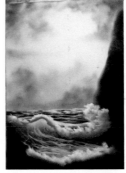

20. . . . you can add small details to the water.

21. Contour the cliff and rocks with the fan brush . . .

22. . . . then brush lightly with the 2" brush . . .

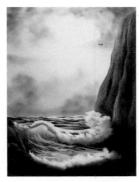

23. . . . to blend and soften.

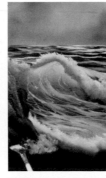

24. Use the fan brush to paint foam . . .

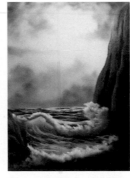

25. . . . at the base of the foreground rocks.

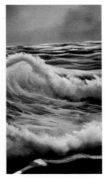

26. Add the water on the beach . . .

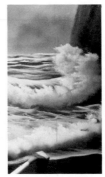

27. . . . then pull it back to blend . . .

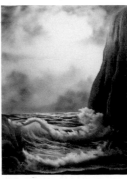

28. . . . and your seascape is ready for a signature!

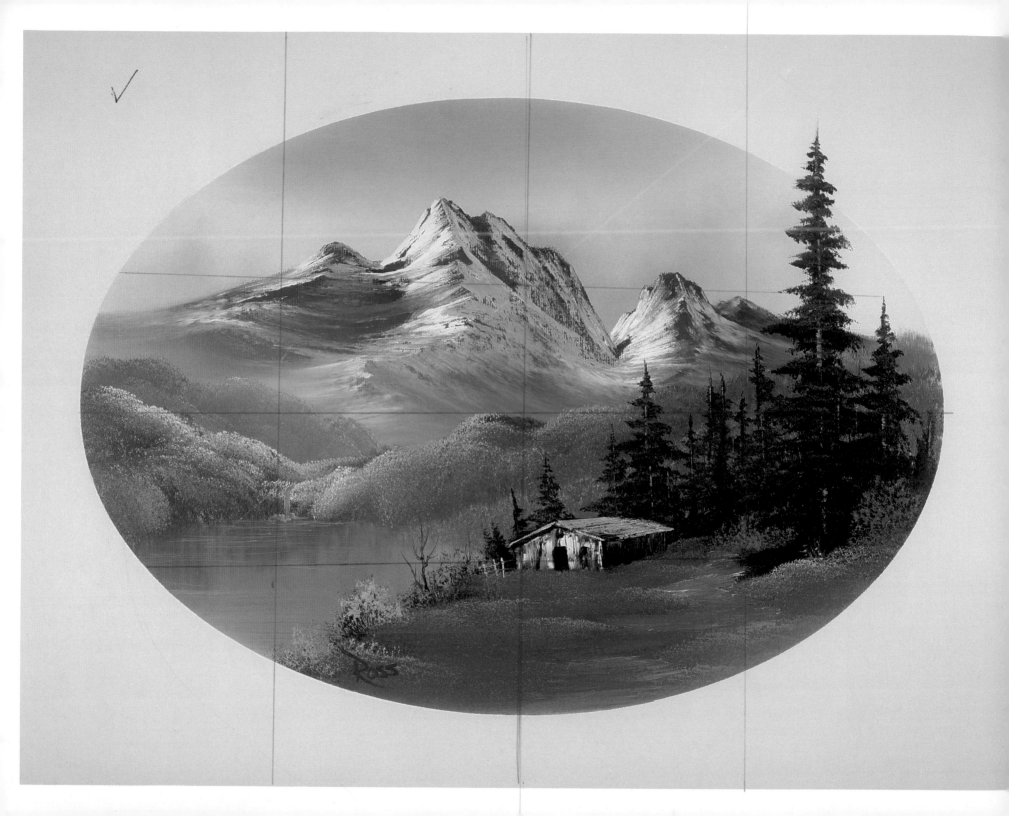

MATERIALS

2″ Brush	Phthalo Blue
1″ Brush	Prussian Blue
1″ Oval Brush	Midnight Black
#6 Fan Brush *trees*	Dark Sienna
#2 Script Liner Brush	Van Dyke Brown
Large Knife	Alizarin Crimson
Small Knife	Sap Green
Adhesive-Backed Plastic	Cadmium Yellow
Liquid White	Yellow Ochre
Titanium White	Indian Yellow
Phthalo Green	Bright Red

Start by covering the entire canvas with a piece of adhesive-backed plastic (such as Con-Tact Paper) from which you have removed a center oval shape. (A 16 x 20 oval for an 18 x 24 canvas.) *(Photo 1.)*

Use the 2″ brush to cover the exposed area of the canvas with a thin, even coat of Liquid White. Do NOT allow the Liquid White to dry before you begin.

SKY

Load the 2″ brush with a small amount of Yellow Ochre and use criss-cross strokes to create a Golden glow in the center of the sky. Without cleaning the brush, re-load it with a small amount of Alizarin Crimson and continue with circular strokes, just above the horizon.

Re-load the brush with Midnight Black and use criss-cross strokes to paint the top portion of the sky *(Photo 2)* and circular strokes just above the horizon *(Photo 3)*.

Underpaint the water on the lower portion of the oval with a mixture of Phthalo Blue and a small amount of Phthalo Green on the 2″ brush. Starting at the bottom of the oval (and working up towards the horizon) use horizontal strokes, pulling from the outside edges of the oval in towards the center. *(Photo 4.)*

Use a clean, dry 2″ brush and criss-cross strokes to blend the sky, then blend the entire oval (sky and water) with long, horizontal strokes. *(Photo 5.)*

MOUNTAIN

To paint the mountain, use the knife and a mixture of Midnight Black and Prussian Blue. Pull the mixture out very flat on your palette, hold the knife straight up and "cut" across the mixture to load the long edge of the blade with a small roll of paint.

With firm pressure, shape just the top edge of the mountain. *(Photo 6.)* When you are satisfied with the basic shape of the mountain top, use the knife to remove any excess paint. Then, with the 2″ brush, blend the paint down to the base of the mountain, creating the illusion of mist. *(Photo 7.)*

Highlight the mountain with a mixture of Titanium White with a very small amount of Dark Sienna. Again, load the long edge of the knife with a small roll of paint. Starting at the top (and paying close attention to angles) glide the knife down the right side of each peak, using so little pressure that the paint "breaks". *(Photo 8.)*

Use a mixture of Titanium White with a small amount of Phthalo Blue and Van Dyke Brown applied in the opposing direction, for the shadowed sides of the peaks. *(Photo 9.)*

Diffuse the base of the mountain by tapping with a clean, dry 2″ brush, carefully following the angles *(Photo 10)* then gently lift upward to create the illusion of mist *(Photo 11)*.

FOOTHILLS

Load the oval brush with a mixture of Midnight Black, Prussian Blue, Sap Green, Van Dyke Brown, Alizarin Crimson and Titanium White. Hold the brush horizontally and just tap downward to shape the rolling hills at the base of the mountain. *(Photo 12.)*

Use the 2″ brush to pull the color down into the water for reflections *(Photo 13)* then lightly brush across.

Re-load the oval brush with various mixtures of Phthalo Green and all of the Yellows to highlight the foothills. Again, just tap downward.

WATERFALL

Paint the waterfall with a mixture of paint thinner and Liquid White on the liner brush *(Photo 14)* then add water lines and ripples to complete the background. *(Photo 15.)*

EVERGREENS

Load the fan brush with a dark-tree mixture of Midnight Black, Prussian Blue, Sap Green, Alizarin Crimson and Van Dyke Brown. Hold the brush vertically and tap downward to paint just the indication of far-away evergreens. *(Photo 16.)*

For the larger evergreens, re-load the fan brush to a chiseled edge with the dark-tree mixture. Holding the brush vertically, touch the canvas to create the center line of each tree. Use just the corner of the brush to begin adding the small top branches. Working from side to side, as you move down each tree, apply more pressure to the brush, forcing the bristles to bend downward and automatically the branches will become larger as you near the base of each tree. *(Photo 17.)*

Add the trunks with a small roll of a mixture of Titanium White and Dark Sienna on the knife. *(Photo 18.)* Use the fan brush to very lightly touch highlights to the branches with a mixture of the dark-tree color and the Yellows.

FOREGROUND

Load the 2" brush with the dark-tree mixture and underpaint the foreground grassy areas by just tapping downward. Use various mixtures of all of the Yellows, Sap Green and Bright Red to highlight the grassy areas. Holding the brush horizontally, gently tap downward *(Photo 19)* carefully creating the lay-of-the-land. *(Photo 20.)*

HOUSE

Use the small knife to remove paint from the canvas in the basic shape of the house. With a small roll of Van Dyke Brown on the long edge of the knife, and paying close attention to angles, paint the back edge of the roof, the front of the roof, the front and then the side of the house.

Use a mixture of Dark Sienna, Bright Red and Titanium White to "bounce" highlights on the roof of the house. Use a mixture of Titanium White, Van Dyke Brown and Dark Sienna to highlight the front and side of the house. Finish the cabin with a Van Dyke Brown door.

Use Van Dyke Brown on the fan brush and horizontal strokes to add the path; graze with Titanium White for highlights. With the Yellow highlight mixtures on the 1" brush, you can add small bushes to the base of the house to complete the oval. *(Photo 21.)*

Remove the Con-Tact Paper from the canvas *(Photo 22)* to expose your painted oval *(Photo 23)*.

FINISHING TOUCHES

Extend a large evergreen outside the painted oval *(Photo 24)* to add an interesting effect to your finished masterpiece *(Photo 25)*.

Haven In The Valley

1. Prepare the canvas with Con-Tact Paper.

2. Use 2" brush to paint sky with crisscross strokes . . .

3. . . . and circular strokes.

4. Underpaint the water with long horizontal strokes.

5. Blend the entire canvas.

6. Shape the mountain top with the knife . . .

Haven In The Valley

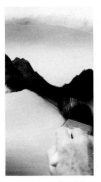

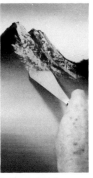

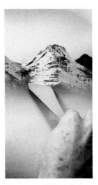

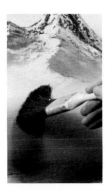

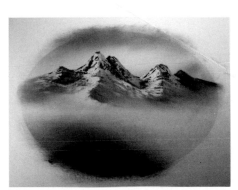

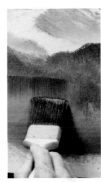

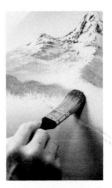

7. . . . then blend the paint down to the base with the 2" brush.

8. Apply shadows . . .

9. . . . and highlights with the knife.

10. Tap the base of the mountain . . .

11. . . . to create the illusion of mist.

12. Use the oval brush to paint the foothills . . .

13. . . . the 2" brush to paint the water . . .

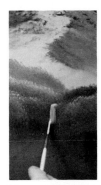

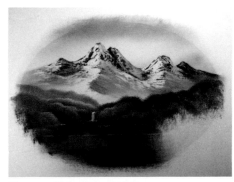

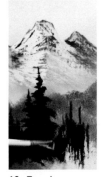

14. . . . and thin paint on the liner brush . . .

15. . . . to add the tiny waterfall.

16. Tap down evergreens with the fan brush . . .

17. . . . and to add branches to the larger trees.

18. Add trunks to the large trees with the knife.

19. Tap down with the 2" brush . . .

20. . . . to paint soft, velvet grass.

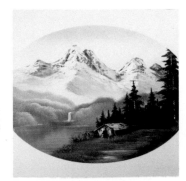

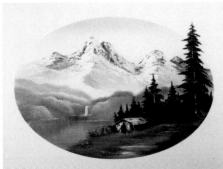

21. When the cabin is complete . . .

22. . . . carefully remove the Con-Tact Paper . . .

23. . . . to expose the painted oval.

24. Extend the tall evergreen . . .

25. . . . outside the oval for an interesting effect.

221

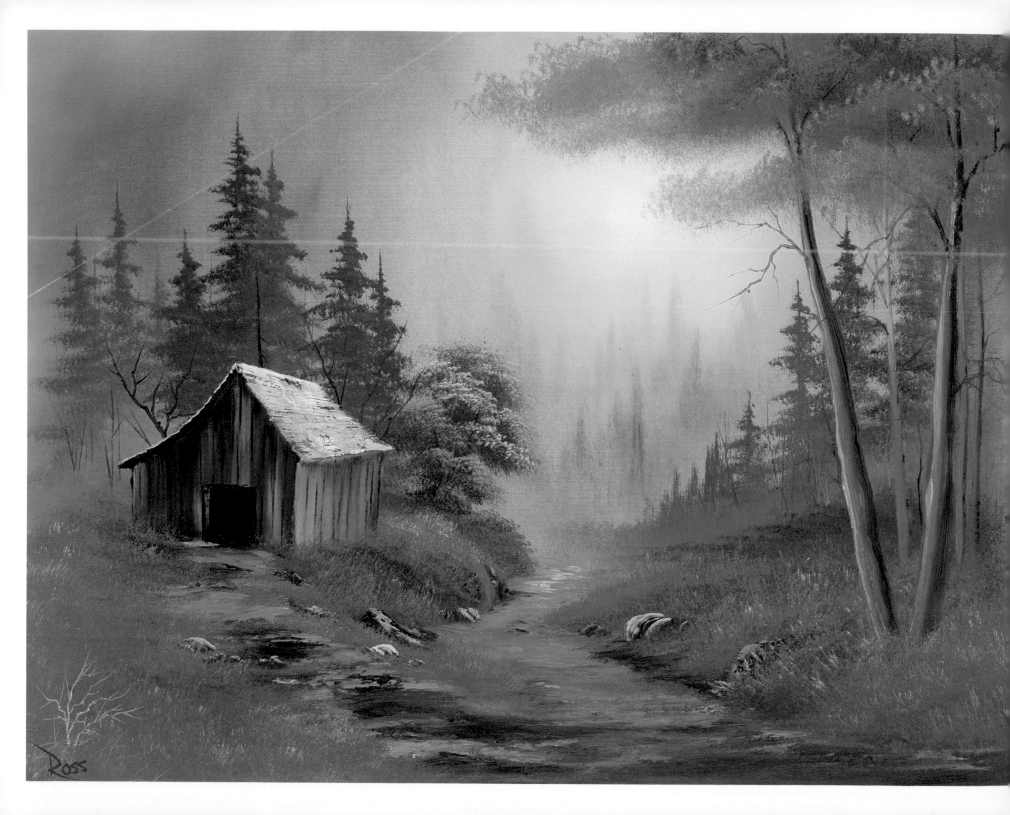

MATERIALS

2″ Brush	Phthalo Blue
1″ Brush	Midnight Black
#6 Fan Brush	Dark Sienna
#2 Script Liner Brush	Van Dyke Brown
Large Knife	Alizarin Crimson
Small Knife	Sap Green
Liquid White	Cadmium Yellow
Liquid Black	Yellow Ochre
Liquid Clear	Indian Yellow
Titanium White	Bright Red

Start by using the 2″ brush to cover the upper, center portion of the canvas with a thin, even coat of a mixture of Liquid White and Liquid Clear. Cover the lower portion and the sides of the canvas with a thin coat of Liquid Black. Use circular, sweeping strokes to lightly blend the harsh division line between the two colors. (Photo 1.)

SKY

Load the 2″ brush with a small amount Yellow Ochre. Starting in the center, lightest area of the sky, begin by making criss-cross strokes. (Photo 2.) As you work outward from the center, still using criss-cross strokes, add Cadmium Yellow to the brush and then a mixture of Yellow Ochre and Dark Sienna. Use Van Dyke Brown on the dark edges of the canvas. Blend the colors together with a clean, dry 2″ brush.

With a clean, dry 2″ brush, use criss-cross strokes to add Titanium White to the light, center of the sky. (Photo 3.) You can even add the indication of the sun with Titanium White on your finger. (Photo 4.) Blend the entire sky. (Photo 5.)

BACKGROUND

Load the fan brush with a mixture of Titanium White, Dark Sienna and Midnight Black. Holding the brush vertically, tap downward to indicate the most distant row of small evergreens along the horizon. (Photo 6.) Use a clean, dry 2″ brush to firmly tap the base of the trees and then lightly lift upward, creating the illusion of mist. (Photo 7.)

Re-load the fan brush with the same mixture, made darker by adding more Dark Sienna and Midnight Black. Working forward in layers, tap downward to add the closer range of trees. (Photo 8.) Again, tap the base of the trees and lift upward, with the 2″ brush, to mist. (Photo 9.)

LARGE EVERGREENS

Working forward in the painting, paint the larger evergreens by loading the fan brush to a chiseled edge with a mixture of Dark Sienna, Van Dyke Brown, Midnight Black and a small amount of Titanium White. Holding the brush vertically, touch the canvas to create the center line of each tree. Use just the corner of the brush to begin adding the small top branches. Working from side to side, as you move down each tree, apply more pressure to the brush, forcing the bristles to bend downward and automatically the branches will become larger as you near the base of each tree. (Photo 10.) Tap the base of the trees with the 2″ brush, to mist.

With the dark evergreen mixture on the 2″ brush, tap downward with one corner of the brush to underpaint the small trees and bushes at the base of the evergreens. (Photo 11.)

After using the point of the knife to scratch in the indication of evergreens trunks, use a mixture of Yellow Ochre and Bright Red on the fan brush to lightly touch highlights to the right sides of the evergreen branches.

Use various mixtures of all of the Yellows, Bright Red and Titanium White on the 2″ brush to highlight the small trees and bushes at the base of the evergreens.

Add the background tree trunks with thinned Van Dyke Brown on the liner brush. Paint the trunks with very little pressure (Photo 12) turning and wiggling the brush to give your trunks a gnarled appearance (Photo 13).

CABIN

Use the knife to remove paint from the canvas in the basic

223

shape of the cabin. With a small roll of Van Dyke Brown on the knife, (and paying close attention to angles) block in the roof, the side and then the front of the cabin.

With a mixture of Titanium White, Dark Sienna and Van Dyke Brown on the knife, highlight the side of the cabin, using so little pressure that the paint "breaks". Use a darker mixture (less White) to highlight the front of the building.

With a very small roll of Van Dyke Brown on the knife, hold the knife vertically and just touch the sides of the cabin to indicate boards, then lightly brush with the 2" brush to give the wood an old, weathered appearance.

With the small knife and Van Dyke Brown, add the door. With the Brown mixture, Titanium White and Midnight Black on the knife, you can "bounce" highlights on the roof to complete the cabin.

Load the 2" brush with a mixture of Van Dyke Brown, Midnight Black and Alizarin Crimson on the knife and tap downward to underpaint the grassy area at the base of the cabin.

Use the 1" brush with various mixtures of Sap Green, all of the Yellows, Midnight Black and Bright Red, to highlight the grassy areas. (Photo 14.)

Add rocks and stones with Van Dyke Brown on the small knife and then highlight with a mixture of Van Dyke Brown and Titanium White. (Photo 15.)

PATHS

To paint the paths, make short, horizontal strokes with the fan brush using a mixture of Van Dyke Brown and Dark Sienna. Highlight by adding Titanium White to the mixture. (Photo 16.) Pay close attention to perspective; the paths should be quite narrow in the background and wider as they move forward. (Photo 17.)

Again, use the 1" brush (Photo 18) to add the grassy highlights to the edges of the paths (Photo 19).

TREES

Load the fan brush with a mixture of Van Dyke Brown and Dark Sienna. Hold the brush vertically and starting at the top of the canvas, use single downward strokes to paint each of the large, foreground tree trunks. (Photo 20.) Highlight the left sides of the trunks with a mixture of Brown and White on the fan brush.

Use thinned Brown on the liner brush to add the limbs and branches to the trunks. (Photo 21.)

With a mixture of Van Dyke Brown, Midnight Black and Phthalo Blue on the 2" brush, underpaint the foliage on the tree. Highlight the foliage with a mixture of Yellow Ochre and Bright Red, forming individual leaf clusters. (Photo 22.)

FINISHING TOUCHES

Use the Yellow highlight mixtures on the 2" brush to add grassy areas to the base of the trees and your painting is ready for a signature. (Photo 23.)

Hidden Delight

1. Pre-paint the canvas with Liquid Black, Clear and White.

2. Paint the sky with criss-cross strokes . . .

3. . . . then add White to the light area.

4. Use your finger to add the sun . . .

5. . . . then blend the entire canvas.

6. Tap down the indication of fir trees . . .

Hidden Delight

 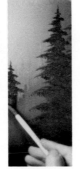 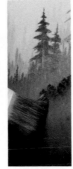 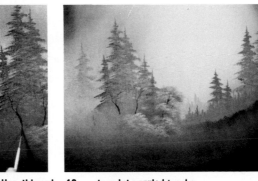

7....then blend the base with the 2" brush.

8. Continue tapping down with the fan brush . . .

9. . . . as you work forward in layers.

10. Larger evergreens are painted with the fan brush . . .

11....and leaf trees with the 2" brush.

12. Use thinned paint on the liner brush . . .

13. . . . to paint gnarled trunks.

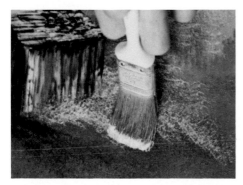 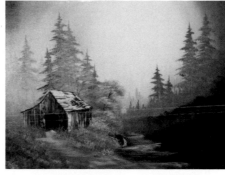

14. Add grassy areas to the base of the cabin with the 1" brush . . .

15. . . . rocks and stones with the small knife.

16. Use the fan brush . . .

17. . . . and horizontal strokes to add the path.

18. Continue adding grassy patches . . .

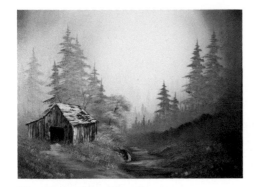 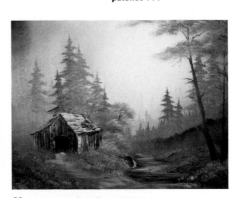

19. . . . to the edges of the path.

20. Paint large tree trunks with the fan brush . . .

21. . . . then use the liner brush to add branches.

22. Add foliage to the large trees . . .

23. . . . to complete the painting.

MATERIALS

2″ Brush	Prussian Blue
1″ Round Brush	Midnight Black
#6 Fan Brush	Dark Sienna
#2 Script Liner Brush	Van Dyke Brown
Large Knife	Alizarin Crimson
Small Knife	Sap Green
Adhesive-Backed Plastic	Cadmium Yellow
Liquid White	Yellow Ochre
Liquid Clear	Indian Yellow
Titanium White	Bright Red
Phthalo Blue	

Cover the entire canvas with adhesive-backed plastic (such as Con-Tact Paper) from which you have removed a center oval. On an 18x24 canvas, the oval I use is 16x20. (Photo 1.)

Cover the center of the exposed area of the canvas with a VERY, VERY THIN, coat of Liquid Clear. Apply a thin, even coat of Liquid White above and below the Liquid Clear. Do NOT allow the Liquid White and Liquid Clear to dry before you begin.

SKY

Load a clean, dry 2″ brush with a very small amount of Phthalo Blue. Starting at the top of the canvas, use crisscross strokes to paint the sky. (Photo 2.) As you work down the canvas, the color will mix with the Liquid White and automatically become quite light as you near the horizon.

Use horizontal strokes to add the color to the bottom of the canvas, pulling from the outside edges. Allow a portion in the center of the canvas to remain quite light, creating the illusion of shimmering light across the water.

Use a mixture of Midnight Black and Prussian Blue on the 2″ brush and circular strokes to shape the clouds. (Photo 3.) Highlight the clouds with Titanium White, using just one corner of the fan brush and tiny circular strokes. (Photo 4.)

Use the top corner of a clean, dry 2″ brush and circular strokes to blend the clouds (Photo 5) then gently lift upward to "fluff" (Photo 6).

BACKGROUND

Load the round brush with a mixture of Midnight Black, Sap Green, Alizarin Crimson and Prussian Blue. Tap downward to shape the background tree along the horizon. (Photo 7.) Firmly tap the base of the trees with a clean, dry 2″ brush, to create the illusion of mist. (Photo 8.) Use a very thin mixture of Titanium White and Dark Sienna on the liner brush to add the tree trunks. (Photo 9.)

Again, use the round brush to highlight the trees with various mixtures of Liquid White, Sap Green and all of the Yellows. (Photo 10.) Use the point of the knife to scratch in small sticks and twigs and that easy, the background is complete! (Photo 11.)

VILLAGE

Load the long edge of the knife with a very small roll of Van Dyke Brown by pulling the paint out flat on your palette and just cutting across.

Use downward strokes with the knife to paint the distant sea wall. Extend the color into the water by pulling straight down with the 2″ brush and then lightly brush across to create the illusion of a reflection. You can indicate the boards in the wall by using the short edge of the knife to firmly remove paint from the wall.

The most distant cabin is made by first using the knife to remove excess paint from the canvas in the basic building shape. Paying close attention to angles, shape the roof and then the front of the cabin with a mixture of Dark Sienna, Alizarin Crimson and Van Dyke Brown on the knife. Again, use the 2″ brush to extend the color into the water and brush across for reflections. With firm pressure on the knife, you can remove paint to highlight the roof and create the board indications on the cabin. Use just Van Dyke Brown to add the doors and windows.

Use a small roll of a mixture of Liquid White, Titanium White and Phthalo Blue on the long edge of the knife to cut in the water lines at the base of the wall and cabin.

Add the posts in the water with Midnight Black and then use the 2" brush to reflect them into the water.

Block in the shape of the closer building with a mixture of Midnight Black and Van Dyke Brown on the knife, then use the 2" brush to reflect the building into the water.

With the small edge of the small knife, you can scrape off the stone shapes on the building. Highlight the roof with a mixture of Dark Sienna, Bright Red and Titanium White on the knife. Use Midnight Black to add the windows and again, remove paint to create the highlights and add small details. When you are satisfied with your reflections, use the Liquid White mixture to cut in the water lines. *(Photo 12.)*

When your buildings are complete *(Photo 13)* remove the Con-Tact Paper from your canvas *(Photo 14)* before continuing with the foreground.

FOREGROUND

Underpaint the basic shape of the large tree and ground area with a mixture of Van Dyke Brown, Dark Sienna, Midnight Black, Prussian Blue and Sap Green on the 2" brush. Allow the tree to extend outside the border created by the removal of the Con-Tact Paper. *(Photo 15.)*

Use the 2" brush to reflect the dark color into the water *(Photo 16)* and then continue underpainting the ground area outside the oval at the bottom of the painting *(Photo 17)*.

Add the tree trunk with the fan brush. Using a mixture of Dark Sienna and Titanium White, start at the top of the tree and pull down. *(Photo 18.)*

Tap downward to highlight the tree and bushes with various mixtures of Sap Green and all of the Yellows on the round brush. *(Photo 19.)* Don't just hit at random, think about form and shape; individual leaf-clusters. Try not to "kill" the dark undercolor, use it to separate the individual shapes.

Use Van Dyke Brown on the knife to add the land areas at the bottom of the painting and then highlight with a mixture of Titanium White and Dark Sienna on the knife, using so little pressure that the paint "breaks". *(Photo 20.)*

With the Yellow-highlight mixtures on the fan brush, use tiny push-up strokes to add the grassy areas. *(Photo 21.)*

FINISHING TOUCHES

Don't forget to use the Liquid White-mixture on the edge of the knife to add water lines and ripples to the new land areas and your little village is finished. *(Photo 22.)*

Country Time

1. Cover the canvas with Con-Tact Paper.

2. Use criss-cross strokes to paint the sky.

3. Add clouds with the 2" brush . . .

4. . . . then highlight with the fan brush.

5. Use the 2" brush to blend the clouds . . .

6. . . . and the entire sky.

228

Country Time

7. Underpaint background trees with the round brush . . .

8. . . . then tap to mist the base of the trees.

9. Use the liner brush to add the trunks . . .

10. . . . and the round brush to add the highlights . . .

11. . . . to the background trees.

12. When the village is complete . . .

13. . . . remove the Con-Tact Paper from the canvas . . .

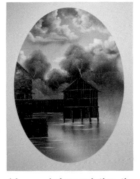

14. . . . before painting the foreground.

15. Underpaint the trees . . .

16. . . . and water, working in layers . . .

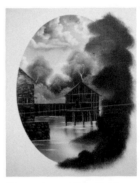

17. . . . to complete the foreground.

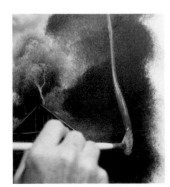

18. Use the fan brush to add the tree trunk . . .

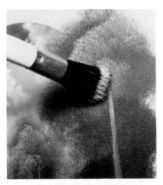

19. . . . then highlight with the round brush.

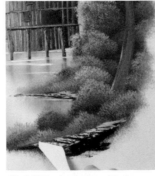

20. Add the land area with the knife . . .

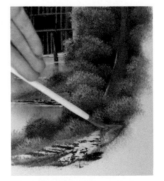

21. . . . then "pop" in grassy areas with the fan brush . . .

22. . . . to complete the painting.

229

MATERIALS

2" Brush	Titanium White
1" Brush	Phthalo Blue
1" Round Brush	Midnight Black
#6 Filbert Brush	Dark Sienna
#6 Fan Brush	Van Dyke Brown
#2 Script Liner Brush	Alizarin Crimson
Large Knife	Sap Green
Black Gesso	Cadmium Yellow
Liquid White	Yellow Ochre
Liquid Clear	Bright Red

Use a foam applicator to cover your canvas with an even coat of Black Gesso, allowing the Gesso to become very thin and feathered around the irregular-shaped area in the sky, which remains unpainted. *(Photo 1.)* Allow the Black Gesso to dry completely before you begin your painting.

Use the 2" brush to cover the dry Black Gesso with an EXTREMELY THIN coat of Liquid Clear. Apply a mixture of Phthalo Blue and Alizarin Crimson over the wet Liquid Clear. Cover the White, unpainted area in the sky with a thin, even coat of Liquid White. Do NOT allow these colors to dry before you begin. *(Photo 2.)*

SKY

Load the 2" brush with a small amount of Phthalo Blue and use criss-cross strokes to apply the color to the upper portion of the light area of the sky. Use a mixture of Titanium White and Yellow Ochre for the lower portion, just above the horizon.

BACKGROUND

Use the 2" brush with a very small amount of the same Phthalo Blue-Alizarin Crimson mixture to tap in the basic shape of the soft, background trees. *(Photo 3.)* Thin the same mixture with paint thinner and use the liner brush *(Photo 4)* to add the tree trunks to the background *(Photo 5)*.

Use the round brush and various mixtures of Sap Green, Cadmium Yellow, Midnight Black and the Lavender mixture to tap in additional small trees and bushes along the horizon.

Use the same mixtures and the 2" brush to highlight the soft grassy areas. Load the brush by holding it at a 45-degree angle and tapping the bristles into the various paint mixtures. Allow the brush to "slide" slightly forward in the paint each time you tap (this assures that the very tips of the bristles are fully loaded with paint). Hold the brush horizontally and gently tap downward, carefully creating the lay-of-the-land. *(Photo 6.)* If you are also careful not to destroy all of the dark color already on the canvas, you can create grassy highlights that look almost like velvet.

Use a mixture of Van Dyke Brown, Dark Sienna and Titanium White for the path. Load the long edge of the knife with a small roll of paint and use short, horizontal strokes. *(Photo 7.)* With a clean, dry 2" brush use horizontal strokes *(Photo 8)* to blend and soften the path *(Photo 9)*.

LARGE TREES

The large tree trunks are made with a mixture of Van Dyke Brown, Dark Sienna and Midnight Black on the fan brush. Holding the brush vertically, start at the top of the canvas and just pull downward. *(Photo 10.)*

The tree-trunk highlights are made with the knife and a mixture of Titanium White, Dark Sienna and Bright Red. In this painting, the source of light is in the center, so highlight the right sides of the trees on the left and the left sides of the trees on the right. With a very small roll of paint on the long edge of the knife, hold the knife vertically, touch the side of each trunk and just pull down to the base. Use so little pressure that the paint "breaks". *(Photo 11.)* Touch Phthalo Blue and Titanium White to the shadow sides of the trunks.

Limbs and branches are added with a very thin mixture of Van Dyke Brown and Titanium White on the liner brush. *(Photo 12.)*

Add foliage to the trees by tapping the bristles of the 1" brush into various mixtures of Liquid White, Sap Green and the Yellows. Just tap downward with the brush *(Photo 13)* to create the leaf clusters. Don't be in too much of a hurry here,

you want individual limbs and branches. You can create form and shape in your trees if you are very careful not to "kill" all of the dark color already on the canvas. (Photo 14.)

FINISHING TOUCHES

Add the tiny people on the path with the filbert brush. Use a single stroke of bright Red for the shirt on one person (Photo 15) and Yellow Ochre for the other (Photo 16). One has a Titanium White skirt (Photo 17), the other is Midnight Black. Use the liner brush and thinned Midnight Black to add the hair (Photo 18) and feet (Photo 19) and the painting is finished (Photo 20)!

Use thinned paint on the liner brush to add the most important part of your painting, your signature! Stand back and admire your masterpiece.

Morning Walk

1. Apply Black Gesso to the canvas.

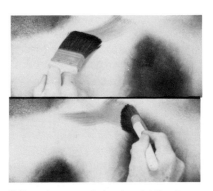

2. Use criss-cross strokes to paint the sky.

3. Soft background trees are made with the 2" brush.

4. Use thinned paint on the liner brush . . .

5. . . . to add the tree trunks.

6. Tap down with the 2" brush to paint the grassy areas.

7. Paint the path with the knife . . .

8. . . . then use horizontal strokes with the 2" brush . . .

Morning Walk

9. . . . to blend the path.

10. Pull down trunks with the fan brush . . .

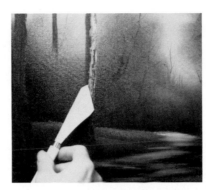

11. . . . then add highlights with the knife . . .

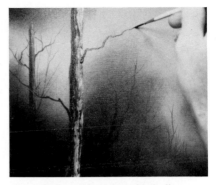

12. . . . limbs and branches with the liner brush . . .

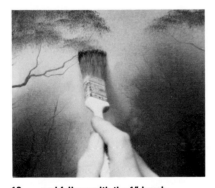

13. . . . and foliage with the 1″ brush . . .

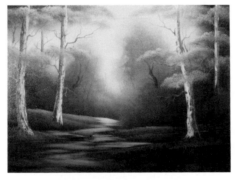

14. . . . to complete the trees.

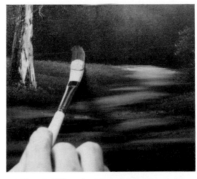

15. Use the filbert brush and a single stroke . . .

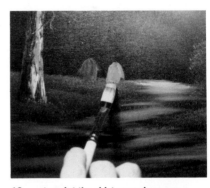

16. . . . to paint the shirt on each person.

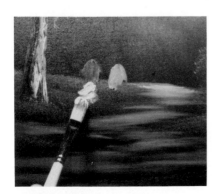

17. Add the skirts . . .

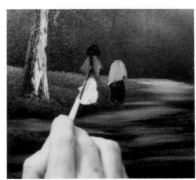

18. . . . and then the hair . . .

19. . . . and feet . . .

20. . . . and your painting is finished.

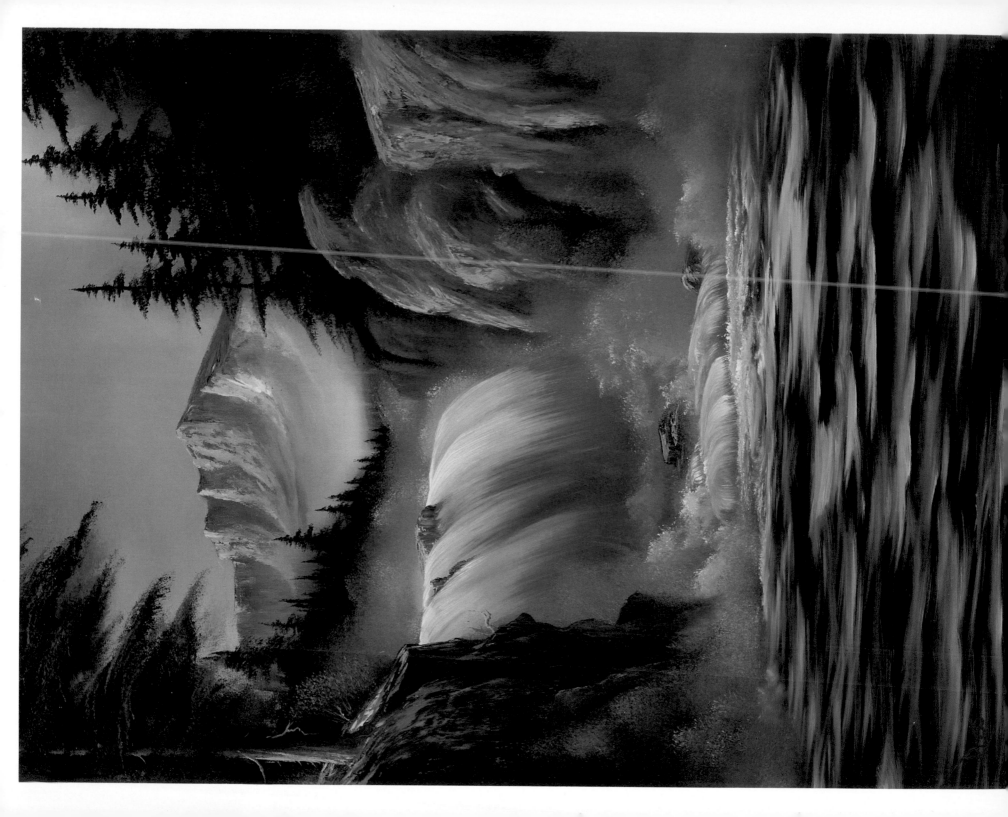

MATERIALS

2" Brush	Phthalo Blue
1" Brush	Prussian Blue
#6 Fan Brush	Midnight Black
#2 Script Liner Brush	Dark Sienna
Large Knife	Van Dyke Brown
Small Knife	Alizarin Crimson
Black Gesso	Sap Green
Liquid White	Cadmium Yellow
Liquid Clear	Yellow Ochre
Titanium White	Indian Yellow
Phthalo Green	Bright Red

Before beginning your painting, use a foam applicator and Black Gesso to block in the basic dark shapes on your canvas. Allow the Black Gesso to dry completely. *(Photo 1.)*

Use the 2" brush to cover the Black Gesso with a VERY, VERY THIN coat of Liquid Clear. Do NOT allow the Liquid Clear to dry.

Apply a thin even coat of a mixture of Phthalo Blue and Alizarin Crimson to the sides of the canvas and a mixture of Dark Sienna and Indian Yellow across the bottom of the canvas. Apply a thin, even coat of Liquid White to the light, unpainted area in the sky. Do NOT allow these paints to dry before you begin.

SKY

Load the 2" brush with a very small amount of Phthalo Blue, tapping the bristles firmly against the palette to ensure an even distribution of paint throughout the bristles. Starting at the top of the canvas and working downward, use criss-cross strokes to paint the sky. *(Photo 2.)*

Load the corner of a clean, dry 2" brush with a mixture of Titanium White and Cadmium Yellow. With the paint-filled corner down, start at the horizon and work upward, still making criss-cross strokes. This will create a very light area just at the horizon. Blend the entire canvas. *(Photo 3.)*

MOUNTAIN

The mountain is made with a mixture of Alizarin Crimson and Phthalo Blue. Pull the paint out very flat on your palette and just cut across to load the long edge of the knife with a small roll of paint. Use firm pressure to shape the top edge of the mountain. *(Photo 4.)* With a clean, dry 2" brush, blend the paint down to the base of the mountain to complete the entire shape. *(Photo 5.)*

Make a Lavender shadow-mixture of Alizarin Crimson, Phthalo Blue and a small amount of Titanium White. The source of light in this painting is from the left side. With a small roll of the Lavender mixture on the knife, apply the shadows to the right sides of the peaks, using so little pressure that the paint "breaks".

The highlights are Titanium White with a very, very small amount of the Lavender mixture and Bright Red. Again, load the knife with a small roll of paint, touch the top of each peak and glide the knife down the left sides. Use the small knife for the small light areas of the mountain. Pay close attention to angles and use so little pressure that the paint is allowed to "break". *(Photo 6.)*

Still following the angles, tap the base of the mountain with a clean, dry 2" brush *(Photo 7)* and then left upward to create the illusion of mist *(Photo 8)*.

BACKGROUND

Load the fan brush with Midnight Black, Prussian Blue and Phthalo Green. Hold the brush vertically and just tap downward to indicate the tiny evergreens at the base of the mountain. *(Photo 9.)* Be careful not to "kill" your nice misty area below the mountain. Use just the corner of the fan brush to add tiny branches to a few of the more distinct trees. *(Photo 10.)*

With a very small amount of Titanium White on the 2" brush, firmly tap the base of the trees *(Photo 11)* to create the illusion of mist *(Photo 12)*.

ROCKS

With Van Dyke Brown, Dark Sienna and Alizarin Crimson on the fan brush, block in the basic shapes of the large rocks

behind the waterfall. Re-load the fan brush with Titanium White, Alizarin Crimson and Prussian Blue to shape and contour the rocks. *(Photo 13.)*

Highlight the rocks with a mixture of Titanium White and Dark Sienna on the knife. Again, use so little pressure that the paint "breaks". *(Photo 14.)* Graze the rocks with the 2" brush, to very lightly blend and contour.

WATERFALL

Load the 1" brush with a mixture of Liquid Clear and Titanium White. Paying very close attention to angles, shape and form, use single, downward strokes to begin painting the waterfall. *(Photo 15.)*

Add the small rocks at the top of the falls with Van Dyke Brown on the small knife (highlight with a mixture of Titanium White and Dark Sienna) and then complete the falls with single, downward strokes. Automatically, the water should be darker at the base than at the top, where the light would strike.

FOREGROUND

Working forward in the painting, continue using the fan brush to add the rocks on either side of the falls. Highlight with the knife and then again, lightly blend with the 2" brush.

Use a mixture of Sap Green and Cadmium Yellow on the corner of the 2" brush to tap in the foliage at the base of the rocks *(Photo 16)*.

Use Titanium White and circular strokes with the top corner of the 2" brush to mist the base of the falls. Tap lightly to blend. *(Photo 17.)*

With Liquid Clear and Titanium White on the fan brush, continue adding the water action: downward strokes for small falls *(Photo 18)* and push-up strokes for the foaming action *(Photo 19)*. Use the small knife to add the small stones to the water.

EVERGREENS

Load the fan brush with a mixture of Prussian Blue, Alizarin Crimson, Midnight Black and Phthalo Green to add the large evergreens on the right side (at the top of the falls). Holding the brush vertically, touch the canvas to create the center line of each tree. Use just the corner of the brush to begin adding the small top branches. Working from side to side, as you move down each tree, apply more pressure to the brush, forcing the bristles to bend downward *(Photo 20)* and automatically the branches will become larger as you near the base of the tree.

After completing the rocks and foliage on the left side of the painting use the fan brush and a mixture of Van Dyke Brown and Titanium White to add the large tree trunk *(Photo 21)*. With a thinned mixture of Van Dyke Brown and Titanium White on the liner brush, add the limbs and branches. *(Photo 22.)*

Very lightly highlight the tree foliage with a dark Green mixture on the fan brush *(Photo 23)* paying close attention to the shape and form of your tree *(Photo 24)*.

FINISHING TOUCHES

Continue moving the water forward with swirling, horizontal strokes with the fan brush *(Photo 25)* and your beautiful waterfall painting is ready for a signature *(Photo 26)*.

Spectacular Waterfall

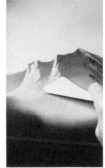
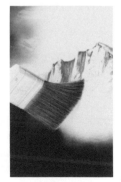

1. Underpaint the dark areas with Black Gesso.

2. Use criss-cross strokes . . .

3. . . . to paint the sky.

4. Shape the mountain top . . .

5. . . . then pull the paint down to the base.

6. Highlight with the knife . . .

7. . . . then tap the base . . .

Spectacular Waterfall

8. . . . to create the illusion of mist.

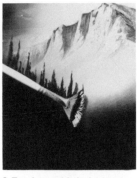
9. Tap down with the fan brush . . .

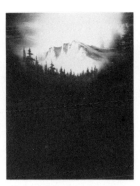
10. . . . to add the distant evergreens.

11. Tap the base of the trees . . .

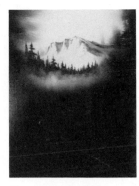
12. . . . to create mist.

13. Shape rocks with the fan brush . . .

14. . . . then highlight with the knife.

15. Use single strokes to paint the waterfall.

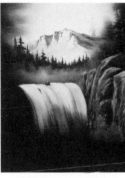
16. Use the 2″ brush to add the foliage . . .

17. . . . and mist to the base of the rocks.

18. Add the small waterfall . . .

19. . . . and foam with the fan brush.

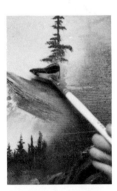
20. Paint large evergreens with the fan brush.

21. Paint the large trunk with the fan brush . . .

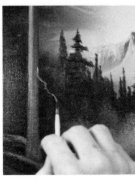
22. . . . then add limbs and branches with the liner brush.

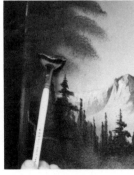
23. Use the fan brush to add foliage . . .

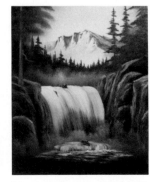
24. . . . to the large foreground tree.

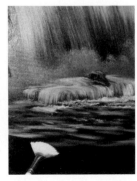
25. Continue moving the water forward . . .

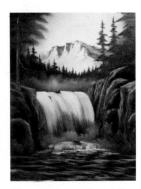
26. . . . to complete the painting.

237

57. FINAL EMBERS OF SUNLIGHT

MATERIALS

2″ Brush	Midnight Black
#6 Fan Brush	Dark Sienna
#2 Script Liner Brush	Van Dyke Brown
Adhesive-Backed Plastic	Alizarin Crimson
Black Gesso	Sap Green
Liquid White	Cadmium Yellow
Titanium White	Yellow Ochre
Phthalo Blue	Indian Yellow
Prussian Blue	Bright Red

Start by covering the entire canvas with a piece of adhesive-backed plastic (such as Con-Tact Paper) from which you have removed a center oval shape. (A 16 x 20 oval for an 18 x 24 canvas.)

I have found that a simple way to cut an oval from Con-Tact Paper is to use a common household item as a template. You can use an oval-shaped placemat, a roaster pan lid, perhaps a turkey platter, etc. Place your "template" on the Con-Tact Paper and carefully trace around the edges with an X-Acto Knife. Presto! You have removed the center oval-shape. BE SURE to do your tracing and cutting on a cutting mat or piece of thick cardboard. (You can ruin a fine table-top with an X-Acto Knife!)

Use a foam brush to apply Black Gesso to the exposed oval-area of the canvas and allow to DRY COMPLETELY.

Over the dry Black Gesso, use the 2″ brush to apply a thin, even coat of Indian Yellow through the center of the oval, along the horizon. Apply Alizarin Crimson above the Indian Yellow and then a mixture of Alizarin Crimson and Phthalo Blue to the top of the canvas and also the entire bottom portion of the canvas.

SKY

Load the 2″ brush by pulling both sides of the bristles through Titanium White. Starting just above the horizon, use criss-cross strokes to begin painting the sky. (Photo 1.) As you work upward, notice how the White blends with the color already on the canvas and automatically the sky becomes darker as you near the top of the canvas. Use a clean, dry 2″ brush and long, horizontal strokes to very lightly blend the entire sky, "three hairs and some air".

The clouds are made with Phthalo Blue and Alizarin Crimson on the fan brush. Use one corner of the brush and small, circular strokes to form the basic cloud-shapes. (Photo 2.) Use horizontal strokes to add the "stringy" clouds. (Photo 3.) Lightly blend with a clean, dry 2″ brush, again using circular strokes for the fluffy clouds (Photo 4) and horizontal strokes for the "stringy" clouds. Gently lift upward to "fluff" (Photo 5).

BACKGROUND

Load the 2″ brush with Alizarin Crimson, Prussian Blue and Van Dyke Brown. Tap downward with just the corner of the brush to shape the small background bushes (Photo 6) and trees along the horizon (Photo 7).

Add the background tree trunks using the same dark mixture and the liner brush. (Photo 8.) (To load the liner brush, thin the mixture to an ink-like consistency by first dipping the liner brush into paint thinner. Slowly turn the brush as you pull the bristles through the mixture, forcing them to a sharp point.) Paint the trunks with very little pressure, turning and wiggling the brush to give your trunks a gnarled appearance. (Photo 9.)

Use the 2″ brush and various mixtures of Sap Green, all of the Yellows, a small amount of Midnight Black and Bright Red to highlight the background trees. Load the 2″ brush by holding it at a 45-degree angle and tapping the bristles into the various paint mixtures. Allow the brush to "slide" slightly forward in the paint each time you tap (this assures that the very tips of the bristles are fully loaded with paint).

Highlight the trees by again, tapping downward with just the corner of the brush. (Photo 10.) At the same time, add the small bushes at the base of the trees. Pay close attention to shape and form and take note of the light source, one side of

each tree should remain in shadow. Try not to just "hit" at random and be very careful not to completely cover all of the dark under-color already on the canvas.

Use the Alizarin Crimson-Phthalo Blue-Van Dyke Brown mixture on the 2″ brush to under-paint the soft grassy areas. *(Photo 11.)*

Continuing to use the same Yellow-highlight mixtures to fully load the bristle tips, highlight the soft grassy areas. Starting at the base of the trees and working forward, hold the brush horizontally and gently tap downward. *(Photo 12.)* Work in layers, carefully creating the lay-of-the-land and at the same time, trying not to extend the grass into the path area. If you are again careful not to destroy all of the dark color already on the canvas, you can create grassy highlights that look almost like velvet. *(Photo 13.)*

PATH

Use a mixture of Dark Sienna, Van Dyke Brown and Titanium White on the fan brush and horizontal strokes to add the path. Very lightly highlight the path with Titanium White on the fan brush. *(Photo 14.)* Watch the perspective here, the path is quite narrow as it disappears into the background. *(Photo 15.)*

TREES

With Van Dyke Brown on the fan brush, hold the brush vertically, and starting at the top of each tree, just pull down to paint the trunks. *(Photo 16.)*

Add limbs and branches to these trunks with thinned Van Dyke Brown on the liner brush. *(Photo 17.)*

Highlight the light side of the trunks with thinned Bright Red on the liner brush. *(Photo 18.)*

Use Midnight Black, Alizarin Crimson and a small amount of Bright Red to paint the foliage on the trees. *(Photo 19.)* Again, tap downward with just the corner of the 2″ brush, carefully forming leaf-clusters. *(Photo 20.)*

Carefully remove the Con-Tact Paper from the canvas *(Photo 21)* to expose your painted oval-sunset *(Photo 22)*.

FINISHING TOUCHES

If you prefer, you can extend the painting beyond the borders of the oval or enjoy your masterpiece as it is.

Don't forget to sign your painting. Again, load the liner brush with thinned color of your choice. Sign just your initials, first name, last name or all of your names. Sign in the left corner, the right corner or one artist signs right in the middle of the canvas! The choice is yours. You might also consider including the date when you sign your painting. Whatever your choices, have fun, keep in mind you are truly experiencing THE JOY OF PAINTING!

Final Embers Of Sunlight

1. Paint the sky with criss-cross strokes.

2. Use circular strokes for the clouds . . .

3. . . . horizontal strokes for the "stringy" clouds.

4. Use the 2″ brush to blend . . .

5. . . . and fluff the clouds.

6. Tap down background bushes . . .

7. . . . and trees with the 2″ brush.

240

Final Embers Of Sunlight

8. Use thinned paint on the liner brush . . .

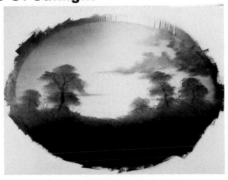

9. . . . to paint the tree trunks.

10. Tap down with the 2" brush to highlight trees.

11. Add soft grassy areas . . .

12. . . . and highlight with the 2" brush . . .

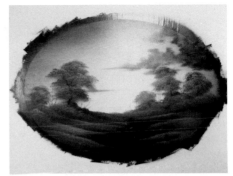

13. . . . paying close attention to the lay-of-the-land.

14. Use horizontal strokes with the fan brush . . .

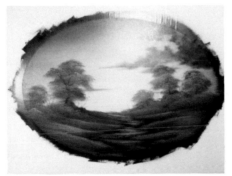

15. . . . to add the path.

16. Large tree trunks are made with the fan brush . . .

17. . . . then use the liner brush . . .

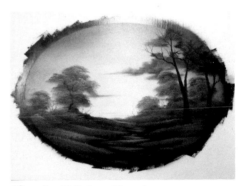

18. . . . to add limbs and branches.

19. Use the corner of the 2" brush . . .

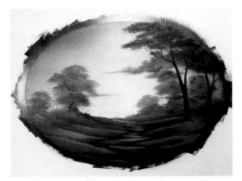

20. . . . to add foliage to the trees.

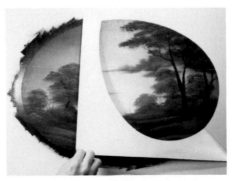

21. Remove the Con-Tact Paper from the canvas . . .

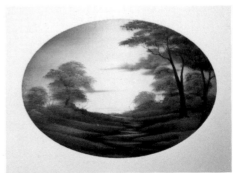

22. . . . to expose the finished painting.

241

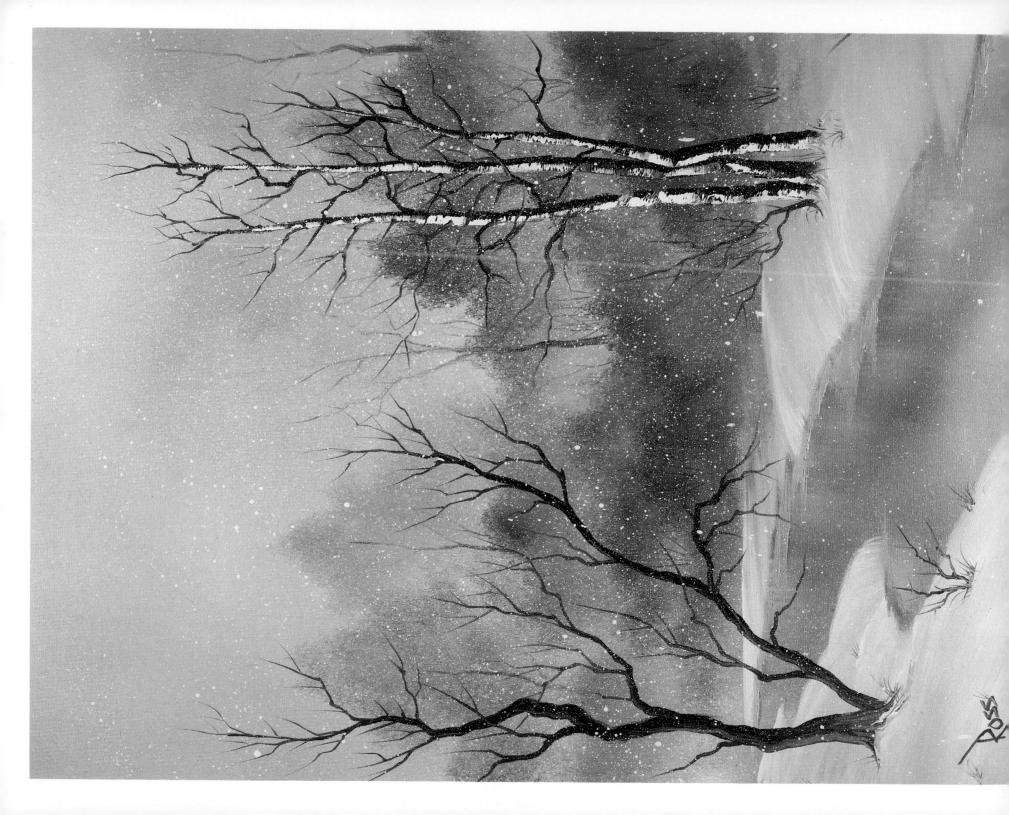

58. SNOWFALL MAGIC

MATERIALS

2" Brush	Dark Sienna
#6 Fan Brush	Van Dyke Brown
#2 Script Liner Brush	Alizarin Crimson
Large Knife	Cadmium Yellow
Liquid White	Yellow Ochre
Titanium White	Indian Yellow
Phthalo Blue	Bright Red
Midnight Black	

Start by covering the entire canvas with a thin even coat of Liquid White. With long horizontal and vertical strokes, work back and forth to ensure an even distribution of paint on the canvas. Do NOT allow the Liquid White to dry before you begin.

SKY

Load the 2" brush with Indian Yellow, tapping the bristles firmly against the palette to ensure an even distribution of paint throughout the bristles. Starting at the top of the canvas, use criss cross strokes to paint the sky. (Photo 1.)

As you work down the canvas, add Alizarin Crimson to the brush to create the "Peachy" areas in the sky. Notice how the color blends with the Liquid White already on the canvas, and automatically the sky becomes lighter as you near the horizon. Blend the entire sky. (Photo 2.)

BACKGROUND

Without cleaning the brush, re-load it by tapping the corner of the bristles into a small amount of a mixture of Bright Red and Midnight Black. With that paint-filled corner up, hold the brush vertically and just tap downward to indicate the most distant, hazy tree shapes along the horizon. (Photo 3.) As you work forward in layers, use more paint on the brush (including various mixtures of Dark Sienna and Van Dyke Brown) (Photo 4) and automatically the background trees will become darker and more distinct (Photo 5).

Add the background tree trunks (Photo 6) using the Midnight Black-Bright Red mixture and also Van Dyke Brown on the liner brush. (To load the liner brush, thin the paints to an ink-like consistency by first dipping the liner brush into paint thinner. Slowly turn the brush as you pull the bristles through the paints, forcing them to a sharp point.) Apply very little pressure to the brush, as you shape the trunks, limbs and branches. (Photo 7.)

Use a mixture of Bright Red and Midnight Black on the 2" brush and long horizontal strokes to under-paint the lower portion of the canvas. This will just be shadows in the snow. (Don't forget, you need this dark in order to show light.) (Photo 8.)

Load a clean, dry 2" brush with Titanium White and a very, very small amount of Bright Red (use Phthalo Blue in the shadowed areas). With horizontal strokes, add the snow-covered ground area at the base of the background trees (Photo 9) carefully forming the lay-of-the-land (Photo 10).

WATER

Again, with the Bright Red-Midnight Black mixture on the 2" brush, just use "pull-straight-down" strokes to add the water. (Photo 11.) You can also use small amounts of all the Yellows (to reflect the sky colors) and then lightly brush across, to blend. Re-define the snow-covered edges of the water with Titanium White on the large brush.

Use a thin mixture of Liquid White and Titanium White on the knife for the water lines. To load the knife with a small roll of paint, first pull the mixture out very flat on your palette. With the handle of the knife straight up, just "cut" across the mixture. (Holding the handle straight up will force the small roll of paint to the very edge of the knife blade.) Use scrubbing, horizontal strokes to add the frozen water's edge. (Photo 12.) Make sure these lines are basically straight (parallel to the top and bottom edges of the canvas) otherwise, your water will run right off the canvas! (Photo 13.)

TREES

You can use the knife or the fan brush to paint the larger background tree trunks. With the knife, load the long edge of the blade with a very small roll of Van Dyke Brown. Holding the knife vertically, use a series of short, horizontal strokes to paint the trunk. Start at the base of the tree and work upward. Notice that the base of the tree is thicker than the tree top. *(Photo 14.)*

To use the fan brush, load the brush with Van Dyke Brown. Holding the brush vertically, start at the top of the tree and just pull down. Apply more pressure to the brush as you near the base of the tree to create the thicker bottom of the trunk. *(Photo 15.)*

Load the long edge of the knife with a small roll of Titanium White. Touch the left sides of the trunks and curve the stroke to the right, to highlight. Now you have birch trees! *(Photo 16.)*

Again, load the liner brush with very thin Van Dyke Brown to add the limbs and branches to the trees. *(Photo 17.)* Use thinned Titanium White on the liner brush to add the snowy details to the base of the tree trunks. *(Photo 18.)*

FOREGROUND

Use Titanium White on the 2" brush to add the foreground snow areas (still paying close attention to the lay-of-the-land) *(Photo 19)* then cut in the water lines, again using Titanium White and Liquid White on the long edge of the knife.

The small tree trunk in the foreground is added with thinned Van Dyke Brown on the liner brush. *(Photo 20.)* By turning and wiggling the brush, you can give the trunk a gnarled appearance. Don't forget to add the small details (sticks and twigs) at the base of the tree. *(Photo 21.)*

FALLING SNOW

Load the fan brush with a very thin mixture of paint thinner and Liquid White. Hold the brush away from the canvas and pull the blade of the knife across the bristles of the brush, allowing paint-droplets to sprinkle onto the surface of the canvas. *(Photo 22.)* (It is a good idea to practice several times before you do this on your painting.)

FINISHING TOUCHES

You can use thinned Van Dyke Brown on the liner brush to add long grasses or other small details and your masterpiece is finished. You have just created a "warm" winter scene. *(Photo 23.)*

Don't forget to sign your name with pride: Again, load the liner brush with thinned color of your choice. Sign just your initials, first name, last name or all of your names. Sign in the left corner, the right corner or one artist signs right in the middle of the canvas! The choice is yours. You might also consider including the date when you sign your painting. Whatever your choices, have fun, for hopefully with this painting you have truly experienced THE JOY OF PAINTING!

Snowfall Magic

1. Use criss-cross strokes to paint the sky . . .

2. . . . then blend with the 2" brush.

3. Start with a light mixture on the 2" brush . . .

4. . . . and then change to a darker mixture . . .

5. . . . to tap in the background trees.

6. Use a thinned mixture on the liner brush . . .

Snowfall Magic

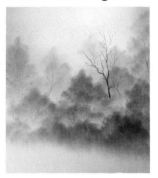

7. . . . to paint the background tree trunks.

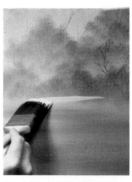

8. Under-paint the lower portion of the canvas . . .

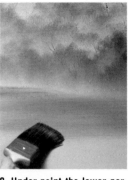

9. . . . before painting the snow . . .

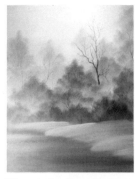

10. . . . paying close attention to the lay-of-the-land.

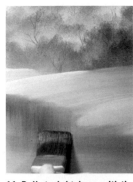

11. Pull straight down with the 2" brush to paint water . . .

12. . . . then use thinned White on the knife . . .

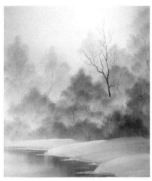

13. . . . to cut in the frozen water's edge.

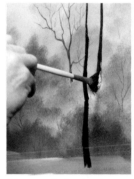

14. Paint tree trunks with the knife . . .

15. . . . or the fan brush . . .

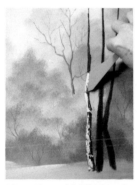

16. . . . then with White on the knife, they become birch trees.

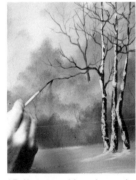

17. Use very thin paint on the liner brush . . .

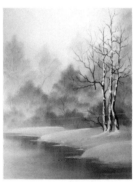

18. . . . to add limbs and branches to the trees.

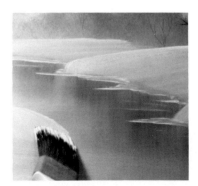

19. Add more snow . . .

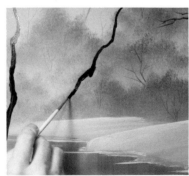

20. . . . and another tree . . .

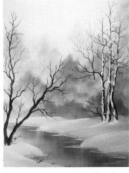

21. . . . to complete the foreground.

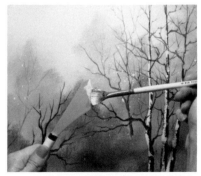

22. "Flip" thinned White off the edge of the knife . . .

23. . . . to create falling snow, and your masterpiece is finished.

245

MATERIALS

2" Brush	Prussian Blue
1" Brush	Midnight Black
#6 Filbert Brush	Dark Sienna
#6 Fan Brush	Van Dyke Brown
#3 Fan Brush	Alizarin Crimson
#2 Script Liner Brush	Sap Green
Large Knife	Cadmium Yellow
Masking Tape	Yellow Ochre
Liquid White	Indian Yellow
Titanium White	Bright Red
Phthalo Blue	

Start by placing strips of masking tape on the canvas to form a square-within-a-square. (Photo 1.)

Use the 2" brush to cover the entire canvas with a thin, even coat of Liquid White. Do NOT allow the Liquid White to dry before you begin.

SKY

Load the 2" brush by tapping the bristles into a small amount of Yellow Ochre. Starting at the top right corner of the canvas, and working downward, use criss-cross strokes to begin painting the sky. Notice how the color blends with the Liquid White already on the canvas and automatically the sky becomes lighter as it nears the horizon. Load a clean, dry 2" brush with a small amount of Midnight Black and use criss-cross strokes to paint the left side of the sky. Blend the entire sky with long, horizontal strokes.

MOUNTAIN

The mountain is made with the knife and a mixture of Midnight Black, Phthalo Blue and Alizarin Crimson. With firm pressure, shape just the top edge of the mountain. (Photo 2.) When you are satisfied with the basic shape of the mountain top, use the knife to remove any excess paint. Then, with the 2" brush, blend the paint down to the base of the mountain, creating the illusion of mist. (Photo 3.)

Highlight the mountain with Titanium White. Load the long edge of the knife blade with a small roll of paint. Starting at the top (and paying close attention to angles) glide the knife down the right side of each peak, using so little pressure that the paint "breaks". (Photo 4.) Use a mixture of Titanium White with a small amount of Phthalo Blue, applied in the opposing direction, for the shadowed sides of the peaks. Again, use so little pressure that the paint "breaks".

Diffuse the base of the mountain by tapping with a clean, dry 2" brush, carefully following the angles (Photo 5) then gently lift upward to create the illusion of mist.

FOOTHILLS

Load the 2" brush with a mixture of the mountain color (Midnight Black, Phthalo Blue and Alizarin Crimson) and Titanium White. Tap downward with one corner of the brush to shape the foothills at the base of the mountain. (Photo 6.)

Re-load the 2" brush with the same mixture and use long, horizontal strokes to underpaint the water on the lower portion of the canvas.

Still with the same mixture on the 2" brush, use downward strokes to reflect the foothills into the water.

With a small roll of Liquid White on the edge of the knife, use firm pressure to cut in the water lines at the base of the foothills.

BACKGROUND

Load the 1" brush with a dark-tree mixture of Midnight Black, Phthalo Blue, Prussian Blue, Alizarin Crimson and Sap Green. Holding the brush vertically, tap downward to indicate just the impression of distant trees. (Photo 7.) Pull some of the color straight down into the water for reflections (Photo 8) then lightly brush across. Use the 2" brush to firmly tap the base of the trees (Photo 9) creating the illusion of mist.

Add a small amount of Van Dyke Brown to the dark-tree mixture and use the 2" brush to tap in the grassy area at the

247

base of the small trees. Working forward in layers, continue reflecting the dark color into the water.

Starting at the base of the distant trees, begin highlighting the soft grassy area by adding various mixtures of all of the Yellows and Bright Red to the 2″ brush. Load the 2″ brush by holding it at a 45-degree angle and tapping the bristles into the various paint mixtures. Allow the brush to "slide" slightly forward in the paint each time you tap (this assures that the very tips of the bristles are fully loaded with paint). Hold the brush horizontally and gently tap downward. *(Photo 10.)*

Working forward in layers, use the dark-tree mixture on the small fan brush to tap in the indication of tiny evergreens. *(Photo 11.)* Continue highlighting the grassy areas, carefully creating the lay-of-the-land. *(Photo 12.)*

EVERGREENS

Load the large fan brush to a chiseled edge with a mixture of Prussian Blue, Midnight Black, Alizarin Crimson and Sap Green. Holding the brush vertically, touch the canvas to create the center line of each tree. Use just the corner of the brush to begin adding the small top branches. Working from side to side, as you move down each tree, apply more pressure to the brush, forcing the bristles to bend downward and automatically the branches will become larger as you near the base of each tree. *(Photo 13.)*

Add the trunks with a small roll of a mixture of Titanium White and Dark Sienna on the knife. *(Photo 14.)* Use the fan brush to very lightly touch highlights to the branches with a mixture of the dark tree color and the Yellows.

Use Van Dyke Brown on the edge of the knife to add the banks to the water's edge *(Photo 15)* then highlight the banks with a mixture of Titanium White and Van Dyke Brown. Use the Yellow highlight mixtures on the fan brush and push-up strokes to add small bushes and patches of grass to the banks.

FOREGROUND

Underpaint the leafy trees and bushes in the foreground with the dark-tree mixture on the 1″ brush. *(Photo 16.)*

To highlight the trees and bushes, first dip the 1″ brush into Liquid White. Then, with the handle straight up, pull the brush (several times in one direction, to round one corner of the bristles) through various mixtures of all of the Yellows, Bright Red and Sap Green.

With the rounded corner of the brush up, touch the canvas and force the bristles to bend upward to highlight the individual trees and bushes. *(Photo 17.)*

Add the foreground tree trunks with Van Dyke Brown and the liner brush. *(Photo 18.)* By turning and wiggling the brush you can give your trunks a gnarled appearance. *(Photo 19.)*

Very carefully remove the masking tape from your canvas *(Photo 20)* to expose the square-within-a-square *(Photo 21)*.

Again, use the liner brush to "weave" the foreground tree trunks through the squares. *(Photo 22.)*

FINISHING TOUCHES

Add the large foreground evergreen *(Photo 23)* and your masterpiece is complete *(Photo 24)*!

Dimensions

1. Prepare a square-within-a-square with masking tape.

2. Shape the mountain top with the knife . . .

3. . . . then blend the paint down with the 2″ brush.

4. Use the knife to highlight the mountain . . .

5. . . . then tap the base with the 2″ brush.

6. Use the 2″ brush to tap in foothills.

7. Tap in small trees with the 1″ brush . . .

Dimensions

 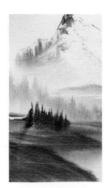 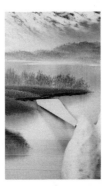

8. . . . then reflect them with the 2" brush.

9. Firmly tap with the 2" brush . . .

10. . . . then begin highlighting with the 2" brush.

11. Tap down the indication of small trees . . .

12. . . . then continue highlighting soft grass.

13. Paint more distinct trees with the fan brush.

14. Add trunks . . .

15. . . . and banks with the knife.

 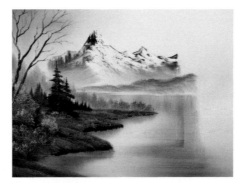

16. Underpaint foreground trees and bushes . . .

17. . . . then apply highlights with the 1" brush.

18. Use thinned paint on the liner brush . . .

19. . . . to paint the foreground tree trunks.

20. Very carefully remove the masking tape . . .

21. . . . from the painted canvas.

22. "Weave" the tree trunks through the squares . . .

23. . . . add a large evergreen . . .

24. . . . and your masterpiece is complete.

MATERIALS

2" Brush	Dark Sienna
#6 Fan Brush	Van Dyke Brown
#2 Script Liner Brush	Alizarin Crimson
Large Knife	Sap Green
Black Gesso	Cadmium Yellow
Liquid Clear	Yellow Ochre
Titanium White	Indian Yellow
Phthalo Blue	Bright Red
Midnight Black	

Start by using a foam applicator to apply a thin, even coat of Black Gesso over the entire canvas. Allow the Black Gesso to DRY COMPLETELY. *(Photo 1.)*

When the Black Gesso is dry, use the 2" brush to cover the entire canvas with a VERY THIN coat of Liquid Clear. (It is important to stress that the Liquid Clear should be applied VERY, VERY sparingly and really scrubbed into the canvas! The Liquid Clear will not only ease with the application of the firmer paint, but will allow you to apply very little color, creating a glazed effect.) Do NOT allow the Liquid Clear to dry.

Still using the 2" brush, cover the Liquid Clear with a very thin, even coat of a mixture of Sap Green, Phthalo Blue and Van Dyke Brown. Do NOT allow the canvas to dry before you begin.

Load the 2" brush with Titanium White and starting at the top of the canvas, use circular strokes to paint the sky. *(Photo 2.)* As you work down towards the horizon, notice how the White blends with the color already on the canvas. Be very careful not to completely cover the canvas, allow some dark areas of the canvas to remain. *(Photo 3.)*

BACKGROUND

Load the fan brush with Midnight Black, hold the brush vertically and starting at the top of the canvas, pull down the most distant, tall tree trunks with single, long strokes. Apply more pressure to the brush near the base of each trunk for added width. *(Photo 4.)*

Load the knife with a very small roll of a mixture of Titanium White and a small amount of Bright Red. Hold the knife vertically and tap highlights to the right sides of the trunks. *(Photo 5.)*

Use a mixture of Titanium White, Phthalo Blue and a small amount of Midnight Black for reflected light on the left sides of the trunks.

Add the limbs and branches to the trunks with a mixture of Midnight Black, Dark Sienna and Van Dyke Brown on the liner brush. (To load the liner brush, thin the mixture to an ink-like consistency by first dipping the liner brush into paint thinner. Slowly turn the brush as you pull the bristles through the mixture, forcing them to a sharp point.) Apply very little pressure to the brush as you shape the limbs and branches. By turning and wiggling the brush, you can give the branches a gnarled appearance. *(Photo 6.)*

Load the 2" brush with various mixtures of all of the Yellows, Midnight Black, Sap Green and Bright Red. Tap downward with one corner of the brush to add foliage to the distant trees and to shape the small bushes at the base of the trees. *(Photo 7.)*

Use the same mixtures to highlight the soft grassy area at the base of the trees. Load the 2" brush by holding it at a 45-degree angle and tapping the bristles into the various paint mixtures. Allow the brush to "slide" slightly forward in the paint each time you tap (this assures that the very tips of the bristles are fully loaded with paint). Hold the brush horizontally and gently tap downward. Work in layers, carefully creating the lay-of-the-land. If you are also careful not to destroy all of the dark color already on the canvas, you can create grassy highlights that look almost like velvet. *(Photo 8.)*

FOREGROUND

Paint the large trunks by holding the fan brush horizontally *(Photo 9)* and again add highlights and foliage *(Photo 10)*.

Continue working forward in layers with tree trunks, highlights, foliage and soft grassy areas.

Load the knife with a small roll of a mixture of Titanium White and Dark Sienna. Hold the knife horizontally and with firm pressure, scrub in the indication of a path meandering through the trees. (Photo 11.)

FINISHING TOUCHES

Use the point of the knife to scratch in the indication of small sticks and twigs and the painting is complete. (Photo 12.)

Don't forget to sign your painting: Again, load the liner brush with thinned color of your choice. Sign just your initials, first name, last name or all of your names. Sign in the left corner, the right corner or one artist signs right in the middle of the canvas! The choice is yours. You might also consider including the date when you sign your painting. Whatever your choices, have fun, for hopefully with this painting you have truly experienced THE JOY OF PAINTING!

Silent Forest

1. Paint the canvas with Black Gesso.

2. Use circular strokes . . .

3. . . . to paint the sky.

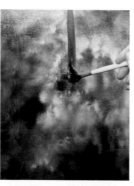

4. Paint tree trunks with the fan brush . . .

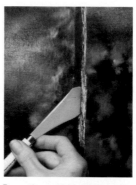

5. . . . then add highlights with the knife.

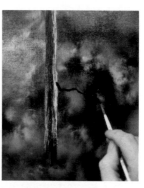

6. Use the liner brush to paint limbs and branches.

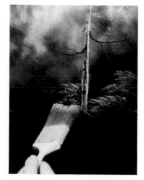

7. Use the 2" brush to highlight small bushes . . .

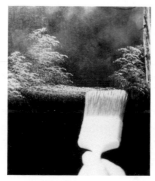

8. . . . and soft grassy areas.

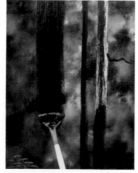

9. Work forward with tree trunks . . .

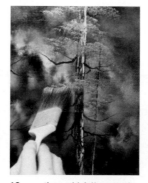

10. . . . then add foliage to the trees with the corner of the 2" brush.

11. Use the knife to scrub in the indication of a path . . .

12. . . . and the painting is ready for a signature.